Passion for the Mountains

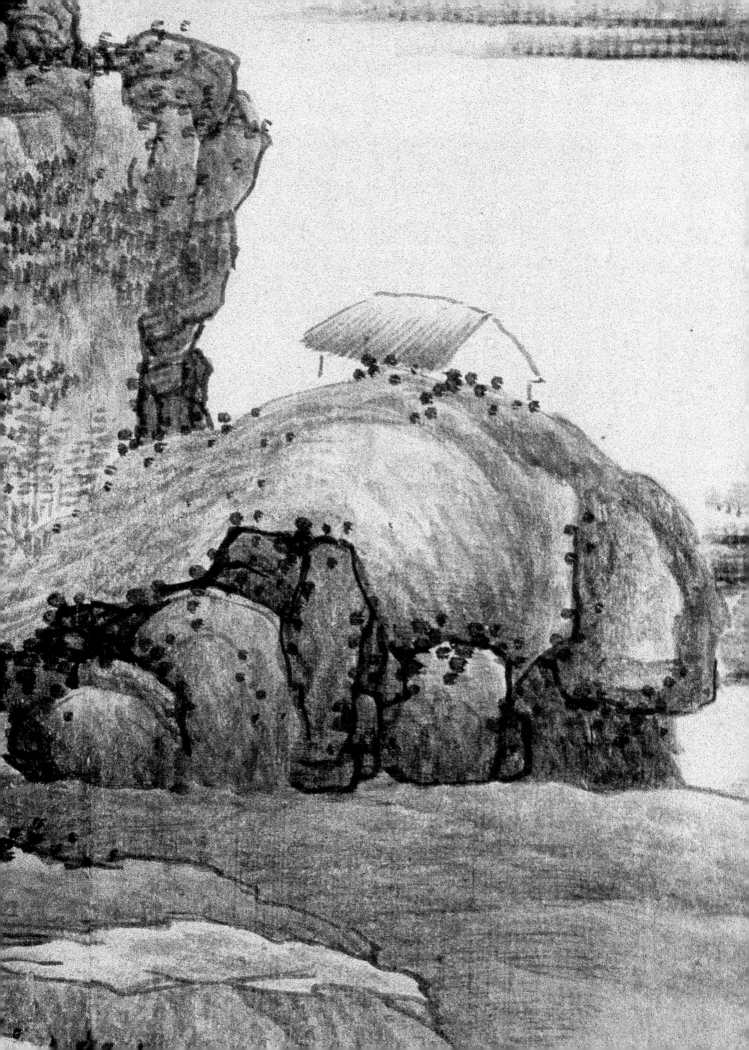

Passion for the Mountains

Seventeenth Century Landscape Paintings
from the Nanjing Museum

Willow Weilan Hai Chang

With an essay by Chu-tsing Li
Poems translated by Ben Wang

China Institute Gallery
China Institute
New York
2003

Distributed by Art Media Resources, Ltd.

This catalog was published to accompany the exhibition
Passion for the Mountains: Seventeenth Century Landscape Paintings from the Nanjing Museum,
organized by China Institute Gallery
in collaboration with the Nanjing Museum.

China Institute Gallery
125 East 65th Street
New York, NY 10021
212-744-8181
September 18–December 20, 2003

**Advisory Committee: Robert Harrist, Maxwell K. Hearn,
H. Christopher Luce and David Ake Sensabaugh**
Editors: J. May Lee Barrett, H. Christopher Luce, Kathleen Ryor
Designer: Peter Lukic
Photo courtesy: Nanjing Museum
Printed by Pressroom Printer and Designer, Hong Kong

Chinese is romanized in the *pinyin* system throughout the text and bibliography except for the names of Chinese authors writing in Western languages. Chinese terms cited in Western-language titles remain in their original form and have not been converted.

China Institute was founded in 1926 by American philosopher John Dewey and Chinese educator Hu Shih, together with other prominent educators. It is the oldest bi-cultural and educational organization in the United States with an exclusive focus on China and is dedicated to promoting the understanding, appreciation, and enjoyment of Chinese civilization, culture, heritage, and current affairs through classroom teaching and seminars, art exhibitions, public programs, teacher education, lectures and symposia.

Cover illustration and Frontispiece: detail (cat. no. 18)
Gong Xian (1618–1689)
A Thousand Cliffs and Myriad Valleys
1673
Handscroll, ink on paper

CONTENTS

SPONSORS OF THE EXHIBITION

*This exhibition and catalog have been made possible in part through the generous support of the following**

BENEFACTOR

Robert T. and Kay F. Gow

PATRONS

Blakemore Foundation
Lee Foundation, Singapore

LEADERS

E. Rhodes and Leona B. Carpenter Foundation
John R. and Julia B. Curtis
H. Christopher Luce and Tina Liu
NYSCA **
Mary & James G. Wallach Foundation

CONTRIBUTORS
Susan L. Beningson
New York Council for the Humanities ***
The Rosenkranz Foundation, Inc.
Mr. and Mrs. Henry H. Weldon

SUPPORTERS

Michael E. and Winnie Feng
J. J. Lally & Co.
Margro R. Long
Pacific Holidays, Inc.
Jane and Leopold Swergold
Charlotte C. Weber
Marie-Hélène and Guy A. Weill
Laurie and David Y. Ying

INDIVIDUALS

Mrs. Christopher C.Y. Chen
Robert H. Ellsworth
Angela H. King
Robert W. and Virginia Riggs Lyons
Clare Tweedy McMorris
Metropolitan Center for Far Eastern Art Studies
Lillian S. Schloss
Wilson Nolen
Theresa M. Reilly
Chi-Chuan Wang
Wan-go H.C. Weng
Kathleen and Dennis C. Yang

We are also grateful for the continuing support to China Institute Gallery from

The Henry Luce Foundation
The Starr Foundation
China Institute's Friends of the Gallery

*At time of printing

**This exhibition and publication is made possible with public funds from the New York State Council on the Arts, a State Agency.

***New York Council for the Humanities, a state program of the National Endowment for the Humanities. Any views, finding, conclusions or recommendations expressed in this publication do not necessarily represent those of the National Endowment for the Humanities.

MESSAGE FROM THE BOARD OF TRUSTEES

The China Institute, which has devoted itself since 1926 to fostering the understanding of Chinese culture, is proud to present the first exhibition it has originated from artworks entirely from the People's Republic of China. This project took no small amount of determination across such large distances. Publishing texts in Chinese as well as English is but one example of the many efforts to achieve mutual cooperation between Chinese and Western scholars. This exhibition thus fulfills China Institute's mission to educate the American public about China, to increase communication and exchange with China and to advance scholarship in the art historical community around the world.

Therefore, on behalf of the Trustees of the China Institute, I would like to thank Xu Huping, Director of the Nanjing Museum, and his able staff for the generous loan of so many treasures from their collection. It is the first time these paintings have been seen in America, but I hope it will not be the last.

The Institute is fortunate to have as its Gallery Director, Willow Hai Chang, a native of Nanjing. It was her connection with the curators at the Nanjing Museum which made possible this exhibition, and it is their deep familiarity with the city of Nanjing, its history and its people that brings so much texture to the story. For, whereas this catalog records an art exhibition which places these paintings in their art historical context, it also richly records that particular place at a specific moment of great ferment and creativity. The narrative flow breathes life into those times, places and people—one visualizes merchants hawking their wares, party-goers floating by on candle-lit boats, students making pilgrimages to private libraries, scholars escaping the heat by reading in the mountains and connoisseurs tasting teas while listening to music.

As a guest curator of exhibitions in this art gallery myself, and the principal editor of this text, I know by my own experience how much work Willow Hai Chang has had to do—her hours of research and writing in both Nanjing and New York, scheduled so as not to interfere with her duties as Gallery Director. I would particularly like to thank the tireless efforts and inspired advice we received from Robert Harrist, Maxwell Hearn, Kathleen Ryor and David Sensabaugh, without whose professional guidance this project would not have been possible.

I hope you take advantage of this rare opportunity to see, in person, these great works of art from Nanjing.

H. Christopher Luce

華美協進社自一九二六年成立以來，便致力于從各個方面來深入地介紹中國的文化和藝術。今天，本社為能首次在我美術館展出全部來自中華人民共和國的美術作品而感到分外驕傲。這次展覽的成功，主要是由於中美雙方的決心和毅力，從中英文的詩文介紹和詮述中，就可見一斑。這一展覽正是中美學者共同努力合作和籌劃的結果，從而真正體現了華美協進社向美國人民介紹中國的文化遺產，增進中美之間的理解和交流，促進世界美術史的學術研究等各方面的神聖宗旨。

因此，我要在此代表華美協進社董事會，向南京博物院的院長徐湖平先生，以及貴院的全體工作人員，致以由衷的感謝。南京博物院將自己的珍藏，惠借給華美協進社中國美術館的盛舉，是空前的，我相信也將不會是絕無僅有的。

本社極以海蔚藍女士為華美協進社中國美術館的館長為榮。海蔚藍女士身為南京人，完全是由于她與南京博物院的長久聯絡和友誼，此次展覽才得以成功。更由于上述各位對南京歷史與人文的深刻了解，該展覽才能包涵如此精彩的內容，展覽的圖錄不僅介紹了作品的歷史次序，並且介紹了作品之所以產生的豐富的文化背景和創造來源，加以作品中優美的詩篇，讓觀眾和讀者深深地感受到那一時代，那一城市和人民的生活狀態，例如商人的辛勞經營，遊人的蕩漾燈舟，學子的孜孜求學，高士的山居讀書，品茗賞鑒等等，都一一地呈現于眼前。

我曾為華美協進社中國美術館的客座展覽策劃，此次擔任展覽圖錄的主要英文編輯，當然深知海蔚藍女士在不忽略館長的職責的同時，奔波于南京和紐約，為籌備展覽和撰寫圖錄所作出的大量工作。我更要特別感謝韓文彬，何慕文，賴愷玲和江文葦諸君不可或缺的大力指導和幫助。

這次展覽十分難得，我亟盼紐約愛好文藝的人士，都能前來欣賞這些遠渡重洋的珍貴畫作。

路思客

FOREWORD

The waning decades of the Ming and the dawning years of the Qing, marked by the sheer force of its creativity, comprise the most significant era in the history of traditional Chinese painting, when a large group of towering and influential master painters emerged with their different styles of painting. In time an important new school took shape in the city of Nanjing and its vicinity, a political and cultural center of that period. This is none other than the Jinling School of Nanjing, where as many as over a thousand fine painters toured, lived and worked within a short span of one and a half centuries. Some masters, such as Dong Qichang, Xiao Yuncong and Shitao, resided periodically in Nanjing, while other great artists, such as Kuncan, Cheng Zhengkui and Gong Xian, made their permanent home in the city. It was in this very city of Nanjing that these artists lived their most glorious and productive years, leaving to the world their timeless and precious legacy of their art. The title *Eight Masters of Jinling*, a group headed by Gong Xian, has become a synonym for the Jinling School, whose high level of artistic merit finds its full manifestation in the works of its three leading members: Kuncan, Cheng Zhengkui and Gong Xian. Indeed, their works represent the peak of the Jinling School and a brilliant, memorable new avenue for Chinese painting during the Ming and Qing dynasties.

Coming from different parts of the country, painters of the Jinling School had markedly different cultural backgrounds. But they had one characteristic in common: their high level of cultivation in matters of scholarship and learning. For example, Kuncan was steeped in Buddhist studies. His dedicated research and practice of Buddhism and his editorial work on the Buddhist *Grand Hidden Scripture* are well reflected in his art. Gong Xian, another case in point, was much influenced by the artistic spirit and theory of Dong Qichang; he placed emphasis on the absorption and continuation of traditional Chinese culture. As for Cheng Zhengkui, he incorporated his profound understanding of Confucianism and his rich experience in traveling to magnificent scenic spots all over China into his paintings and developed his own artistic style.

Thus, built on the foundation of maintaining tradition while stressing each artist's own individuality, the Jinling School also focused on the artists' keen observation and full appreciation of nature, as well as the expression of their inner feelings through nature. Gong Xian's profound observations of light, mist, smoke and mountain haze in nature resulted in his realization that there existed the illusory in the real and the real in the illusory—a realization that culminated in paintings that reached such a high realm of magic and poetry that many Western art critics have lavished praise on Gong Xian's works, proclaiming them to be works of "Oriental Realism."

Because of the tumultuous historical background against which the Jinling Painting School was born, the hearts of Chinese artists who witnessed the demise of the Chinese Ming monarchy and the rise of the Manchu dynasty were filled with fierce nationalism and patriotism. As conquered but unbending literati, their works reflect the feelings and thoughts of artists holding adamantly onto inflamed nationalistic senti-ments. All of this contributed to the general cultural and artistic characteristics of the Jinling School of Painting. The originality, artistic concepts and some special painting techniques manifested in the works of the Jinling School exerted immeasurable influence on and enlightened other painting schools of the day in the surrounding areas, such as the Anhui School and the Yangzhou School. The influence was such that some subsequently became branches of the Jinling School. Thanks to the creative activities of the artists of Jinling, the artistic magic and spell of their works have endured and will flourish forever.

With the exhibition of *Passion for the Mountains: Seventeenth Century Landscape Paintings from the Nanjing Museum* at the China Institute Gallery in New York, we wish to offer an opportunity for more people to enjoy the landscape paintings of this specific school and thereby erect a finer cultural bridge of understanding and appreciation between the citizens of the People's Republic of China and the United States of America.

Xu Huping
Director
The Nanjing Museum

(Translated by Ben Wang)

明末清初，是中國繪畫史上最具有創造活力的一個特殊的歷史時期，繪畫風格流派紛呈，誕生了一大批在繪畫史上极具有影響力的宗師巨匠。由于特殊的政治、文化位置，南京（即金陵）地區逐漸形成了一個新的繪畫流派：金陵畫派。在前後不到一百五十年的時間內，在這裏生存了數以千計的藝術家，他們不斷來南京游歷、定居，如董其昌、蕭雲從、石濤（石濤在南京居留長達九年）等人均在南京停留過，髡殘、程正揆、龔賢則長期定居南京。這些优秀的藝術家，在南京度過了他們輝煌的藝術創造期，留下了諸多的繪畫精品。以龔賢為首的"金陵八家"已經成為金陵畫派的代名詞。髡殘、程正揆、龔賢作為金陵畫派的三大家，更是代表了金陵畫派的最高水平，在中國明清美術史上寫下了亮麗的一筆。

金陵畫派的畫家來自不同的地區，帶來了不同的文化因素，其中最為明顯的特點便是注重文化修養。如髡殘有着深厚的佛學基礎，他的繪畫是在校閱《大藏經》和不斷的佛學修養的基礎上進行的；龔賢的畫風來自與董其昌繪畫思想的理論影響，注重傳統文化的繼承和吸收；程正揆則有着深厚的儒學根基和遍閱祖國山川的經歷，熔鑄為繪畫，成就自己的繪畫風格。在注重傳承和個性的基礎上，金陵畫派也注重對自然的觀察、體悟，借自然山水來表述自己內心的感受。如龔賢對于光、霧、煙、嵐的深刻觀察，實境中有幻境，幻境中有實境，在畫面上形成了如夢如幻的詩意境象，以致于某些美術史家認為是"東方現實主義"的繪畫，給以高度的評價與讚揚。由於金陵畫派誕生于明末清初，大多數畫家經歷了明清巨變，因而具有深刻的民族意識、民族感情和愛國主義情懷，是一極具有民族氣節的遺民畫家群體，他們的思想感情在畫面中都有所反映。這些都構成了金陵畫派繪畫的整體文化特徵。他們所表現出來的藝術原創力和繪畫觀念乃至一些繪畫方法，也給週邊地區的繪畫流派如黃山（安徽）畫派、揚州畫派以相當的影響和啟迪，有些則是金陵畫派的延伸。正是金陵畫家們的創造活動，使金陵畫派產生了永恒的藝術魅力。

我們來美麗的美利堅合眾國的華美協進社中國美術館舉辦"金陵畫派展覽"，旨在讓更多的民眾欣賞領會"金陵畫派"高雅的繪畫藝術，架起中美人民互相溝通、理解的文化橋樑。是為前言。

徐湖平
南京博物院院長
二零零三年春日

PREFACE

The idea for this exhibition was conceived about five years ago. Living far from my home in Nanjing, I have come to consider New York my home city. In many ways modern New York City resembles seventeenth-century Nanjing as a center for art, literature, performance and book publishing. Often referred to by its ancient name, Jinling, Nanjing was one of the four most famous ancient capitals of China and a noteworthy locus of landscape painting in the seventeenth century. Surprisingly, Nanjing is not well known to the rest of the world. It was to share my love for this city and its cultural heritage that I approached the Nanjing Museum with a proposal to borrow from their superb collection for this exhibition. From the very beginning, two essays were planned for the exhibition catalog: one to introduce the historical and cultural background of the city as well as the social and physical environment of its artists in the seventeenth-century, and the other, written by Professor Chu-tsing Li, to introduce the art of the Nanjing School. The exhibition itself is organized thematically in three parts, the first to explore the physical landscape of Nanjing, the second, its fashionable life styles and the third, the artists' self-expression through painting. The florescence of Nanjing landscape painting was a great phenomenon of the time, and I was glad to discover one of the motivations for the theme in a colophon by the seventeenth-century artist Liu Yu. He points out in this colophon (see cat. no. 3) that "the mountains of home are a joy forever" or "one's passion is only for the mountains of home" (*wei you jia shan bu yan kan*). Such a passion underlies all the Jinling landscape paintings and is timelessly contagious.

Over a thousand artists, including some who were very distinguished, gathered in Nanjing over the course of the seventeenth century. Yet, the designation of a Jinling School is still controversial, mainly because the definition of a school is arbitrarily based on the traditional criteria of its teachers' lineage and a uniform style among the artists in the group. However, from the artwork created by the Nanjing masters, we may see that they made a clear effort to pursue their own style rather than follow that of others, especially in such a major metropolis where the influences and interactions of many schools can be encountered. This pursuit of individualism, which hints at a more modern attitude about the value of an artist, can be seen as one characteristic of a Jinling School. Furthermore, many similarities can be found throughout their works: the subject of the painting, some of the painting techniques, the motivation of the artist and the expression of personal cultivation. From a broader perspective, all of these similarities are worth considering in the designation of the Jinling masters as a school.

In this original China Institute Gallery project and international collaboration with a Chinese museum, it was determined that the exhibition catalog should be published in two languages. To suit the different needs of Chinese and English readers, the two texts do not directly match. The English version is shortened while the Chinese version goes into more detail for the benefit of more scholarly readers.

The completion of this project comes after several years of work with the help and support of many people. I am greatly indebted to all of them. First of all, I would like to thank Director Xu Huping of the Nanjing Museum for granting the loan and for being so accommodating in making the exhibition possible, including providing all the transparencies and assigning Zhuang Tianming, Lin Bo, Liu Sheng, Zhu Xiaoguang and Zhou Guangyi to assist in examining the artwork and to make the numerous necessary arrangements.

My heartfelt thanks go to the various foundations and individual patrons whose contributions made this project possible. I am particularly indebted to Robert T. and Kay Gow for their generosity in initiating an endowment to fund China Institute Gallery's exhibitions and exhibition catalogs. My gratitude is also extended to all the Friends of the Gallery; their interest is a driving force behind the activities of China Institute Gallery.

14

The trustees of the China Institute have been a source of continuing support and encouragement. I am also indebted to the Gallery Committee, chaired by John Curtis, in particular, members of the special Advisory Committee of this project, H. Christopher Luce, Maxwell K. Hearn, Robert E. Harrist and David Sensabaugh, who offered their advice and expertise to ensure the scholarly integrity and quality of the catalog. Within China Institute, I would like to thank gallery staffers Leigh Tyson and Pao Yu Cheng for their diligent work in handling the numerous tasks and details involved in a complex project. My sincere thanks also go to all the gallery docents, volunteers and interns for their invaluable and selfless service. In addition, the entire staff of China Institute, under the president, Jack Maisano, lent their support when needed. The vice president, Nancy Jervis, supervised the related exhibition symposium and made valuable suggestions in the planning of this project. Furthermore, it was Dr. Jervis who sparked my curatorial career ten years ago.

A team of independent specialists and professionals contributed their best efforts to the completion of this project. My thanks go to J. May Lee Barrett for her careful editing of the original manuscript and her insightful suggestions ensuring that the text conveys the author's thoughts in a clear and lively manner; to Perry Hu for an exhibition design and installation which enhances the beauty and significance of the artwork; to Peter Lukic for the handsome design of this catalog and the graphics for the exhibition; and to Nicole Straus and Margery Newman for working to bring the exhibition to the attention of the public.

China Institute Gallery has over the course of time benefited from the generous friendship of scholars and art experts. This exhibition is no exception. Professor Chu-tsing Li contributed an essay to the catalog and suggested the initial list of paintings by the Eight Masters of Jinling, drawing from *The Catalog of Chinese Ancient Painting and Calligraphy*, edited by renowned painting specialist Xie Zhiliu. Ben Wang translated all the Chinese poems and ancient literary quotes which enliven the text. Dr. Ju-hsi Chou, Curator of Chinese art at the Cleveland Museum of Art, and Dr. Joseph Chang, Associate Curator of Chinese Art at the Arthur M. Sackler Gallery and Freer Gallery of Art, approved the final checklist of my selections; Mr. Wan-go Weng and Dr. Chou proofread my essay in the Chinese version and provided valuable suggestions; and Liu Dan helped to refine the exhibition title. Kathleen Ryor, Associate Professor at Carleton College, was called in at the last minute as a special editor to help ensure the quality of the catalog. A special note of thanks goes to Mr. H. Christopher Luce, who worked diligently to help shape the text of the catalog and bring out its poetic beauty. Another special note of thanks goes to Professor Annette Juliano, who brought me to the China Institute Gallery about fifteen years ago: that moment shall always be remembered.

There were many people in China who lent their assistance to this project. My sincere gratitude goes to Professor Zhou Xiaolu of Beijing Normal University for his research assistance over a long period of time. He also assisted me in identifying the calligraphy and seals on each painting, with additional help from Zhou Zhengliang, Hu Minggang, Hai Tao and Wang Yiyu. Professor Jiang Zanchu of Nanjing University and Mr. Liang Baiquan, the former Director of the Nanjing Museum, provided much valuable information and also proofread the Chinese essay.

To my many friends who provided unwavering encouragement and support: although I cannot mention all the names here, you are always in my heart. Finally, I am heavily indebted to my husband Jerry Chang and my two boys, John and Jeffery, who supported me when I devoted myself to the project and neglected them for long periods of time. Thank you.

Willow Weilan Hai Chang
Exhibition Curator and
Director
China Institute Gallery

序

大約五年前，這個展覽的設想在思鄉的愁緒中萌發。去國萬里，總是不由自主地在以之為家的紐約尋找故鄉的足跡。紐約，這個當今世界文學藝術，圖書出版，收藏鑒賞等等的文化中心，從許多方面都仿佛是十七世紀南京的再現。可是這個曾經幾度風雲一時的中國古都，卻很少為世界所知。于是，在與南京博物院商討後，決定通過以金陵八家為首的十七世紀山水畫為媒介，來介紹充滿魅力的南京及其藝術。

展覽申請伊始，便設計兩篇論文，一篇介紹南京的歷史文化背景以及十七世紀的人文環境，另一篇則由李鑄晉教授提供，介紹南京畫派的藝術。展覽則從金陵勝景，生活時尚，山水抒懷三方面來形象地表現十七世紀的南京，藝術家的生活，及其藝術風格和文化內涵。在研究過程中，讀到十七世紀的畫家柳堉以一句"唯有家山不厭看"的古詩，來讚賞金陵藝術家的創作激情，心不禁為之動，對故鄉的熱愛，已為時人所識，正是金陵山水畫的靈魂之所在，而這種熱愛，無論時空的變幻，都具有無限的感染力。

十七世紀的南京，聚集著數以千計的藝術家，然而對于金陵畫派的成立與否，至今仍無定論。若以傳統的標準按照師承和相襲的繪畫風格來確定畫派，那麼在金陵畫家中確實難以找到明顯的跡象，然而若從整體上看，則可注意到金陵畫家在繪畫題材，美學觀念，具體的技法等方面都有著相似之處，尤其是其各各追求個性的表現，在觀念上不啻于當代的藝術家，這種致力于個性化的風格，或可成為一個顯著的特徵，融入對金陵畫派的考慮之中。

這是華美協進社美術館建館三十七年來的第一個原創的國際性展覽，因此展覽圖錄以中英文印行。為適合不同讀者的需求，中英文略有不同，英文部分經編輯而簡要，中文部分則基本保留了原始資料和細節，以便有志之士的進一步研究。

這個項目的大功告成仰賴多方的支持和合作。首先謹向南京博物院的徐湖平院長致意，感謝他允諾和保證了借展的一切事宜，并安排了庄天明，凌波，劉勝，朱小光和周光儀等協助閱覽書畫，和處理各類細節，確保展覽的順利進行。

我衷心感謝所有的基金會和所有支持該展覽的贊助者，尤其對羅伯特和凱。高夫婦的慷慨捐贈深表謝忱。所有的美術館之友，歷來是我美術館的堅強後盾，借此機會，我向所有的朋友們致以不盡的謝意。

我衷心感謝華美協進社董事會的支持，尤其是以約

翰。克特斯為主席的藝術委員會的支持和鼓勵。該項目的顧問委員路思客，何慕文，韓文彬，江文葦，以學者的正義心和特長保證了該展覽圖錄的質量，對此我深懷敬意和感謝。華美協進社的社長梅三樂和同事們給與了該展覽支持，尤其是美術館的館員邱欣麗和鄭寶玉不厭其煩地解決了許多瑣碎細節，還有美術館的解說員，義工和實習生，都為展覽的順利進行作出了貢獻。副社長賈楠監督了展覽討論會的事宜，十年前，由于她的建議，我才開始了展覽策劃的職業生涯，借此機會，一并致謝。

我衷心感謝該項目的技術組成員，鍾美梨不僅以她細緻的編輯工作，忠實和生動地表現了作者的原意，而且還提供了許多有益的建議；胡維智的展覽設計總是為展品增色；皮特。魯克斯的圖錄設計一如既往的精美；尼克爾。斯鑽絲和瑪吉蕊。紐萌的公關宣傳工作，使得展覽為世人所知。

該展覽還得到了美術史界同行和專家的協助，李鑄晉教授貢獻了介紹南京藝術的論文，并基于謝稚柳主編的【中國古代書畫目錄】，在一開始便提供了金陵八家繪畫作品的名單；汪班先生翻譯了所有的古詩文，使拙文頓生華采；克利夫蘭博物館的周如式博士和弗利爾美術館的張子寧博士審閱了由我選擇的全部展品清單；周如式博士和翁萬戈先生還審閱了我的中文論文并提出了可貴的建議。劉丹協助了展覽中文題目的潤色。卡爾頓學院的教授賴愷玲在最後關頭協助了展覽圖錄的編輯；路思客先生長逾三個月的辛勤編輯，尤其使論文和展品的英文介紹顯露了詩意的光采，在此一并致謝。借此機會，我謹向十五年前引介我踏入華美協進社中國美術館的阿耐特。菊麗安教授致以深深的謝意，那一時刻將永遠難忘。

許多中國的同行和專家們也提供了協助，北京師範大學的周曉陸教授在很長時間內，協助了各方面的研究并幫助辨認每張繪畫作品的書法和印章，周正良，胡明綱，海濤和王一羽也提供了相應的各種幫助。南京大學的蔣贊初教授和前南京博物院的梁白泉院長不僅審閱了我的中文論文，而且還提供了許多史料和建議，謹此致以衷心的感謝。

對許多一向鼓勵和支持我的朋友們，盡管我無法一一提及你們的名字，我内心永遠滿懷著感激。最後，我必須向我的丈夫張曉軍先生和兒子張靜山，張海青表示感謝，當我在數年內專心致力于這個項目，而無法顧及他們的的時候，他們給予了理解和支持。謝謝你們。

海蔚藍
華美協進社
中國美術館館長
暨展覽策劃

CHRONOLOGY

Chinese Dynasties and Historical Periods

Golden Age of Antiquity prior to Xia dynasty	
Xia	21st–16th century B.C.
(Erlitou period)	19th–16th century B.C.
Shang	16th–11th century B.C.
Zhou	11th century–256 B.C.
Western Zhou	11th century–771 B.C.
Eastern Zhou	770–256 B.C.
Qin	221–206 B.C.
Han	206 B.C.–A.D. 220
Western Han	206 B.C.–A.D. 9
Eastern Han	A.D. 25–220
Six Dynasties	220–589
Three Kingdoms	220–280
Wu	222–280
Shu Han	221–263
Wei	220–265
Western Jin	265–317
Eastern Jin	317–420
Period of Northern and Southern Dynasties	386–581
Sui	581–618
Tang	618–906
Five Dynasties	907–960
Song	960–1279
Northern Song	960–1127
Southern Song	1127–1279
Jin	1115–1234
Yuan	1279–1368

Ming	1368–1644
Hongwu	1368–1398
Jianwen	1399–1402
Yongle	1403–1424
Xuande	1426–1435
Zhengtong	1436–1440
Jingtai	1450–1457
Tianshun	1458–1464
Chenghua	1465–1487
Hongzhi	1488–1505
Zhengde	1506–1521
Jiajing	1522–1566
Longqing	1567–1572
Wanli	1573–1620
Taichang	1620
Tianqi	1621–1627
Chongzhen	1628–1644
Qing	1644–1911
Shunzhi	1644–1661
Kangxi	1662–1722
Yongzheng	1723–1735
Qianlong	1736–1795
Jiaqing	1796–1820
Daoguang	1821–1850
Xianfeng	1851–1861
Tongzhi	1862–1874
Guangxu	1875–1908
Xuantong	1908–1911

MAP OF CHINA

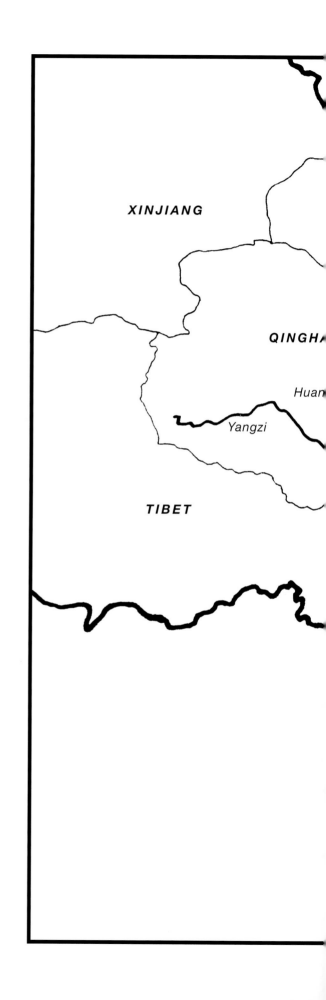

XINJIANG

QINGHA

Huan

Yangzi

TIBET

JILIN

LIAONING

INNER MONGOLIA

HEBEI

Beijing

Tianjin

Lower Huanghe

Upper Huanghe

NINGXIA

SHANXI

Anyang

SHANDONG

Middle Huanghe

GANSU

Xi'an

Zhengzhou

JIANGSU

SHAANXI

HENAN

ANHUI

Lower Yangzi

Nanjing

Shanghai

HUBEI

SICHUAN

Middle Yangzi

ZHEJIANG

JIANGXI

HUNAN

FUJIAN

GUIZHOU

YUNNAN

GUANGXI

GUANGDONG

TAIWAN

HAINAN

21

THE SOCIAL MILIEU OF SEVENTEENTH-CENTURY NANJING

Willow Weilan Hai Chang

Nanjing, whose ancient name Jinling means "Gold Mountain," was one of the four most famous ancient capitals of China, along with Xi'an, Luoyang and Beijing (Fig. 1). Today, it is the modern capital of Jiangsu Province. During its long history, Nanjing served as the capital of ten different dynasties and kingdoms. For much of its history, it was also the cultural capital of Jiangnan, a general term for the region south of the Yangzi River delta. Despite its importance to Chinese history, however, Nanjing never attained a reputation comparable to those of other capital cities. Nevertheless, given the area's geographic beauty and historic background, a distinct way of life was nurtured there. This allowed Nanjing to play a special role in the development of the region's culture, a role which climaxed in three moments of greatness: during the Six Dynasties period, from the third through the sixth century; the Southern Tang dynasty in the tenth century; and the Ming-Qing dynastic transition in the seventeenth century. During this third moment, Nanjing became a magnet for talented painters from among its residents and across the empire, creating an unusually diverse world of art.

In 472 B.C., during the Eastern Zhou dynasty, Gou Jian, the King of Yue, destroyed the Wu kingdom and ordered his prime minister Fan Li to build a city near the Qinhuai River in the southern part of modern Nanjing, a place named Yuecheng. This was the earliest city to be built there. During the Warring States period (475–221 B.C.), Nanjing was considered important by the various kingdoms competing for supremacy in China. According to *The Gazetteer of Jingding* (*Jingding zhi*), when the Chu kingdom defeated the kingdoms of Yue and Wu in 333 B.C. and occupied their territory, the Chu people buried gold in a local mountain. The *Records of Jiankang* (*Jiankang shilu*) notes that the "King Wei of the Chu kingdom named the city Jinling."[1] Since that time, the name "Jinling" has appeared frequently in literature and artworks regardless of changes in regimes.

It was during the period of the Three Kingdoms following the disintegration of the Han Dynasty that Nanjing played its first significant role in Chinese history. In 229 A.D., one of the leading generals of this contentious period, Sun Quan, declared himself emperor and chose Jianye, present-day Nanjing, for the capital of the Wu dynasty. From that time on, Nanjing continued to be an important center, serving as capital of the following Southern Dynasties (317–589), which, combined with the Wu kingdom, are known as the Six Dynasties (220–589). The site subsequently served as the dynastic capital of several other regimes, meriting Nanjing's sobriquet as "Capital of Ten Dynasties." During its long history the site had more than a dozen names (see Appendix I), but Jinling was the most commonly used.

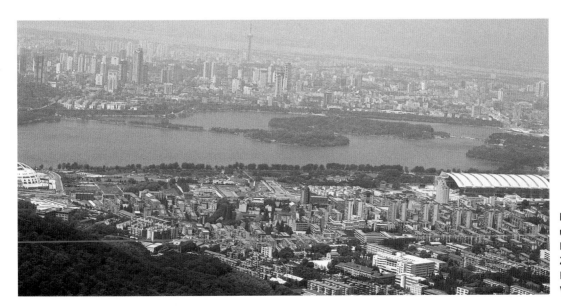

Fig. 1. View of the northern part of Nanjing city from Zhongshan. Photo by Willow Weilan Hai Chang

NANJING DURING THE ESTABLISHMENT OF THE MING DYNASTY (1368-1644)

Toward the end of the Mongol Yuan dynasty (1260–1368) a poor young monk named Zhu Yuanzhang (1328–1398) joined the peasant Red Turban rebellion and rose to become its leader. Zhu used the Nanjing region as his military base, and, after more than a decade of fighting, finally controlled the regions north and south of the Yangzi River. In the next year, 1368, Zhu crowned himself ruler and named his kingdom Ming. He designated his reign Hongwu, located his capital in Yingtianfu and changed its name to Nanjing, or Southern Capital. This site, with its legendary reputation of producing rulers, became, for the first time in its history, the capital of a unified empire.[2] Thereafter, the Hongwu emperor devoted his time to restoring the city. He carefully fashioned its design, ordered an empire-wide corvée and taxed the wealthy subjects to enlarge the city. It took over twenty years alone to build an immense brick wall 21 miles in circumference, a feat unprecedented in Chinese urban history. In his study of the history of Nanjing, F.W. Mote described the city design as "probably the most irregular shape of any major Chinese city…and the highest, longest, widest, firmest and most impressive city wall in China."[3] It was also the largest walled city in the world at that time.[4]

The design of Nanjing was different from that of the traditional square-shaped city plan used in the earlier Han (206 B.C.–220 A.D.) and Tang (618–907) dynasties, in which the imperial court was situated at the north end of the central axis. Here the city wall, designed to serve a defensive function, followed the natural geographic features and, consequently, was irregularly shaped (Fig. 2). The imperial court was located in the eastern part of the city, while the northern section was generally reserved for the military, the boat factory and the docks. The southern and southwestern parts of the city were occupied by the craft industries and commercial establishments, and the southern and central areas housed schools and residences of officials. In the north, the city wall was built along the entire southwest side of Xuanwu Lake, and, in the south, along the bank of the Qinhuai River. There were thirteen city gates that not only served as entry points but also as military posts. Each gate was built with high towers, especially the south gate, Zhonghuamen. This portal was a sophisticated construction with four layers of walls. The space between the walls, called *wengcheng*, housed the troops and their supplies. For even better defense, the Hongwu emperor (r. 1368–1398) further ordered the construction of a rammed earth outer wall about 59 miles in circumference which follows the natural terrain, punctuated by 16 gates.

Nanjing continued to serve as the Ming capital until 1421, when the third emperor, Yongle (r. 1403–1424), who had usurped the throne in 1402, moved the capital to Beijing due to his concern about military threats north of Beijing and court politics in Nanjing. He designated Nanjing as the Remaining Capital (Liu Du). Although the role of this parallel administration was largely ceremonial, this system, which was established in 1441 under the Zhengtong emperor (r. 1436–1449), lasted until the end of the Ming in 1644. Every year, the emperor would send officials to the southern capital to conduct ceremonies.[5] Throughout the entire Ming dynasty, the importance of this area as the imperial ancestral homeland was fundamental in the minds of the intellectuals and officials of the empire.

Even though Nanjing served as a secondary capital, it was still a cosmopolitan center of commerce and culture. European visitors, including merchants, scholars and missionaries, came to live and work there. It was also from Nanjing that legendary admiral Zheng He (1371–1435) launched his ships on successive expeditions that took Chinese sailors to Southeast Asia, India and on to the east coast of Africa more than seven times between 1405 and 1435. His voyages established contact with dozens of foreign countries and enabled commercial and cultural exchanges, making Nanjing an important port and center for international relations. Its location on the Yangzi River near the intersection with the Grand Canal also meant that the city was a major hub of domestic trade during this period.

NANJING'S POLITICAL CLIMATE DURING THE MING-QING TRANSITION

The seventeenth century was a complex historical period. Benefiting from the peace and economic development of the preceding 100 years, the Jiangnan region enjoyed unprecedented economic prosperity and cultural florescence. However, the treachery of the court eunuchs who controlled political affairs and the intense factionalism of government officials caused the suffering of many. Natural disasters and corruption at the court brought about popular unrest and peasant rebellions. After this period of decline, as the Ming court was weakening and the Manchu army was approaching Beijing, high officials and generals looked to Nanjing as a key line of defense. In 1644 Beijing was overthrown by the peasant rebellion of

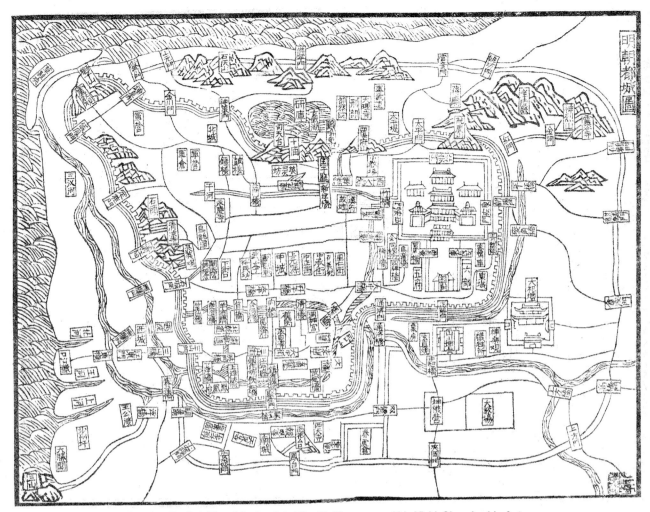

Fig. 2. Map of the Ming Dynasty Capital. Woodblock print. After Ye Chucang and Liu Yizhi, *Shoudu zhi—fu tu* (reprint, Shanghai: Shanghai shudian, 1991)

Li Zicheng (1606–1645), after which the invading Manchu army proceeded to conquer the rest of the country and establish the new Qing dynasty. After the reigning emperor took his life, some Chinese officials attempted to continue the dynasty by installing a young prince as the new emperor and setting up court in Nanjing. As a result, Nanjing once again became a Ming capital, if only in the south. This period was very brief, however; after the brutal massacre of Yangzhou citizens in 1645, Nanjing surrendered. Because Chinese officials in Nanjing immediately surrendered to the invading Manchu army, the metropolis was spared much of the destruction that occurred in other cities around the region. Nevertheless, its brief role as capital of the Southern Ming caused many to associate Nanjing with resistance and Ming loyalism.

For this reason, the first Qing emperor never trusted the intellectuals, especially the ones of this city. He ruled harshly, and the literati lived under the fear of an inquisition at any time. Burdened by such calamitous circumstances, some

literati went into hiding as monks, some chose to live as recluses, some curried favor and took jobs with the new regime and some of them escaped reality through the intoxication of wine and singing girls. But none could escape a lingering sadness for their lost country, and they often diverted their sentiments into poetry and painting. Nanjing's importance was nonetheless greatly enhanced by the formation of a new court under the Qing dynasty, which continued the two-capital system that entitled Nanjing to have the same governmental structure as the court in Beijing.

TOPOGRAPHICAL AND CULTURAL CHARACTERISTICS OF THE JINLING LANDSCAPE

Whether as the primary capital of the Ming dynasty in the beginning, or as the secondary capital, or southern capital, later on, Nanjing had a seductive charm. Both the city's natural scenery and long history had a strong appeal for writers and artists. Situated on the south bank of the lower Yangzi River, it is about 200 miles from the

Pacific Ocean. To its west is the hilly terrain of southern Anhui Province, an area which produced a large merchant class; to the north are the Yangzi and Huai Rivers, the agricultural base of the area; to the south is the prosperous Lake Tai area; to the immediate east, the Ningzhen mountain range forms Bell Mountain (Mount Zhong or Zhongshan), and to the west, is found Stone Mountain. Nanjing is situated in a strategically advantageous location. With the convenience of a river transportation system and the protection of natural barriers, Nanjing became an important economic center. Moreover, embraced by mountains and waters, the city is graced with beautiful scenery. The region around Nanjing is characterized by soft, hilly terrain criss-crossed with rivers. With its subtropical climate and abundant rainfall, it is highly suited for agriculture.[6] The city is also easily accessible by river transport to other prosperous cities of the southern Yangzi region—Huizhou, Suzhou, Songjiang and Hangzhou.

A tributary of the lower Yangzi River, the Qinhuai River runs south of the city of Nanjing for over 70 miles. Southeast of the city the river divides into two—the inner and outer Qinhuai. The outer Qinhuai served as the city's southern moat in the Ming dynasty. The inner Qinhuai flowed into the city from the east, past the Confucian Temple and under the Zhenhuai Bridge. Nanjing's largest entertainment district lay between Tongji Gate and Jubao Gate. This residential and commercial area became known as "the land of gold and rouge of the ancient Six Dynasties period." Along the banks of the inner Qinhuai River, from Wuding Bridge to Changban Bridge, past the Peach Leaf Ferry, and on to Dazhong Bridge, could be found wine pavilions, teahouses, courtesans' houses and leisure homes for the wealthy, delicately decorated with carved open-work railings and silk draperies.

Buddhist institutions also thrived in this environment, and religious architecture added to the beauty of the city. There were over 170 temples in Nanjing during the Wanli reign (1573–1620), and by the end of the Ming dynasty, that number had increased to over 300. Among the monuments of the city, the Temple of Repaying Kindness (Bao'ensi) was an architectural masterpiece much admired beyond the borders of China. Built by order of the Yongle emperor in 1412, it took more than sixteen years to complete and became one of the three most famous temples in Nanjing. Its octagonal pagoda had nine stories and measured 262 feet in height. The outer walls were covered by white ceramic tiles molded with designs of Buddhist figures, flowers and auspicious ani-

mals, and covered with colorful glazes. When it was near completion, the Yongle emperor added the encomium: "The First Pagoda in the World." A Ming writer called it "the largest antiquity of China [and] the largest porcelain ware of the Yongle era…[During] the Yongle reign, people from over 100 countries came to visit Bao'ensi and left with admiration, saying that they had never seen such a sight anywhere else in the world" (Fig. 3).[7]

Landscape paintings by artists working in Nanjing often highlighted specific sites and topographic features of the Nanjing area. Nanjing is immediately surrounded by rolling hills and low, green mountains, culminating with the summit of Bell Mountain rising to a height of 1,450 feet.[8] With regard to the surrounding scenery, the late Ming scholar Gu Qiyuan (1565–1628) observed that:

Topographers describe the mountains of Jinling as resembling the southern tail of a dragon, looking supremely grand. Possessing a subtle beauty, they exude an aura of grace. In emerald green and moist blue, they look like halos about the head of the Buddha or the exquisite shades on the brows of a beauty. But most unique to Nanjing's mountains is how the strange-looking peaks and cliffs, like crystal spears and jade swords, rise until they merge with the heavens.[9]

Thus, the Jinling painters tended to depict low hills and verdant mountains that were inspired by the local scenery, in contrast to the immense rocky peaks of north China that were the subject of the monumental landscape painting tradition.

Nanjing is also graced with numerous rivers and lakes. Gu Qiyuan's description of the city's landscape features continues:

Furthermore, there is the awe-inspiring sight of the Yangzi River roaring toward the east, with its waves surging and rushing, against which even the sun looks wan and dim. On windless and peaceful nights, the sound of the waves can be distinctly heard. At night I have lain in bed near the river at Yanji listening to the river waves thundering, and the walls in my room would shake as if they would collapse. The mirror-like Lake Mochou, with its rich growth of delicate weeping willows and other plants on its banks and surrounded by all the majestic mountains, looks especially seductive and charming. Contemplating this, the only feature that Nanjing lacks are the waterfalls and cascades near Hangzhou.[10]

26

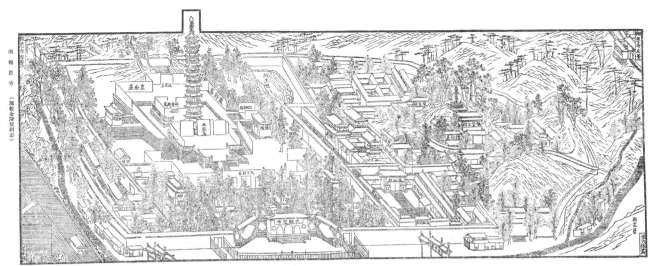

明報恩寺（閣載金陵梵剎志）

Fig. 3. Ming Dynasty Bao'ensi. Woodblock print. After Ye Chucang and Liu Yizhi, *Shoudu zhi — fu tu*
(reprint, Shanghai: Shanghai shudian, 1991)

Because of the proximity of the Yangzi River to the city, depictions of pleasure boats, waterside activity and background scenery appear frequently in representations of the Jinling landscape.

The area also has specific weather conditions that affect the appearance of the landscape. Due to the high humidity levels of this semi-tropical environment, the presence of fog and mist is common in the mountains and on the lakes of Nanjing. In the winter months, the temperature differences between day and night cause fog to form easily over water; during summer, the combination of hot and moist air creates a haze that hangs like smoke between the ground and sky. These atmospheric qualities are described in countless poems and inscriptions on works of art. In landscape paintings by Nanjing artists, this moisture is captured in its various manifestations—wispy or dense, dark or suffused with light—through the painter's nuanced use of ink wash (see cat. nos. 4, 18–21).

In addition to particular topographical features, there are specific natural motifs and architectural monuments that have come to be associated with the city, such as the pine trees of Bell Mountain (cat. nos. 2a, 4j and 5g). When the first emperor of the Ming built his mausoleum there, he resumed the custom of planting pine trees on the mountain.[11] The national observatory was located on top of Chicken Nest Hill (*Jilongshan*) in the center of the city, continuing the traditional observatory techniques passed down since the Six Dynasties period and handling astronomical and astrological issues for the court. Along the banks of the Yangzi River was China's largest marine facility, the Dragon River Treasured Boat Factory (Longjiang Baochuan Chang). Most of the boats used by the renowned Zheng He came from this factory.

From the love of local scenery and landmarks emerged a special Nanjing landscape subject—the Forty-eight Views of Jinling. This theme wove together history, anecdotal narratives and the city's natural scenery celebrated in both poems and paintings. Eventually, the theme was reproduced in woodblock prints for the pleasure of every class of society.[12] Often paintings were grouped as the Eight (cat. no. 2), Ten, Eighteen or Twenty-four Views of Jinling. Zhu Zhifan (1564–?), a native of Nanjing who passed the imperial examination in 1595, was the first to collect data and anecdotes about Nanjing and compiled the text of the *Forty Views of Jinling*. He then traveled to those sites in order to paint pictures and compose poems of these views. With the addition of eight more scenes to those gathered earlier, the Forty-eight Views of Jinling were finalized during the early Qing dynasty (see Appendix II). Included in this exhibition are two paintings by Fan Qi (1616–after 1694) that were originally part of the handscroll *Sightseeing in Jinling*, which depicted historical sites of Nanjing (cat. no. 3). According to its colophon, the scroll included *Yanji* and *Mochou* by Wu Hong (?–ca. 1690), *Qingliang* and *Sheshan* by Gong Xian (1618–1689), *Tiantan* and *Yecheng* by Chen Zhuo (1634–after 1709), and *Tianyin* by Liu Yu (active late 17th c.)—all titles that were included among the forty-eight views. Importantly, Liu Yu's colophon on the handscroll survives. He records the enthusiasm of Nanjing residents for collecting paintings of these various views. Collectors commissioned renowned artists to paint the themes. Such a collaborative project would have been regarded as a festive event. Although the promotion of the genre undoubtedly had commercial motives, it is also true that both artists and their clients were particularly proud of their hometown and wished to celebrate its beauty.

27

Nanjing has always been known for its scenic beauty, cultural heritage and sophisticated lifestyle, and these characteristics served as inspiration for poets and painters. Thus representations of the Jinling landscape in poetry and painting often consciously evoke specific historical associations. The events and anecdotes during the Six Dynasties period were a special source of inspiration for generations of literati. The most famous poets of the Tang dynasty, like Li Bo (701–762), Du Fu (712–770), Li Shangyin (813?–858) and Liu Yuxi (752–842), all visited Jinling and composed poems there. They were stirred not only by the beauty of the site, but also by the recollection of bygone heroes and events. Such reminiscences were especially popular during the difficult years of transition to foreign rule in the seventeenth century. In the poem "Reminiscences of Jinling," Gong Xian, one of the Eight Jinling Masters, wrote:

> With sounds of the flute comes sadness,
> The riverboat will leave when night has ended.
> The moon rises again on this land of battles,
> As the river tide laps the banks in this war-weary city.
> The withered willows wish to disappear,
> While the mourning snow-geese call me as they pass.
> Only the rocky cliff, unable to fly,
> Sits here lamenting so much wasted love.[13]

Here, to express his own sadness over the defeat of his country, Gong Xian refers to a moment in history when the Western Jin army conquered the Wu kingdom in 280 A.D. and the Wu king, Sun Hao, was vanquished from Nanjing. In another poem, Gong wrote:

> This romantic southern city of the Six Dynasties period
> Has been the land of culture and refinement.
> But look in vain for Wang Xizhi, the master
> calligrapher, today,
> And there are no more fine painters after Gu Kaizhi.
> Having a great capacity for wine, I'm not drunk yet,
> So don't stop me when I hold forth on the
> merits of poetry.
> I must find some money quickly and retire
> into the wilderness,
> As I long to sit among dense foliage and listen to the
> trilling of the orioles.[14]

These words reflect the cultural contributions of the Six Dynasties, as well as the painter's admiration for the great artists of that period and the lifestyle that they led.

The history and cultural contributions of this period were strongly associated with Nanjing, and references to that period were used repeatedly among the literati of the seventeenth century. For Ming loyalists living under Manchu rule, reminiscences of this kind were a celebration of Chinese cultural achievements as well as an expression of empathy with past heroes who lived through parallel political situations.

A BUSTLING URBAN ENVIRONMENT

In the seventeenth century, Nanjing was one of the most populous cities in China, composed of bureaucratic officials, senior military officers, wealthy businessmen needing to live near the seat of government, craftsmen drafted from around the empire and students preparing for the imperial examination, among others. Supervised and encouraged by the government, the wealth, talents and labor of immigrants, sojourners and native residents contributed to the prosperity of the city. The Ming dynasty handscroll *Prosperity of the Southern Capital* (*Nandu fanhui tu*) vividly depicts the booming business activities of Nanjing.[15] Over 100 different businesses and trades—oil shops, dye houses, fabric stores, grocery stores, banks and over 1,000 figures—can be observed (Fig. 4). On the store signs, the characters indicate the specific function of each shop: bookstores (*shupu*), galleries (*huayu*), framing shops (*biaohua*), calligraphy and rubbings of stone stele (*gujin zitie*), and seal-carving shops (*kezi juanbei*). Many skilled craftsmen worked in these stores, and "these people were proud of making a living by their own skills. Whether as musical instrument repairmen, porcelain repairmen, fan makers, mounters of painting and calligraphy or carvers, they were pleased to be associated with the literati rather than the powerful officials."[16]

Nanjing's attraction for poets and painters was also related to its economic prosperity in addition to its beauty and ancient heritage. The city offered a pleasing lifestyle, convenient craftsmen, as well as art patrons among the upper classes. Many of Nanjing's artistic activities were stimulated by the wealth of its inhabitants and the competitive nature of its merchant class. At the time, it was not uncommon for rich merchants to enhance their reputations by purchasing paintings from famous artists or by inviting them to decorate their residences. Such demands on their services no doubt stimulated the development of an art market—artists from all over China came to Nanjing to find patrons.

A popular format for painting, the "Jinling Folding Fan" was one of the products among the Nanjing handi-

crafts that captured the nation's attention. Fans were convenient to carry around and particularly practical in the humid summer months. Their production involved specialized processes, with the fan surface and the fan ribs being made by separate workshops. Old names associated with the locations of workshops, like Fan Ribs Battalion (Shangu Ying), remain today to reflect the special division of labor that existed then. Folding fans were not only a regular item of daily use, but also became fashionable as commemorative gifts. So popular were they, in fact, that the imperial court established rules regulating the emperor's use of commissioned fans as gifts to his officials. During the Zhengtong reign, the custom of giving fans spread throughout society to the common people. Folding fan production advanced during the Chenghua reign (1465–1487).[17] By the late Ming it had become commonplace as a gift among intellectuals and officials as evidenced by the many inscriptions on extant fans. The general populace, too, fancied folding fans, especially those embellished with paintings by recognized artists, who elevated the craft to a higher art form and transformed a gift into an object denoting sophistication (cat. no. 6).

While the popularity of folding fans provided work for painters as well as for fan manufacturers, the production of implements for the arts of the brush and mountings for paintings and calligraphy also developed. Most of the skilled craftsmen who responded to these needs stayed beside the Qinhuai River in the southern part of the city where their professions are reflected to this day in the names of locations, such as Biaohualang (The Alley for Mounting Paintings).

The production and appreciation of art and literature were closely linked to education. Nanjing was praised as "the primary study center of the southeast,"[18] because it was the site of the provincial and national examinations for candidates for government office in the Jiangnan region. The most important educational institution was the Guozijian, the Imperial Academy for the training of students from around the country to become officials in the civil bureaucracy. This academy was the most authoritative institution of higher education in the country, admired throughout the Ming and early Qing dynasties. Besides training students, the Imperial Academy was also involved in editing and publishing. The *Yongle Encyclopedia* (*Yongle Dadian*), the most impressive encyclopedia in ancient Chinese history, was compiled and completed there during the Yongle reign, making Nanjing respected throughout the nation.

Stimulated by this government activity, the private woodblock printing business in Jinling flourished. Social customs also helped develop the printing industry. After a scholar passed the imperial examination and received an official post, he usually arranged to have a book printed and published to enhance his reputation. The inexpensiveness of the woodblock printing process encouraged this. To fill the demands of a strong market, craftsmen from near and far came to Nanjing. New techniques were also invented—wooden or bronze letter boards, two-color printing in red and black and color registration. By end of the Ming dynasty, such techniques reached a high point with the sophisticated work of master carver Hu Zhengyan (ca.1584–1674). In 1627, he completed the first edition of the color-illustrated *Ten Bamboo Studio Manual of Painting and Calligraphy* (*Shizhuzhai shuhua pu*). These multi-colored illustrated books broke new ground in woodblock printing history, and famous artists became involved with their design. Illustrated books produced throughout the country benefited from the development of these techniques, earning the city praise as "Jinling, the capital of books."[19]

The best evidence of the development of this industry was the quantity of books published. Bookstores thrived; they not only printed and sold books, but also served as cultural and social meeting places. The Cai Yisuo Bookstore on Three Mountain Street (Sanshan Jie), for example, brought together intellectuals of the Donglin and Fushe societies.[20] The flourishing of woodblock printing and publishing also encouraged the growth of book collections throughout Jiangsu Province. Leading Nanjing figures such as Qian Qianyi (1582–1664) and Huang Yuji (1629–1691) were known for the richness of their collections, which were housed in graceful settings. Students came on lengthy visits to study at these private libraries.[21] Collectors not only published and edited works, but also wrote scholarly essays for the sake of transmitting their cultural heritage.

SOCIAL LIFE AND LEISURE ACTIVITIES OF THE LITERATI

Social networks were extremely important to the creation of painting as well as the collecting and appreciation of such works of art. Moreover, since artists and patrons were educated individuals, they sought a lifestyle that reflected the cultural values of the *wenren*, the élite literati class. Traditionally, this term referred to scholars who had received an extensive education in preparation for the civil service examinations and were especially proficient in literature. But by the seventeenth century, wealthy

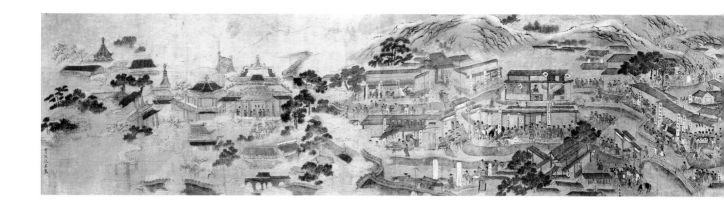

people from diverse social backgrounds also pursued activities that had long been viewed as essential to cultural refinement and spiritual cultivation.

Read Ten Thousand Books, Travel Ten Thousand Miles

Reading is the essence of the literati life. Du Fu, the great Tang dynasty poet, said: "Read and wear out ten-thousand books; write as if helped by the gods."[22] It is not only a matter of quantity, but, most importantly, it is also the understanding, digestion and fusion of all the knowledge contained in them that is necessary to reach a high level of self-cultivation through a lifetime journey. The Chinese literati have long believed that one's degree of self-cultivation would be inevitably revealed through one's artwork, and the theoretical relationship between reading and artistic conception was clearly emphasized. This attitude is reflected in a contemporary comment: "One must peruse several dozens of volumes of fine books or become low and common."[23] Even more specific is the comment "Do not discuss paintings with those who do not read books."[24] Reading was obligatory for serious painters. In a colophon dated 1676 when he was 59 years old, Gong Xian commented on the relationship between reading and self-cultivation in the pursuit of an ideal artistic concept:

> When I was about 20, I saw *The Portrait of Clouds and Mountains* by Mi Fu (1052–1107). It so overpowered me that I was convinced it was a supreme piece of artwork. Though I've many times wished to paint in its style since then, I couldn't put down anything when the paper and brush were laid out. Today, forty years later, quite unexpectedly, I've finally painted on paper this scene of clouds and mountains that has been so long on my mind. I've come to realize that one of the most urgent practices for a painter is to cultivate his energy and spirit by reading more fine books.[25]

The importance of books can be seen in the number of images of reading and reading huts in paintings of the period. Among the Jinling masters in this exhibition, for instance, Wu Hong's *Zhexi Thatched Hut* (*Zhexi caotang tu*; cat. no. 14) and Gong Xian's *Reading Hut in the Pine Forest* (*Songlin shuwu tu*) specifically depict this activity.[26]

Equally if not more important to the process of self-cultivation was the observation of nature. Literati of the late Ming and early Qing dynasties stressed the value of traveling among mountains, regarding such sojourns as one of the most important methods of self-cultivation. By extension, both knowledge of books and travel in nature were essential to good painting. The eminent late Ming artist, critic and collector, Dong Qichang (1555–1636) said, "If one does not travel ten-thousand miles, nor read ten-volume books, how can one become a master in painting?"[27] The monk and artist Kuncan (1612–1673), who lived near Nanjing, expressed his understanding of the concept in this way: "Those painters who capture the quintessence of painting must be both readers of literary and historical books and travelers to mountains and rivers."[28] The scholar Wei Xi (1624–1681) even created a "twenty-year" plan to execute this adage: between childhood and old age one should read for twenty years, travel for twenty years, and write for twenty years.[29]

Travel could be divided into two types: indirect and direct. The indirect study of nature was called "mind travel" (*shenyou*). One way of doing that was to study the works of ancient masters of landscape painting. For example, Gong Xian studied and learned from other artists, both contemporary and ancient. In a colophon of 1674 on his *Cloudy Summit* handscroll, Gong listed over twenty names of masters with whom he had studied. It revealed his willingness to absorb essentials from various masters. Other Jinling masters, such as Fan Qi (1616–after 1697) and Gao Cen (active 1643–1687), also studied the masters of the Song and Yuan dynasties.

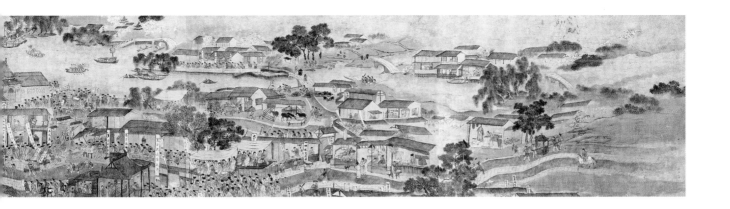

Fig 4. Anonymous Ming dynasty artist, attributed to Qiu Ying (16th c.), *Prosperity of the Southern Capital* (*Nandu fanhui tu*). Handscroll, ink and color on silk. Photo courtesy of private collector

The direct study of nature involved physical travel to mountains. During the Ming dynasty, there was an unprecedented enthusiasm for travel. This interest was reflected in several parallel phenomena. One was the publication and popularity of many travel guidebooks, such as the *Elegant Travel in Jinling* (*Jinling yayou bian*), compiled by the famed Nanjing scholar Yu Menglin (act. early-17th century), with pictures and poems vividly introducing the attractive sites of Jinling.[30] Other special travel books of the period include *Elegant Collections on Travel Accessories* (*Youju yabian*) written by Tu Long (1542–1605). In the book, he carefully listed items like a cane, bamboo hat and fishing pole, and described all of them as accessories for the literati to enhance their self-cultivation.

Accomplished landscape artists were often experienced travelers. In the inscription on his handscroll *Endless Mountains and Streams* (*Xishan wujin tu*), Gong Xian stated: "I feel that it's easy to paint the wide and flat land, but it's difficult to paint the high and steep mountain and river scenes. For only after one has toured the five great mountains and traveled for ten thousand miles does one realize that mountains and rivers have their origins and branches."[31] Gong Xian himself, although limited in his finances, may still have climbed many mountains and seen many rivers.[32] That the experience of travel broadened his vision is revealed through his comprehensive depictions and the verity of his landscape forms. Evidence of travel is reflected in the work of other Jinling masters like Fan Qi, whose painting, *Wandering Through Mountains in Springtime*, shows a visit to the mountains in springtime (cat. no. 12), and Gao Cen, whose *Gold Mountain Temple* portrays that historical site in the nearby city of Zhenjiang (cat. no. 13). Wu Hong, in order to investigate historical sites, crossed the Yellow River to visit the ancient ruins of the Warring States period (476–221 B.C.), where he could recall stories of heroes and their sense of spirit. After his return,

the noted Nanjing art patron and critic Zhou Lianggong (1612–1672) commented that, "his brushwork suddenly changed [and is now applied] with great ease and luxuriance that revealed the many merits he learned from various masters but with his own ideas."[33]

In addition to traveling, living in the mountains (*shanju*) was a popular way to experience nature. Although some literati only practiced this custom to gain a reputation as a recluse, others were deeply sensitive to the sights and sounds of natural phenomena and genuinely desired a mountain residence. This, too, became a theme in painting, as in Gong Xian's *Living in the Cloudy Mountain* (*Yunlin shanju tu*).[34] Gong built a few rooms on a tiny plot at the foot of Mount Qingliang (Qingliangshan, "Pure and Cool Mountain") on the western side of Nanjing, where he spent the rest of his days living out a simple and quiet life. There, he could concentrate, observe the changes in nature—the season, the directional lighting, the climate—and be inspired by it all. His paintings of Mount Qingliang are imbued with the kind of details that could only have come from extensive observations over a long period of time.[35]

Literary Societies

Although solitary communion with nature was seen as fundamental to artistic creation, Chinese scholars appreciate and treasure friendship, considering it important to the chemistry of inspiration. The story of Zhong Ziqi and Boya, two people living during the Spring and Autumn period (770–476 B.C.) who understood each other through the music of "Vast Mountains and Floating

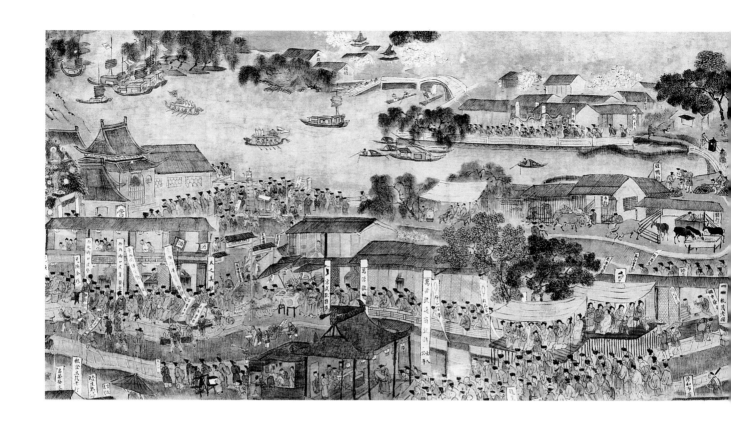

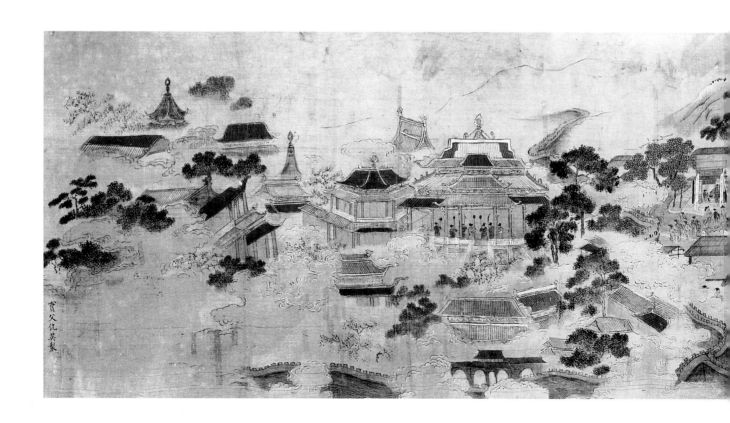

Fig. 4a. Detail

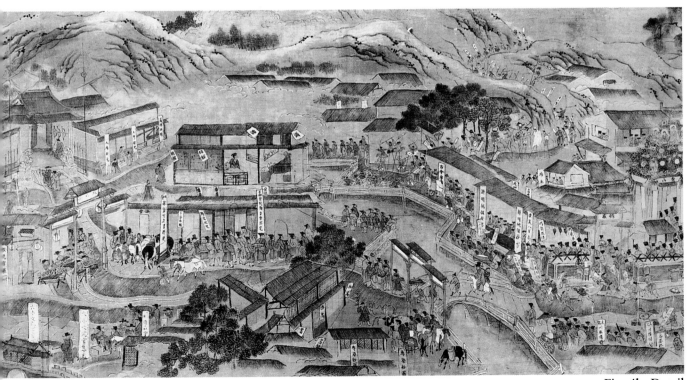

Fig. 4b. Detail

Water," has become a classic analogy for soulmates.[36] During the late Ming dynasty, the literati were active at many societies (she), which were analogous to the literary salons of Europe. Members gathered according their common interests and held occasional meetings, some of which became social events.[37] The largest such society in the Jiangnan area, the Revival Society (Fu She), was established in the 1620s as a literary group and gradually grew to include over two thousand members. Many members of this society were talented intellectuals who commented on and criticized the affairs of the imperial court. The society presented forums to share their political concerns. Many members of that society became leading advocates of political reform. Gong Xian was a close friend of several such members.[38] Other Jinling masters, like Ye Xin (d. ca. 1671), also took part (cat. no. 6e).

The scholarly élite also pursued such traditional literary activities as poetry: clubs were formed on an unprecedented scale around such leading figures as Qian Qianyi and Gu Mengyou (1599–1660). Exemplifying the cross-pollination of the art forms resulting from personal relationships, Gu was also a good friend of Gong Xian, possibly the most talented painter of the Eight Masters of Jinling. A contemporary scholar recorded:

> Scholars such as Gu Mengyou and Hu Yijian (1609–1665) were close friends of Gong Xian. Together, they would spend day after day composing poems dedicated to one another or boating beside the Peach Leaf Ferry. And while floating on the clear river water, they would write fine verses, that, upon completion, would be passed around to readers of the day. Huang Yuji had an extensive collection of fine books which he kept in his "Wide World Hall." A great admirer of Gong Xian, he founded a poetry club near the Qinhuai River for that artist.[39]

Gong wrote that: "At the gathering of the literary club by the Qinhuai River, poetry reigns supreme among the more than 100 literati attending."[40] They drank, composed poems, made paintings as gifts and wrote inscriptions for each other. Other pursuits during social gatherings included playing the qin (a type of musical instrument; cat. no. 8), tasting tea and drinking wine—activities which frequently appeared in paintings.

Tea Tasting

During the Ming and Qing dynasties, tea became a favorite beverage among all levels of society, and tea growing was greatly expanded. Outside of Nanjing, the slopes of Ox-Head Mountain (Niushou Shan) and Clouds Perch Mountain (Qixia Shan) were planted with a tea named "Cloud and Mist" which was picked by monks to be served to honored guests.[41] Tea was considered one of the seven household necessities, and teahouses were popular in the city, as the general populace of Nanjing increasingly enjoyed drinking tea as a social activity (cat. no. 9). Disliking the muddy flavor of river water, residents collected rainwater in ceramic pots and stored it for three years before drinking to make a better tasting tea. A popular aphorism stated: "To remember Jinling, a city of distinction, / Every family should prepare tea with rainwater."[42]

Among the literati tea consumption was elevated to the level of high art, leading them to become involved in all aspects of tea preparation from the selection of tea leaves to the choice of water, charcoal and utensils, as well as the proper setting.[43] The importance of tea drinking as an activity related to self-cultivation during the late Ming and early Qing period resulted in the publication of many texts on the subject. Authors such as Wen Zhenheng (1585–1645) and Zhang Dai (1597–1679) devoted several chapters to the topic of tea in their writings.[44] The relationship between tea drinking and refinement of character is evident in this description by the late Ming scholar Tu Long:

> As a beverage, tea is best suited for inspired and cultivated persons…Such a person should practice this art [of tea making] diligently and regularly, not sporadically—only then may he fully appreciate its true flavor. Intoxicated with the fine taste of tea, he will soon realize that it is comparable to the finest wines. At this point, a gentleman becomes a true tea connoisseur. But, if the drinker is a common fellow, then the fine tea is wasted, which would be like watering an unworthy weed with clear cascade water. This would be a major offense.[45]

Tea drinking was a social act and a way of sharing time with friends. Fang Wen (1612–1688), a poet and good friend of Gong Xian, expressed his happiness when having tea with a friend, saying, "Having a cup of fine tea under the blossoms makes one feel heavenly."[46] Drinking tea in a beautiful natural setting is also a frequent theme in the landscape paintings of seventeenth century Nanjing painters.

Wine Drinking

Wine was another stimulus to artistic inspiration among the literati (cat. no. 3). A favorite theme associated with literati drinking was The Seven Sages of the Bamboo Grove (*Zhulin qixian*), a group of men who lived after the fall of the Han dynasty and left society to live in nature and indulge in wine. Although their stories originally took place in central China, they were so revered in Nanjing that their pictures were molded into brick murals and installed in the tombs of locals who admired them as models during the Six Dynasties era.[47] Wine is frequently celebrated in poetry. It is also said that Li Bo, the famous Tang dynasty poet, got drunk and jumped into the Qinhuai River to embrace the moon.[48] Another Tang poet, Du Mu (803–852), in his poem "Qingming" (Pure Brightness) described the anxiety of looking for wine in the Apricot Village section of Nanjing. Ever since then, "Apricot Village" has been used as an allusion to wine.

Wine was often imbibed at scholarly gatherings, as reflected in the growing number of late Ming texts devoted to the connoisseurship of wine and drinking etiquette. Works such as *The Way of Drinking* (*Shang zheng*), by the late Ming author Yuan Hongdao (1568–1610), and *The History of Wine* (*Jiushi*), written by Feng Shihua (late 16th c.), described in detail the rules governing drinking including the preparation of the vessels, the decoration of drinking locations, proper behavior while tipsy and how to address one's inebriated friends. A drinking party at the home of the collector and art patron Zhou Lianggong was described in the following way:

> At these occasions, as wine was poured, [the guests] would engage in conversations on all subjects humorous or philosophical, past or present. They would also discuss nature and other topics. So tireless were members of the group that they would play new and exciting games while sipping wine. All would be elated and intoxicated before the party broke up.[49]

Even after Zhou Lianggong left his official post in 1669, he hosted memorable poetry and wine parties in Nanjing, inviting local artists, poets and recluses.

During the Ming-Qing transition, wine also provided solace to the "left-over subjects" (*yimin*) of the Ming who were deeply grieved by the loss of their country. The poems of Gong Xian, for instance, are filled with evidence of drinking. The characters for "wine" and "drunk" appear in almost every poem he wrote. In one poem he expressed hopelessness and despair, saying, "As the Way declines, one is better off drinking oneself into oblivion."[50] Gong was not alone in his sentiments. Dulling themselves with wine to forget the grief of losing their country to foreign conquerors was a common reaction of the *yimin* literati.

Popular Theater and the Performing Arts

In addition to the consumption of tea and wine as aspects of literati self-cultivation, the wealthy residents of seventeenth century Nanjing also patronized popular forms of literature, theater and the performing arts. The renowned playwright Li Yu (1611–1680?), for example, engaged in a number of activities that merged scholarly pursuits with popular entertainment. His Mustard Seed Garden (Jieziyuan) served as a publishing house and workshop, where he printed illustrated novels, dramas and the *Mustard Seed Garden Painting Manual*. Nanjing's development as a center for the performing arts grew out of the active patronage of the imperial court. Ming emperors were fond of operas, so much so that the Hongwu emperor (r. 1368–98) once remarked that "the Five Classics are like cotton twill and grain—something kept in every household. But the opera *Pipa Ji* by Gao Ming (Zecheng, fl. 1345) is like the most precious delicacy in life, an indispensable luxury item for every affluent family."[51] The third Ming emperor, Yongle, built the national theater in Nanjing. Succeeding emperors also showed their appreciation of opera, and their sponsorship of productions helped elevate all of the performing arts.

During the seventeenth century, over a dozen different types of opera and drama were prevalent in the Jiangnan area, including Wuju, an opera performed in the Jinhua dialect and prevalent in today's Zhejiang Province, and Kunqu, performed in the Suzhou dialect common in Jiangsu Province. One official, Ruan Dacheng (ca. 1587–1646), employed his own performers, wrote his own plays and even directed the performances of *The Swallow Letter* (*Yanzi Jian*). Dramatic troupes strove for excellence in stage setting, costume design and quality of performance. Opera performances were also welcomed on various ceremonial occasions and for entertaining guests in teahouses or hostels.[52] Literati gatherings were often accompanied by music and plays.[53]

In the evening, pleasure boats with lanterns and music plied the Qinhuai River. The lantern boat was a special feature of this river ever since the lantern festival of 1369, when the Hongwu emperor ordered the lighting of over ten thousand lanterns along the Qinhuai. One writer of the period recorded:

The sight of the lantern boats on the Qinhuai River was unparalleled in its grandeur. One could see them moored along the banks of the river, with their delicately carved railings and finely painted sills, gauze windows and silk draperies, and miles of beaded portières. And when dusk fell, they formed a queue resembling a fire dragon generating a blinding light. Drums were beat, their sounds echoing in the rippling river water. A boisterous excitement extended from the Jubao Gate to the Tongji Gate all night long until sunrise the next day.[54]

This section of the Qinhuai River, with its music and singing girls, was a cultural phenomenon famous throughout the country. Of the music and performances in the river-houses and boats, a contemporary observer commented: "The sounds of the oboe and drum would go on day and night."[55]

Nanjing's glamorous pleasure quarter became a magnet for talented female performers. These young girls were trained from childhood in art and literature. Romantic affairs, even marriage, between literati and singing girls became popular gossip. The most famous of these women were known as The Eight Beauties of Qinhuai. The *Portrait of Kou Mei* (cat. no. 16) tells a tale of the renowned Qinhuai culture and exemplifies the attractions of the Jiangnan lifestyle. Boating along the Qinhuai River, listening to music and drinking with singing girls while composing poems was typical of literati behavior in the late Ming and early Qing dynasties.

THE LITERATI AESTHETIC

The character *qing* (purity) was favored by the intelligentsia of the late Ming and early Qing dynasties. The aesthetic concept came from a sense of etiquette common during the Wei and Jin dynasties (220–265; 265–420) known as *Wei-Jin fengdu*, which emphasized class origin, proper appearance and deportment, iconoclastic "pure talk" (*qing tan*), as well as a free-spirited, escapist and even nihilistic attitude. As reinterpreted later by the Ming literati, the concept is key to understanding their lifestyle and manners. They linked the state of purity with other concepts, such as "purity and elegance" (*qing ya*), "pure tranquility" (*qing jing*) and "pure modesty" (*qing xu*). Purity, in the sense of noble, unsullied and transcending the vulgar, was considered the highest realm for a human to aspire to (Fig. 5).[56]

To achieve this state, the Ming literati practiced "pure talk"—witty, dialectic conversation which had been fashionable in the past and became so again in the

seventeenth century. Among the Jinling masters, Wei Zhihuang (1568–after 1645; cat. no. 10) was fond of this kind of discourse, earning the respect of his contemporary intellectuals. In literature the practice resulted in the flowering of short essays which reflected the thoughts and aspirations of the literati. Chen Jiru (1558–1639), in his *Secluded Notes beneath the Cliff* (*Yanqi youshi*), described many facets of this lifestyle, which included dwelling in mountains, reading, appreciating paintings, tasting tea and commenting on poems.

The literati also commonly practiced daily "purity lessons" (*qing ke*). Some of them would "burn incense, prepare tea, meditate, visit monks to study Buddhism, follow the way of Chan (Zen), discuss Buddhist teachings and conduct Buddhist rites...."[57] Gong Xian described his daily purity lesson as "idling away my long summer days in the mountains. I place a chair and a stool in the bamboo grove every morning and sit down to paint and compose poems to complement the paintings. I can complete one painting with poetry each day. This activity is none other than my session of purity lessons."[58]

The literati did not limit their self-cultivation to talk and lessons, but also implemented the concept through the many details of their daily life and the creation of an appropriate living environment which reflected their sensibilities. As a result, there were a quite number of books published in the Ming dynasty that listed and described in detail the commodities of daily life as a lifestyle guide for the literati. One such book was Tu Long's *Notes on Accessories* (*Kaopan yushi*), which commented on study accessories, stoves, bottles, and the dress and personal adornment for this class. He also wrote *Youju yabian*, listing such travel accessories as a bamboo hat, cane and fishing pole as tools for self-cultivation. Although Ji Cheng's (b. 1582) *The Art of the Garden* (*Yuan ye*) talks about creating a physical garden, he has, in fact, drawn a picture of an ideal environment for an enlightened scholar. Tu Long expressed his yearning for a quiet and remote retreat:

In what do we cultivate our spirit? None but the green mountains and the white clouds. And with what do we amuse our eyes? None but sunrises and sunsets. Above are the tall woods, and below the winding streams. Golden deer appear during the day, and gibbons wail at night. In my ear, I hear the pines whisper in the wind. Resting on a huge rock, I cup some water from the cool, clear cascade. Ah, the joy of living in the mountains, where I can take casual strolls that bring me sometimes to a rocky cave in a cliff—a cave that is narrow at the

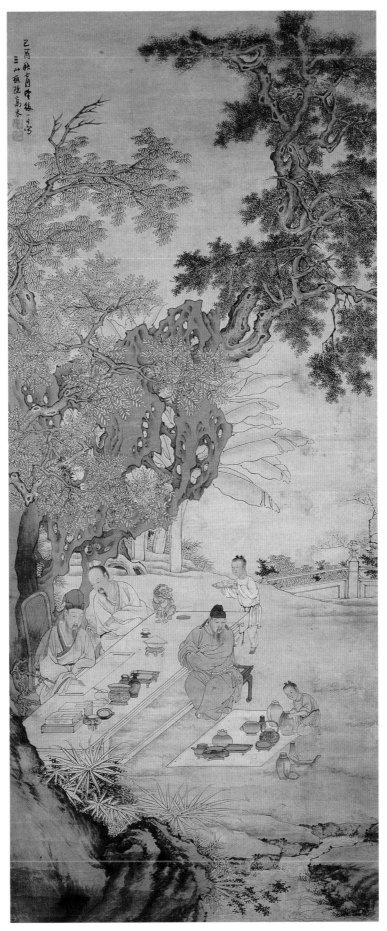

Fig. 5. Gao Cen
(act. 1643–1687),
*Purity Interests under the
Shade of Banana Trees*
(*Jiao yin qing xing tu*).
Hanging scroll,
ink and color on paper.
Photo courtesy of the
Nanjing Museum

entrance but opens wide as you climb inside. And how the cool quietude inside a bamboo hut contrasts with the sunlit openness of a stone temple! When a guest comes, I ask that he speak whatever is on his mind; and when alone, I am content with my own company. Thus, far from the human world, my spirit blends into the serene infinite. I have but one thought in my mind: burn incense and open a book.[59]

The yearning for a leisurely lifestyle in a mountain retreat, as well as the transformation of the details of daily life into a rarefied art form, is in part a reflection of the escapist attitude of the late Ming and early Qing dynasties—a restatement of the fantasy ideal of "Peach Blossom Spring."[60] With corruption commonplace, economic hardships increasing, wide-spread rejection of the ruling Qing dynasty, and sentimental attachment to the fallen Ming, this theme of escapism brought an undercurrent of pathos to their poetry, painting and calligraphy—as well as to their daily lives. They affected a stylishness in part to distract them from their political disenfranchisement.

The literati ideal of purity also influenced the world of art, coloring the appreciation of paintings. A Ming artist proposed: "Good paintings should contain four qualities: literary refinement, purity, aloofness and [the ability to] experience [vast] distances within one foot."[61] The artist and scholar-official Dong Qichang advocated the study of certain ancient masters as models for painting. By Dong's standard, paintings which revealed a literary quality are on a higher level; paintings of craftsmen show skill but lack artistry.[62] This one-sided promotion of literati art, mainly in the form of landscape painting, reached its peak during the late Ming and early Qing. The standards of purity and elegance had become aesthetic measures that were to continue for the next three hundred years.

This concept grew to include all categories of literature, painting, architecture and performance, and was gradually accepted and appreciated by others. Hence, typical literati forms of art like calligraphy, seals, painting and poetry began to be made as commodity objects, particularly in porcelain. Potters, such as those from Dehua, also took up the use of seals to state their thoughts and sign their work.[63]

A RICH ARTISTIC CULTURE

Before the Manchu invasion, Jiangnan artists enjoyed an easy lifestyle. They were "distinguished in their appearance, ambitious in their mind, debonair in their manner, romantic in their speech" and "active in both the academic and entertainment realms."[64] Their paintings reflected this sense of leisure.

The city not only offered abundant patronage for these artists but also provided them with many opportunities for these artists to meet, discuss art or study with each other. Gong Xian, for instance, frequently associated with Kuncan, Shitao (1642–1707) and Cheng Zhengkui (1604–1676). He also painted together with other Jinling masters. In 1679, for instance, he worked jointly with Zou Zhe (1636–ca. 1708), Wu Hong, Fan Qi, Gao Cen, Wang Gai (1645–1707), Liu Yu and Xie Sun (active ca. 1679) on an album of landscapes and flowers. The painter Cheng Sui (ca. 1605–1691) indicated in a handscroll that he would often get together with Wu Hong, Dai Benxiao (1621–after 1691), Gong Xian and Liu Yu to drink and talk about paintings (cat. no. 3).

The paintings in the current exhibition are so diverse that it is hard to find a common style or regard them as from the same school. Nevertheless, this loose group of artists experienced the turbulence of the Ming-Qing dynastic transition together and were drawn to the beauty and sophistication found in Nanjing. They expressed their feelings and communicated with each other through poems and paintings. A small circle of friends, they shared their thoughts on art and life—about painting techniques and about their role in society. These discussions could as readily take place in the pleasure quarters as they could during the meeting of a literary society. Arguments about the limitations of the different schools did not concern them. Indeed, they believed that art should express the feelings of each individual, leading them to study the merits of many methods and schools. Nanjing's advantageous location and agreeable environment nurtured the rich artistic eclecticism found in the works of these painters.

1. Ye Chucang and Liu Yizhi, *Shoudu zhi*, vol. 1 (reprint, Nanjing: Nanjing gujiu shudian, 1985), p. 3.

2. According to the *Jiankang shilu*, when Qin Shihuangdi passed through Jinling on an inspection tour of the country, a *fengshui* master predicted that in five hundred years, Jinling would produce an emperor (Ye Chucang and Liu Yizhi, *Shoudu zhi*, vol. 1, p. 4). Coincidentally, the Western Jin dynasty emperor Yuan came to Nanjing about five hundred years after the prediction.

3. F. W. Mote, "The Transformation of Nanking, 1350–1400," in G. William Skinner, ed., *The City in Late Imperial China* (Stanford: Stanford University Press, 1977), p. 134, mentioned that the American military, in a survey during World War II, measured the Ming dynasty city wall to be 37.3 km (23.2 miles) in girth, which is approximately 70 *li*.

4. The second largest city in the world at the time was Paris, with a city wall measuring 29.5 km in girth. Ji Shijia and Han Pinzheng, *Jinling shengji daquan* (Nanjing: Nanjing chubanshe, 1993), p. 91.

5. Gu Qiyuan, *Kezuo zhuiyu* (reprint, Beijing: Beijing zhonghua shuju, 1997), vol. 3, pp. 70–71.

6. Ouyang Hai, *Nanjing qihou zhi*, in *Nanjing wenxian*, vol. 4 (reprint, Shanghai: Shanghai shudian, 1991), p. 17.

7. Zhang Dai, *Tao'an mengyi* (reprint, Changchun: Jilin wenshi chubanshe, 2001), vol. 1, p. 4.

8. Ou Yanghai, *Nanjing qihou zhi*, p. 2.

9. Gu Qiyuan, *Kezuo zhuiyu*, vol. 10, p. 311.

10. Ibid.

11. Mentions of this event in the *Jiankang zhi*, *Yidi zhi* and *Moling ji* are cited in Ye Chucang and Liu Yizhi, *Shoudu zhi*, vol. 3, pp. 233 and 242.

12. For instance, the woodblock-printed *Jinling yayou bian* (Elegant Travel in Jinling) compiled by Yu Menglin.

13. Xiao Ping and Liu Yujia, *Gong Xian* (Changchun: Jilin meishu chubanshe, 1996), p. 321.

14. Ibid., p. 300.

15. The painting was in the collection of the Weng family in Changshu, and it carries the purported signature of Qiu Ying (mid-16th c.). It is now in the collection of the Chinese Historical Museum in Beijing. A study of the painting has been written by Wang Hongjun and Liu Ruzhong, "Mingdai houqi Nanjing chengshi jingji de fanrong he shehuishenghuo de bianhua," in *Zhongguo lishi bowuguang guankan* (1979, no. 1): 99–106.

16. Jin Ao, *Jinling daizheng lu* (1844; woodblock reprint, Jinling, the second year of Guangxu [1876]), juan 8, p. 7.

17. Ji Shijia and Han Pinzheng, *Jinling shengji daquan*, p. 757.

18. Jin Ao, *Jinling daizheng lu*, juan 8, p. 1.

19. Chen Zuolin, *Jinling suozhi wuzhong* (woodblock edition, n.p., Guangxu *yiyounian* [1885]), vol. 2, p. 14. For more information about early printing techniques and Jinling's contribution, see Wang Qingzhen, "The Arts of Ming Woodblock-printed Images and Decorated Paper Albums," in Chu-Tsing Li and James C.Y. Watt, *The Chinese Scholar's Studio: artistic life in the late Ming period* (New York: Asia Society, 1987), pp. 56–60.

20. The Donglin academy in seventeenth-century Jiangsu province was an autonomous organization of high-minded public officials and intellectuals. They conducted lectures and held meetings for the purpose of discussing public affairs and advocating reform during a time of misgovernment and corruption at court. In 1626 this society was harshly repressed for what was seen as interfering in political affairs. Members of the new Fushe, or Restoration Society, took up the cause in the 1630s and had substantial influence in the Nanjing region. Under the Qing dynasty, however, many of its members were executed or driven into exile.

21. Qian Hang and Cheng Zai, *Shiqi shiji Jiangnan de shehui shenghuo* (Taipei: Taibei nantian shuju, 1998), p. 188.

22. *Dufu quanji* (Shanghai: Shanghai guji chubanshe, 1996), vol. 1, p.1.

23. Zhou Lianggong, preface to *Du hua lu*, vol. 10 of *Huashi congshu*, ed. Yu Anlan (Shanghai: Shanghai renmin meishu chubanshe, 1963), p. 2.

24. Zhou Lianggong, *Du hua lu*, juan 1, p. 3.

25. From an album in the collection of the Shanghai Museum. Lin Shuzhong, "Gong Xian nianpu," in *Dongnan wenhua* (1990, no. 5): 61.

26. The 1684 Gong Xian painting is in the collection of the Lushun Museum in China and published in *Jinling bajia huaji* (Tianjin: Tianjin renmin meishu chubanshe, 1999), p. 83.

27. Dong Qichang, *Huachanshi suibi*, cited in Shen Zicheng, *Lidai lunhuamingzhu huibian* (Beijing: Wenwu chubanshe, 1982), p. 269.

28. Liu Gangji, *Lidai huajia pingzhuan*, vol. 2 (Hong Kong: Zhonghua shuju, 1986), p. 28.

29. Wei writes, "One can live almost a hundred years, the average is around 70 or 80 years. Excluding the twenty years of childhood and old age, during the remaining 50 or 60 years one must read for twenty years, travel for twenty years, and write for twenty years [in order] not be conscience-stricken by the adage of "Read ten volume books, travel for ten thousand miles." Qian Yong, *Luyuan conghua* (Beijing: Zhonghua shuju, 1997), juan 23, pp. 604–5.

30. *Exhibition of the Peking University Library's Collection* (Beijing: Beijing University and Youling Tang of Japan, 1987), p. 24.

31. *Jinling bajia huaji*, p. 65.

32. Xiao Ping and Liu Yujia, *Gong Xian*, p. 21.

33. Zhou Lianggong, *Du hua lu*, juan 3, p. 42.

34. Suzuki Kei, *Comprehensive Illustrated Catalog of Chinese Paintings* (Tokyo: University of Tokyo Press, 1983), vol. 4, p. 331, JP30–20.

35. *Jinling bajia huaji*, pp. 79 and 80.

36. The story is told in the "Tangwen" (Questions of Tang) chapter of the *Liezi*, in *Zhuzi jichang*, vol. 3 (Shanghai: Shanghai shudian, 1986), p. 61. See also Kenneth J. DeWoskin, "The Chinese *Qin*," in Stephen Addiss et al., *Resonance of the Qin in East Asian Art* (New York: China Institute Gallery, 1999), p. 24.

37. Xie Guozhen, *Mingqing zhiji dangshe yundong kao* (Beijing: Zhonghua shuju, 1982), p. 8.

38. James Cahill also pointed out Gong's social involvement with members of the Fushe in *The Compelling Image* (Cambridge, Mass.: Harvard University Press, 1982), p. 168.

39. Cited in Xiao Ping and Liu Yujia, *Gong Xian*, p. 3.

40. Lin Shuzhong, "Gong Xian nianpu," p. 51. The people mentioned in Gong Xian's poem about the event were members of the Donglin Party and notable poets and painters of the time.

41. Chen Zuolin, *Jinling suozhi wuzhong*, vol. 2, p. 5.

42. Ibid.

43. In his letter "Responding to Gong Banqian" Kong Shangren wrote, "When I acquired some interesting paintings and fine poetry books, I would place them on the desks and stools in my studio. They would transform common people (who see them) into elegant ones who would then refer to a small boat as a showboat of paintings and books. And when I ask them to sit down in my humble abode and serve them tea, they, holding the tea in their hands, would change even in their appearances and manner and would become quite refined looking. So who ever said that the vulgar could not be refined?" Kong Shangren, "Bingyindingmao Cungao," in *Shiwen ji*, *juan* 7, *Zha* (Beijing: Beijing Zhonghua Shuju, 1962).

44. Wen Zhenheng's (1585–1645) *Changwu zhi* includes several chapters on tea: a guide for decorating a teahouse, how to wash tea ware, how to choose the best charcoal for boiling water, and so on. In it he mentions purple pottery vessels (Yixing ware) as the best tea pots, but not those with vulgar shapes like the double peach and reclining melon. See Wen Zhenheng, *Changwu zhi* (Nanjing: Jiangsu kexue jishu chubanshe, 1984), *juan* 1, p. 31, and *juan* 12, pp. 418–9. Zhang Dai's (1597–1679) *Dream of the Tao'an Studio* (*Tao'an mengyi*) and Yuan Mei's (1716–1798) *Cuisine Manual of Sui Garden* (*Suiyuan shidan*), both have chapters discussing the topic of tea. 84.

45. Tu Long's comments in his *Peng wan* are cited in Wu Chengxue, *Wanming xiaopin yanjiu* (Nanjing, Jiangsu guji chubanshe, 1998), p. 66.

46. Xiao Ping and Liu Yujia, *Gong Xian*, p. 23.

47. Liang Baiquan, *Nanjing bowuyuan cangbaolu* (Shanghai: Shanghai wenyi chubanshe and Sanlian shudian, 1992), p. 264. See also Alexander C. Soper, "A New Chinese Tomb Discovery: the Earliest Representation of a Famous Literary Theme," *Artibus Asiae* 24 (1961), no. 2: 79–86, and Ellen Johnston Laing, "Neo-Taoism and the 'Seven Sages of the Bamboo Grove,' in Chinese Painting," *Artibus Asiae* 36 (1974), no. 1/2: 5–54.

48. *Nanjing minjian gushi* (Nanjing: Jiangsu renmin chubanshe, 1962), p. 98.

49. The comment by Wang Zhuo (b. 1636) from his *Jinshi shuo* is cited in Qian Hang and Cheng Zai, *Shiqi shiji Jiangnan de shehui shenghuo*, p. 302.

50. Xiao Ping and Liu Yujia, *Gong Xian*, p. 30.

51. The emperor's remarks as recorded by Xu Wei in *Nanci xulu* is cited in Qian Hang and Cheng Zai, *Shiqi shiji Jiangnan de shehui shenghuo*, p. 234.

52. Zhang Dai recorded the performance for a hotel guest in Taizhou in *Tao'an mengyi*, vol. 4, p. 93, and recorded the performance for the Autumn Festival in Suzhou in vol. 5, p. 109.

53. In a poem written for a gathering of a Qinhuai poetry club, the artist Gong Xian recorded his impressions of the entertainment: "Drums and bassoons are played day and night, as actors and puppets ascend the stage. Oh, how wondrous life is in the city of Jinling, where even the surrounding Zhongshan mountain is covered with music and joy!" Lin Shuzhong, "Gong Xian nianpu," p. 1.

54. Yu Huai, *Banqiao zaji* (Shanghai: Dada tushu gongyingshe, 1934), pp. 3–4. An English translation of this text has been published as *A Feast of Mist and Flowers : the gay quarters of Nanking at the end of the Ming*, trans. Howard S. Levy (Yokohama: the Translator, 1966).

55. Xie Zhaozhe, *Wu za zu* (reprint, Kyoto: Kobayashi Shobe, Kansei 7 [1795]), vol. 3, p. 22.

56. Wang Siren, in his *Qingke shiyin*, writes, "Only those of purity and clarity are the envy of Heaven. On a cloudy and misty or a windy and stormy day, as we are separated from purity and clarity, we feel sad and low. But on a clear autumn day, when the azure can be fully viewed, we can feel the infinite. We are elevated to a higher spiritual realm, and our hearts are elated. We can thus gather that Heaven keeps the loftiest possessions to itself. Heaven makes human beings who are sages and saints, and great statesmen or warriors. There are five kinds of happiness in human life: longevity, wealth, health, benevolence, and natural death. But purity and clarity are not included. For Heaven keeps only to itself purity and clarity." Cited in Wu Chengxue, *Wanming xiaopin yanjiu*, p. 272.

57. *Yuan Hongdao ji jianjiao*, *juan* 11, *Zhang Youyu* (Shanghai guji chubanshe, 1991), cited in Wu Chengxue, *Wanming xiaopin yanjiu*, p. 35.

58. *Gong Xian ceye* (Nanjing: Jiangsu guji chubanshe, 1986), cited in Lin Shuzhong, "Gong Xian nianpu," p. 62.

59. Tu Long' comments in *Suiyuge pingxuan tu chishui xiansheng xiaopin* are cited in Wu Chengxue, *Wanming xiaopin yanjiu*, p. 67.

60. The Eastern Jin dynasty poet Tao Yuanming (ca. 376–427) wrote an essay, "Taohuayuan Ji," in which he described an isolated location in southwestern Hunan Province. The people there did not know of any war or disaster, but lived in a peaceful and harmonious world, a rustic paradise. Later on, the term Peach Blossom Spring (*Taohuayuan*) became an expression for such an ideal place. For an English translation of the essay see Cyril Birch, *Anthology of Chinese Literature: from early times to the fourteenth century* (New York: Grove Press, 1965), pp. 167–8. Richard Barnhart, in *Peach Blossom Spring: Gardens and Flowers in Chinese Painting* (New York: Metropolitan Museum of Art, 1983), pp. 13–17, discusses the artistic inspiration drawn from Tao Qian's persona and his written works.

61. The comment by Ming dynasty artist Tang Zhiqi in his *Huishi weiyan* is cited by Zhou Jiyin, *Zhongguo hualun jiyao* (Nanjing: Jiangsu meishu chubanshe, 1997), p. 153.

62. Wang Bomin, *Zhongguo huihua shi* (Shanghai: Shanghai renmin meishu chubanshe, 1983), pp. 483–5. For the influence of contemporary literary movements and Chan Buddhism in the formulation of Dong Qichang's theory see Wen C. Fong, "Creating a Synthesis," in Wen C. Fong and James C. Y. Watt, *Possessing the Past: Treasures from the National Palace Museum, Taipei* (New York: The Metropolitan Museum of Art, 1996), pp. 420–23.

63. See P.J. Donnelly, *Blanc de Chine* (London, Faber and Faber, 1969), p. 354, for a list of potters' seals.

64. Zhao Yi, *Ershi'ershi zhaji*, *juan* 34, cited in Qian Hang and Cheng Zai, *Shiqi shiji Jiangnan de shehui shenghuo*, p. 87.

THE NANJING SCHOOL OF PAINTING
Chu-tsing Li

Both politically and culturally Nanjing has played an important role in the history of China. However, even though it occupies a key geographical position in the lower reaches of the Yangzi River and has served as the capital for several dynasties and kingdoms, its reputation has never been as great as capitals like Chang'an (modern Xi'an), Hangzhou and Beijing. In art, Nanjing has had less cultural identity than that possessed as well by Suzhou, Yangzhou and Shanghai. One seldom hears about a Nanjing School of painters, even though one existed. Nevertheless, Nanjing has played an important role in the development of art and literature throughout Chinese history. Influential artists have worked in this ancient capital for more than 1,600 years. But it was during the seventeenth century that Nanjing attracted the greatest number of them, a period which coincided with the Ming-Qing dynastic transition and was a time of dramatic upheavals in Chinese society. This moment in time is the context for the present exhibition, which focuses on paintings by seventeenth century Nanjing artists from the collection of the Nanjing Museum itself.

NANJING'S CONTRIBUTIONS TO CHINESE ART

Nanjing became a capital city as early as the Warring States period (475–221 B.C.), but it was not until the Eastern Jin dynasty (317–419) that this city saw the first flourishing of its culture, especially in the art of calligraphy. Two of the greatest calligraphers in Chinese history, Wang Xizhi (321–379) and his son Wang Xianzhi (344–386), lived and worked here. During the Six Dynasties period (220–589), following the demise of the Eastern Jin, Jiankang, as Nanjing was known at that time, continued to distinguish itself by its culture. During this period one of the great masters of early Chinese painting, Gu Kaizhi (345–406), lived here. With such talented pioneers, Nanjing's position in the history of Chinese art was firmly established.

The second period when Nanjing played a central role in art was the Southern Tang dynasty (937–975). Under two art-loving emperors, Li Jing and Li Yu, art and literature flourished. In Nanjing, known as Jiangningfu by that time, they established a painting academy at the court and appointed many of the important

artists of the day as its members. One of the most notable painters at the Southern Tang court was Gu Hongzhong (active 10th c.), whose masterpiece, *The Night Banquet of Han Xizai*, can still be seen in the Palace Museum in Beijing. The imperial academy included several outstanding figure painters such as Zhou Wenju (act. 937–942) and Wang Qihan (act. 961–975), who depicted court life. In the bird and flower genre, Xu Xi (d. before 975) established a stylistic tradition that was followed by generations of artists. During this period there was also a painter named Zhao Gan (active mid- 10th c.), who, though known only as a student in the academy, left a masterful landscape painting, *Early Snow on the River*, now in the National Palace Museum, Taibei. In addition, two of the most influential landscape painters, Dong Yuan (d. 962) and Juran (act. ca. 960–985), were also connected with the court in the last days of the kingdom. Although they were not well known during their lifetime, their art became models of landscape painting in successive eras, especially during the Northern Song (960–1127) and Yuan (1279–1368) dynasties. Together with some calligraphers and poets, including the two emperors, these artists represented the flowering of cultural life in Nanjing during that short period.

Nanjing again was a leading center of cultural life in China in the early Ming Dynasty. Zhu Yuanzhang (1328–1398), during his last years as a rebel leader, began to use Nanjing as his headquarters. In 1368, after his army had captured Beijing, he proclaimed himself emperor and made Nanjing capital of China. However, in 1421, his son, the Yongle Emperor, who had usurped the throne in 1403, moved the capital to his former princely quarters in Beijing. During the more than fifty years that Nanjing was the capital, the grand palace built by the Ming founder supported a thriving artistic culture with numerous painters and poets.

From the fourteenth until the sixteenth century, painting in Nanjing was dominated by professional artists who mostly came from the region near the former Southern Song capital of Hangzhou in Zhejiang Province. These so-called Zhe School painters continued Song court painting traditions, but combined the dense compositions depicting

the majestic mountains of Northern Song landscape painting with the broad brushstrokes (called "large axe-cut strokes") and more dramatic compositions associated with the Ma Yuan-Xia Gui style of the Southern Song. Despite the association of the Zhe School with Hangzhou, many of the leading professional painters from this school spent significant portions of their career in Nanjing. Painters such as Dai Jin (1388–1462), Wu Wei (1459–1509) and Jiang Song (fl. ca. 1500) developed a bold, deeply saturated style of landscape painting that remained popular until the beginning of the sixteenth century.

Toward the end of the Ming Dynasty, Nanjing again became a center of politics and culture. As the Manchu army was threatening Beijing, some high officials and generals looked to Nanjing as a strategic defensive bastion. In 1644, after the Manchus had captured Beijing and the Ming emperor had hanged himself, some officials and generals attempted to maintain the dynasty by establishing a new court in Nanjing. As a result, Nanjing again became the capital of the empire (if only for one year) and attracted many accomplished people, especially artists. Some high officials who came to Nanjing were also noted calligraphers; they include Wang Duo (1592–1652), Shi Kefa (1602–1645), Huang Daozhou (1585–1646), Ni Yuanlu (1593–1644) and Yang Wencong (1597–1646).

CHARACTERISTICS OF NANJING PAINTING IN THE SEVENTEENTH CENTURY

At the beginning of the seventeenth century, painting in Nanjing was not identified with a distinctive style of its own, unlike Suzhou, Songjiang and Anhui Province, each of which fostered artistic schools that were dominated by one or more leading painters. The Wu School, centered in Suzhou, was the most influential from the fifteenth through the early seventeenth centuries, because Shen Zhou (1427–1509) and Wen Zhengming (1475–1559) were the foremost practitioners of the literati tradition at that time. They were followed by a host of other literati painters, as well as by some professional artists who worked in their own individual styles, like Tang Yin (1470–1524) and Qiu Ying (ca. 1495–1552). Their style was different from that of the Zhe School, with its adherence to bolder Song court styles. The Huating School, located in Songjiang, derived its principle identity from the theories and works of Dong Qichang (1555–1636), whose career as a high official took him to Beijing and Nanjing. Drawing inspiration from the canon of Song and Yuan scholarly masters, Dong created a style based on careful study of past models, but executed in the

literati manner of the Wu School. During the Ming-Qing transition, the Xin'an School flourished; its members like Hongren (1610–1664) often depicted the mountainous scenery of their native Anhui Province in a spare dry brush manner. After the fall of the Ming, these depictions came to be associated with political isolation, just as the region itself was remote from the world of the Qing court.

In contrast to these schools, painting in Nanjing did not have a set of identifiable characteristics or a dominant artist like Wen Zhengming, Dong Qichang or Hongren who was able to influence a generation of younger painters. The styles seen in Nanjing at that time exhibit points of connection with the Wu, Zhe, Huating and Xin'an schools, but none exerted a dominant influence. Rather, because artists from other regions often visited Nanjing, they brought to the city a diversity of influences. As a result, no one style came to characterize painting in Nanjing.

The Nanjing school also lacked a clear identity because its artists flourished in sudden spurts of creative energy, but only from time to time—it would always be of insufficient duration to establish and maintain a common tradition. Such was the case with the calligraphers Wang Xizhi and Wang Xianzhi during the Eastern Jin period. Although they became models for all calligraphers in later periods, their influence affected the entire Chinese tradition rather than a local one. Similarly, the legendary artists of the Southern Tang period, especially Dong Yuan and Juran, became models for painters in later periods nationwide, but they did not create a specific Nanjing tradition. Finally, in the early Qing, while there was a great amount of artistic expression in the works of painters such as Gong Xian (1619–1689), Shitao (1642–1707), Kuncan (1612–1673) and Cheng Zhengkui (1604–1676; see cat. no. 11), there was, again, no continuation of this development into the eighteenth century.

Even those who were not natives of Nanjing spent time there and associated extensively with Nanjing artists. Several came to live in Nanjing for much of their careers. Nanjing's reputation as a center for artists during that period is articulated in an inscription the painter Gong Xian wrote on an album of his close friend and patron Zhou Lianggong:

Nowadays painting flourishes especially in Jiangnan, and among the fourteen counties of Jiangnan the first county [Nanjing] has the largest number. Within this county there are dozens of famous painters, and if you include many of those who know a little about painting the number will probably reach a thousand.[1]

Some of the artists who lived in the city were later known as *yimin*, or "leftover subjects," since they still harbored a strong sense of loyalty to the Ming even though they had accepted Qing rule. Their art revealed an independent spirit with great innovations, and their interest in coming to Nanjing was partly based on the fact that Nanjing, as the capital of Southern Ming, still reflected the spirit of the fallen dynasty.

THE JINLING MASTERS

During this period a number of local artists emerged. While the principal artists are now known as the Eight Masters of Jinling, it was not a coherent group with a common style or set of goals; it is an appellation created in the eighteenth century by the writer, Zhang Geng, in his book, *Paintings of the Qing Dynasty* (*Guo chao hua zheng lu*). Indeed, these artists never came together in the same workshop, nor did they practice a single style. And even though the early Qing dynasty can be called the golden age of Nanjing culture, it was a short-lived period when several of the most important painters happened to live and work in proximity to each other. The diverse styles of Nanjing painting at this time is epitomized by *The Mustard Garden Painting Manual* by Wang Gai (1645–ca. 1710). Wang's painting manual summarized his understanding of the history of Chinese painting and was based on paintings from previous periods then available in Nanjing collections.

The noted collector Zhou Lianggong, who was a friend of many of these painters, recorded their biographies in his book, *The Record of Painters* (*Du Hua Lu*). Zhou did not group them together under any particular category, and several of them were in fact not native to the city. While these artists came from different places, they all lived in Nanjing during their active years. Attracted to the city because of its cultural atmosphere and its art market, these artists shared a similar lifestyle—living modestly and never serving in the government—while in their art, each developed his own distinctive mannerisms. The present exhibition shows works by most of these masters and illustrates their variety and vitality.

Artists included in this group are Gong Xian, Fan Qi (1616–ca. 1694), Gao Cen (fl. ca. 1645–1689), Wu Hong (ca. 1610–after 1683), Hu Cao (active ca. 1650–1662), Ye Xin (fl. 1647–1679), Zou Zhe (ca. 1610–after 1683) and Xie Sun (active ca. 1679). By examining a few of these artists, the eclecticism of seventeenth century Nanjing painting can be seen.

Among the Eight Masters, Fan Qi, like Gong Xian, was regarded as one of the leaders of the Nanjing School. He was born in 1616, two years before Gong Xian, but seems to have lived longer, into the 1690s. He is well represented in this exhibition, with more than five paintings in a range of approaches, which demonstrate his many-faceted talents. His handscroll, *Sightseeing in Jinling* (cat. no. 3), depicts the sights of Nanjing in a straightforward, realistic manner. The scroll also bears colophons by prominent literati of the day. In contrast to this topographic landscape, the exhibition also includes Fan's portrait of a beautiful Nanjing courtesan, Kou Mei, done in 1651, with background trees and other details executed by Wu Hong, another of the Eight Masters. While Fan Qi is best known as a painter in the Song manner, like his snow scene dated 1666 (cat. no. 20), he also depicted quite personal views in small paintings such as a fan that depicts a gentleman seated in a boat surrounded by reeds and rocks (cat. no. 6b). Among his extant works, one of the most interesting is a long handscroll of rocks along a river, which is now in the Museum of East Asian Art in Berlin. This painting shows his versatility in evoking Song landscape traditions. Together, these works demonstrate Fan Qi's talent at using a wide range of artistic styles— from the literati manner of Huang Gongwang (1269–1354) to the professionalism of the Zhe School— especially in his depicting rocks and mountains.

Of the six other masters little is known; how and why each came to be classified as one of the Eight Jinling Masters remains an open question. Their surviving works are few, very likely the result of the widespread destruction in Nanjing during later periods of political turbulence, such as the Taiping Rebellion (1851–1864). From the *Album of Fan Paintings by the Eight Masters of Jinling* (cat. no. 6), one can see their indebtedness to Song and Yuan Masters in their compositions and brushwork. Among the eight fans in this album, in addition to those by Gong Xian and Fan Qi, the most interesting is that of Xie Sun, which presents a fantastic landscape panorama, executed with exquisite detail (cat. no. 6g). Xie's fan is filled with a host of finger-like high peaks that stretch far into the distance. On the left are strange rock formations with high waterfalls running through the rocks and trees. In the middle section is a large cave with stalactites, above which is a group of houses that look like a small village. Further back is a hill situated in the middle of the fan with a pagoda rising above the buildings of a temple. On the right, several tall trees grow from the slopes of a mountain. Their sizes dwarf the gentleman on horseback head-

ing toward the village above the cave. This complex composition not only evokes the landscape paintings of some Song masters, but also of Wu Bin (1573–1620), who lived in a temple outside of the city during this period. Another interesting fan, painted in dark ink by Gao Cen, depicts a gentleman sitting on a boat in a river surrounded by mountains and trees (cat. no. 7). This fan derives its concept from the Yuan painter Wu Zhen (1280–1354). Gao Cen has another major work in the Nanjing Museum, *Autumn Mountains and Myriad Trees*, which, according to his inscription, is based on a painting of the same title by the Northern Song painter Fan Kuan (active ca. 990–1030). The scene is dominated by a high mountain with a fantastic formation on the top, overlooking a valley below with trees and rocks (cat. no. 27).

Ye Xin's fan in the same album is also based on Song and Yuan landscapes, combining a Song style composition with the ink tonalities of Yuan literati painting (cat. no. 6e). A similar landscape in both composition and execution is the work by Zou Zhe (ca. 1610–after 1683), which is dominated by strange mountain peaks surrounding a pavilion in the center (cat. no. 6d). Together, these fans reveal many sources from the long Chinese painting tradition.

THE GREATEST JINLING ARTIST: GONG XIAN

The greatest artist that Nanjing produced during this period, Gong Xian grew up with parents who regarded Kunshan (near Shanghai) as their ancestral home. Unlike some of his contemporaries, Gong Xian displayed a strong interest in artistic innovation and self-expression. In his youth, he must have been disappointed by the widespread political corruption of the late Ming, for he became associated with members of the Revival Society (Fushe), an group of intellectuals in the Jiangnan region who tried to rekindle traditional Confucian morality and contemporary governmental reform. Because of this guilt by association, he was forced to move several times to avoid persecution. After the Manchu army took over the city, he left Nanjing and spent almost ten years wandering in the northern part of Jiangsu province. After conditions became more settled, he returned to Nanjing and lived a simple life. Establishing himself on a small hill called Mount Qingliang (located just inside the city's western wall), he began to give lessons in painting and calligraphy and supported himself by selling his art.

His last years seemed to be mainly in poverty, for when he died, his descendents were not able to hold a proper burial for him. It was one of his close friends, Kong Shangren (1648–1708), a playwright known for his drama, *The Peach Blossom Fan*, who took care of the funeral expenses, brought up his son and published a volume of his essays. Since few of his early works have come down to us, we do not know much about his painting teachers and his early development. However, his later years, especially after his return to the Nanjing area from his years of wandering, was the period of his greatest artistic maturity. The Nelson-Atkins Museum of Art contains several of these works. An album of landscapes in ink shows his wide-ranging style. A few leaves follow the monumental style of Northern Sung masters such as Dong Yuan and Juran, while others depict retreats that may have belonged to the artist or some of his friends.

Two handscrolls in the same museum show his mature artistic style in their depiction of interweaving mountain ranges and river views throughout the picture. Indeed, the complex compositional relationship between these elements is his greatest strength in this format. At the Rietberg Museum in Zurich, Gong's *A Thousand Peaks and Myriad Ravines* represents the culmination of his art in a single composition. In a rectangular format, the painting depicts mountains after mountains stretching into the distance. They are shown in various shapes, from horizontal to vertical to triangular. Streaks of clouds and waterfalls enliven the composition. The interplay of all these forms and their sharp contrasts of light and dark create a somber and moody atmosphere. This style was typical of his later years and reflects his abiding loyalty to the fallen Ming Dynasty.

The collection of the Nanjing Museum has several paintings that illustrate the range of styles over the many years of Gong Xian's life. The earliest of these is *A Fisherman's Cottage in the Autumn River* (cat no. 21), a work that derives from the work of Wu Zhen and Ni Zan (1306–1374). The composition is divided into two sections: the upper one with mountain ranges above rivers and lakes is depicted with heavy outlines and light strokes; the lower section with cottages and trees on low sand banks is executed in horizontal lines and dots. It is a scene of a quiet river view that comes directly from Wu and Ni. In the midst of this scene there appears a motif that is characteristic of Gong Xian—a single, lonely pavilion that symbolizes his own situation during this period. Above, the artist has added a poem of his own composition, a practice typical of the literati tradition. Based on its style, the painting appears to be a work of the 1660's when Gong was in his forties.

A fan painting in pure ink, *Mountain Pavilion Beside a Stream* (cat. no. 26) dated 1679, is representative of the next phase of Gong's artistic development. Here, the painter creates a more complex composition, with the left side dominated by eight trees, while the right contains rocks and streams. Again in the center is the single lonely pavilion. In this painting the kind of brushwork typical of Gong's later years has emerged; it employs a heavy line that is used to describe trees and rocks with dark dots in between, a combination of brushwork characteristics of the four masters of the Yuan dynasty (Wu Zhen, Huang Gongwang, Ni Zan and Wang Meng). Even in such a small composition, Gong Xian shows his mastery in both composition and expression.

Among the five paintings by Gong Xian from the Nanjing Museum there is one work in the long handscroll format, *A Thousand Cliffs and Myriad Valleys*, done in 1673 (cat. no, 18). Here he depicts rivers and lakes with a range of mountains beyond, and alternates his composition between open and closed views. Continuing this dynamic rhythm for over eight feet, he contrasts the horizontal waves of the water, the vertical planes of trees, and the rise and fall of curving profiles of rocks, hills and mountains. With a few details of waterfalls, houses and pagodas, he transforms this composition into a masterful play of blacks and whites. This work was produced during the most creative period of Gong's life, when he was in his fifties. At this time, he executed several handscrolls of similar quality, including one in the Palace Museum of Beijing and two in the Nelson-Atkins Museum of Art. All of these works exhibit characteristics that find their fullest development in the version of *A Thousand Peaks and Myriad Ravines* at the Rietberg Museum.

In addition to this handscroll, there are two other paintings in the Nanjing Museum collection that may be related stylistically to his later life, when he was in his sixties and seventies. One of them, *Summer Mountains After the Rain* (cat. no. 19) is a hanging scroll with a simple composition of twelve tall trees set against a background of mountains. These mountains extend from the foreground to the background at the upper edge of the composition. Gong may have used a more absorbent type of paper here, since the trees are darker and the mountains appear more solid. This painting lacks the vitality of his handscrolls, however, which derive their power from the complex interplay of natural forms. The other late work in this exhibition is another fan painting (cat. no. 6a) with a composition somewhat similar to *Mountain Pavilion Beside a Stream*, part of an album of landscapes by eight Jinling masters. This one differs from the earlier fan, as it is executed in the free and quick brushwork typical of his late work. It demonstrates that at his advanced age Gong Xian felt quite at ease and executed his works in an authoritatively brisk manner.

Geographically, Nanjing has been an important city in the lower reaches of China's Yangzi River since the Spring and Autumn Annals and the Warring States periods. Besides its significant role in the political history of China, Nanjing has also occupied an important role in China's cultural history. In the visual arts, the outstanding achievements of artists working in Nanjing have made major contributions to the development of both calligraphy and painting. In the Six Dynasties period, a pivotal moment in the history of calligraphy occurred when Wang Xizhi and his son Xianzhi liberated the art from the formal and regulated ancient scripts of *zhuan* and *li* styles by perfecting the free and spontaneous semi-cursive (*xing*) and cursive (*cao*) styles. In the history of painting, Dong Yuan and Juran of the Southern Tang dynasty were instrumental in shifting the emphasis from the strictly formal genre of figure painting to the more self-expressive subject of landscape. Toward the end of the Ming dynasty and the beginning of the Qing, Nanjing once again became a center of the art world when a number of creative Ming loyalist painters, as well as local artists, worked here in the seventeenth century. The stylistic eclecticism of the so-called Eight Masters of Jinling reflects the richness and diversity of the Nanjing artistic community at that time, while the paintings of Gong Xian exemplify the way in which some of these artists reached a new level of individualistic expression.

Note:
1. Lin Shuzhong, "Gong Xian nianpu," in *Dongnan wenhua* (1990, no. 5):58.

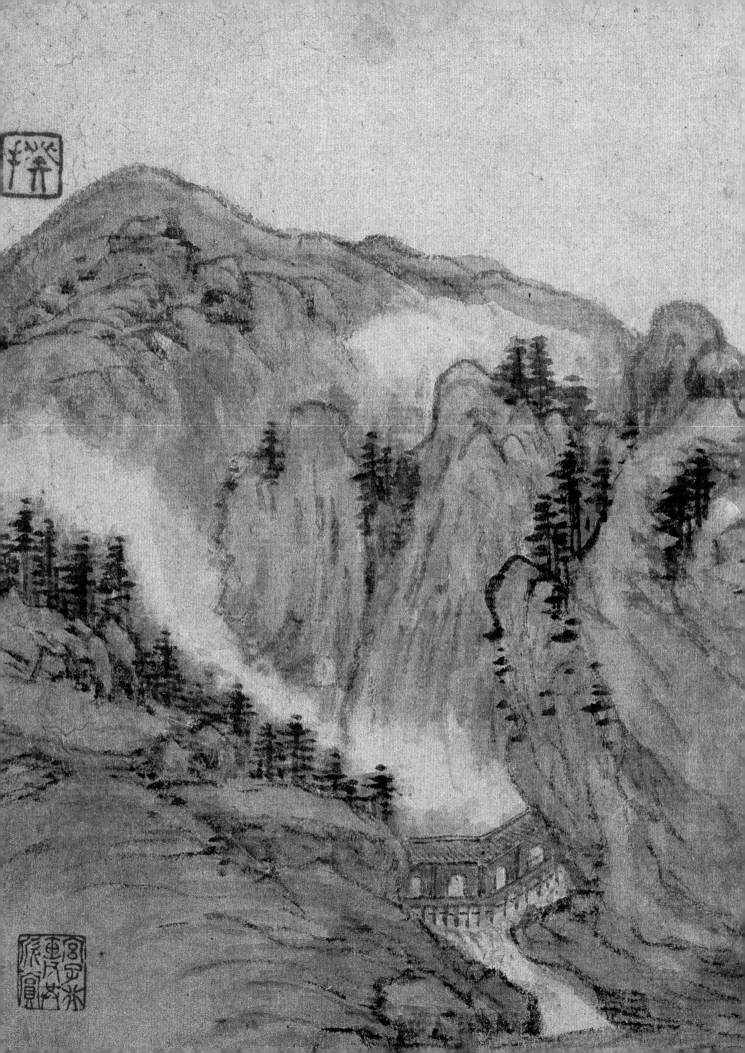

A PLACE OF BEAUTY

Jinling, or "Gold Mountain," an ancient name for Nanjing, is often used to refer to Nanjing in literary works and is still in wide use today. Also known as "The City of Mountains and Forests" (Shanlin Chengshi), Nanjing is encircled and intersected by a dozen graceful mountains.

In China as elsewhere, mountains have been appreciated for their natural beauty and panoramic views. But since the time of Confucius, mountains have also been revered as being "virtuous gentlemen" who benefited people with their generous resources. Later, the literati developed an even greater love for mountains, as they came to symbolize many other desirable attributes. They were seen as being lofty, as a high-minded scholar; remote, as a recluse without commercial motivations; natural and lovely, as the state of purity and elegance sought by literati; and cool, a place of comfort and retreat during hot summer months.

In mountains, people could escape from their urban existence and worldly anxieties to enjoy themselves and lift their spirits. Mountains have additional significance because their Chinese character, *shan*, is used with other characters to create important concepts. Thus, "mountain-water"(*shanshui*) means "landscape," and "river-mountain" (*jiangshan*) has come to mean "the nation." A passion for mountains was thus deeply rooted in their psyche. Paintings of mountains, by extension, held special symbolic value because their representation conveyed these cultural connotations.

With its many scenic places to gather, Jinling was a wellspring of artistic and intellectual creativity over the centuries. This was especially true during the seventeenth century, when it became a popular subject in literature and painting. As the secondary capital of the Ming dynasty, Jinling held a special symbolic and emotional significance for Ming loyalists and refugees ("left-over subjects," or *yimin*) immediately following the fall of the Ming and the conquest of China by the Manchus, a semi-nomadic people who established their own dynasty.

(Seals, colophons, additional imformation and notes for each entry are in the Catalog Appendix.)

1. Map of Qing Dynasty Jinling

金陵省城古跡圖

Qing dynasty (1644–1911)

Woodblock print mounted as hanging scroll,
 ink on paper

H. 202 cm (79⅝ in.); W. 91 cm (35⅞ in.)

This map of the Qing provincial capital clearly shows the city walls that were built in the Ming and the topographical features that served as the city's natural defense and as well as the settings for Jinling's landscape painters.[1]

To the east of the city lies Bell Mountain (Zhongshan or Mount Zhong) and to the northeast is Recuperating Mountain (She Shan). To the north lay Swallow Cliff (Yanziji), Curtain Hall Mountain (Mufu Shan), Lion Mountain (Shizi Shan) and Stone Mountain (Shitou Shan); and to the northwest Horse Saddle Mountain (Ma'an Shan). To the south Ox-Head Mountain (Niushou Shan) and Square Mountain (Fang Shan). The Yangzi River flows from the northwest to the southeast along the edge of the city. The Qinhuai River flows from the southeast across the city to the northwest, where it joins the Yangzi.

In addition to showing major city streets and outlines of the Ming Imperial Forbidden City, the map also indicates sites of scenic, historic, cultural and anecdotal significance. Some ancient sites, such as Pottery Temple (Waguan Si), which dates to the Six Dynasties (220–589), are noteworthy for their art historical associations.[2] Other famous sites on this map include Sunchu's Wine Pavilion (Sunchu Jiulou), Phoenix Terrace (Fenghuang Tai) and Apricot Blossom Village (Xinghua Cun).[3]

Among the places noted is Plum Hill (Mei Gang), also known as

Pebbles Hill (Shizi Gang), in the southern part of the city. A celebrated site for viewing plum blossoms, it is surrounded by the mausoleums of notable historical figures.[4] Mount Fang, also known as Celestial Seal Mountain, in the southeast is associated with Qin Shihuangdi (r. 221–210 B.C.), the first emperor of the Qin dynasty (221–206 B.C.). Legend has it that he believed Jinling's setting had an aura that could create rulers; fearing competition, he cut into the mountain to break the aura, releasing its waters to flow into the Qinhuai River. Surrounding this mountain are the Dinglin Temple and the tombs of some high ranking officers of the Ming dynasty.

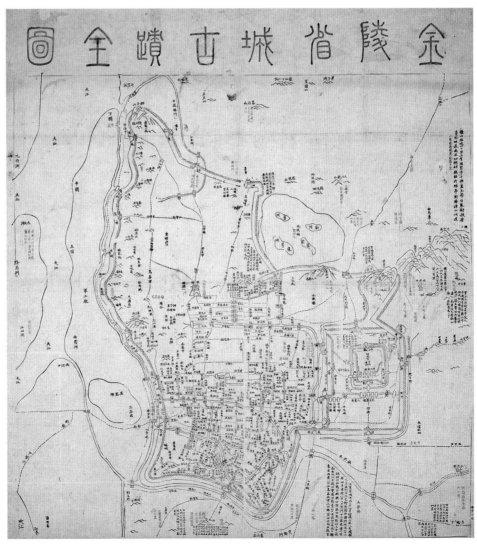

2. Guo Cunren (ca. 1580–1620)
Eight Views of Jinling
郭存仁 金陵八景圖卷
1600
Handscroll, ink and color on paper
H 28.5 cm (11¼ in.); W 645 cm (21 ft. 2 in.)

Guo Cunren is described as proficient in large-scale landscapes and competent in composition, brushwork and use of color.[1] His *Eight Views of Jinling* shows local scenes of Nanjing, each view accompanied by a poem. This early example of the eight views theme used to depict actual Nanjing topography was a specialty of Jinling landscape painters and increased in popularity during the late seventeenth century. Now mounted as a handscroll, these eight album leaves are each positioned with a painting to the right and an accompanying poem to the left. The concept of showing a series of scenes from one locale expanded over time to include some forty-eight such scenes, highlighting the special features of the city from every angle—historical, literary and anecdotal (see Appendix II).

The theme of "Eight Views of the Xiao and Xiang Rivers" (Xiao Xiang ba jing) began with Song Di (active 1078–1091), an academic painter of the Song dynasty known for his "level distance," or *pingyuan*, landscapes. According to the *Colophons on Calligraphy and Painting in the Pushuting Collection (Pushuting Shuhua Ba)*, by the scholar Zhu Yizun (1629–1709), Song Di was the first to compose eight views of the Xiao and Xiang Rivers which flow through present-day Hunan Province. These eight views were not actual depictions of local scenery but poetic evocations of landscape in different weather conditions, seasons or times of day. Nevertheless, since the Yuan dynasty, the concept was continually adopted to illustrate local scenery, including Beijing, Nanjing and other regions of the empire.[2]

2a. Clear Clouds Encircle Bell Mountain 鍾阜祥雲
The verdant hills of Bell Mountain are depicted with dry ink strokes laid over bluish wash, while gracefully swirling clouds and gushing springs are depicted with fine, fluid lines on bare paper.

Poem written in archaistic small seal script *(xiao zhuan shu)*:

Surrounded by magnificent green and purple mountains
rising to the heavens,
This land and city are indeed the choice to serve as our
grand capital!

Overlooking the wide sea, Mount Zhong makes isles of
myth seem small.
Beneath the mountain, Jinling prospers as a peaceful
metropolis.
The city glitters in many hues when His Majesty, the sun,
is present,
And the palace, blessed by the merciful spirit of Buddha,
deserves high praises.
With graceful music playing, I gaze at the horizon.
And yes! I see an imperial procession approaching!

The poem praises lofty Mount Zhong and its symbolic importance to the capital of the Ming dynasty. It also quotes the classics to praise the auspiciousness of the purple cliffs, which glitter in the light of the sun as if they were flecked with gold.

2b. Snow Falls on Stone Citadel 石城瑞雪
A peaceful, snowy Nanjing scene is depicted through dry brush strokes. Leafless, spiky branches suggest the bleak and chilly winter. The cold, gray sky is reflected in the icy waters, while the earth and rooftops are covered by a uniform whiteness. Two recluses in red robes, one holding a walking stick, step outside to appreciate the snow.

Poem written in standard script *(kai shu)*:

How the giant rocks protrude precariously into the sky!
Against layers of peaks and cliffs, they appear
so prominent.
As the night watches are beaten and echo over the hills
beyond the city walls.
Evening tide has brought in the boats that now moor
on Dragon River.
The snow, like blossoms, is spread onto the
Imperial Gardens,
And, like white jade, is scattered about the city
by the Heavens.
Oh, what auspicious omens has the snowfall brought.
Its citizens sing to greet the coming year of prosperity!

2c. Evening Rain Settles on Dragon River 龍江夜雨
The painting depicts Dragon River Pass (Longjiang Guan), which is located in the north side of the city, facing the Yangzi River, on a quiet, rainy night. Dragon River Pass was the location of the customs house during the Ming dynasty and also the location of the famous Treasured Boat Factory of Dragon River (Longjiang Baochuan Chang). This factory supplied most of the boats used by the successful and celebrated Ming dynasty

屼薴中天瞖爹齸草庚价
臥宧稻草鎣麦滌棗薴菓
小雞隣盦盦蕍肇禾乂名
陷迴膲曰皃九重搽掭摒雁
岩圣傷揚㳺霊肜墀上粘
引竜車翿海兆
夕鐘早祥

2a.

危石巉巖倚半天千尋峭壁
勢何堅山廻雜堞寒鳴柝潮
接龍江夜泊舡滕六散花歸
閬苑天孫種玉遍藍田禎祥
三白符先地試聽詩謠大有
年

右石城瑞雪

2b.

天輕西來一派橫百川嶺附向
東瀛卯酣不洗英雄眼牛夜偏
牽牜容情蓬辰蕭暝未稽枕
還滴夢難成岈岈頭暗促雞殼
急夢少鳳帆待曉晴

右龍江煙雨

2c.

烏臺百尺倚株樓戈鼓濤
茹坎蒼然然郭零禾未雲注
澄玉晉志階依然之九新
帬辰三更湏銀浮凉生芸
秒秋扚迗六釛烈裒地屐怜
圓鏡朏芭芒丘

右螢臺秋月

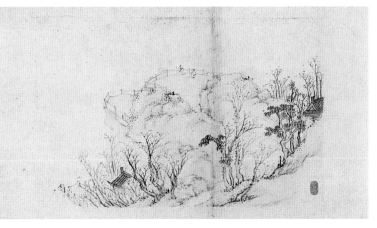

2d.

navigator Zheng He (1371–1435) for his journeys throughout Asia, Africa and the Middle East.[3]

Poem written in clerical script (*li shu*):

Lying to the west is the Yangzi River;
And, flowing to the east, are a hundred streams.
So many fascinating tales of warriors since
 the Six Dynasties
Are keeping the wayfarer awake at this midnight hour.
Listening to the desolate rain pattering on the wicker
 roof, sleep does not come;
With drops streaming down next to the pillow,
 there is no hope for sweet dreams.
Thus, sleepless, he hears the roosters' crowing
 on the riverbanks growing louder.
And, with other travelers, he impatiently awaits
 first light to set sail

2d. Autumn Moon Shines on Phoenix Terrace 鳳臺秋月
The painting depicts the renowned Phoenix Terrace with two recluses sitting at ease and enjoying a conversation. The simplified brush strokes and lightly applied washes of ink and color heighten the isolated and relaxed atmosphere.

Poem written in cursive script (*cao shu*):

Leaning on the city tower is a high chamber
From which the clear sound of a bugle gives rise
 to wistful memories.
Heavy clouds hover—there is no news of the coming
 of the exotic phoenix.
Music from a jade oboe ends abruptly in a long,
 sleepless night.
The icy moon looks desolate at this dark hour.
Under the Milky Way, signs of nature proclaim
 the coming of autumn,
And in this glorious land once known for song
 and dance,
Sad is the sight of deserted graves shadowed
 by a cool moon.

Phoenix Terrace (Fenghuang Tai) is located southwest of the city, on present-day Flower Dew Hill (Hualu Gang), and has been famous since the Six Dynasties period (220–589). It is said that during the Liu Song period (5th century A.D.) three peacock-like birds flew here and attracted a gathering of many birds, the so-called Hundred Birds Meet the Phoenix (*Bai niao chao feng*). Considering this an auspicious omen, the government built a high terrace to celebrate the occasion and perpetuate the

good luck. After the Tang dynasty poet Li Bo (701–762) paid a visit here and composed the poem "On Climbing to the Phoenix Terrace of Jinling," the terrace came to be remembered as a poetic site.[4]

2e. White Egrets Soar over Glistening Waves 白鷺晴波
Here one sees weeping willows along the river bank, with anchored boats suggested by the masts that rise above the willow branches. Double lines are used to depict the rippling waves of the river while washes of blue describe the weeping willows.

Poem written in seal script (*zhuan shu*):

Water birds can be seen on this river sandbank
Which forks into waters on both sides of the isle.
The clouds have lifted; the moon has turned the sky
 into a bright mirror;
The rain has stopped, the wind quieted down and
 the world become emerald green.
How busy are the fishermen, as the tides rise and ebb,
Busy as the river, greeting wayfarers day in
 and day out.
Standing still amidst nature and idly taking in this sight,
I see distant places and the infinite sky blended into
 one hue forever.

White Egret Islet (Bailuzhou) is located on the west side of the city, near present-day East River Gate (Jiangdongmen). But a thousand years ago, when the poet Li Bo visited Jinling, it was still an islet in the middle of the Yangzi River. Therefore, he wrote, "The Yangzi River branches into two rivers at the White Egret Isle" in the poem "On Climbing to the Phoenix Terrace of Jinling."[5]

2f. Sunset Seen in Black Robe Alley 烏衣夕照
Famous for its beauty, Black Robe Alley (Wuyixiang) is here vividly depicted with loose, dry brush strokes, and many dots of bluish color. The floating, smoke-like clouds add romantic touches to the scene.

Poem written in running standard script (*xing kai shu*):

So many years since the Red Magpie Bridge
 was torn down;
The tale of the old Black Robe Alley is seen
 only in storybooks.
As the setting sun lingers at these old sites,
Colorful but darkening clouds languish
 in the distant sky.

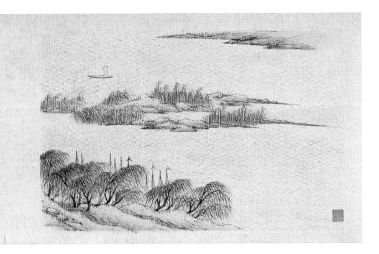

2e.

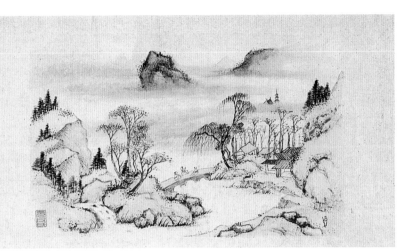

右烏衣夕照

2f.

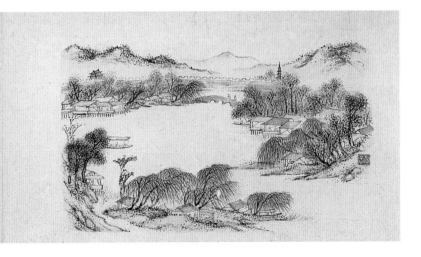

右秦淮鱠笛

2g.

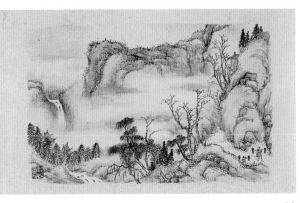

右天印樵歌

2h.

Who would have thought that the birds which
once nested in gilt eaves,
Now make their homes in thatched huts?

The Black Robe Alley cited in the poem is located in the southern part of the city, on the south bank of the Qinhuai River in the area of Confucian Temple (Fuzimiao). During the Three Kingdoms period in the third century, a station of the imperial security forces was located here. Their black uniforms gave the street its name. During the Six Dynasties, many nobles, such as the prominent families of prime ministers Wang Dao (act. 4th c.) and Xie An (320–385), chose this site for their houses, making Wuyixiang synonymous with luxurious residences. This site was the inspiration of many poems since the Tang dynasty.[6]

2g. Playing a Flute Beside the Qinhuai River 秦淮漁笛

Near Nanjing, a scene unfolds of a tranquil Qinhuai river with waterside pavilions and paddling pleasure boats, behind which lie willow trees and verdant mountains. A pagoda appears in the forest beneath the mountain in the distance, and the city wall is visible in the haze.

Poem written in clerical style (*li shu*):

Why did the strong State of Qin decide to
capture Jinling?
Simply because they heard this was a city of rulers.
Here, the peach blossoms embellish ancient lakes,
And weeping willows brush against the clear waves.
Where so many lovely singsong girls once
entertained their guests,
A fishing boat passes, rowed by a young man,
Who, lowering his rod after fishing,
Raises his flute to compose a peaceful melody.

The largest river flowing through the city of Nanjing, the Qinhuai River rises from two sources: in the north, the Jurong River, which flows from Mount Baohua of Jurong County and in the south, the Lishui River which flows from Mount Donglu of Lishui County. Both rivers join southeast of Nanjing city. Then, the Qinhuai flows into the city of Nanjing through the Shangfang Gate (Shangfangmen) to the east and heads northwest to join the Yangzi River on the northwestern of the city.

The banks of the Qinhuai River inside the city developed as the area's most prosperous commercial and residential location from the third century on. Especially prosperous was the section near the Confucian Temple, with its many courtesan houses, student dormitories, wine

pavilions and teahouses where there were musical and story-telling performances.[7] The name of this river, known in ancient times as Huaishui, is said to be associated with Qin Shihuangdi, the first Emperor of Qin, who directed the waters of Mount Fang toward the city (see cat. no. 1).

2h. Woodcutters' Songs Heard on Celestial Seal Mountain 天印樵歌

In this scene, two woodcutters carrying their loads are chatting with each other while returning home. Their surroundings appear to be an idyllic site high on a mountain, with a cascading waterfall, rushing stream, low-hanging clouds and colored temple finials, which convey the deep quietness of the mountain.

Poem written in cursive script (*cao shu*):

Like the imperial seal, mountains soar with
* a myriad peaks*
Around which form colorful clouds like
* seal script calligraphy.*
The water of the red ink is drawn from the
* Qinhuai River;*
Crystallized in colorful brushwork are hues from the
* well of Master Ge.*
On this clear day the lovely flowers bloom:

truly, what a glory is spring!
Fragrant blossoms on the long, winding lane
* are covered in mist.*
On their way home, after day's work is done,
* woodcutters hear greetings;*
In a spirit of joy, they respond with exuberance to
* the approach of friends.*

3. Fan Qi (1616–after 1697)

Sightseeing in Jinling
樊圻 金陵尋勝圖卷
1686
Handscroll, ink and color on paper
H. 32.5 cm (12⅞ in.); W. 249 cm (98⅛ in.)

This handscroll fragment contains only two paintings: *Enquiring for Wine at Apricot Village* (*Xingcun Wenjiu*) and *Boating on Qingxi River* (*Qingxi Youfang*). Both use light color and soft brush strokes to depict places of note near Nanjing. After each painting, there are several colophons recording the comments of viewers. The handscroll includes two additional titles and colophons for *Verdant Mount Qingliang* (*Qingliang Huancui*) and *Magnificent View at Qixia Mountain* (*Qixia Shenggai*), but these have been lost.

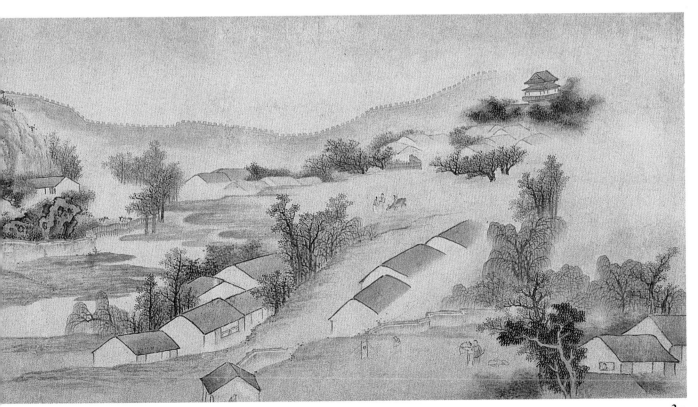

3a.

55

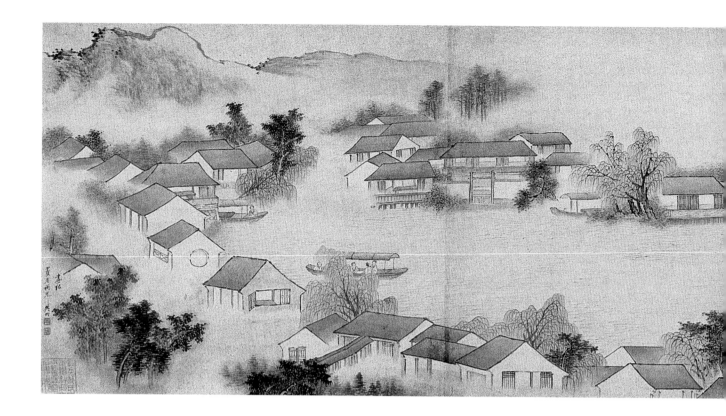

Native to Nanjing, Fan Qi was proficient in landscape, figure and flower painting, and he was praised by the collector and patron Zhou Lianggong (1612–1672): "[Fan Qi] has achieved a marvelous level in painting for every subject." His older brother, Fan Yi, was also proficient in painting. The two brothers lived in a wood hut fenced by sparse greenery near the Huiguang Temple and did their paintings like immortals. They lived a reclusive lifestyle and kept apart from common society.[1] Among the important Jinling masters, their paintings are quite delicate, often with soft brush strokes and light applications of colors. This soft and delicate quality was often criticized as the "Jinling habit" (Jinling xiqi) possibly because it appeared in so many of the local paintings produced for mass consumption during the Lantern Festival.

3a. Enquiring for Wine at Apricot Blossom Village
杏村問酒

Enquiring for Wine at Apricot Blossom Village (*Xingcun wenjiu*) depicts private residences and gardens near the city wall on a warm and beautiful spring day. There are touches of fresh green color on the weeping willows and pink color on the apricot trees. A few visitors are depicted asking for directions while some youngsters play games.

Apricot Blossom Village was located southwest of the city near Phoenix Terrace, which was made famous by Li Bo's poem "On Climbing to the Phoenix Terrace of Jinling." The village itself was made famous by another Tang poet, Du Mu (803–ca. 852), in his poem "Pure Brightness" ("Qingming"). Thereafter, Xinghuacun became known for wine shops.[2] Since then, it was a custom in Nanjing that, while on excursions to enjoy the spring scenery, one visited Xinghuacun to buy wine.

Two poems by the artist Wang Ji (act. 17th c.):

Why envy he who, with steed neighing outside,
 gets drunk with courtesans.
When I hear orioles sing, I fetch my walking cane
 and go for a stroll.
Seductive red blossoms blooming near a wine shop
 lures many drinkers;
And flowers' lovely reflections enhance the mood
 of the strollers.
Don't let the spring breeze bring in the drizzle —
Just invite the new moon to ascend the high hill!
The cicadas' droning must feel soothing
 to those who can sleep.
As for me, I'll let my servant boys help me down the
 high dune.

The incessant rain mixes with soft breezes—
 such is the March season.
The colors of spring are now brilliant
 around the wine shop.

56

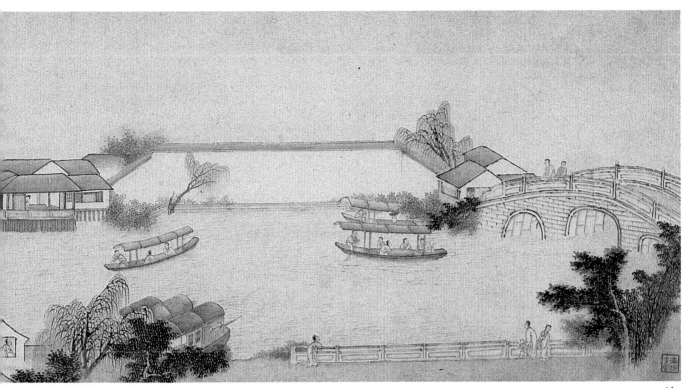

3b.

Orioles sing their light tunes to greet the sun rising.
Holding blossoming branches,
 I remember my lost youth.
We all know that troubles fill a man's life,
So let's all learn from Li Bo, the ancient bard—
 Get drunk while we can!
Oh, so long as we have the gregarious
 and the poetic as our drinking pals,
Who cares if we owe wine debts all our lives!

A poem by the artist Liu Yu (1637–after 1689):

The Apricot Blossom Village sits
 next to Phoenix Tower,
Where tourists spend freely on drinks.
See how the blossoms planted by God resemble fine satin,
And where shepherd boys have passed,
 the lawn appears like smoke.
Banners and pavilions from long ago are swept away
 in the flowing water;
Swallows have remained, but the sweet belle
 in the chamber is no more.
Holding the purple horse whip, you ought to go easy,
 my gentle friend,
Cherish the new moon rising over distant trees.

3b. Detail

3b. Detail

3b. Boating along the Qingxi River 青溪游舫

Boating along the Qingxi River (Qingxi youfang) depicts
a river flanked by green willows and pink peach blossoms
on which pleasure boats carry visitors to enjoy the view.

Qingxi River was one of the major water systems of
Nanjing in the Six Dynasties period. It rises from the
southern base of Mount Zhong and then flows south-
ward, crossing the city to meet the Qinhuai River. In addi-
tion to serving as an important natural defense for the
east side of the city, it provided a beautiful location for
sightseeing. With its many curves, the river earned the
nickname "Nine Curved Qingxi." It was recorded that
starting from the Eastern Jin dynasty (317–420), it was
a custom to compose one poem at the turn of each curve
while riding a boat on the Qingxi. The nobles of the suc-
ceeding Southern Dynasties (421–589) also liked to have
their residences built along this river.[3] Boating along the
Qingxi remained a popular pastime through the Ming
and Qing dynasties and was recorded as one of the Forty-
eight Views of Jinling.

Two poems by Wang Ji:

3a. Detail

Who divided the stream into these branches of water?
I see so many grand mansions along the stream.
Music is played out at midnight on the showboats
 from Suzhou,
While candles burn throughout the evening
 in the gilt towers.
Endlessly in view are misty waves of the five lakes;
Fragrant breezes caress great stretches of land.
People drink from hundreds of wine pitchers;
Egrets and gulls frolic with joy upon the waters.

See how the red bridges line up over green water,
In which ripples like fine emerald silk
 flow around the boats.
In a village festooned with apricot blossoms,
 people get blissfully tipsy.
Passing the river-crossing, lovely young maidens
 are sure to be seen,
As the spring breeze caresses the door sills
 inside the mansions.
The late moon shines on high towers,
 flooded by sounds of an oboe.

A poem by Liu Yu:

Like leaves, like gulls, the boats float quite lightly,
The Qinhuai River flows toward a wooden bridge.
With hallways empty, emerald portières and
 beaded curtains abandoned,
The mansions at Black Robe Alley are gone;
 the swords put away.
When summer comes, the lotus with dew drops
 adorns the cool mats.
When fall arrives, the high towers are cooled
 by wind through the willows.
When I listen to music played on our brightly lit boat,
I hear it melding with tones of the Hu in the distance.

4. Zou Zhe (ca. 1610–after 1683)

Landscapes

鄒喆 山水圖冊

17th century
Album of 12 leaves, ink or light color on paper
H. 12.3 cm (4 ⅞ in.); W. 13.7 cm (5 ⅜ in.)

This album depicts landscape views and activities associated with Jinling: a cliff, trees, changing views in the spring or autumn season, hiking with friends, boating on the Qinhuai River, viewing sails from Stone Citadel (Shicheng) or admiring the pine forest on Bell Mountain. The scenes are skillfully captured, and, although the dimensions of the paintings are not large, some paintings feel monumental. This is particularly true of compositions with pine trees for which the artist is famed. (cat. no. 4l and 6d).

Zou Zhe was a native of Wu County in Jiangsu Province and moved to Nanjing with his father, Zou Dian (act. 1637–1646), a painter proficient in landscape and floral subjects. Zou Zhe showing great respect for his father, studying painting with him. They communed with only a few friends, shunning a busy social life. And, despite being poor, they retained their self-esteem and continued to excel at painting.

4a. With light washes of ink and blue and green color, this leaf depicts the scene of a pavilion on a rocky hillside above a receding shore and distant sailboat.

4b. The two steep mountainsides are composed like a stone gate, opening dramatically to reveal a narrow view of distant mountains and a deep valley. A lonely hut on the left and an empty trail on the right convey the remoteness of the site.

4c. The soft, wet brush strokes of this leaf describe a charming Nanjing scene of lakeside pile-dwellings sur-

rounded by floating duckweed and weeping willows in the early summer.

4d. Different tones of pale ink wash and layers of soft brush strokes depict a sparse forest with spiky trees wrapped in haze and drifting mist.

4e. The composition of this leaf writhes with the forceful movement of tilted peaks, anchored by the strong linear rhythm of the standing pine trees.

4f. The densely packed brushstrokes and tight space of this composition convey the wild lushness of a deep mountain hollow and the isolation of a small village sitting close to the edge of a sheer embankment.

4g. In the season for appreciating colorful fall foliage, two gentlemen enjoy a conversation as they cross a mountain stream.

4h. A tall pagoda glows in the light of a low-hanging sun, while the deepness of the pine forest lost in hazy mist is captured through the layering of the ink and the strokes of the brush.

4i. A gentleman in a high mountain pavilion under majestic pines is shown viewing a powerful cliff face and the wide stream below.

4j. This close-up view of a pine forest is wrapped in mist; several upright trees in the foreground represent the unbending character attributed to pines.

4k. On the Yangzi River, boats sail past the cliff face of Stone Citadel.

4l. A frozen lake and snowy mountains beyond convey an air of peace.

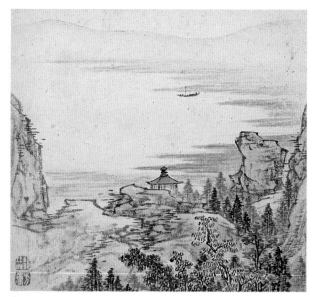

4a.

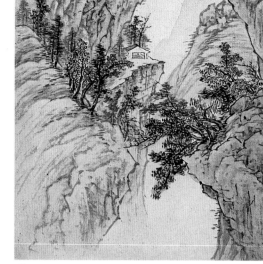

4b.

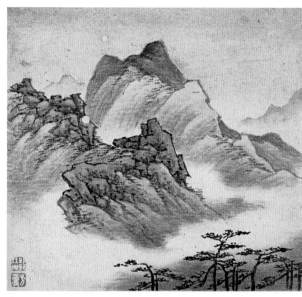

4e.

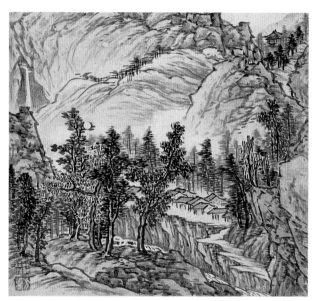

4f.

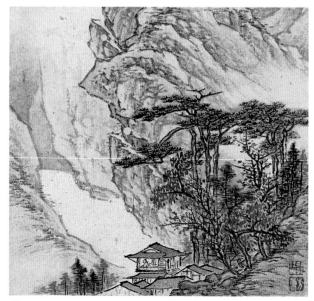

4i.

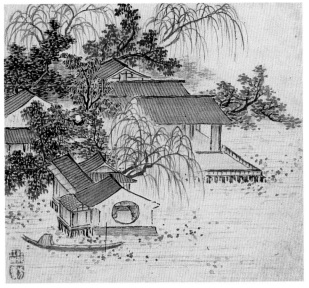

4c.

4d.

4g.

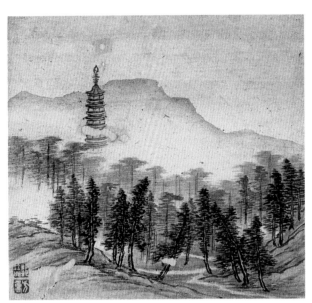

4h.

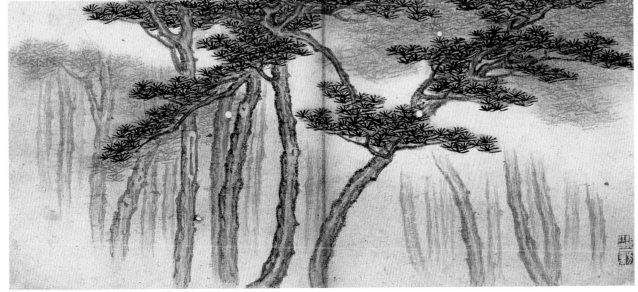

4j.

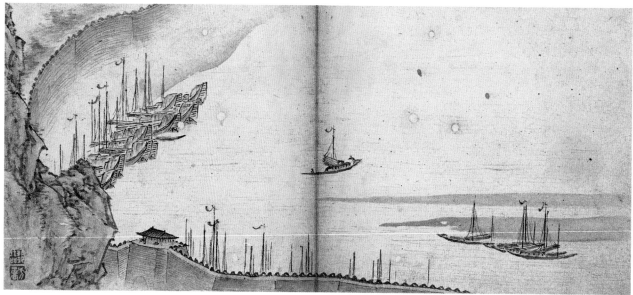

4k.

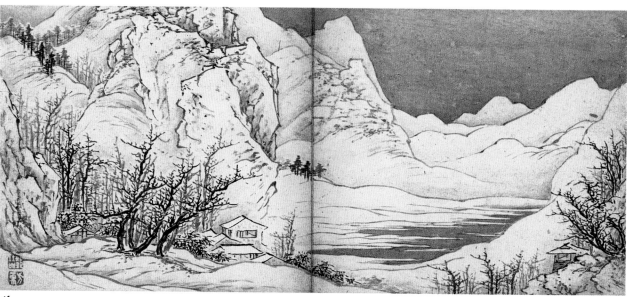

4l.

5. Gao Cen (active 1643–after 1687), et al.

Landscapes

高岑 等 金陵各家山水冊

ca. 1660

Album of 10 leaves,
 ink or ink and light color on paper

H. 29.4 cm (11 ⅝ in.); W. 35 cm (12 ⅞ in.)

Gao Cen was a native of Hangzhou but moved to Nanjing, where he died shortly thereafter. He was proficient in landscape and flower painting as well as poetry and enjoyed reading the Tang classics. Gao Cen was said to be handsome, wearing a long beard. A believer in Bud-

dhism, he studied with experienced monks. Zhou Lianggong related that: "he lived an austere life like a monk. Uncharacteristic of a man so young, he was mature and quiet, with no impetuousness about him. He studied the painting style of his contemporary Zhu Hanzhi, but created his own style as he grew older."[1]

He also recorded an account of how Gao Cen created his paintings: "The brushwork of Master Chen Xin [a friend of Zhou Lianggong] is among the best, and his art collection among the richest. I have seen Gao Cen and Chen Xin spend a whole night discussing the design of a painting. While they spoke, I could almost see the picture come alive on the white wall of the studio in which the

conversation took place. Gao Cen would quickly write down on the paper what they had spoken of, and, as he started to paint, they would exchange ideas, which were exquisite and profound. But, when the painting was completed, not one stroke was what they had discussed. His works are so fine and memorable, among the very best...[Gao] Cen and his brother were both inspired artists, living in houses surrounded by ferns. They were two masters leading languorous lives within all this cool, emerald green." [2]

The ten-leaf album is a collection of works by contemporary artists including the group known historically as the Eight Masters of Jinling. It features scenes of mountains, lakes and architecture of Nanjing and its environs, as well as the activities of its people. Most of the paintings are carefully composed yet exhibit free and proficient brushwork.

5a. Fang Wei (active ca. 1661), *Landscape*
方維　山水

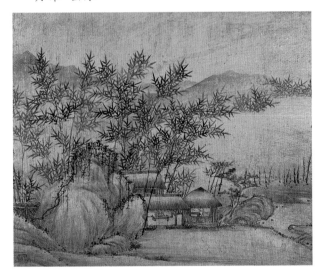

Mountains rise in the background, while thatched cottages sit in a dense, mist-shrouded grove of bamboo along a stream. New bamboo shoots in the foreground suggest a spring morning. The empty room, neatly set up with day bed and stool, seems to be just waiting for the masters of the house. A sense of quiet ease is conveyed through the graceful brushwork.

Zhou Lianggong recorded Fang Wei as an artist active around the year *xinchou* (1661), who studied with Zheng Qianli (act. 1614–1635) and followed Zheng's style.

5b. Unsigned, *Landscape*
無名　山水

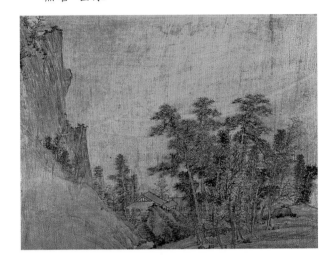

A precipitous cliff rises on the left, balanced by a stand of large trees, chiefly pines, on the right. Nestled between the two is a small stream that flows toward a nearby building complex. Just above the houses, low on the horizon, the faint silhouette of a blue-tinted peak suggests the location of the scene high on a mountaintop, while some trees with newly changed red foliage suggest early autumn.

5c. Zou Zhe (ca. 1610–after 1683), *Landscape*
鄒喆　山水

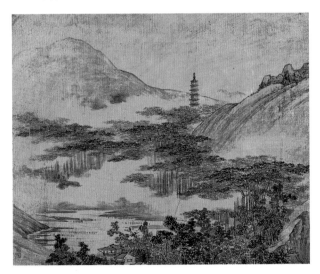

Pine trees and floating mist surround the foreground lake and fill the valley between the rolling hills. At the horizon, against the faint blue silhouette of distant mountains, a towering red pagoda rises above the trees. A single figure stands in the waterside pavilion to view the beautiful scene. This is a popular landscape view among the paintings of Nanjing artists and may be the scenery east of the city, near Mount Zhong.

5d. Zou Zhe, *Landscape*
鄒喆 山水

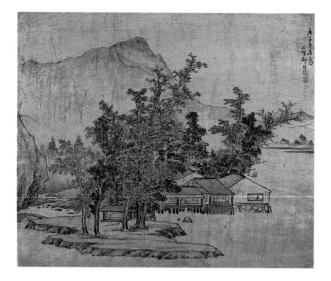

Dominating the center of this composition is a large group of trees with luxuriant foliage painted in a variety of brush strokes. They are set against the silhouette of precipitous mountain peaks painted with simple outline and washes of ink and light color. Touches of red on the trees suggest autumn. On the left a small arching bridge over a stream provides access to the small islet and the lakeside houses. Built out into the water are pavilions on piles and another on an ice-cracked stone terrace. A gentleman can be seen in one building viewing the lake, while his attendant is seen in another, bringing a *qin* (zither) for his master to play.

5e. Zou Zhe, *Landscape*
鄒喆 山水

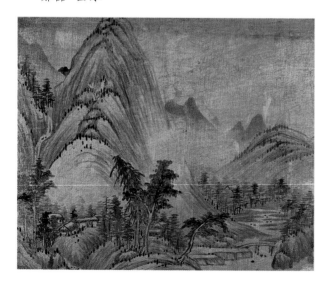

With a loose and rhythmic application of ink strokes, the artist has constructed an image of empty mountains with a few thatched huts and a lonely bridge.

5f. Zou Zhe, *Landscape*
鄒喆 山水

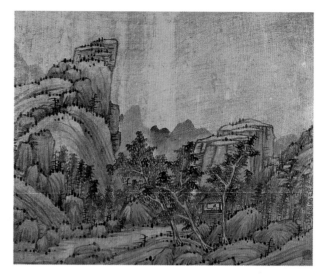

Lofty cliffs, rough rocks and luxuriant foliage of trees and brush are broadly depicted with a variety of loose brush strokes and light wash. In a high pavilion built near the stream, a lone gentleman sits quietly observing the mountain view.

5g. Unsigned, *Landscape*
無名 山水

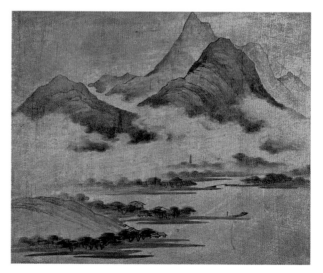

Colored in washes of blue and brown, the distant mountains seem to be adrift among the low white clouds that swirl about their base. Below the massive mountains lies a vast and peaceful lake with a pagoda emerging out of the mist in the distance. In the foreground, a docked boat, houses and leafy trees are sketched along the lake shore. This is a popular view of Mount Zhong and Xuanwu Lake on the northeastern outskirts of Nanjing.

5h. Ye Xin (act. ca. 1640–1673), *Landscape*
葉欣 山水

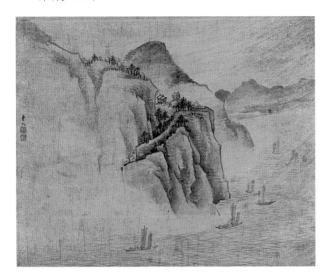

5i. Gao Cen, *Landscape*
高岑 山水

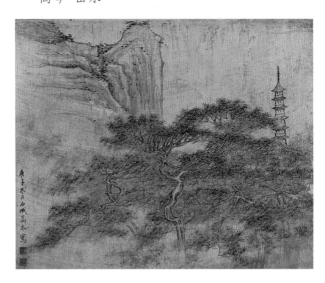

With unassuming brushwork, the artist has depicted a riverside cliff with sparse trees and bushes and a couple of pavilions. The space on the left side has been left empty to suggest the mountainside continuing into the mist, while the right side of the composition opens to a view of distant hills and sailboats drifting up the vast river. This is a view of Qixia Mountain located near the Yangzi River in the northeastern outskirts of Nanjing.

Ye Xin was a native of Songjiang who moved to Nanjing. He was particularly influenced by the style of Zhao Lingrang (act. ca. 1080–1100),[4] but painted in his own recognizable style. Zhou Lianggong wrote: "I've collected Ye Xin's paintings and look at them often. His works would invariably affect me quite emotionally. As he was good at design, even the most banal objects would be transformed into something interesting and special. Any viewer would be drawn to his paintings." Ye Xin also transcribed 100 poems by Tao Yuanming (376–437) for Zhou Lianggong; it was said that his sophisticated brushwork enhanced the spirit of reclusiveness and aloofness in Tao's poetry.[5] Zhou Lianggong treasured this work and built a boat named *The Boat for 100 Poems by Tao Yuanming (Bai Tao Fang)* in which to store the works.

The combination of green mountain, pine trees and pagoda is a popular theme in Jinling landscape paintings. This may be a view of Spiritual Valley Temple (Lingu Si), which is located on the eastern outskirts of Nanjing. The main focus of this painting is the foreground group of pine trees, with their twisted and extended branches and emphatic pattern of pine needles.

5j. Gao Cen, *Landscape*
高岑 山水

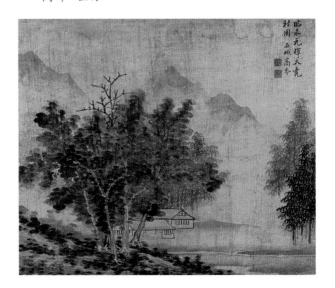

In imitation of the Song dynasty Mi-family style, large wet dots of ink are applied to depict the lush foliage of trees and underbrush while light washes of ink depict distant mountains lost in mist. A meditating gentleman sits tranquilly in a simply rendered thatched cottage by the side of a stream.

A Stylish Life

In the seventeenth century, the literati paid great attention to cultivating an enviable lifestyle. To demonstrate their worthiness as members of this élite class and to distract them from their feeling of melancholy after the fall of the Ming, they participated in such pastimes as painting fans for gifts (see cat. nos. 6, 7), playing music (cat. no. 8), tasting tea (cat. no. 9), communing with nature (cat. nos. 7, 11, 12), traveling to scenic sights (cat. no. 13), reading (cat. nos. 14, 15), appreciating courtesan culture (cat. no. 16) and saying farewell in a poetic or symbolic manner (cat. no. 17).

Friendships among the élite would include taking up the brush to collaborate on paintings, poetry and calligraphy. In particular, writing colophons on each others' works was a favorite custom, through which they could praise another's ability and character, while, at the same time, showing off their own (cat. nos. 14-16).

6. Gong Xian (1618–1689), et al.
Landscapes by the Jinling Masters
龔賢 等 金陵八家山水扇面冊
17th century
8 fan paintings mounted as album leaves,
 ink and light color on paper flecked with gold
H. 16–19 cm (6⅜–7½ in.); W. 51–57 cm (20⅛–22½ in.)

This album consists of eight fan paintings by the group known as the Eight Masters of Jinling: Gong Xian, Fan Qi, Gao Cen, Zou Zhe, Xie Sun, Wu Hong, Ye Xin and Hu Zao. With the exception of Wu Hong's painting of bamboo, the leaves of this album depict landscape scenes around Nanjing and the lower Yangzi River region.

The folding fan was a popular painting format during the late Ming and early Qing dynasty. Its small size made it convenient to carry, and its common utility made it appropriate as a gift. Yet once painted by a leading artist, it became, as well, an object of artistic appreciation and a sign of the circles one traveled in. Therefore, it was common to see fan paintings dedicated to specific acquaintances and done on specific occasions. For these reasons, the decorated fan became popular with members of every class of society, causing literati taste to spread to and influence those less learned than the élite.

6a. Gong Xian (1618–1689), *Landscape*
龔賢 山水

This tranquil scene of two thatched cottages near a river, rocks and trees is depicted with a lively application of bold ink strokes and vivid dots.

Originally from Kunshan in Jiangsu Province, Gong Xian moved to Nanjing at an early age, eventually settling west of the city in the neighborhood known as Mount Qingliang (Pure and Cool). His landscape style, which derived in part from the tenth century master Dong Yuan, employed a bold approach to the application of ink which won him great fame. Considered the leading artist of the Eight Masters of Jinling, he also achieved fame as a poet. His early poems were published in a book entitled *Collected Poems from the Hall of Fragrant Grasses (Caoxiang Tang Ji)*.

According to the records of collector and patron Zhou Lianggong, the artist was unsociable and eccentric, and only dealt with a few people that he knew. During the last twenty years of his life, Gong Xian lived as a recluse and made his living through writing poetry and

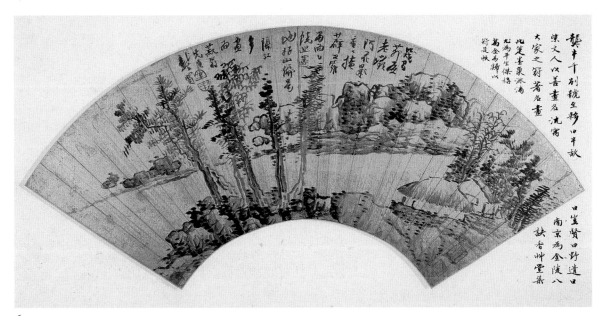

6a.

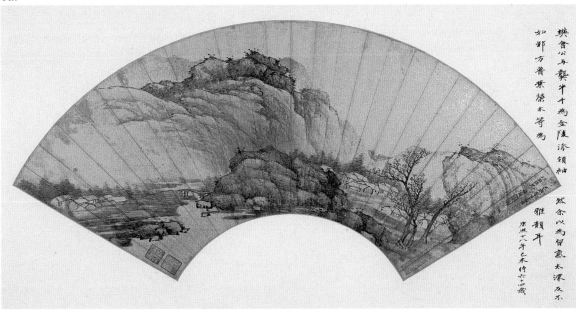

6b.

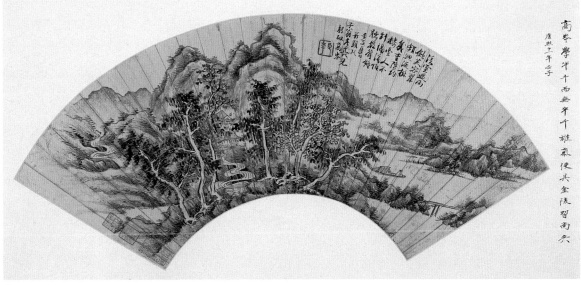

6c.

67

selling paintings. He was often commissioned to create large hanging scrolls for his wealthy clientele.

Poetic inscription:

A few thatched huts sit in the old mountains,
Where shadows of blossoms have obscured the wild ferns.
This is a rich and hidden land of peace,
Where, even finer, are the mountains across rivers.
 Dedicated to Master Shuweng

6b. Fan Qi (1616–after 1697), *Landscape*
樊圻　山水

A village parted by a gently meandering stream with a wooden plank bridge is embraced by rugged hills and distant blue mountains. The foreground trees standing by the large rock bear fresh buds. With simple brush strokes and light applications of color, the artist has captured a warm spring day.

6c. Gao Cen (active 1643–after 1687), *Landscape*
高岑　山水

The composition focuses on the central cluster of trees and rocky hills, where pavilions lie half-hidden beside a winding stream. There are low hills on the left and a lone fisherman in a boat on the right; both sides fade away to distant mountains on the horizon. It is a typical scene along the shore of one of Nanjing's lakes or rivers which depicts a gentleman sitting on a boat in a river surrounded by mountains and trees.

Poetic Inscription:

The rain having passed, clouds reflect in the stream.
Behind rich foliage, the hibiscus looks demure,
And the emerald waters flow.
The far towers are now in sight,
*　but my friend has not come;*
In the distance, I hear bells from across the wide water.

6d. Zou Zhe (ca. 1610–after 1683), *Landscape*
鄒喆　山水

The Yangzi River is viewed from such a great height that the towering rock on the opposite shore seems to hang dangerously above the pavilion, rocks and trees in the foreground. Such an angle conveys both the loftiness of mountain and the vastness of the river. Zou Zhe was from Jiangsu Province, but moved to Nanjing with his father, also an artist.

6e. Ye Xin (act. ca. 1640–1673), *Landscape*
葉欣　山水

Compositions with streams, villages and mountains have always been popular, and the use of a light ink wash is naturally appealing; together they convey a leisurely quality. Ye Xin's compositions are reminiscent of the Song dynasty and his ink tones resemble the Yuan. Indeed, this quality contrasts sharply with the creative power of Gong Xian, who was in the company of other artists who demonstrated their interest in innovation and powerful expression.

6f. Hu Zao (active ca. 1650–1662), *Landscape*
胡慥　山水

The dark foliage of the roughly painted foreground trees and the flock of returning birds suggest dusk. A recluse in a red robe hurries back to his rustic home located beneath the trees and rocks. His attendant follows him, holding his master's zither (*qin*).

A native of Jinling, Hu Zao, whose exact dates are unknown, was proficient in landscape and figure painting, and especially good at painting chrysanthemums. His landscape painting is unrestrained and vigorous. Zhou Lianggong gives a vivid description: "A sturdy gourmand with a protruding belly, Master Shigong was, even so, good at martial arts. Chrysanthemums were his painting specialty. Considered 'blossoms of the cold,' they bloom in late autumn. In other aspects of life, Master Shigong was a bon vivant, which was his unique quality. Oh, what a shame that he should die before sixty!"[1]

Poetic Inscription:

A flock of ebony crows flying by —
Could it be instead the darkening clouds?
And, as thundering sounds echo in the ancient trees,
I'm almost certain the rain has come.

6g. Xie Sun (active ca. 1679), *Landscape*
謝蓀　山水

With a composition of vigorously moving forms and light applications of color, this painting shows a kind of purity of spirit and eccentricity of style that makes it different than the other leaves in the album. Xie Sun, was a native of Lishui in Jiangsu Province but lived in Nanjing. He was proficient in painting landscape and flowers.

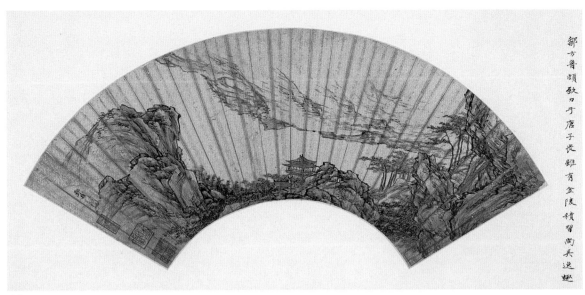

鄒方魯頗效刀于唐子畏雖有金陵餘習尚其逸趣

6d.

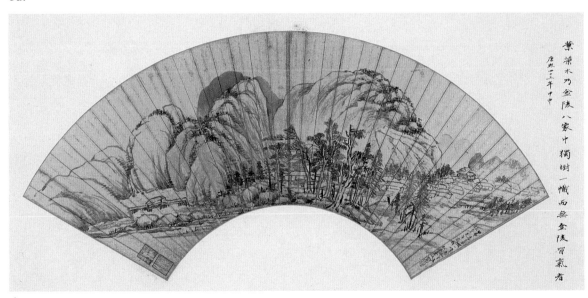

葉榮木乃金陵八家中獨樹一幟而無金陵習氣者

庚眠二十三年中中

6e.

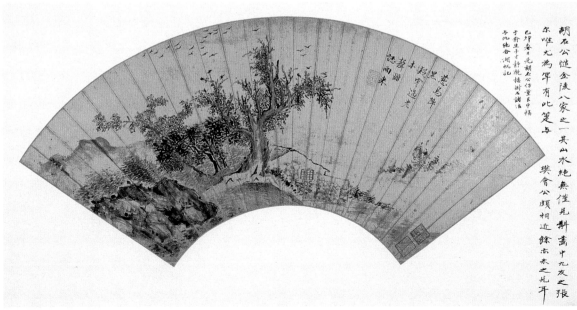

胡石公慥金陵八家之一其山水純無徒見斜畫中九友之張尒唯尢為罕有此笔与

慈鳥噪黑雲彌漫穹迥去聲断愁雨央

己卬春日亮朗石公倩置正中幅于斯坐于君虎情樓樹石譜也与此他各湖帆記

與石公頗相近餘尚木之见平

6f.

69

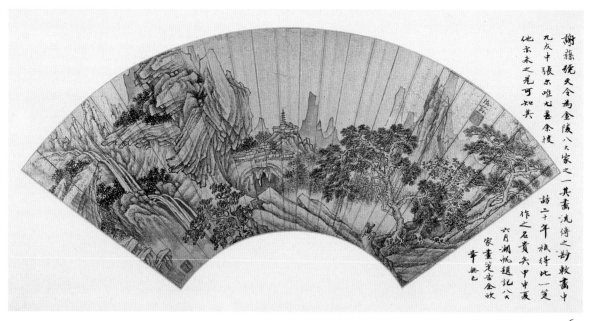

<div align="right">

他宗未之光可知其
九友中張尔唯t甚余校
謝蓀彷天令為金陵八大家之一其畫流傳之妙敦盡中

作之名貴矣甲申夏
訪二十年祇得此一箋
六月湖帆題記父
家畫箋宏金欽
章無巳

</div>

6g.

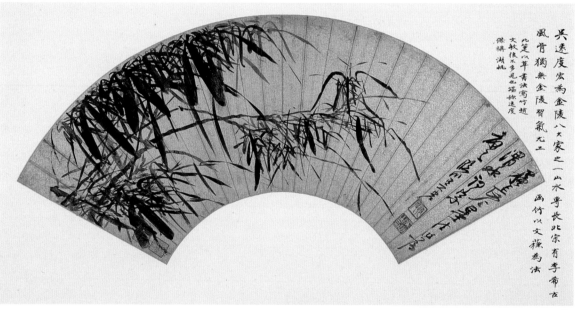

<div align="right">

風骨獨無金陵習氣九工
吳透度宏為金陵八大家之一山水專長北宗有李希古

心笔以草蒿法寫竹題
大較後不多見也塔稱遂度
傑構湖帆

画竹以文譲為法

</div>

6h.

6h. Wu Hong (ca. 1610–ca. 1690), *Bamboo*
吳宏 墨竹

Wu Hong used free and sweeping brush strokes to paint the dense bamboo leaves, which cover the upper left side of the fan and the new bamboo shoots below. The artist and collector Wu Hufan (1894–1968) observed that the greatness of his work is in his use of a cursive calligraphic style to sketch bamboo.

A native of Jiangxi Province, Wu Hong moved to Nanjing when he is a child. He was so proficient in painting bamboo and landscape that Zhou Lianggong praised him highly: "Fond of painting since childhood, he painted in his own style without copying others. During the years

1653 and 1654, he traveled north of the Yellow River and toured the Snow Garden region (Xueyuan). When he returned to Nanjing, he changed his painting style, and his works became more assured and bold. He based his painting style on those of the great masters before him, but then elaborated them with his own artistic point of view."

The character, *hong*, in Wu Hong's name means grandeur or magnanimity, and Wu's personality and brushwork reflected that name.[2] After seeing his paintings, Song Wan, his contemporary, wrote: "I saw that Master Wu was not only well-read and well-spoken, but also a debonair man. I realized then that a great painter's true nature could be represented in his works. Master Wu told me that he had once visited the tomb site of one of the four

70

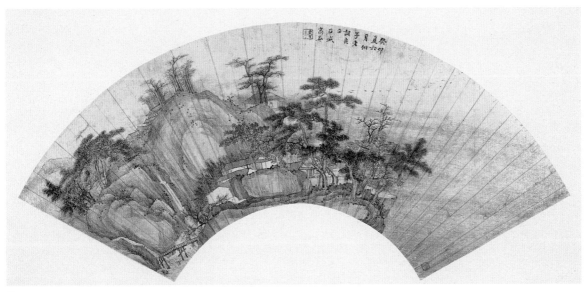

7.

legendary ancient princes known for their generosity and magnanimity, and that he could feel [afterward] that he had acquired something spiritual from that visit."[3]

7. Gao Cen (active 1643–after 1687)
Gazing Out from a Mountain Pavilion
高岑　山樓登眺圖
1663
Fan painting mounted as album leaf,
 ink and color on paper
H. 17.3 cm (6⅞ in.); W. 54.9 cm (21⅝ in.)

Excellent brushwork and delicate coloring are employed in this balanced but dramatic composition that depicts a rocky mountainside with waterfalls, a gushing stream, luxuriant green pines and leafy trees tinged with autumn color. The empty space on the left side of the fan reveals a vast expanse of water meeting an open sky. In this wild environment, a rustic wooden bridge connects the scattered houses with the outside world. Distant rooftops suggest a larger community beyond the hills. An old man, barely visible in a high pavilion at the center of the fan, gazes into the far distance, following the line of birds as they fly over the hazy lake or river to an unseen horizon. The image is profoundly contemplative while the vivid pattern of ink dots adds vitality to the painting surface.

8. Chen Zhuo (1634–after 1709)
Carrying a Qin to Visit a Friend
陳卓　攜琴訪友圖軸
1694
Hanging scroll, ink and color on silk
H. 255 cm (8 ft. 4½ in.); W. 67 cm (26⅜ in.)

A simple, rustic bamboo fence and gate are surrounded by verdant trees at the base of a steep mountain at the right side of the painting. This gate appears to be the entryway to a group of waterfront pavilions that face a peaceful lake. The open view into the distance on the left terminates in the hazy blue of far away mountains. An old man sits alone in one pavilion while a young attendant stands by in another, as if waiting for the gentleman approaching in the foreground. The visitor walks on a solitary path leading to the open gate, while his servant follows behind him carrying his master's *qin*.

The *qin* is an ancient Chinese musical instrument that resembles a zither. Because its tones are thought to be the sounds of the natural world, its music is often interpreted as evoking landscape imagery such as lofty mountains or flowing water. With its melancholy and subtle, soul-stirring voice, the *qin* is difficult to master and also difficult to appreciate, because it requires both the performer and the listener to be equally trained and to share the same aesthetic sensibilities. Therefore, the *qin* has always been treasured by Chinese intellectuals, who have considered it a tool for communication between like-minded individuals.[1]

The story of the bond between Boya and Zhong Ziqi, one a *qin* player and the other a listener, was passed down for generations, and, as a consequence, the term *zhiyin* (one who understands the music) has become a synonym for

soul mate.[2] Thus, playing the *qin* became a favorite pastime among cultivated gentlemen, and carrying a *qin* to visit a friend became a common theme in literati painting.

Chen Zhuo was a native of Beijing but settled in Nanjing. His brush strokes captured the precision of the Northern Song manner of landscape painting, but lacked the spiritual aloofness of later Yuan dynasty masters. He was also proficient in figure and flower painting. In 1669, Chen attended a banquet hosted by the respected collector and patron Zhou Lianggong with numerous artists in attendance.[3] Just 35 years old, he was already counted among the most talented poets and painters of Nanjing. His paintings were highly praised by Zhou Lianggong.[4]

9. Cai Ze (active 1662–1722)
Tea Tasting under the Shade of Pines
蔡澤　松蔭品茶圖卷
1701
Handscroll, ink and color on silk
H. 36 cm (14¼ in.); W. 200 cm (78¾ in.)

Surrounded by sturdy old pine trees and rough rocks, two old gentlemen sit conversing beside a rushing stream. One sits on a rock, while the other leans on a crooked pine. Two young boys in short tunics and straw shoes prepare tea; one bends toward the stove, while the other sets off with the serving tray. The figures are well-observed and finely detailed, from the folds of their loosely hanging robes to the upturned toes of their shoes, from their individual expressions to their wispy beards. Their light color and detailed depiction contrast the strong brush strokes and dark ink of the pine trees

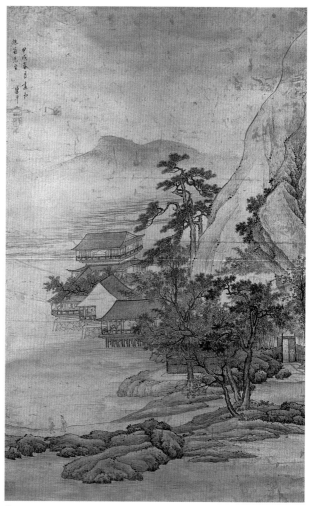

8.

and rocks, which convey the unrestrained spirit of the moment and the shady coolness of their chosen place for rest.

Tasting tea was considered one of the "lessons in purity" (*qing ke*) methods of self-cultivation for Ming

9.

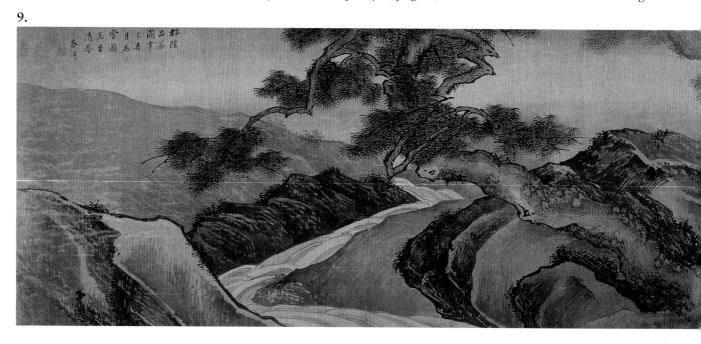

literati. For that reason, Waiting for Tea by a Rock became a popular subject in Ming landscape painting. A renowned literatus of that period, Wen Zhenheng (1585–1645), suggested in his book *Superfluous Things* (*Changwu zhi*) that all literati should build a tea house near a mountain and equip it with a set of tea wares and a young boy to take care of tea preparation. In this way, the literati could converse all day long.[1]

The theme, Tasting Tea under a Pine, has a long tradition. Wang Anshi (1021–1086), a literatus and prime minister of the Song dynasty, lived in Nanjing in his later years and built his house at the foot of Mount Zhong. He wrote a poem that included the lines "I have traveled with my friend to this eastern city to try the tea / Worn out by traveling, we recline upon the rock beside the pines."[2] Proficient in painting landscapes, flowers and birds, Cai Ze, vividly illustrated Wang's poem in this painting.

10. Wei Zhihuang (1568–after 1645)

Water Pavilion

魏之璜　水閣圖扇面

1613

Fan painting mounted as an album,
 ink on gold-flecked paper
H. 63 cm (24⅞ in.); W. 61 cm (24 in.)

A thatched pavilion stands at the water's edge under a perilously looming rock and overhanging trees. Within the pavilion two gentlemen sit at ease, engaged in conversation. The delicate application of dry brush strokes and light ink wash suggest the austere spirit of the artist.

A pioneering painter of Nanjing, Wei Zhihuang painted *Misty Drizzle over the Mountain* in 1645 and died shortly thereafter. "He rose from poverty and painted to make a living. Studying from and copying Wang Xizhi's [masterpieces] he became a fine calligrapher whose work was distinguished by its perfectly balanced structure and flowing beauty. As a landscape painter, he emulated no one and created his own style, which was well reflected in his cliffs, valleys, trees and rocks. No two paintings of his looked the same. As he aged, he started to apply heavy and dark brushwork to create an antiquated, rather than a romantic, mood. He was also good at painting flowers and plants with a lightly inked brush, which resulted in an otherworldly, exquisite, but natural look."[1]

Zhou Lianggong wrote of Wei: "He was good at landscape paintings, some of which could be called masterpieces. His brushwork became more powerfully impressive as he grew older. As for his flowers and plants in light ink, their natural look made it quite clear that their creator was a master of painting. I got to meet the master, a dark, fine-bearded man resembling a cultivated Daoist priest hibernating in the deep mountain, who commanded high respect from others. Orphaned at an early age and having grown up in poverty, he kept to himself, leading a solitary existence. But he was caring to his relatives and kind to his friends, providing for relatives of generations before him and fostering his younger brothers. And he was completely independent, never going to anyone for loans or help."[2] Wei liked drinking and conversation, and he earned great esteem among his literati peers. His works are important to the history of painting in Nanjing.

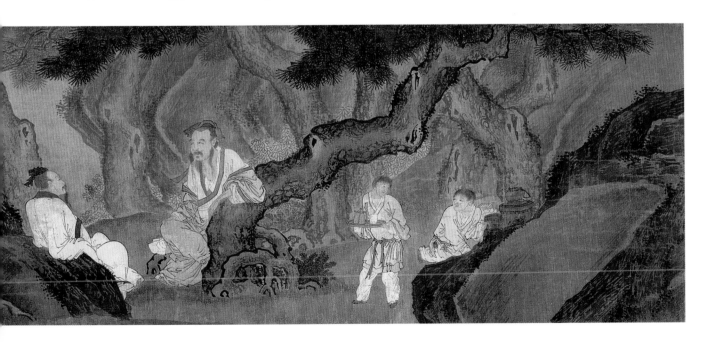

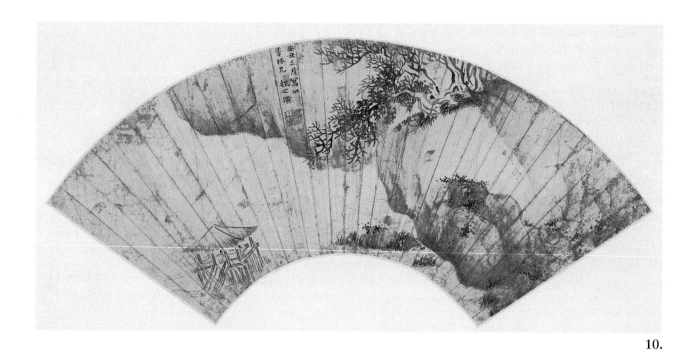

11. Cheng Zhengkui (1604–1676)

Landscape

程正揆　山水冊

Qing Dynasty

Album of six leaves, ink and light color on paper

H. 31 cm (12¼ in.); W. 52.2 cm (20⅝ in.)

The scenes depicted are likely to be those surrounding Nanjing, which would have been visited by the literati while enjoying popular pastimes like hiking through the mountains or taking tea at resting places with lovely views. Combining dark and light strokes of ink, his brushwork is spirited, while the compositions of these album leaves are simple, with finely sketched forms and subtle use of color.

A scholar-official artist, Cheng followed Li Yong (678–747) in his calligraphy, but was not limited by Li's style, developing a desolate style of his own. In landscape painting, he first studied with Dong Qichang (1555–1636) and then went off on his own. He liked to use bold brush strokes that were dry and simple in combination with light, delicate coloring. He painted one subject, Dream Journeys Amid Rivers and Mountains, over 500 times.

Zhou Lianggong said of him: "I have seen 300 paintings by him, some of which were more than ten feet long and others a few feet high. All those paintings looked different—some complex and some simple, some painted with dark ink and some with light ink—and all of them looked distinguished. But he was reserved and selective in letting others own his work, with the exception of Monk Shi[xi], to whom he gave whatever was asked for."

His paintings possess great elegance, presumably influenced by the hundreds of books he had read.[1]

11a. Single leaf; ink and light blue pigment.
Two large rocks face each other like two leaves of an open door. Through the opening, gushes a stream fed by a tall waterfall. The rocks fade away in mist, leaving unclear whether the sky is visible. A single figure sits in meditation on a flat rock before the waterfall.

11b. Single leaf; light ink, blue and brown pigment.
Towering over a mountain cottage are a line of flat-topped hills, with scattered trees in which two recluses are seen chatting in a cottage.

11c. Double leaf; ink and light color.
A variety of rough brush strokes are sparsely employed in this naïve depiction of huts in a clearing among simplified rocks and trees. The resulting landscape has a rustic and aloof spirit.

11d. Double leaf; ink and light color.
A panoramic scene of rolling hills and mountain streams is depicted with lively brush strokes and ink wash. The foreground is separated from the background hills by a band of floating mist and is dominated by a twisting, rocky peak rising up from the stream bed near the center of the painting. Behind the peak, a line of red-walled houses with blue tile roofs is built on piles across the stream. Barely visible on the far right of the painting, a

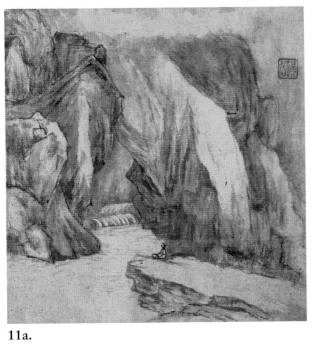

11a.

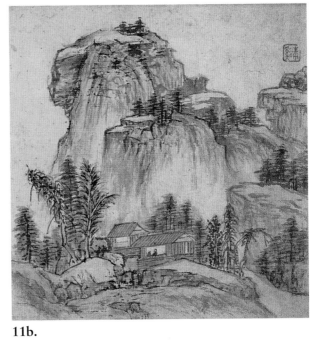

11b.

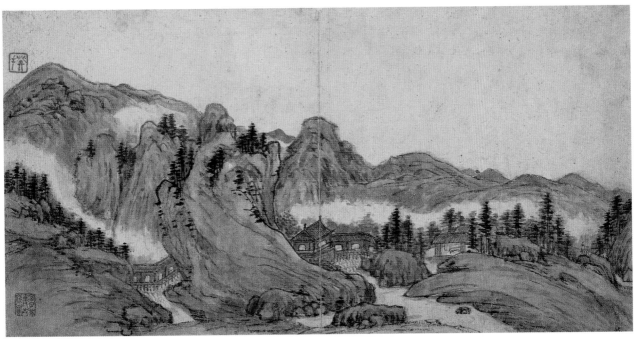

11c.

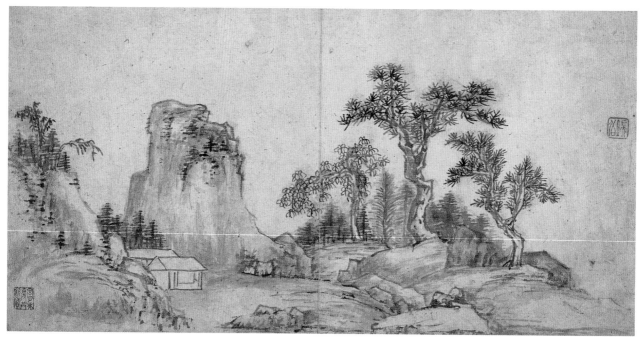

11d.

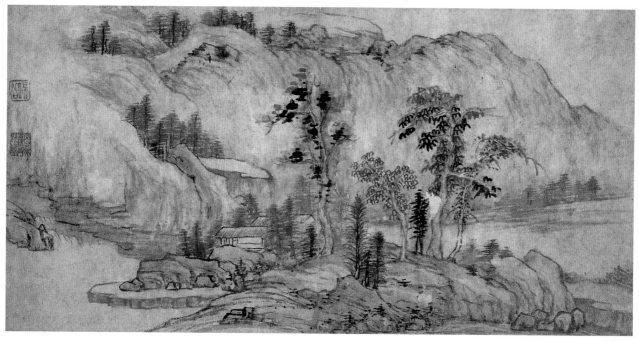

11e.

gentleman and his young attendant are walking along a narrow path flanked by trees.

11e. Double leaf; ink and light blue and brown pigment. Pale ink line and texture strokes, enlivened by scattered dabs of darker ink depict a lakeside scene with a gurgling stream on the left, a rocky islet with several trees and a couple of houses along the shore. The sparse composition and simple brushwork conveys an austere spirit like that seen in the work of Ni Zan.

11f.

76

11f. Single leaf, with inscription by Cheng Zhengkui:

"Lu Guimeng said, 'plowing and weeding is the resource of leisure time in the heyday.' If the world is not peaceful and people are running for their lives, how can agriculture be practiced? Thus, I can only express myself with ink and brush."[2]

12. Fan Qi (1616–after 1697)
Wandering Through Mountains in Springtime
樊圻 春山策杖圖軸
1694
Hanging scroll, ink and light color on paper
H. 79 cm (31⅛ in.); W. 47.4 cm (18¾ in.)

A mountain scene is filled with pale pink blossoms on plum trees, fresh green leaves on the willow trees and a cold stream tumbling into the foreground lake. An empty hut perched on a hill waits for visitors. In this slightly hazy, early spring day, an old gentleman leans on his walking stick and turns his head back, seemingly reluctant to pull himself away from a place fit for immortals.

Soft brush strokes, light washes of ink, and delicate coloring seen in this carefully composed painting exemplify Zhou Lianggong's comments: "The paintings of the Jinling school are the most graceful in the southern Yangzi River area."[1] It may be associated with the custom of Nanjing's lantern festival paintings, commercial works made to please the taste of the local citizens. Thus, historically, it has been disparagingly labeled the School of Lantern Painting (Shadeng Pai).[2] Perhaps because of the popular appeal of such paintings, the modern collector Wu Hufan criticized Fan Qi and Zou Zhe several times for having "the Jinling habit" (cat. no. 6).

Although painted when the artist was at the advanced age of 79, the painting is still full of purity and freshness—a reflection of the artist's character. Zhou Lianggong recorded that the brothers of Fan Qi built a hut near the Huiguang Temple and lived a reclusive life, cutting themselves off from the material world to concentrate on their painting.[3] The dreamlike landscape in this painting reflects their "aloof" lifestyle and presumably moral character.

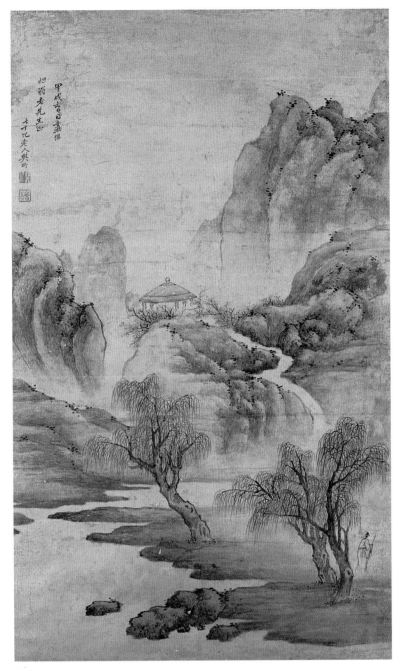

12.

13. Gao Cen (active 1643–after 1687)
Gold Mountain Temple
高岑 金山寺圖軸
17th century
Hanging scroll, ink and color on silk
H. 181 cm (71¼ in.); W. 94.7 cm (37⅜ in.)

Like a narrow section of a vast panorama, this tall composition captures a deep view across the mighty Yangzi River from the near shore, with its old pine trees and rocks, to the hills in the great distance. Sailing boats direct the viewer's gaze to the temple complex standing timelessly on an island at the center of the large void that rep-

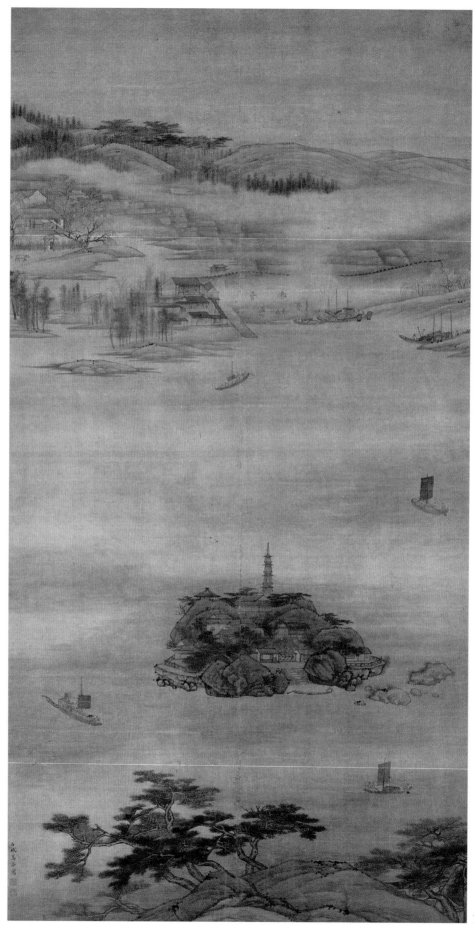

13.

resents the grand river. On the far shore, rendered in light brush strokes, are hazy glimpses of docked boats by a city wall and a peaceful village in the early morning.

The Gold Mountain Temple is located in the northwestern section of the nearby city of Zhenjiang and has long been a renowned historical site along the southern reaches of the Yangzi River. The Temple for Immersing One's Mind (Zexin Si) was established there during the Eastern Jin dynasty (317–420). In the Tang dynasty, deposits of gold were unearthed, and the site was named Gold Mountain. Built along a cliff, the temple compound is well integrated into the topography, and the beauty of its architecture has been highly praised throughout history.

The Song dynasty prime minister Wang Anshi composed the following poem after visiting the temple:

In the high chamber lying upon rocks,
Breezes sail in through open windows
 in the four walls,
Only when suddenly seeing birds soar,
Did I realize how marvelous it must be
 to hang in midair!

14. Wu Hong (ca. 1610–ca. 1690)
Zhexi Thatched Hut
吳宏　柘溪草堂圖軸
1672
Hanging scroll, ink and light color on silk
H. 160.5 cm (63 ¼ in.); W. 79.9 cm (31½ in.)

Using the tall, hanging scroll format favored in that period, Wu Hong depicts a scene in the northern area of the Yangzi River in Jiangsu Province. A twisting river winds from the foreground back into the hazy mist, which obscures the distant horizon. Luxuriant trees, reeds and pavilions line the shore of the river. A small wooden footbridge and spit of land in the foreground leads the viewer into this serene world. This seems to be a perfect location for its reclusive owner to build his studio and live apart from society. In a pavilion near the water, two friends are discussing books by an open window, while outside their compound a boat has just pulled ashore, and two young servants are unloading books.

The Qiao family was proud of this painting and showed it among their friends, even while traveling. They often invited friends to visit their studio. Friends and associates recorded their comments and feelings upon viewing the painting. Thus, all the space around the painting is filled with colophons, which include several by celebri-

ties of the time—the scholars Zhu Yizun (1629–1709) and Liang Qingbiao (1620–1691) and the painters Zha Shibiao (1615–1698) and Cheng Sui (1605–1691).

Wu Hong painted the Zhexi Studio at the invitation of Qiao Lai (1642–1694), a native of Baoying County in the northern part of Jiangsu Province. The studio belonged to Qiao Lai's father, Qiao Keping, both of whom were officials in the imperial government. Qiao Lai qualified as a presented scholar (*jinshi*) in the early Kangxi period; he took a post in the central government and participated in compiling the *History of the Ming Dynasty (Ming shi)*.[1] His father was a *jinshi* in the Tianqi period (1621–1627) of the Ming dynasty and held the post of *yushi* (inspector); he fought against corruption in the government and subsequently left his post.

During the short period of the Southern Ming (1644–1662), when Ming imperial princes fleeing the Manchu invaders set up independent kingdoms in the south, the elder Qiao was placed in charge of the Henan area and was only able to return home after the Southern Ming failed.[2] Qiao Keping abandoned his high official position for the sake of his moral principles and chose to live in the remote countryside like a recluse. To live his life as he wished, devoting himself to the joy of reading, was something which earned Qiao high regard among his contemporaries. As a place hidden from society, the Zhexi Studio became a personal "peach blossom spring," an ideal understood by the literati since the Six Dynasties period.

15. Hu Zongxin (active 1620–1664)
Solitary Hut among Autumnal Trees
胡宗信　秋林書屋圖軸
1664
Hanging scroll, ink and light color on paper
H. 56 cm (22⅛ in.); W. 37 cm (14⅝ in.)

In this carefully arranged composition a central rock is set against the side of a partially obscured mountain, while a gushing stream from a distant cataract tumbles over rocks in its descent to a foreground pool. The dense trees, which shield the base of the mountain, are lightly colored by the newly changed leaves, which announce the autumn season. In a thatched hut along the banks of the stream, a red-robed gentleman with his hair combed into a topknot sits cross-legged on a straw mat. A tea bowl and books are set in front of him.

Hu Zongxin was a native of Shangyuan, a borough of Nanjing, and belonged to a family of artists; both his older brother, Zongren (cat. no. 17), and younger

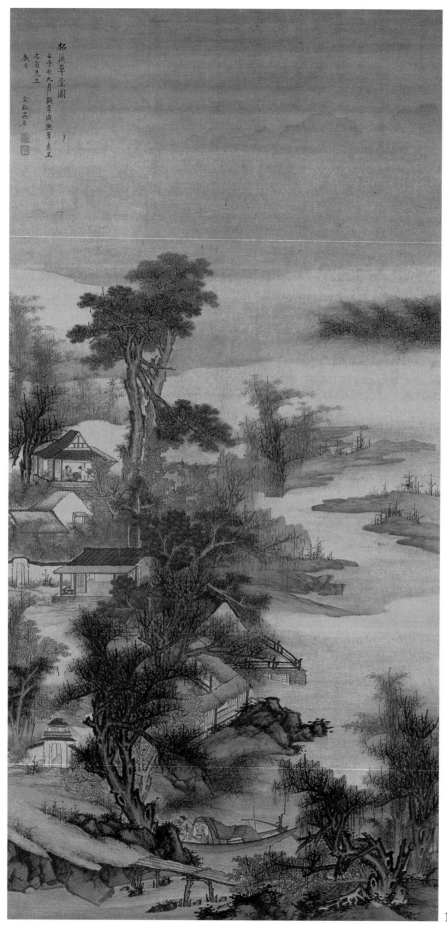

松溪草堂圖

壬子秋九月擬草堂爲
石谷先生
敬之
金陵吳石

14.

brother, Zongzhi, were described as proficient in landscape painting. His son Hu Yukun (ca. 1607–1687) excelled at landscapes, while his other son, Hu Shikun (act. 1649–1676), preferred orchids. In 1664, Shikun painted a handscroll for the great patron and memoirist Zhou Lianggong, who wrote that the family "all knew how to paint. Their wooden door would be shut by the day, [allowing them to work] among tea stove and bowls—every space was strewn with brushes… Imagine the joy of that family."[1]

Reading was promoted during the seventeenth century as a method of self-cultivation and a gesture of reclusion from a troubled society and a conventional life. Humble reading studios in the mountains were considered ideal places for the literati; they became frequent subjects in paintings of this period. Inviting artists to depict the owner's actual or imagined studio was a popular practice, as seen in the painting of *Zhexi Thatched Hut* by Wu Hong (cat. no. 14) and as recorded by Zha Shibiao in a colophon attached to Wu Hong's painting.

Zhou Lianggong commented: "[Hu's] painting derives from Wen Boren (1502–ca. 1575), Wang Meng (ca. 1308–1385) and Huang Gongwang (1269–1354). His brushwork has a classical quality and a simplicity that usually appear in artwork before the Five Dynasties period (907–960). When he got old, he often wore a monk's robe and walked with a cane, his long beard drifting in the air. People looked at him and felt he acted like an immortal…Originally from a rich and noble family, he became poor as he grew old. But he never demeaned himself… and earned the respect of his contemporaries."[2] The artist claimed to imitate the style of the renowned landscape painter Li Cheng (919–967).

16. Fan Qi (1616–after 1697) and Wu Hong (ca. 1610–ca. 1690)

Portrait of Kou Mei
樊圻，吳宏 寇湄像軸
1651
Hanging scroll, ink on paper
H. 273 cm (8 ft. 11½ in.);
W. 80 cm (31½ in.)

Rendered in contrasting ink tones and loose brush strokes, the new grass by the stream, the young bamboo shoots and tender buds that spring forth from the broken branches of old trees, announce the arrival of spring. Restrained brushwork is used to carefully describe a young lady sitting quietly beneath the old tree, her hair combed into a bun with a band placed over her forehead. Dressed in a high-collared white garment, she rests her left hand on her knees, supports her chin with her right hand, while she lifts her head high and gazes at a world unseen by others.

This painting is an unusual example of a collaboration between two Jinling painters. Here, one artist painted the figure while the other painted the surroundings. While it was common for artists to

15.

81

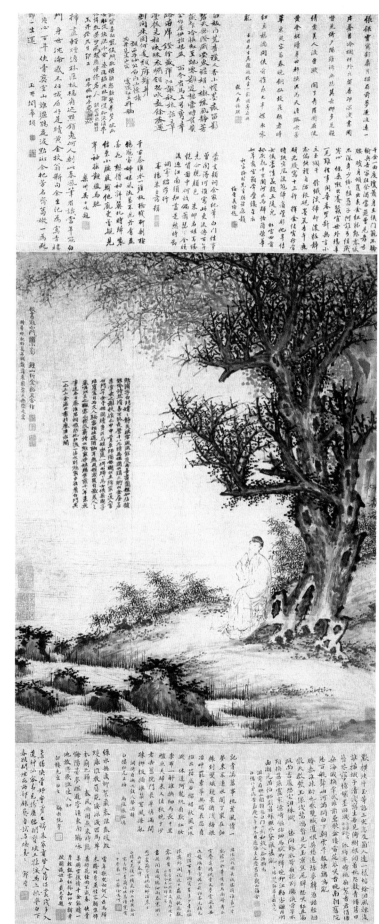

16.

add colophons on each other's works, it was less common for them to contribute jointly to one painting.

The subject of this painting, Kou Mei, reflects the courtesan's world of Jinling. She gained praise and sympathy among the literati because of her unusual life experience and personal integrity. The colophons on the painting relate her unusual story. Also known by the name of Baimen, Kou Mei was an ethereal beauty, possessing a romantic and free aura. She could compose music and was good at painting orchids. Well versed, she could also write poetry. Marked by quick and changeable nature, however, she was unable to complete her study of the art.

In 1642, Zhu Guobi, the prince Baoguo (17th c.), paid a high price to get Kou Mei released from a courtesan house and followed this with an unprecedented wedding ceremony in Nanjing. He ordered five thousand soldiers holding red lanterns to welcome the bride, after which he kept her in a grand mansion built especially for her.

In April 1644, invading rebel forces took Beijing, the capital, overcame the Ming court and captured Prince Zhu Guobi and his family. Zhu intended to sell Kou Mei and others for his own freedom, but Kou Mei asked Zhu to let her return to Jinling where she would raise the funds to bail him out. The prince agreed, and Kou Mei escaped on horseback. Through the help of the courtesans of Jinling, Kou Mei successfully raised over 10,000 *liang* of gold and freed Zhu from imprisonment.

When Zhu asked to renew their romantic relationship, Kou refused, saying that "you once saved me from the floating world [of a courtesan's life], and now, in return, I have freed you as well." After this, she built a large house with a garden in Jinling at which she led the life of a legendary female cavalier, entertaining men of letters and artists, drinking, composing poems and painting. Sometimes, after much drinking, she would sing or weep, lamenting her own precarious life, her passing youth and the falling of the Ming dynasty.[1]

The chivalrous and patriotic behavior of Kou Mei drew respect from and echoed the sentiments of the literati, who inscribed many colophons on her painting when it was circulated. One colophon notes that: "So beautiful was the young Kou lady, for eighteen years she bewitched the world. But beware of running into her today in Jinling. For, if you do, her tears, mixed with rouge, may splash on your robe."

17. Hu Zongren (active ca. 1598–1618)

Landscape

胡宗仁　山水圖軸

1618

Hanging scroll, ink on paper

H. 108 cm (42½ in.); W. 33 cm (13 in.)

Depicting desolate scenes with a rustic hut and sparse rocks and trees along a river, this work shows similarities to paintings by the Yuan dynasty master Ni Zan in its sparing use of ink, sparse composition and sense of purity. A native of Nanjing, he was also proficient in ink bamboo paintings, poetry and Han-dynasty-style clerical script.[1] His contemporary, the literatus Gu Qiyuan (1565–1628) wrote that "his poetry has the beauty of the peculiar and the original."[2]

This hanging scroll was a gift for Hu's friend Zhang Longfu, who was returning to his hometown, Mount Wuyi in Fujian Province. It reflects two notable phenomena of literati culture: that of the *she*, a type of society or social group that was particularly prevalent during the seventeenth century through which intellectuals maintained relationships, and, second, the long tradition of commemorating a friend's departure on a long or difficult journey. From the inscribed poems, which occupy almost all of the available space above the composition, it is clear that when Zhang stayed in Nanjing, he socialized with members of this poetry group. Before his departure, the friends had a party for him where they drank and composed poems to express their feelings. The painting was inscribed by his friends as a farewell gift.

The Chinese have long regarded leave-taking as a significant occasion. They developed certain customs when seeing off friends. Besides having a party, it was customary to accompany a friend for a certain distance; the longer the distance, the closer the connection. The most famous example of this parting ritual was the custom among Han dynasty residents of Chang'an (present-day Xi'an) of escorting their friends or relatives dozens of miles beyond the city walls to the Ba Bridge, where they would break off a willow branch as a farewell token.[3] In Nanjing, since the Six Dynasties period, people often accompanied departing friends from the city to Mount Fang by boat, a journey of many miles. There, they would stay the night, saying farewell the next morning.[4] The melancholy tone and homesick sentiment seen in the following inscribed poem were common at this time for those who longed for the reestablishment of a native dynasty as the Ming had been:

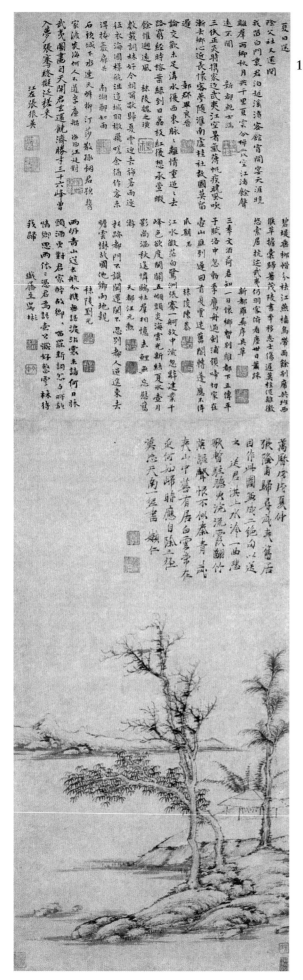

17.

When I saw you off at the river, the water appeared
* so cool.*
When I sang you a sad song of parting, you stopped,
* and you listened.*
Reflections of sunset in the river flicker like
* wind-tossed bamboo;*
As my voice is choked with grief,
* the music sounds not as it should.*
You know my old home on Mount Wuyi in the south.
I hope that, like clouds, it'll ever be there.
When I return, I'll have to sweep the paths myself;
So please don't forget me, your friend, in Wuyi.

AN EXPRESSIVE ART

As in some other cultures, landscape painting in China has always gone beyond mere representation of physical reality. Artists invested this subject with their emotions and their vision of an ideal world. This was particularly true in the seventeenth century, when the fall of the Ming dynasty caused deep feelings of nostalgia and longing for a return to the past (see cat. nos. 18, 28). Loyalist artists refused to serve the newly established Qing dynasty, and many of their paintings incorporated symbolic references reflecting that sentiment.

But at the same time, the art was purely expressive, without reference to political or social conditions. In particular, subtle uses of light or dark ink washes (cat. nos. 18–21), minimalist or vigorous gestures of the brush (cat. nos. 22, 23, 25, 26, 28) and deft compositions (cat. nos. 24, 25, 28) create delicate yet indelible works of art. There was also a distinct and conscious return to past masters to find models for their art (cat. nos. 25–28). Combined, these attributes of technique and intent resulted in individualistic statements by such memorable artists as Gong Xian and Kuncan (cat. nos. 19, 28).

18. Gong Xian (1618–1689)

A Thousand Cliffs and Myriad Valleys

龔賢　千岩萬壑圖卷

1673

Handscroll, ink on paper

H. 27.8 cm (11 in.); W. 980 cm (32 ft. 1⅞ in.)

This painting is meticulously composed using the so-called layered ink method, or *jimo fa*, to create a grand vision of the southern Yangzi River valley.[1] This technique was created by the painters of the Song dynasty (960–1279). Here, brush strokes of fresh, wet ink are applied in layers to achieve a rich, blurred effect to represent three-dimensional forms.

In his own practice, Gong Xian further developed the technique: first, he applied dots; second, additional dots; third, he added texture strokes and waited until the painting was dry; then he applied dark and light dots for a total of over six, or even seven, layers of brushwork.

More than 32 feet long and composed like a film sequence, this handscroll starts with an open view of the vast river and then directs the viewer's eyes through magnificent passages of mountains and waterways highlighted by rolling hills covered with luxuriant greenery, mist-soaked valleys, cloud-wrapped summits, gushing streams, tall waterfalls, wooden footbridges, boats resting near reeds and a temple hidden in the trees. Layers of ink create dark, almost ominous mountain forms while, by contrast, the empty white areas representing water, mist and clouds are eerily luminous. The vastness of the space and the uneasy mood of the dark, uninhabited mountains reveal an artist of broad vision and complex emotions.

Wang Yuanqi (1642–1715), a leading master of the early Qing dynasty, commented that: "Great painters in the past would not create long horizontal works randomly or hastily. It would take them months or years to finish, for the completion of a long painting takes not only strenuous design, but determination as well."[2]

In the last twenty years of his life, Gong Xian painted a number of long handscrolls that not only reflect the maturity of his art, but also reveal his deep, unspoken sentiments for a country lost to the Manchus. Under threat of reprisal from the Qing ruler, few literati could openly speak their true feelings. These "left-over" Ming subjects could only voice their love of the old empire through their brushwork.[3] Some scholars have calculated that there are about 16 handscrolls painted by Gong Xian, most made after 1666.[4] As first-hand records, the colophons on these paintings are important documentation for understanding the inner world of the artist.

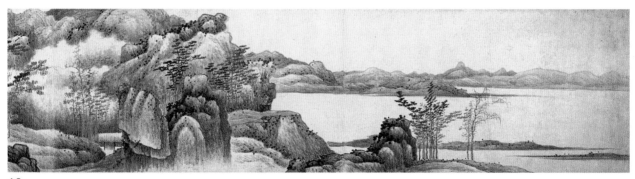

18a.

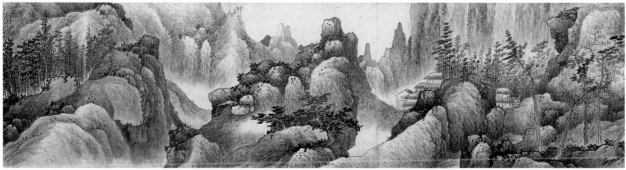

18b.

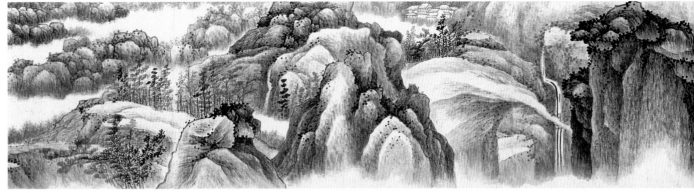

18d.

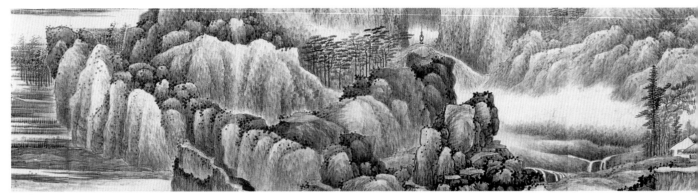

18f.

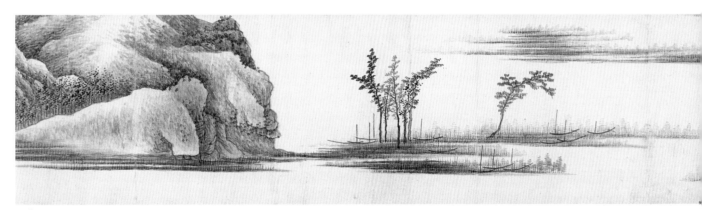

18h.

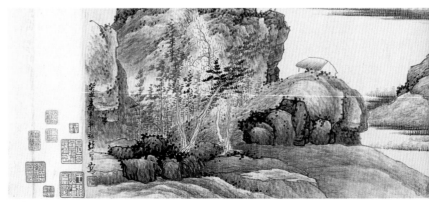

18j.

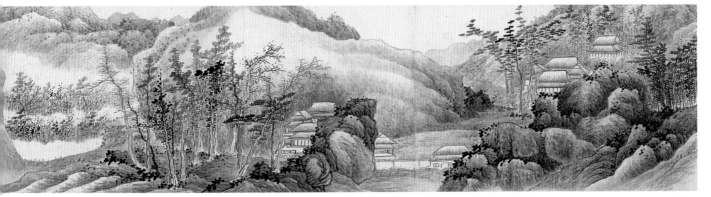

18c.

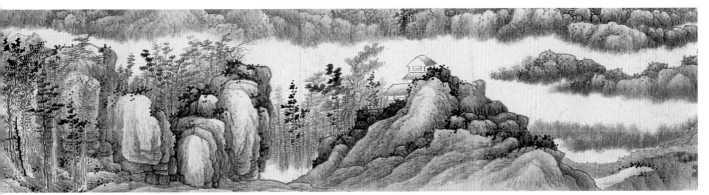

18e.

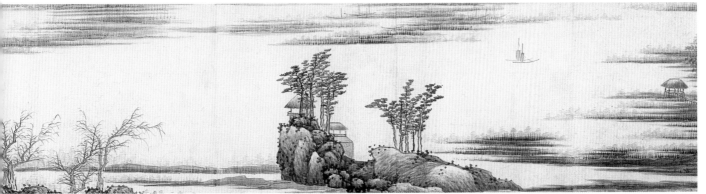

18g.

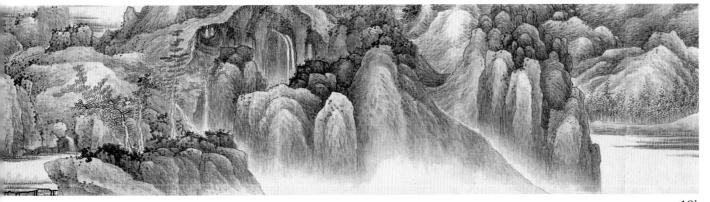

18i.

19. Gong Xian (1618–1689)
Summer Mountains After the Rain
龔賢 夏山過雨圖軸
Early Qing Dynasty
Hanging scroll, ink on silk
H. 141.7cm (55⅞ in.); W. 57.8 cm (22¾ in.)

This scene of leafy trees and piled peaks, one rising higher than the other, is interrupted by large unpainted areas which represent mist meandering from the foreground into the distance. While this blank area increases the depth and lofty scale of the mountains, a natural tendency to read the mist as a flat shape inhibits the illusion of space. But the appearance of a few houses tucked discreetly into the composition brings the mountains to life and reminds the viewer that this is still a human landscape.

Gong Xian began painting when he was 13. Through many years of effort, he became a leading figure among the Jinling artists due to their recognition of his technical artistry. People praised him, saying "Mr. Gong's ink work is the best in the Jiangdong region [the east side of the Yangzi River]."[1]

In the first thirty years of his painting career, he focused on the use of various linear techniques with only light applications of texture strokes. As a result, these works came to be called white (*bai*) Gong.

Between his late 30's and mid 40's, Gong Xian focused his painting method on applications of light ink texture strokes to create a blurred effect, beginning a period known as the gray (*hui*) Gong.[2] He described the technique fully in his textbook *Catalog of Lessons in Landscape Painting (Shanshuiketugao)*. There, we are told that even in painting a leaf, he would apply more than five layers of ink.[3] Gong Xian's development of this technique matured during his forties.[4]

The Nanjing scroll is one of the best examples from the so-called black (*hei*) period, which is characterized by a maturing of the artist's brushwork after his mid-forties. The change of style can be tied to a few significant experiences in the fourth decade of Gong's life, the first of which were visits to art collections in Yangzhou which broadened his vision.[5] Later, when Zhou Lianggong returned to Nanjing in the 1660's, Gong benefited from their friendship and was able to view Zhou's painting collection. Finally, after over thirty years of painting, Gong felt ready to experiment with Mi Fu's ink-dot style of painting. Doing so pushed him to complete his own interpretation of the layered ink technique as well as several other methods of aesthetic expression, thereby

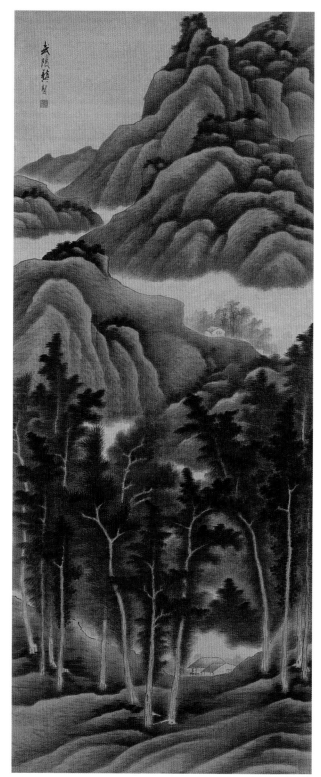

19.

finally being able to fully realize his own individual artistic identity.[6]

The Self-Collected Album of Landscapes (Zicang shanshui ce) in the Beijing Palace Museum is a good example of this mature black Gong style. While his *Land-*

88

scape in *Imitation of Dong and Ju* in the Honolulu Academy of Arts may be his last work, one can see from its colophon that, to the very end, he was following in the footsteps of such Northern Song masters as Dong Yuan and Juran as well as the Yuan masters Ni Zan and Huang Gongwang in his life-long pursuit of the two highest levels of achievement in Chinese painting: spiritual, or *shen pin*, and untrammeled, or *yi pin*.[7]

20. Fan Qi (1616–after 1697)
Snow Scene
樊圻　雪景山水圖軸
1666
Hanging scroll, ink and color on silk
H. 83 cm (32¾ in.); W. 48.3 cm (19 in.)

A light ink wash darkens the winter sky to represent the cold, wintry gloom and to highlight a snow-covered landscape. Strong contour lines give shape to the hard and lofty mountains standing like open stone doors. The icy, aloofness of the rocks is broken by the soft welcome of a lonely temple, surrounded by snow-topped pine trees in a high mountain valley.

Although the subject of winter has a long history in Chinese landscape painting, it was not as popular as depicting other seasons, because snow scenes require different kinds of brushwork and composition. Often one sees a predominance of blank space, a reduction of busy, complicated brushstrokes and a subtle gradation of ink tones. A Qing dynasty literatus wrote: "Lofty mountains seem to be made from jade; they purify one's spirit."[1]

The beauty of the snowy landscapes of Nanjing in the winter has been much praised by literati during the seventeenth century. The scholar Zhong Xing (1574–1624) composed an essay that recalled the beauty of the Nanjing snow scene: [2]

The snow was at its most ethereally beautiful at Treetop Pavilion with its beauty derived from the trees and mist. As I gazed from the Temple of the Rooster's Crow at the lake behind it, I saw that the snow at Lake Black Dragon was at its most secluded and serene, [qualities] which were derived from the lake, the trees and the mist. Snow at the Imperial Mausoleum was at its most masculinely majestic, whereas, viewed aboard the boat on the Qinhuai River, snow takes on a different, entirely unique, experience. Finally, the snow falling on Mount Zhong must be seen, as it appears to sparkle to those gazing up from the water below.

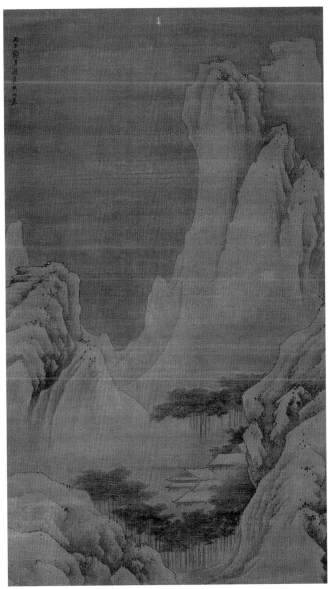

20.

21. Wu Dan (active ca. 1667–1684)
Misty Mountains
武丹　林巒烟靄圖軸
1677
Hanging scroll, ink and light color on paper
H. 248 cm (97⅝ in.); W. 60 cm (23⅝ in.)

Emerging out of a soupy mist, dark-toned hills and mountains create a distinct zigzag pattern on the painting surface. Here and there, signs of human occupation encourage the viewer's eye to travel up and back into space. Starting with the faint image of a wooden bridge over a stream in the left corner, the hillocks recede diagonally to a half-hidden cluster of pavilions in the lower right side. The hills turn sharply left to a lone hut in an open clearing. A line of houses moves diagonally up a hillside toward the right, where a looming cliff directs our

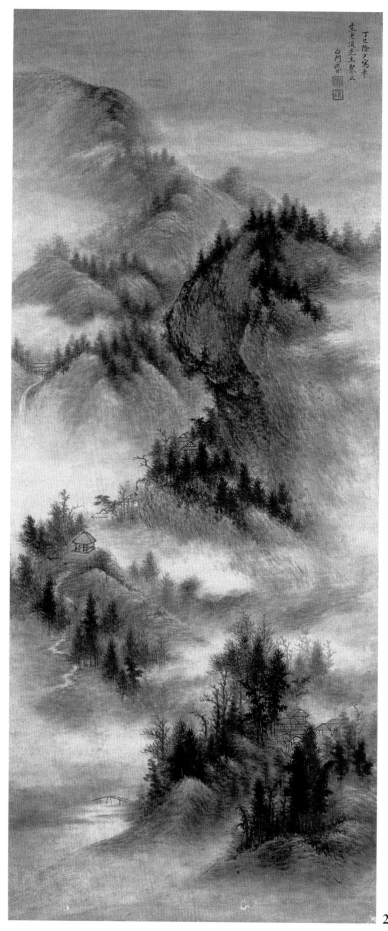

丁巳除夕寫來
畫壽道先生土鑒正
白門寄石

21.

gaze back to yet another mountain, which rises to a great height with the same zigzag movement. The accomplished use of brush strokes and varying tones of ink here create a moist and hazy effect that transforms the mountains and pavilions into a dreamlike vision.

Little is known about Wu Dan. That he was a native of Nanjing can be assumed from his signature on this painting in which he referred to himself as from Baimen, an ancient name of Nanjing. A handful of dated works shows him to have been active in the 1670s and 1680s.[1]

22. Gong Xian (1618–1689)
A Fisherman's Cottage in the Autumn River
龔賢　秋江漁舍圖軸
17th century
Hanging scroll, ink and color on silk
H. 142 cm (56 in.); W. 58 cm (22⅞ in.)

The painting depicts the sun setting over a lake at the peak of autumn. By recapitulating the concepts associated with the landscape style of the tenth-century master Dong Yuan, Gong has painted the softly rounded distant mountains with textured hemp-fiber strokes (pima cun) and then lightly colored them with a wash. Bold dots are used to emphasize the red foliage and green weeds in the near and middle distance, while lighter dots peppering the hills represent distant foliage and enliven the painting surface. Man-made elements—rustic village, thatched huts, wooden bridge and a fishing boat—are sketched with only a few, bold strokes.

Derived from the spare manner of Wu Zhen and Ni Zan of the Yuan dynasty, the composition of this painting is divided into two sections: the upper one with ranges of mountains over the river or lake, done with heavy outlines and light strokes, and the lower section with some cottages and several trees on some low sand banks done in paralleled horizontal lines and dots. A quiet river scene reminds one of those early masters. In the midst of this scene there appears something unmistakable in the style of Gong Xian—a single, lonely pavilion standing prominently in the middle of the painting, a symbol of his own situation during that period.

Inscribed along the top of the painting is a poem by the artist which is typical of work in the literati tradition. In style, it appears to have been done in the 1660s when Gong was in his forties. The free and unrestrained calligraphy echoes the bold brushwork of the painting. The poem alludes to a long tradition of pure-minded men who would rather live free than serve in government:

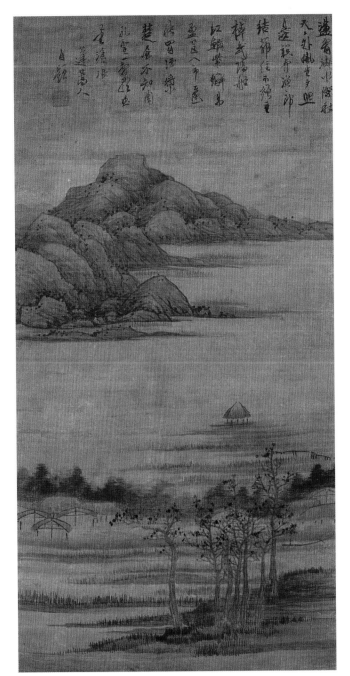

22.

The lake water cleanses my mind—it's autumn now.
A breeze is brought by the sunset in the horizon.
I've given my word to stay in a fisherman's hut,
For I will have no need to search for a heaven on earth.
Pink shrimp and purple crabs will leap into my basket;
Once in town, I can trade them for wine.
Such a bucolic life of abandon avoids Confucian teaching,
I joyously celebrate my life on the Canglang River.[1]

23. Zou Zhe (ca. 1610–after 1683)

Cloudy Mountains and a Village by the Water

鄒喆 雲巒水村圖軸

1661

Hanging scroll, ink on paper

H. 154.2 cm (60¾ in.); W. 47.8 cm (18⅞ in.)

Boldly painted, lofty mountains are outlined with strong, unbroken lines and textured with hemp-fiber strokes. Rocks are decorated with dots to indicate plants. Clouds rise from the valleys, separating the hills from the foreground where a wooden bridge crosses a rock-flanked stream, and waterside pavilions welcome the breeze. The leafy trees are described by a variety of brush strokes and light colors.

24. Gong Xian (1618–1689)

Yueyang Tower

龔賢 岳陽樓圖軸

Early Qing Dynasty

Hanging scroll, ink on silk

H. 390 cm (12 ft. 9⅝ in.); W. 266 cm (8 ft. 8¾ in.)

This monumental hanging scroll is a carefully balanced composition with a view of the far distance framed by a clearly rendered and highly detailed foreground. On the left a tall cliff looms over a city wall and large pavilion, partially obscured by the upper branches of leafy trees cut off by the bottom edge of the painting. The rest of the painting opens up to a wide vista of a vast lake. In the upper right corner, rolling hills along the distant shore and horizon are indicated in a light ink wash and a rocky island floats dreamlike in the center of the lake.

Yueyang Tower is one of the most famous ancient pavilions in China.[1] Originally constructed in the Three Kingdoms period and rebuilt in the Tang dynasty, it was the tower of the west gate of Yueyang city in Hunan Province. With its waterfront view of Lake Dongting, it remained through its various restorations a favorite site for literati visitors who celebrated the tower in their poems and essays.[2] These comments made the site legendary, transforming it into a frequent theme for artists, whether they had seen it or not.

There is no clear documentation to prove that Gong Xian ever visited this famous historical site. He has depicted not a specific tower, but rather his response to a poetic vision. While the inscribed poem describes an exquisite moment on a moonlit night, his thick brush strokes with layers of heavily-applied ink have captured the darkness of

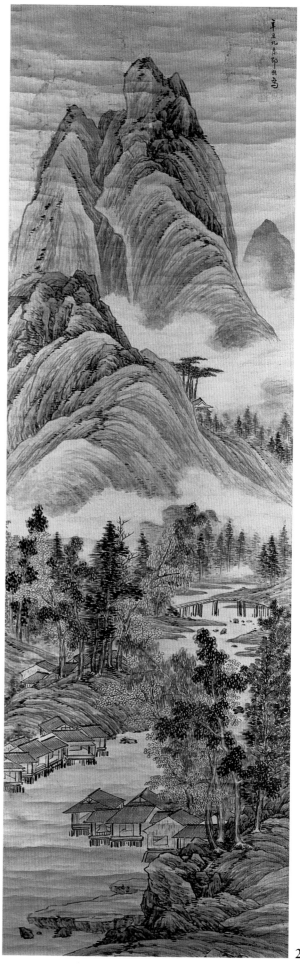

23.

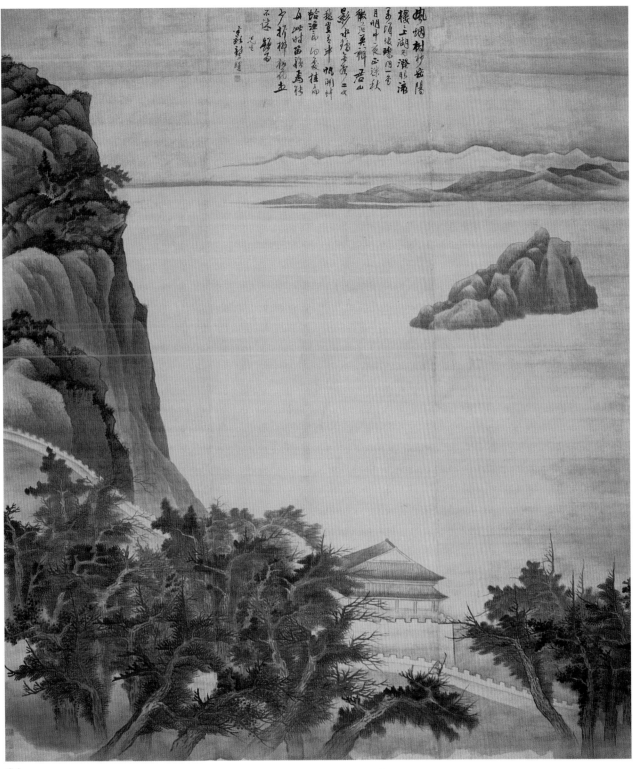

24.

mountain forms, the emptiness of the lake and the floating quality of an island on bright moonlit waters.

Inscribed poem:

Obscured by breezes and mist and above treetops,
the Yueyang Tower rises,
From which one can view the lovely sight of a lake.
Its boundless water resembles a mirror—
its reflections all move as if one.
Under this moonlit evening, I realize it's late autumn.
As in the darkness, the shape of the mountain
cannot be deciphered.
The cranes of the river remain silent and sad,
And no boat has hoisted its sail at this hour.
How can the young fisherman find his way home?
This is the moment when the flute is so perfect.
As I pick a willow branch, my thoughts linger
on plum blossoms.

25. Chen Zhuo (1634–after 1709)
White Clouds and Green Mountains
陳卓 青山白雲圖軸
1703
Hanging scroll, ink and color on silk
H. 257 cm (8 ft. 5¼ in.); W. 66 cm. (26 in.)

In this well-ordered composition, made by the artist at the age of 70, a deep ravine and a mountain stream fed by a waterfall springs from the summit of the towering, mist-wrapped peak at the top. Figures are seen crossing over a bridge in the foreground, perhaps on their way toward a jagged wood plank path that hugs the cliff by the waterfall. Their eventual destination seems to be the temple compound that sits among clouds halfway up the composition.

An example of the "high and distant" (*gaoyuan*) compositional type in Chinese landscape painting, it follows the methods of the Song landscape masters, the artist used strong outlines and "ax-cut texture strokes" (*fupi cun*) to convey the rough surfaces of the rocks. At the same time, the blue-and-green landscape style of the Tang dynasty is evoked with the use of colorful, opaque pigments: white highlights on the outlined, curling clouds, green needles of pines, red foliage, blue and green rocks and multi-colored details of the finely drawn architecture. The decorative quality of this style is combined with dense brushwork, the feeling of solidity and the roughness of mountains typical in Northern Song landscape painting.

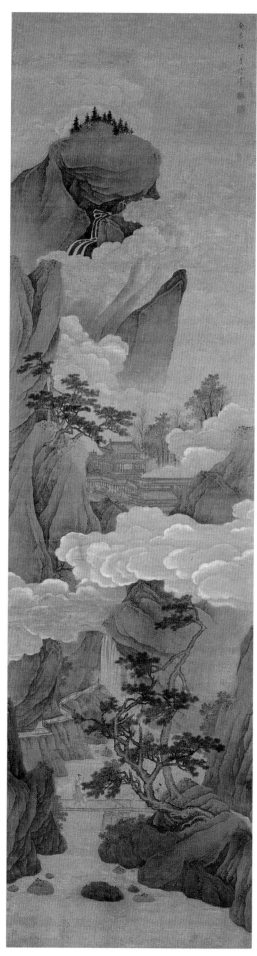

25.

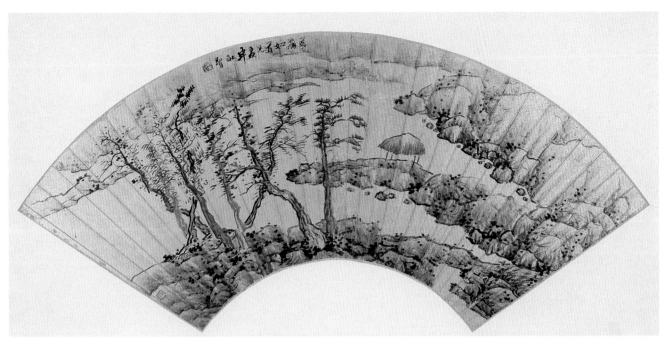

26.

26. Gong Xian (1618–1689)
Mountain Pavilion by a Stand of Trees
龔賢　山亭溪樹圖扇面
1679
Fan painting mounted as an album leaf, ink on paper
H. 20.9 cm (8¼ in.); W. 60.4 cm (23⅞ in.)

With rough ink lines and a variety of texture strokes, the scene of an isolated hut on a peaceful lakeshore appears to be secondary to the ink play. A light monochromatic ink wash depicts the remote mountains, with darker ink for the closer hills and piled rocks. Scattered dots of dark ink represent the foliage and underbrush and at the same time create a strong rhythmic pattern on the paper surface. This is a fairly complex composition, with the left side dominated by eight trees, the right side by rocks and streams. In the center stands a lonely pavilion.

The entire painting is an artistic expression of the purity of desolation and wildness typical of Gong's later years, with a heavy line used to describe trees and rocks and dark dots scattered about. Its basic composition and appearance were derived from the works of Ni Zan, while the looser, sparser brushwork was a development of Gong's old age. In Gong's painting manual, which he edited in his later years, he revealed the concept behind such leisurely work. "This is what's known as a work combining the styles of Ni Zan and Huang Gongwang—Yuan landscape painting masters. Ni's minimalism is adapted, and Huang's looseness serves as the inspiration.

The styles of Ni and Huang complement each another so much that only when the two styles are blended into one can the brushwork look mature and beautiful. And only then can the ink look rich, moist and smooth."[1]

His paintings recaptured the style of Northern Song landscapes with awe-inspiring compositions and attention to detail, and yet he retained touches of the spiritual aloofness of the Yuan dynasty landscape painters. "As a

26. Detail

painter, he shunned the conventional, creating his own unique style. He described himself as like 'no one before, and no one after'.[2]

His contemporary, the artist Cheng Zhengkui (cat. no. 11), rarely praised other artists, but admired Gong Xian, saying: "There are two schools of painting. [First there is] the complex Northern Song style, with myriad mountains, peaks, vales and trees, where not one stroke can be taken out. Then there are paintings of the Yuan dynasty, which are known for their simplicity, adorned with just a few withered branches and haggard rocks, where not one stroke can be added. Gong Xian is the one who currently grasps this artistic essence."[3] The special characteristics of Gong's composition and brushwork in landscape paintings have influenced later generations.

27. Gao Cen (active 1643–after 1687)
Autumn Mountains and Myriad Trees
高岑　秋山萬木圖軸
Early Qing Dynasty
Hanging scroll, ink and color on silk
H. 148 cm (58¼ in.); W. 57.7 cm (22¾ in.)

Deep in the mountains, a lofty summit stands out like a pillar into the sky, dominating the composition. Its top is covered with luxuriant foliage while a narrow waterfall drops precipitously down its central crevice. A thick mist drifts through the autumn-tinged trees and floats back into the valley obscuring the base of the summit. In the foreground a wooden bridge crosses the rocky streambed and leads to a winding path traveled by a red-robed gentleman wearing a black hat and carrying a walking stick.[2] His young servant, dressed in a blue tunic and carrying a bag, lags behind.

Mountain hiking or traveling, whether accompanied by a servant or with friends, was a favorite activity of the gentleman. The pastime was especially popular during the seventeenth century, when it appeared more frequently as a subject in painting.

Like Cheng Zhengkui, Hu Zongxin and Gong Xian in catalog numbers 11, 15 and 26, many Jinling artists were nurtured by the Song and Yuan masters, and their work reveals that reverence for the past and its influence on the painting of their own time. In just this spirit, Gao Cen's painting clearly takes its inspiration from the magnificent Northern Song painting by Fan Kuan, *Travelers Amid Streams and Mountains*. Gao's composition is strikingly close to that of his eleventh-century model, but Gao Cen's brush strokes have been applied with a slightly mannered method that loses some of the power of the

original. Gao's painting thus lacks the powerful expression of that earlier master. It is nevertheless a successful evocation, especially in how it captures the movement of mist and clouds, a typical southern touch.

28. Kuncan (1612–after 1686)
Green Mountains Reach to the Sky
髡殘　蒼翠凌天圖軸
1660
Hanging scroll, ink and color on paper
H. 226 cm (89 in.); W. 59 cm (23¼ in.)

With vibrant brushwork, the landscape forms in this painting seem to be constantly moving: the diagonally receding rocks, the waterfall that drops down in stages from a summit on the left, and a narrow path on the right that snakes up to a temple hidden in the mountain mist and a gate tower at the very top. The perspective shifts dramatically from corner to corner of the composition, creating simultaneously individual areas of depth and an overall sense of compression. Gazing serenely from his hut in the lower left corner, an old man in red robes and a black hat offers the viewer psychological access to the painting. The light washes of color add a touch of warmth to the composition.

Kuncan was a native of Wuling in Hunan Province but later came to live near Nanjing. After he became a monk, he lived in the Ox-Head Temple just south of Nanjing where he became a reticent, unsociable man who was frequently ill. His bad health is reflected in his self-reference as a Decrepit Monk (*Candaoren*). He was an excellent poet and a talented amateur artist, "playfully" painting landscapes—often magnificent compositions with luxuriant mountains. Lacking sophistication or training, Kuncan nevertheless sought to emulate the spirit of the Yuan dynasty masters; his nervous brushwork and writhing forms may be found in the paintings of Wang Meng.

Historically, Kuncan's name was linked to that of Shitao (1642–1707), one of the best-known individualist monk-painters of the early Qing period. Although their painting styles have little in common and there is no evidence that the two had ever met, they were often referred to as the Two Stones (*er shi*), Shitao being Stone Wave and Kuncan being Stone Stream (*shixi*).[1] Kuncan probably had little social contact with Nanjing artistic circles, but one of the few people that he enjoyed seeing was Cheng Zhengkui. Gong Xian wrote that the two artists, Kuncan and Cheng, were called *er xi,* The Two Streams, i.e., Shixi and Qingxi (see Appendix III). There is also evi-

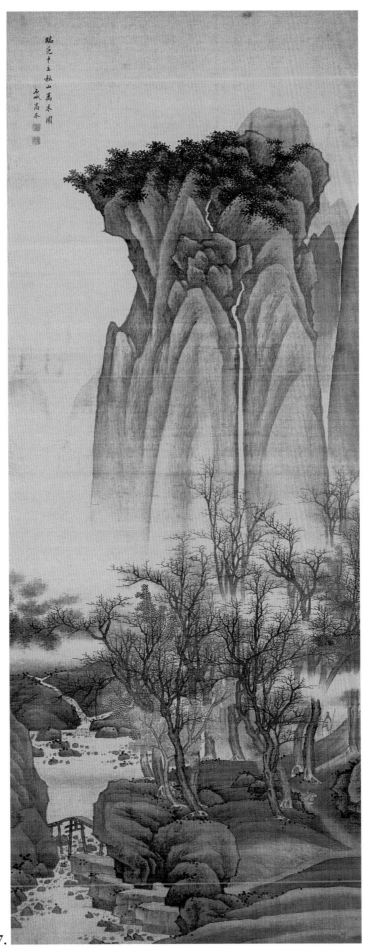

27.

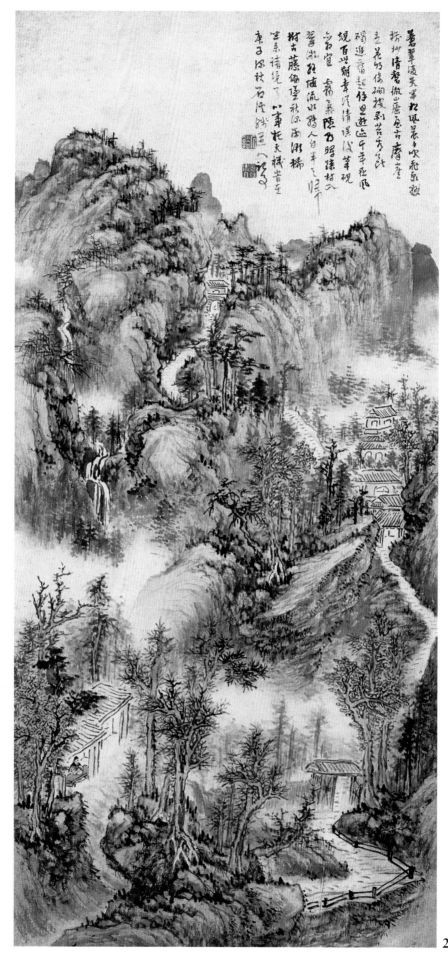

28.

A PLACE OF BEAUTY

1. Map of Qing Dynasty Jinling
Collection of the Nanjing Museum, 7.1.2193n

Mount Zhong is also known as Purple Gold Mountain (Zijin Shan 紫金山). Recuperating Mountain (She Shan 攝山) is also known as Cloud Perched Mountain (Qixia Shan 棲霞山). Square Mountain is also known as Celestial Seal Mountain (Tianyin Shan 天印山).

Notes:
1. In the second year of the Shunzhi era in the Qing dynasty [1645], the government named Nanjing as the capital of the lower Yangzi River region. Ye Chucang and Liu Yizhi, *Shoudu zhi* (Nanjing gujiu Shudian, 1985), juan 1, p. 30.
2. This temple was famous for its "three excellences": the mural of Vimalakirti by the great painter Gu Kaizhi (ca. 345–406); the Buddhist sculptures by the renowned sculptors Dai Kui (?–396) and his son Dai Yu; and a four-foot-high white jade figure of the Buddha sent as a gift from the Lion Kingdom (present-day Sri Lanka). Jiang Zanchu, *Nanjing shi hua* (The History of Nanjing) (Nanjing: Nanjing Chubanshe, 1995), pp. 69–70.
3. The wine pavilion was named after Sun Chu of the Western Jin dynasty who was renowned for his eloquence. *Zhanggu dacidian* (Beijing: Beijing tuanjie Chubanshe, 1990), p. 742.
4. These include the Eastern Jin dynasty minister Xie An (320–385) and the Five Dynasties official Han Xizai (902–970), the subject of the renowned *Night Banquet of Han Xizai*, painted by Gu Hongzhong (active 943–961).

2. Guo Cunren (ca. 1580–1620)
Eight Views of Jinling
Collection of the Nanjing Museum, 7:7779

Guo Cunren, style name Shuicun 水村, was also known as Guo Ren 郭仁.

Title section: *Eight Views of Jinling in Paintings and Poetry by Guo Shuicun of the Ming Dynasty* (*Ming Guo Shuicun Jinling bajing tuyong*) is written in seal script and followed by a colophon in running script: "This handscroll deserves to be called 'the three excellences' with Shuicun's [painting], profound poems and calligraphy. In addition, it depicts scenes of our hometown. Thus, it is most proper for my brother Gen to treasure it. Viewed in the seventh month of the year *xinwei* [1631] in Wumen (present-day Suzhou). Inscribed by Deng Bangshu, Qunbi, from Jiangning (an ancient name for Nanjing)."
Signed with the intaglio-legend square seal, *Deng Bangshu yin* (鄧邦述印) and relief-legend square seal, *Qunbi jushi* (群碧居士).

2a. Clear Clouds Encircle Bell Mountain
In ancient times Bell Mountain was also known as Purple Gold Mountain (Zijin Shan), Gold Mountain (Jin Ling 金陵) and Jiang Mountain (Jiang Shan 蔣山). It is located on the eastern outskirts of the city, and forms the western section of the Ningzhen mountain range (referring

to Nanjing and Zhenjiang). From east to west, Mount Zhong measures 7 km and, from north to south, about 3 km. The entire mountain covers over 20 square km. Lofty Mount Zhong is covered with trees, especially pines, and is sprinkled with famous sites like Dense Pines in Spiritual Valley (Linggu shensong 靈谷深松) and the special outdoor reading place of the Six Dynasties Prince Zhaoming (501–530). Both sites were included in the famous Forty-eight Views of Jinling of later date (see Ji Shijia and Han Pinzheng, *Jinling Shenji Daquan* [Nanjing: Jiangsu Nanjing Chubanshe, 1993], pp. 453–9).

Artist's seal: square intaglio legend, *Guo Cunren yin* (郭存仁印).
Artist's seals (following poem): square intaglio legends, *Cunren zhiyin* (存仁之印), *Yuanfu* (元父) and *Tiandansheng* (恬淡生).

2b. Snow Falls on Stone Citadel
Stone Citadel (Shicheng 石城), also called (Shitoucheng 石頭城), is located near the northwest side of present-day Caochang Gate (Caochangmen 草場門). It was established along the Yangzi River in ancient times, when Sun Quan (182–252) of the Wu kingdom built it on the old ruins of Jinlingyi, a city of the Chu kingdom (3rd century B.C.). Famed as the "Stone Citadel Crouching like a Tiger" (Shicheng huju 石城虎踞), the site served as the important west gate for the city and has always been the scene of military battles (see Ji Shijia and Han Pingzhen, pp. 516–7).

Artist's seal: square relief legend, *Yuanfu* (元父).
Artist's seals (following poem): square intaglio legends, *Cunren* (存仁) and *Guoshi Yuanfu* (郭氏元父).

2c. Evening Rain Settles on Dragon River
Artist's seals: coupled square relief legends, *Cun* (存) and *Ren* (仁).
Artist's seals (following poem): coupled square intaglio legends, *Cun* (存) and *Ren* (仁), and square intaglio legend, *Yuanfu* (元父).

2d. Autumn Moon Shines on Phoenix Terrace
Artist's seals (following poem): coupled square relief legends, *Cun* (存) and *Ren* (仁), and square intaglio legend, *Guoshi Yuanfu* (郭氏元父).

2e. White Egrets Soar over Glistening Waves
Artist's seal: square intaglio-legend in what seems to be the highly stylized bird script, possibly *Guo Cunren* (郭存仁)
Artist's seals (following poem)): rectangular relief legend, *Yuanfushi* (元父氏), and square intaglio legend, *Zhilanshi* (芝蘭室).

2f. Sunset Seen in Black Robe Alley
Artist's seal: rectangular relief-legend, *Yuanfushi* (元父氏).
Artist's seals (following poem): square relief legend, *Tiandansheng* (恬淡生), and square intaglio legend, *Yumushiju* (與木石居).

2g. Playing a Flute Beside the Qinhuai River
Artist's seal: square intaglio-legend, *Cunren* (存仁).
Artist's seals (following poem): square intaglio legends, one possibly *Guo Cunren* (郭存仁) in bird seal script, and the other, *Yuanfu* (元父)

2h. Woodcutters' Songs Heard on Celestial Seal Mountain

Celestial Seal Mountain (Tianyin Shan), originally named Square Mountain (Fang Shan 方山), is located southeast of the city, about 20 km outside Zhonghua Gate (Zhonghuamen 中華門). It was named for its resemblance to a large square seal dropped from Heaven. The mountain measures 208 meters high and occupies about 3.3 square km. It is an inactive volcano, with cultivated fields on an indented mountain top. Standing on a flat plain, the mountain is the only high spot available for viewing the distance. It was also an important transit point. According to tradition, this was where Nanjing residents came to see off their friends (Ji Shijia and Han Pinzheng, pp. 30–32.)

Artist's seal: square intaglio-legend, *Guoshi Yuanfu* (郭氏元父).
Artist's seals (following poem): square intaglio legends, *Guo Cunren yin* (郭存仁印) and *Tiandansheng* (恬淡生).

2j. Inscription in running-cursive script:

"The old gentleman of Xiangshan provided me with this piece of silk and asked me to paint the Eight Views of Jinling. Thus I also made eight poems to accompany the paintings. Though it is not proficient, what can I do, except to amuse him in the middle of the night. In the spring of the *gengzi* year in the Wanli era [1600], noted by Guo Cunren."

Artist's seals: square intaglio legends, *Guo Cunren yin* (郭存仁印) and *Yuanfu* (元父).
Collector's seal: rectangular intaglio legend, *Yiqingguan cang* (頤情館藏).
Colophon: "Four days after *xiazhi* [around mid-June] in the *xinyou* year of the Xianfeng era [1861], Ma Lisheng of Jiexiu [in Shanxi Province] noted his appreciation on viewing this painting in a hostel in Wuling [in Jiangsu Province]." Signed with one intaglio-legend square seal, *Lijin changshou* (礪金長壽).

Notes:

1. Yu Jianhua, *Zhongguo Meishujia Renmin Cidian* (1981; reprint, Shanghai: Shanghai Renmin Meishu Chubanshe, 1996), p. 948.
2. Zhu Yizun's text, *Pushuting Shuhua ba*, is published in Huang Binghong and Deng Shi, ed., *Meishu congshu* (1928; reprint, Nanjing: Jiangsu guji Chubanshe, 1986), juan 1, p. 535. A discussion of Song Di and the Eight Views can be found in Alfreda Murck, "Eight Views of the Hsiao and Hsiang Rivers by Wang Hung," in Wen Fong, et al., *Images of the Mind* (Princeton, N.J.: The Art Museum, Princeton University, 1984), pp. 214–235.
3. Ji Shijia and Han Pinzheng, *Jinling Shenji Daquan* (Nanjing: Jiangsu Nanjing Chubanshe, 1993), pp. 562–3.
4. Qing dynasty scholar Chen Zuolin recorded in his *Fenglu xiaozhi* details of the history of the Fenghuangtai and the poems that it inspired. See Chen Zuolin, *Fenglu Xiaozhi*, in *Nanjing Wenxian*, juan 2, P. 23-72, reprint, Shanghai: Shanghai Shudian, 1991).
5. Yu Shouzhen, ed., *Tangshi Sanbaishou* (Beijing Zhonghuashuju, 1982), p. 225. For an English translation of the poem see Wu-chi Liu and Irving Yucheng Lo, ed., *Sunflower Splendor: Three Thousand Years of Chinese Poetry* (Garden City, New York: Anchor Books, 1975), p. 113.
6. Lü Wujin, *Anecdotes of Locations of Nanjing* (Nanjing: Nanjing Chubanshe, 1998), p. 94.
7. Ji Shijia and Han Pinzheng, pp. 491–7.

3. Fan Qi (1616–after 1697)
Sightseeing in Jinling
Collection of the Nanjing Museum, 7:6672

Fan Qi also used the names Huigong 會公 and Qiagong 洽公.

In one of the colophons of this handscroll, the artist Liu Yu (1637–after 1689) recorded that in Nanjing the local people eagerly collected Jinling landscape paintings. Another colophon on this handscroll, written by the artist Cheng Sui (ca. 1605–1691), records that the original owner of this handscroll, Ben Shiye, invited famous artists of the time, including Fan Qi, Wu Hong, Gong Xian and Chen Zhuo to each paint one scene to be put together as a handscroll. This kind of enthusiasm for the landscape of Jinling was rarely matched in other cities of the time.

3a. Enquiring for Wine at Apricot Blossom Village

Apricot Blossom Village (Xinghuacun 杏花村) was also known as Xingcun 杏村. Du Mu (803–ca. 852), in his poem "Qingming" (Pure Brightness, the fifth solar term), recorded that a certain famous painter, Wu Wei (Xiaoxian, 1459–1508), liked to visit Xinghuacun every year together with his noble friends (see Zhou Hui [fl. 1610], *Jinling suoshi*, juan 2 [Beijing: Beijing wenxueguji kanxingshe, 1955]).

Inscription: "In the winter of *bingyin* [1686], painted for respected older brother Ben by Fan Qi at the age of seventy one."
Artist's seals: square relief legend, *Qi* (圻), and square intaglio legend, *Huigong* (會公).
Collectors' seals: rectangular relief legend, *Changping Zhushi zhi liaoshu sifu jiancang jinshi Shuhua Ji* (長平祝氏之鐐叔私父鑒藏金石書畫記), and square intaglio legend, *Bishi jiacang* (畢氏家藏).
Artist's seals (following two poems by the artist Wang Ji): square intaglio legend, *Wangji zhiyin* (王楫之印), and square relief legend, *Fenzhong* (汾仲).
Artist's seals (following poem by the artist Liu Yu): square relief legend seal, *Liu Yu* (柳堉), and square intaglio legend, *Gonghan* (公韓).
Collector's seal: square relief legend, *Haiti zhencang* (海梯珍藏).

3b. Boating Along the Qingxi River

Inscription: "Painted for respected brother Ben by Fan Qi."
Artist's seals: square intaglio legend, *Fan* (樊), and square relief legend, *Qi* (圻).
Collector's seals: square relief legend, *Changping Zhushi Liaoshu sifu jiancang jinshi Shuhua Ji* (長平祝氏之鐐叔私父鑒藏金石書畫記), and square relief legend, *Haiti shouding* (海梯手定).
Artist's seals (following two poems by Wang Ji): square intaglio legend, *Wang Ji zhiyin* (王楫之印), and a square relief legend, *Fenzhong* (汾仲).
Artist's seals (following poem by Liu Yu): square relief legend, *Liu Yu* (柳堉), and square intaglio legend, *Gonghan* (公韓).

Additional colophons

There are several other colophons not directly related to the painting. One of them. written by Liu Yu, records the contemporary Nanjing custom of collecting local landscape paintings: "Because some Jinling native collectors favor paintings of the Jinling landscape, fine works by the Jinling masters are in demand. As some ancients put it, 'Only the mountains of home are a joy forever', or in other words, 'One's passion is only for the mountains of home.' The line was of course a takeoff from Li Bo's 'We find everlasting joy gazing at each other, only Jingting Mountain and I,' yet the rewritten line has its own charm that bespeaks an old truth."

The remaining colophons and those belonging to the additional two titles, *Qingliang huancui* and *Qixia shenggai*, have been transcribed in Chinese on p. 142.

Notes:

1. Zhou Lianggong, *Du hua lu*, juan 4, p. 44, in *Huashi congshu*, juan 9 (Shanghai: Shanghai Renmin Meishu Chubanshe, 1963). For the role of Zhou Lianggong in the artistic life of seventeenth-century Nanjing see Hongnam Kim, *The Life of a Patron: Zhou Lianggong (1612–1672) and the Painters of Seventeenth-Century China* (New York: China Institute, 1996). A translation of *Du hua lu* by Dr. Kim is forthcoming.
2. Several places in China claim that they are the Xinghuacun celebrated by Du Mu, for example, Guichi in Anhui Province and Fen County in Shanxi Province. According to Professor Jiang Zanchu, a scholar specializing in the history of Nanjing, in an interview in the summer of 2002, specialists have determined, from climate, custom and other aspects, that Du Mu's village should be the Xinghuacun in ancient Jinling.
3. Ji Shijia and Han Pinzheng, pp. 502–3.

4. Zou Zhe (ca. 1610–after 1683)
Landscapes
Collection of the Nanjing Museum, 7:79

Zou Zhe's sobriquet was Fanglu 方魯. His father, Zou Dian 鄒典 (style name, Man 滿), was a painter proficient in landscape and floral subjects.

Seals: Each leaf of the album is uninscribed, but impressed with the artist's square intaglio legend seals, *Zou Zhe* (鄒喆) and *Fanglu* (方魯). On the last leaf of the album, there is a collector's seal with a square relief legend, *Bohan zhencang* (伯韓珍藏).

5. Gao Cen (active 1643–after 1687), et al.
Landscapes
Collection of the Nanjing Museum, 7:82

Gao Cen's sobriquet was Weisheng 蔚生. His older brother, Gao Fu 高阜 (also named Kangsheng 康生), was just as famous for his painting, and his nephew Gao Yu 高遇 (also named Yuji 雨吉) was good at painting as well.

5a. Fang Wei (active ca. 1661), *Landscape*
方維　山水
Artist's seal: square relief legend, *Fang Wei* (方維).

5b. Unsigned, *Landscape*
無名　山水

5c. Zou Zhe (ca. 1610–after 1683), *Landscape*
鄒喆　山水
Artist's seals: two square intaglio legends, *Zou Zhe* (鄒喆) and *Fanglu* (方魯).

5d. Zou Zhe (ca. 1610–after 1683), *Landscape*
鄒喆　山水
Inscription: "In the winter of *gengzi*, painted beside the Stone Citadel [an ancient name for Nanjing] Zou Zhe."
Artist's seals: square intaglio legends, *Zou Zhe* (鄒喆) and *Fanglu* (方魯).

5e. Zou Zhe (ca. 1610–after 1683), *Landscape*
鄒喆　山水
Artist's seal: square intaglio legend, *Zou Zhe* (鄒喆).

5f. Zou Zhe (ca. 1610–after 1683), *Landscape*
鄒喆　山水
Artist's seal: square intaglio legend, *Zou Zhe* (鄒喆).

5g. Unsigned, *Landscape*
無名　山水
Xuanwu Lake was also called Hou Lake and was on the northeastern outskirts of Nanjing.

5h. Ye Xin (d. ca. 1671), *Landscape*
葉欣　山水
Ye Xin, also named Rongmu, was a native of Huating in present-day Songjiang County within Shanghai municipality but moved from there to Jinling. He learned landscape painting from Zhao Lingrang.

Inscription: "Ye Xin."
Artist's seals: two square intaglio legends, *Ye Xin* (葉欣) and *Rongmu* (榮木).

5i. Gao Cen (active 1643–after 1687), *Landscape*
高岑　山水
Inscription: "Winter of *gengzi* [1660], painted by Gao Cen of Shicheng [Stone Citadel, another name for Nanjing]."
Artist's seals: square intaglio legends, *Gao Cen* (高岑) and *Weisheng* (蔚生).

5j. Gao Cen (active 1643–after 1687), *Landscape*
高岑　山水
Inscription: "In imitation of Mi Yuanhui's [Mi Youren, 1074–1151] *Dayao Village*, by Gao Cen of Shicheng [Nanjing]."
Artist's seals: square intaglio legends, *Gao Cen* (高岑) and *Weisheng* (蔚生).

Notes:

1. Zhou Lianggong *Du hua lu*, juan 3, pp. 42-43. The biography of Gao Cen, written in Zhou Lianggong's own hand, accompanies Gao's painting of a landscape in the collection of the Freer Gallery, Washington, D.C. It is translated in Kim, *The Life of a Patron*, pp. 176–7.
2. Ibid.
3. Zhou Lianggong, *Du hua lu*, juan 4, p. 49.
4. Zhao Lingrang (act. ca. 1080–ca. 1100), also known as Zhao Danian, was a member of the Song imperial family. He favored level-distance landscapes, especially intimate, misty river scenes with naively drawn cottages. See Shen Roujian, *Zhongguo Meishu cidian*, p. 126. Also, Wen Fong, *Beyond Representation: Chinese Painting and Calligraphy 8th–14th Century* (New York: The Metropolitan Museum of Art, 1992), pp. 160–61.
5. Tao was a great poet of the Eastern Jin dynasty. His poetry speaks of his simple pleasures, love of nature and his aversion for snobbish society. For Chinese intellectuals, then, Tao represented the ideal of the recluse.

A STYLISH LIFE

6. Gong Xian (1618–1689), et al.
Landscapes by the Jinling Masters
Collection of the Nanjing Museum, 7:289–7:296

The album was assembled by the well-known painter-collector, Wu Hufan (1894–1968), the grandson of the renowned scholar and painter Wu Dacheng (1835–1902) of the late Qing dynasty (see Shen Roujian, *Zhongguo Meishu cidian* [Taipei: Taiwan xiongshi Meishu, 1989], p. 258). Wu Hufan treasured this album and inscribed the title strip, *Fan paintings by the Eight Masters of Jinling. Collected and authenticated by Master Wu of the Plum View Studio (Wushi Meijing Shuwu).*" On the title page, he carefully labeled in seal script calligraphy, "Collected Fan Paintings by the Eight Masters of Jinling" and further inscribed, "Gong Banqian and others of the Eight Masters established the Jinling school, which was as important as Huating and Loudong. Collected by Meijing Shuwu. Hufan." (The Huating school was originally lead by Gu Zhengyi and his descendants, and the Loudong school by Wang Yuanqi. These two painting schools of the seventeenth century were both located near present-day Shanghai. See Shen Roujian, *Zhongguo Meishu cidian*, pp. 79–80.) Wu Hufan and his wife, Pan Jingshu, have also left their collectors' seals on most of the fan paintings, each of which is accompanied by short comments by Wu. It is interesting to see from his colophons the collector's iron-strong will. Once Wu set about collecting the Eight Masters of Jinling, it took twenty years to achieve his goal. He was so excited over its completion that he spontaneously inscribed the colophon "with endless happiness and excitement."

6a. Gong Xian (1618–1689), *Landscape*
龔賢　山水

Gong Xian also used the names Qixian 豈賢 and Banqian 半千, with the additional names Yeyi 野遺, Banmu 半畝 and Chaizhangren 柴丈人. There are several opinions about his birth year, variously given as 1599, 1617, 1618, 1619 and 1621. The question is discussed in various essays included in a special issue of the journal *Dongnan wenhua* (Nanjing: Nanjing Museum, 1990), no. 5.

The artist lived as a recluse in Half-Acre Garden on Mount Qingliang 清涼山 in the western part of Nanjing. Despite his pride and aloofness, Gong Xian did have great esteem for Cheng Zhengkui. He said: "Minister Cheng's paintings possess the spirit of those by Mi Fu (1052–1107), which makes his paintings comparable to the calligraphy of Dong Qichang of the Ming dynasty. For the past few hundred years, if Wang Xizhi (303–361) of the fourth century is considered the towering master of brushwork in calligraphy, Dong Qichang of the Ming is not too far behind him. As for brushwork in painting, Minister Cheng's and Shixi's [Kuncan's] (1612–1686) are compatible with it" (see National Palace Museum, Taipei, "Zhou Lianggong Ji Mingjia shanshuice," in Lin Shuzhong, "Gong Xian nianpu," *Dongnan wenhua* [1990], no. 5: 58).

Artist's seal: coupled square relief legends, *Ban* (半), *Qian* (千).
Colophon by Wu Hufan: "Gong Banqian was also named Zhihuo, Banmu, Qixian, Yeyi and Chaizhangren. He was famous for his proficiency in painting and lived in Nanjing. He was considered the leader of the Eight Masters of Jinling. He is the author of *Formulae of Renowned Paintings (Minghua jue)* and *Caoxiang tang Ji*. This fan painting, with its dripping wet ink and brushwork, is his best work and if [I] spend ten thousand *liang* [about 625 pounds] of gold, it would be worth it for this piece."
Collectors' seals: square intaglio legends, *Tianjinglou* (天景樓) and *Xiangyulou* (香雨樓), and square relief legend, *Jian wu jia zu* (兼吾佳足).

6b. Fan Qi (1616–after 1697), *Landscape*
樊圻　山水
Fan Qi also used the names Huigong 會公 and Qiagong 洽公.

Inscription: "In the spring of *jiwei* [1679], painted for respected brother Yizhen, by Fan Qi." (One practice in the writing of this kind of dedication is worth noting here. On the paintings of this period, the words *ni* [拟], *si* [似] and *zuo* [作] are often used for dedicating the painting to a particular person. Though the characters look and sound different, they can all be translated as "for." According to Xiaolu Zhou, professor and paleography specialist at Beijing Normal University, these three characters are derived from the same ancient root and thus have the same meaning. Also, during this period, to show respect to the dedicatee, a blank space is usually left before the first character of the name. These practices were common in the inscriptions or colophons at that time.)
Artist's seal: rectangular relief legend, *Huigong* (會公).
Colophon by Wu Hufan: "Fan Huigong [Fan Qi] and Gong Banqian [Gong Xian] are together the leaders of the Jinling School. But in my opinion, Fan's painting has too much of the Jinling habit, and is not as elegant as Zou Fanglu [Zou Zhe] and Ye Rongmu [Ye Xin]. [Fan] painted [this] in the eighteenth year of Kangxi [1679] when he was sixty-four."
Collectors' seals: rectangular relief legend, *Meijing shuwu* (梅景書屋), square intaglio legend, *Pan Jingshu zhencang* (潘靜淑珍藏) and square relief legend, *Wu Hufan zhencangyin* (吳湖帆珍藏印).

6c. Gao Cen (active 1643–after 1687), *Landscape*
高岑　山水
Artist's seal: square relief legend, *Chen Cen* (臣岑).
Colophon by Wu Hufan: "Gao Cen intended to learn from Banqian, but lacked his masculine majestic spirit. Then he fell into the common Jinling habit [of painting pleasant paintings for sale]. He painted this in the eleventh year of the reign of Kangxi [1672]."
Collector's seals: square intaglio legend, *Pan Jingshu zhencangyin* (潘靜淑珍藏印); square relief legend, *Wu Hufan zhencangyin* (吳湖帆珍藏印); rectangular relief legend, *Meijing shuwu miji* (梅景書屋秘笈). An oval relief-legend seal on the upper right corner is undecipherable.

6d. Zou Zhe (ca. 1610–after 1683), *Landscape*
鄒喆　山水
Inscription: "Zou Zhe"
Artist's seals: two square intaglio legends, *Zou Zhe* (鄒喆) and *Fanglu* (方魯).
Colophon by Wu Hufan: "Zou Fanglu studied diligently with Tang Ziwei [Tang Yin, 1470–1524]. Although Tang also had the Jinling habit [of painting pleasant paintings for sale], he retained some charm of aloofness."
Collectors' seals: rectangular relief legend, *Wu Hufan cang* (吳湖帆藏); square relief legend, *Tie di lou* (鐵笛樓); square intaglio legend, *Limang shending* (儢芒審定); rectangular relief legend, *Meijing shuwu* (梅景書屋); square relief legends, *Pan Jingshu zhencangyin* (潘靜淑珍藏印) and *Wu Hufan zhencangyin* (吳湖帆珍藏印).

6e. Ye Xin (d. ca. 1671), *Landscape*
葉欣　山水
Inscription: "In the third month, the spring of *jiashen* [1644], imitating the old man of Yifeng (Huang Gongwang, 1269–1354) for Mr. Lü Tang to correct me. By younger society brother Ye Xin."
Artist's seal: coupled square relief legends, *Ye* (葉) and *Xin* (欣).
Colophon by Wu Hufan: "Ye Rongmu [Ye Xin] is the special one

among the Eight Masters of Jinling whose painting is without the Jinling habit [of painting pleasant paintings for easy sale]. *Jiashen*, the forty-third year of Kangxi [1644]."

Collectors' seals: square intaglio legend, *Pan Jingshu zhencang* (潘靜淑珍藏), and square relief legend, *Wu Hufan zhencangyin* (吳湖帆珍藏印).

6f. Hu Zao (d. ca. 1662), *Landscape*
胡慥　山水

Hu Zao was also named Shigong 石公. His sons, Hu Qing 胡清 and Hu Lian 胡濂, were painters.

Artist's seal: rectangular intaglio legend, *Shigong* (石公).

Colophon by Wu Hufan: "Hu Shigong Zao is one of the Eight Masters of Jinling. His landscape painting is rarely to be seen. It is even harder to find than the work of Zhang Erwei, who is one of the Nine Friends of Painting (*huazhong jiu you*). This fan painting has a style similar to that of Fan Huigong [Fan Qi], I also have not seen it before. In the spring of the year of *jimao* [1939], I saw Hu Shigong's hanging scroll in imitation of Dong [Yuan] and Ju[ran] at Mr. Yu's studio, which is named Jingguan Tower. In that hanging scroll, the method of painting the trees and rocks are exactly same as in this fan painting. Noted by Hufan." (For Zhang Erwei see Zhou Lianggong *Du hua lu*, juan 3. P. 32. For *huazhong jiu you*, refer to Shen Roujian, *Zhongguo Meishu cidian*, p. 81.)

Collectors' seals: an undecipherable circular relief legend; square intaglio legend, *Pan Jingshu zhencangyin* (潘靜淑珍藏印); and square relief legend, *Wu Hufan zhencangyin* (吳湖帆珍藏印).

6g. Xie Sun (active ca. 1679), *Landscape*
謝蓀　山水

Xie Sun, also known by his style names Xiangyou 緗酉 and Tianling 天令, was a native of Lishui in Jiangsu Province but often lived in Nanjing. He was proficient in painting landscape and flowers.

Inscription: "Xie Sun"

Artist's seal: square intaglio legend, *Xie Sun* (謝蓀).

Colophon by Wu Hufan: "Xie Sun, also named Tianling, is one of the Eight Masters of Jinling. His paintings are rarely circulated, even less than those of the painter Zhang Erwei of the Nine Friends of Painting. I have searched for over twenty years and have only found this one fan painting. The rarity of his painting is clear. Recorded by Hufan in the sixth month, the summer of *jiashen* [1944]. I have thus completed the [set of] Eight Masters fan paintings with endless excitement and happiness."

Collectors' seals: square intaglio legend, *Jie wu shen you* (籛吾神游); rectangular relief legend, *Songge xinshangwu* (頌閣心賞物); and square intaglio legend, *Tianjing lou* (天景樓).

6h. Wu Hong (ca. 1610–ca. 1690), *Bamboo*
吳宏　山水

Wu Hong was also known by the names Yuandu 遠度 and Zhushi 竹史.

Inscription: "Using the ink brush method of Su Changgong (Su Shi, 1036–1101), painted for the Poetry Master of Weishui for correction by Wu Hong of Linchuan." (Su Shi [1036–1101] was a Song dynasty poet, calligrapher and painter known especially for adopting a calligraphic method in painting ink bamboo.)

Artist's seals: square relief legend, *Yuandu* (遠度), and square intaglio legend, *Wu Hong zhiyin* (吳宏之印).

Colophon by Wu Hufan: "Wu Yuandu is one of the Eight Masters of Jinling. His landscape painting is proficient in the [style of the]

Northern School and has the strength of character of Li Xigu (Li Tang, ca. 1070s–ca. 1050s) but without the Jinling habit [of painting pleasant paintings for sale]. He is especially proficient in painting bamboo, following the method of Wen [Tong, 1079–1079] and Su [Shi]. This fan painting uses the cursive calligraphy style to paint bamboo, which is rarely seen after Zhao Wenmin (Zhao Mengfu, 1254–after 1300). It can be rated as a great piece by Yuandu. Hufan."

Collectors' seals: square intaglio legend, *Pan Jingshu zhencangyin* (潘靜淑珍藏印), and square relief legend, *Wu Hufan zhencangyin* (吳湖帆珍藏印).

Notes:
1. Zhou Lianggong, *Du hua lu*, juan 3, p. 45.
2. Zhou Lianggong, *Du hua lu*, juan 3, p. 42.
3. Song Wan's comment in his *Anya tang Ji* is quoted by Feng Jinbo (18th c.), ed., *Guochao huashi*, in Lu Fusheng, ed., *Zhongguo Shuhua quanshu*, juan 10 (Shanghai: Shanghai Shuhua Chubanshe, 1996), p. 590.

7. Gao Cen (active 1643–after 1687)
Gazing Out from a Mountain Pavilion
Collection of the Nanjing Museum, 7:6242

Inscription: "In the sixth month, the summer of the *guimao* year [1663], painted for the Poetry Master Zi for correction, by Gao Cen of Shicheng [Nanjing].

Artist's seal: square relief legend, *Gao Cen* (高岑).

Collector's seal: square relief legend, *Baitao* (白匋).

Colophon by Wu Baitao (1902–1992) on the reverse side of the fan (not illustrated): "The inscription on this painting was damaged by water and remounted by an inexperienced person. Thus, it lost its original spirit. At first glance, everyone would suspect its authenticity. In the winter of *xinchou* [1961], Mr. Han Shenxian and Zhang Congyu used magnifying glasses to examine it very carefully, and they determined it to be an original painting by Weisheng. Noted by Baitao." Following the colophon is a relief-legend rectangular seal impression, *Fenghe* (鳳褐). (Wu Baotai was, a native of Yangzhou in Jiangsu Province was a graduate of the University of Jinling in the 1930s. He was proficient in literature, history and traditional opera. Wu served in a few government cultural posts and was also a professor at Nanjing University. He taught literature, ancient language and the appreciation of Chinese painting. Known as the Gentleman of Wu (Wu Lang), Wu composed several operas, including *Turning a Millstone Together* [*Shuangtuimo*], *The Dream of the Red Chamber* [*Hong Lou Meng*] and *Lead by a Hundred-Year-Old* [*Baisui Guashuai*]. Han Shenxian was the director of the Tianjin Art Museum, and Zhang Congyu was a renowned connoisseur of Chinese painting. Both of them were members of the first national group of Chinese painting specialists in the 1950s.)

8. Chen Zhuo (1634–after 1709)
Carrying a Qin to Visit a Friend
Collection of the Nanjing Museum, 7:75

Chen Zhuo, style name Zhongli 中立, also used the name Chunchi Laoren 純痴老人. He was a native of Beijing.

Inscription: "In the spring of the *jiaxu* year [1694] painted for Mr. Xuweng, by Chen Zhuo."

Artist's seals: square intaglio legend, *Chen Zhuo* (陳卓), and square relief legend, *Zhongli* (中立).

Collector's seal: rectangular relief legend, *Shigutang shuhuayin* (式古堂書畫印).

Notes:
1. See Stephen Addiss et al., *Resonance of the Qin in East Asian Art* (New York: China Institute Gallery, 1999).
2. The story is told in the "Tangwen" chapter of the Chinese classic *Liezi*. See Kenneth J. DeWoskin, "The Chinese *Qin*," in Addiss, *Resonance*, p. 24.
3. Yu Jianhua, *Zhongguo meishujia*, p.1002.
4. In the "Wu Ziyuan" section of Zhou Lianggong, *Du hua lu*, juan 4, pp. 56-57.

9. Cai Ze (active 1662–1722)
Tea Tasting under the Shade of Pines
Collection of the Nanjing Museum, painting 10327

Cai Ze, style name Cangsen (蒼森) was also known as Lincang (霖滄 or 霖蒼) and Xueyan (雪岩). He was a native of lishui County in Jiangsu Province.

The Nanjing Museum has another painting by Cai Ze, *Old Pine Trees near the Autumn Stream*. An inscription on the painting states that it was made in the *gengchen* year [1700] in the studio of Blue Wave Mountain Hall (Bilang Shantang) by Xueyan Cai Ze and is signed with the square relief-legend seal *Ze* and the square intaglio-legend seal *Lincang*. Another example of his work, *Paulownia Tree*, in the Chinese History Museum in Beijing, is likewise signed "painted by Xueyan" and accompanied by the seals *Ze* and *Lincang*.

Inscription: "Picture of Tasting Tea under the Shady Pine Trees. In the "Month of Apricots" [the third lunar month] of the *xinsi* year [1701], painted for the pure appreciation of Mr. Xueyuan by Cai Ze."
Artist's seal: square relief legend, *Ze* (澤).

Notes:
1. Wen Zhenheng, *Changwu zhi* (reprint, Jiangsu kexuejishu Chubanshe, 1984), p. 31.
2. Gu Qiyuan, *Kezuo zhuiyu*, juan 3. (reprint, Beijing: Zhonghua shuju, 1997) p. 87.

10. Wei Zhihuang (1568–after 1645)
Water Pavilion
Collection of the Nanjing Museum, 7:6252

Zhou Lianggong wrote: "Moling [another ancient name for Nanjing] painting, at first only the ones by Wei Kaoshu and his brothers were known" (Zhou Lianggong, *Du hua lu*, juan 1, P. 9.). Later scholars also considered the Wei brothers to be pioneers of the Jinling school (see Lin Shuzhong, "Jinling huapai yu Jinling wenhua," *Dongnan wenhua* [1989, no. 4/5]:144.

Inscription: "In the third month of *guichou* [1613], painted for brother Fanglin by Wei Zhihuang."
Artist's seal: square relief legend, *Wei Zhihuang yin* (魏之璜印).
Collector's seal: square relief legend, *Baitao* (白匋).
Colophon by collector: on the reverse side of the album leaf, "*Guichou* is the forty-first year of Wanli, 1613, recorded by Baitao." Signed with rectangular relief-legend seal, *Fenghe* (鳳褐).

Notes:
1. Yu Jianhua, *Zhongguo Meishujia*, p. 1498.
2. Zhou Lianggong, *Du hua lu*, juan 1. p. 7.

11. Cheng Zhengkui (active 1631–1657)
Landscape
Collection of the Nanjing Museum, 7:84

Cheng Zhengkui (style names Duanbo 端伯, Qingxi Daoren 清溪道人, Qingxi Laoren 清溪老人 and Qingxi Jiushi 清溪舊史) was a native of Xiaogan in Hubei Province. His name, Zhengkui, was written in one set of characters (正葵) when he earned his "presented scholar degree" (*jinshi* earned by successful candidates in the highest imperial examination) in 1631 and changed to another set (正揆) in the early Qing dynasty. Cheng served in the government until his resignation in 1657, but he remained in Nanjing until he returned to his hometown in 1673 (see Lin Shuzhong, "Gongxian Nianpu," *Dongnan wenhua* (1990), no. 5: 62). A scholar-official artist, Cheng followed Li Yong (Beihai) in his calligraphy, but was not limited by Li's preferred style.

11a. Single leaf; ink and light blue pigment.
Artist's seal: square relief legend, *Duanbo* (端伯).
Collector's seal on the facing leaf: square relief legend, *Gongzixing yinfu gongxinshang* (宮子行寅父共欣賞).

11b. Single leaf; light ink, blue and brown pigment.
Artist's seal: square relief legend, *Qingxi* (青谿).

11c. Double leaf; ink and light color.
Artist's seal: square relief legend, *Duanbo* (端伯).
Collector's seal: square relief legend, *Gongzixing yinfu gongxinshang* (宮子行寅父共欣賞).

11d. Double leaf; ink and light color.
Artist's seal: square relief legend, *Kui* (揆).
Collector's seal: square relief legend, *Gongzixing yinfu gongxinshang* (宮子行寅父共欣賞).

11e. Double leaf; ink and light blue and brown pigment.
Artist's seal: square relief legend, *Duanbo* (端伯).
Collector's seal: square relief legend, *Gongzixing yinfu gongxinshang* (宮子行寅父共欣賞).

11f. Single leaf, with inscription by Cheng Zhengkui:
Signed: "Qingxi."
Artist's seal: square intaglio legend, *Chen Zhengkui* (臣正揆).
Collectors' seals, on the inscription leaf: square intaglio legend, *Shou wu guo yan* (守吾過眼), and rectangular intaglio legend, *Kangfu* (康甫). On the facing leaf: rectangular relief legend, *Taizhou gongshi zhencang* (泰州宮氏珍藏), and square relief legend, *Ke wei zhizhe dao* (可為知者道).

Notes:
1. Zhou Lianggong, *Du hua lu*, juan 2, pp. 22-23.
2. Lu Guimeng was a Tang dynasty literatus (died probably 881).

12. Fan Qi (1616–after 1697)
Wandering Through Mountains in Springtime
Collection of the Nanjing Museum, 7:74

Inscription: "On a spring day in the *jiaxu* year of [1694] painted for Mr. Xuweng for correction, by 79 year-old man Fan Qi."
Artist's seals: square intaglio legend, *Fan Qi* (樊圻), and square relief legend, *Huigong* (會公).
Collector's seal: *Shigutang shuhuayin* (式古堂書畫印).

Notes:
1. Zhou Lianggong, "Ti Hu Yuanrun Huace," in *Laigutang shuhuaba*, in Lu Fusheng, *Zhongguo Shuhua quanshu*, juan 7, p. 941. (Shanghai: Shanghai Shuhua Chubanshe, 1994).
2. Lin Shuzhong, "Jinling huapai yu Jinling wenhua," *Dongnan wenhua* (1989), no. 4/5: 146.
3. Zhou Lianggong, *Du hua lu*, juan 4, p. 44.

13. Gao Cen (active 1643–after 1687)
Gold Mountain Temple
Collection of the Nanjing Museum, 7:5911

Called Gold Mountain since the Tang dynasty (618–917), the site is also known as Mount Difu (Difushan), Gold Turtle Hill (Jin'aoling) and Floating Jade Mountain (Fuyushan). The mountain rises to a height of about 60 meters. It was once an island in the middle of the Yangzi, and the Kangxi emperor bestowed on the temple there the title of The Temple connecting River and Sky (*Jiangtianchansi*). But because of the changing course of the river, the island came to be connected with the mainland in the Daoguang reign (1821–1850). The Song dynasty emperor Zhenzong, in the Tianxi reign period (1016–1021), had a dream about this temple and bestowed on it the name "Visited by a Dragon" (Longyousi).

Inscription: "Written by Gao Cen of Shicheng [Nanjing]."
Artist's seal: square intaglio legend, *Gao Cen zhiyin* (高岑之印), and square relief legend, *Weisheng* (蔚生).

14. Wu Hong (ca. 1610–ca. 1690)
Zhexi Thatched Hut
Collection of the Nanjing Museum, 7:5496

Inscription: "Picture of Zhexi Studio. In autumn, the ninth month of the *renzi* year [1672], following Li Xianxi's [Li Cheng] style, painted for Mr. Shiweng for his correction, by Wu Hong of Jinxi."
Artist's seals: square intaglio legend, *Wu Hong siyin* (吳宏私印), and square relief legend, *Yuandu* (遠度).
Colophons: ten inscriptions on the surrounding mounting area. For the Chinese text of each see p. 152 to p. 153.

Notes:
1. See 'Historical Figures,' in *Zhongguo renmingdacidian* (Shanghai: Shanghai cishu Chubanshe, 1990), p. 136.
2. Xu Zi, *Xiao tian jizhuan* (woodblock printed, Jinling: n.p., Guangxu 13 [1887]), juan 14.

15. Hu Zongxin (active 1620–1664)
Solitary Hut among Autumnal Trees
Collection of the Nanjing Museum, 7:31

Hu Zongxin, style name Kefu 可復, was a native of Shangyuan (present-day Nanjing) and a painter of landscapes. He belonged to a family of artists; both his older brother, Zongren 宗仁 (see cat. no. 17), and younger brother, Zongzhi 宗智 (usually known as Xuecun 雪村), were described as proficient in landscape painting. The sons of Zongzhi — Hu Yukun 胡玉昆 (ca. 1607–1687) and Hu Shikun 胡士昆 (act. 1649–1676) — were also proficient in painting; the latter was especially good at orchids. In the third year of Kangxi (1664), Shikun painted a handscroll of ink orchids for the great patron and biographer Zhou Lianggong (1612–1672).

Title strip: "*Study Hut among the Autumn Trees* by Hu Kefu. Inscribed by Yunhu (Gu Yun, 1835–1896)." (Yunhu is Gu Yun, painter and native of Wu county in Jiangsu Province. See Yu Jianhua, *Zhongguo meishujia*, p. 1547.)
Inscription: "On the twenty-fourth day of the second month, in the spring of the *jiachen* year of [1664], [I] painted *Study Hut among the Autumn Trees* for Mr. Changqian, by Hu Zongxin." (Changqian is Fan Yunlin (1558–1641), a native of Wu county, Jiangsu Province, and a *jinshi* of the Wanli period. He was good at landscape painting and at one time was just as famous as Dong Qichang. See Yu Jianhua, *Zhongguo meishujia*, p. 637.)
Artist's seals: square intaglio legends, *Zongxin* (宗信) and *Kefushi* (可復氏).
Collector's seals: square relief legends, *Fengyu lou* (風雨樓), and *Zuoxi zhenmi* (怍昔珍秘).

Notes:
1. Zhou Lianggong, *Du hua lu*, juan 2, p. 20.
2. Ibid.

16. Fan Qi (1616–after 1697) and
Wu Hong (ca. 1610–ca. 1690)
Portrait of Kou Mei
Collection of the Nanjing Museum, 7:3530

It is known from the colophons and literary records that she was a famed Jinling beauty and one of the renowned Eight Beauties of Qinhuai (Ma Xianglan, Dong Xiaowan, Li Xiangjun, Liu Rushi, Bian Yujing, Gu Mei, Chen Yuanyuan and Kou Mei). A colophon on the left side of the painting notes that "There were several beautiful sisters from the Kou family, and Baimen was one of them. These notes were written by Yu Danxin at the Water Tower on the bank of the Qinhuai River."

Inscription: "Portrait of *jiaoshu* Kou Baimen Mei [this character impressed with an intaglio-legend seal, *mei* (湄)], by [Fan] Qi of Mount Zhong and [Wu] Hong of Jinxi. At the end of autumn in the *xinmao* year [1651], in the residence The Hall of Boundless Blue Sky of the Zhu Garden in Longtan, Shicheng [Nanjing]" (*jiaoshu* is an elegant term for a courtesan).
Artists' seals: square intaglio legend, *Fan Qi zhiyin* (樊圻之印); square relief legend, *Huigong* (會公) and *Wu Hong* (吳宏); and square intaglio legend, *Yuandu* (遠度).
Collectors' seals: rectangular relief legend, *Mingshang jushi jianshang* (明尚居士鑒賞), and *Liangxi qinqing cengcang* (梁溪秦清曾藏); square relief legend, *Yimeilu Qintongli cangshuhuayin* (頤梅盧秦

通里藏書畫印); rectangular relief legend, *Qu Boqian shending shuhuayin* (瞿伯謙審定書畫印); and square relief legend, *Cheng-nan xinshang* (城南心賞).

Colophons: Fifteen colophons fill the mounting area which surrounds the painting. For the Chinese text, see p. 155 to p. 156.

Note:

1. Yu Yunyao, *Qinhuai gujin daguan* (Nanjing: Jiangsu kexuejishu Chubanshe, 1990), pp. 157–8.

17. Hu Zongren (active ca. 1598–1618)
Landscape
Collection of the Nanjing Museum, 7:30

Hu Zongren, also named Pengju 彭舉 and Changbai 長白, was a native of Shangyuan.

Inscription: "In mid-summer of the *wuwu* year [1618] of the Wanli reign era, Zhang Longfu returns to his hometown of Wuyi, [we] painted this together with two poems as a gift for him."

Artist's seals: square intaglio legend, *Pengju* (彭舉), and square relief legend, *Hu Zongren yin* (胡宗仁印).

Collectors' seals: square intaglio legend, *Lanshu* (賴叔); square relief legend, *Fengyu lou* (風雨樓); and square intaglio legend, *Xishan Huashi zhenshang* (錫山華氏珍賞).

Colophons: The colophons are mounted directly above the painted image, as if a part of the original composition. There are over ten poems by various artists and friends including Wu Bin (active 1568–1626) and Wei Zhihuang (1568–after 1645). These poems reveal the ideal personality traits respected by the literati as well as their social customs. The Chinese text of each colophon is transcribed on p. 157.

Notes:

1. Yu Jianhua, *Zhongguo meishujia*, p. 621.
2. Gu Qiyuan, *Kezuo zhuiyu*, juan 10, p. 314.
3. *Zhanggu dacidian*, p. 14. In explanation of the expression "breaking off a willow branch at Baling" (*baling zheliu*), Cheng Dachang of the Song dynasty, in his *Yan fan lu*, quotes the *Sanfu huangtu*: "Ba Bridge willow, refers to the bridge over the Ba River; since the Han dynasty, people would see their guests off here and break a willow branch to say goodbye. Thus, Li Bo wrote in a poem: 'Every year the view of willow, reminds [me of] the sadness of parting at Baling.'"
4. Lu Wujin, *Anecdotes*, pp. 30–32.

AN EXPRESSIVE ART

18. Gong Xian (1618–1689)
A Thousand Cliffs and Myriad Valleys
Collection of the Nanjing Museum, 7:4356

A colophon written by the Gong Xian himself on the *Cloudy Summit* handscroll in the collection of the Nelson-Atkins Museum which is dated to 1674, names all the masters that he has followed or benefited from. The colophon is translated in the entry for the painting in the exhibition catalog *Eight Dynasties of Chinese Painting: the collections of the Nelson Gallery-Atkins Museum, Kansas City, and the Cleveland Museum of Art* (Cleveland, Ohio: Cleveland Museum of Art, 1980), p. 282.

Inscription: "In the *jiaping* month [12th lunar month] of the *guichou* year [1673], written by Banmu Gong Xian."

Artist's seal: square relief legend, *Gong Xian* (龔賢)

Collectors' seals: square intaglio legends, *Xifan shending* (錫蕃審定), *Shiwuzhai jiancangyin* (是吾齋鑒藏印), *Yuhangong duhuaji* (于邗公讀畫記), *Chen Jinyuan yin* (臣近源印) and *Youqing kaocang shuhua* (幼卿考藏書畫); square relief legends, *Quantang Yao Yuyu jiancang shuhua* (泉唐姚玉漁藏書畫) and *Yushi zizisunsun yongbaozhi* (于氏子子孫孫永寶之); rectangular relief legend, *Suzhuang zhuren jianding* (蘇莊主人鑒定); and a square intaglio legend, *Weng Zhilian yin* (翁之廉印), in the blank area.

Notes:

1. *Gong Banqian shanshuiketushuo* (Chengdu: Sichuan Provincial Museum), in Xiao Ping and Liu Yujia, *Gong Xian* (Changchun: Jilin Meishu Chubanshe, 1996), p. 240.
2. Wang Yuanqi's statement, from his *Lutai tihuagao,* is quoted in Zhou Jiyin, *Zhongguo hualun jiyao* (1985; reprint, Nanjing: Jiangsu Meishu Chubanshe, 1997), p. 117.
3. Gong Xian's poetry of this period is preserved in the collections *Jinling shizhen* and *Mingmo sibaijia yiminshi*, as well as in Xiao Ping and Liu Yujia, *Gong Xian*.
4. Xiao Ping and Liu Yujia, *Gong Xian*, p. 20.

19. Gong Xian (1618–1689)
Summer Mountains After the Rain
Collection of the Nanjing Museum, 7:72x

Inscription: Wuling Gongxian (Wuling is in Hunan Province. Its use here does not refer to Gong's origin, but implies his proud noble background and desire for an ideal land. See Lu Li, "Gong Xian yanjiu buyi," *Dongnan wenhua* [1988, no. 5]: 139.)

Artist's seal: square intaglio legend, *Gong Xian* (龔賢)

Collector's seals: square intaglio legends, *Xiangqia zhiyin* (香洽之印), and *Jufeng jianshang* (巨峰鑒賞).

Notes:

1. From an inscription on Gong Xian's painting; see Fang Wen, *Tushan ji,* (Shanghai: Shanghai guji Chubanshe, 1979), p. 24 .
2. For more on this subject see James Cahill, "The Early Styles of Kung Hsien," *Oriental Art*, n.s. 16, no. 1 (1970): 51–71.
3. *Gong Banqian shanshuiketugao* (Beijing: Beijing shangwu yin-shuguan, 1935) in Xiao Ping and Liu Yujia *Gong Xian*, p. 74.
4. Xiao Ping and Liu Yujia, *Gong Xian*, p. 54.
5. In one of Gong's colophons, he relates how, in order to view those paintings, he had to become nice to rich merchants and how he

copied his favorite paintings over a hundred times. Xiao Ping and Liu Yujia, *Gong Xian*, p. 250.

6. Xiao Ping and Liu Yujia, *Gong Xian*, pp. 56–57.

7. See James Cahill, *The Compelling Image: Nature and Style in Seventeenth-Century Painting* (Cambridge, Mass.: Harvard University Press, 1982), p. 74.

20. Fan Qi (1616–after 1697)
Snow Scene
Collection of the Nanjing Museum, 7:83

Zhong Xing prefaced his statement about snow scenes with, "No one has observed snow as comprehensively as I, Zhong Xing, at Jinling in the months from late *gengzi* [1600] through early *xinchou* [1601]. I remember watching the snow at Treetop Pavilion, under the pagoda of the Temple of the Rooster's Crow, at Black Dragon Lake, the Imperial Mausoleum (Ming Xiaoling) and aboard a boat on the Qinhuai River." Snow scenes in Nanjing became one of the famous Forty-eight Views of Jinling, under such titles as "Snow Ends at Shicheng," and appeared among the works of many painters (see Appendix II).

Inscription: In the chrysanthemum month [the ninth lunar month] of the *bingwu* year [1666], painted by Fan Qi of Zhongling [Nanjing]. Artist's seals: *Fan Qi zhiyin* (樊圻之印) and *Huigong* (會公).

Notes:
1. From a statement about painting snow scenes written by Tang Dai (1673–1752) of the early Qing dynasty in his *Huishi fawei*; see Huang Binghong and Deng Shi, juan 1, p. 261.
2. From Zhong Xing , "Poems on Viewing Snow," *Yinxiu xuan Ji*, in Wu Chengxue, *Wanming xiaopin yanjiu* (Nanjing: Jiangsu guji Chubanshe, 1999), p. 173.

21. Wu Dan (active ca. 1667–1684)
Misty Mountains
Collection of the Nanjing Museum, painting 5399

Inscription: On the eve of the New Year of the *dingsi* year [1677], written for the respected Mr. Qilao for his correction, by Wu Dan of Baimen [Nanjing]. Artist's seals: square combination relief and intaglio legend, *Wu Dan zhiyin* (武丹之印), and a square relief legend, *Zhongbai* (衷白).

Note:
1. Seven dated paintings by Wu Dan, ranging from 1667 to 1681, are listed in Osvald Siren, *Chinese Painting: Leading Masters and Principles*, part 2 (New York: Ronald Press,1958), vol. 8, p. 450. The Nanjing hanging scroll is not among them. Additionally, a painting of *Plum Studio*, dated to 1684, is mentioned in Yu Jianhua, *Zhongguo meishujia*, p. 536.

22. Gong Xian (1618–1689)
A Fisherman's Cottage in the Autumn River
Collection of the Nanjing Museum, painting 5667

Inscription: "Self inscribed by Penhaoren." (Gong Xian used the term *Penhaoren* ("man of unworthiness") to refer to himself and perhaps to imply that being under the rule of the Manchu is like being homeless in the field. The term comes from the poem by Tang dynasty poet Li Bo: "Raising my head and bursting out laughing, I'm leaving; I don't want to be thought of as a man of unworthiness." Lu Li, "Gong Xian yanjiu buyi," *Dongnan wenhua* [1988, no. 5]: 134–144.)

Artist's seal: square intaglio legend, *Chen Xian siyin* (臣賢私印). (Gong Xian never served in any government position, but still he referred to himself as *chen* (official). This may be one way to express not his service to the Qing, but rather his loyalty to the lost Ming dynasty. Zhang Baochai, "Gong Xian 'Qiujiangyushe tuzhou' shixi," *Dongnan wenhua* [1988, no. 5]: 150.)

Collector's seal: square intaglio legend, *[?] Xi Wang You hao Zhongqing shangjian zhizhang* ([?]西王柚號仲清賞鑒之章).

Colophon (in the mounting area) by collector Di Pingzi (1872–1940): "The brushwork of *A Fisherman's Cottage in the Autumn River* has antiquity and vigor with the concept of the Yuan [dynasty] masters. Old man Banmu once lived in Jinling. His residence was called Sweeping Leaves Pavilion (*Saoye Lou*) which can still be found in its original location. The painting depicts a fishing hut along the shore, much like the scene of Moling [Nanjing]. It may have been done at his residence. Yuyang Shanren [Wang Shizhen, 1634–1711) composed this poem: 'On the riverbanks mark the homes of all the fishermen, next to which are a few water chestnut ponds and weeping willows. Let us wait until the sun has set and the wind let up, before tasting the perch by the river, in which reflections of the maples take up half of the water.' This poem sounds as if it were composed for this painting. It is ironic that lately people favor the old man's [Gong Xian] painting more because the Japanese hold high esteem for him and thus the price of his paintings has also risen. Inscribed by Pingzi." Signed with relief-legend square seal *Pingdengge zhuren* (平等閣主人).

Note:
1. This is an allusion to the poet Qu Yuan (343–277 B.C.) and is associated to his poem "Fishman's Song": "Smiling in gaiety, the fisherman oared his boat and took off, while singing: 'How clear is the water of Canglang, with which I can wash these feet of mine!' At the completion of the song, the fisherman left without speaking another word to him." See Chen Zizhan, ed., *Chu ci zhijie* (Nanjing: Jiangsu guji Chubanshe, 1988), p. 295. For a translation of the entire poem, see David Hawkes, *Ch'u Tz'u: the Songs of the South* (1959; Boston: Beacon Press, 1962), pp. 90–91.

23. Zou Zhe (ca. 1610–after 1683)
Cloudy Mountains and a Village by the Water
Collection of the Nanjing Museum, painting 10301

Inscription: "In the ninth month of the *xinchou* year [1661] written by Zou Zhe."
Artist's seals: square intaglio legend, *Zou Zhe yin* (鄒詰印), and square relief legend, *Fanglu* (方魯).

24. Gong Xian (1618–1689)
Yueyang Tower
Collection of the Nanjing Museum, 7:5387

The painting was acquired by the famous painter Liu Haisu (1895–1990) during the 1930s and was shown to other renowned painters and connoisseurs of the day, such as Wu Hufan, Zhang Daqian (1899–1983) and Zhu Qizhan (1891–1996). All of them had high praise for the painting. Liu later donated the painting to the Nanjing Museum in the fifties.

Inscription: Banmu Gong Xian.
Artist's seal: square intaglio legend, *Gong Xian zhiyin* (龔賢之印).
Collector's seals: *Haisu huanxi* (海粟歡喜), *Yihai shang* (藝海賞), *Hai weng* (海翁), *Liushi jiacang* (劉氏家藏).

Notes:
1. The other famous pavilions are the Yellow Crane Pavilion (*Huanghelou*) in Wuhan, Hubei Province; the King Teng's Pavilion (*Tengwangge*) in Nanchang, Jiangxi Province; and the Penglai Pavilion (*Penglaige*) facing the sea in Penglai, Shandong Province.
2. Famous Tang poets like Li Bo, Du Fu, Han Yu and Bo Juyi wrote poems to celebrate the Yueyang Tower. Du Fu said: "Long ago I heard about the waters of Dongting, and today I've ascended Yueyang Tower. Here is what divided the Wu and Chu to the east and south, as day and night the world floats in these changing waters. From my loved ones I've received not a word. Old and ill, I have but my solitary boat. The war-horse will take me to the north of the passes; I lean on the railing, and tears flow" (Yu Shouzhen, ed., *Tangshi sanbaishou*, p. 182). In the fifth year of Qingli (1045) of the Song dynasty, the county governor Teng Zongliang renovated the tower and had the famous scholar Fan Zhongyan write an essay, "The record of Yueyang Tower," for the occasion. A line from this essay, "Be the first to worry about the world, and the last to enjoy life," became a motto for later generations, which added to the fame of Yueyang Tower.

25. Chen Zhuo (1634–after 1709)
White Clouds and Green Mountains
Collection of the Nanjing Museum, painting 48

Research has not yielded many extant paintings by Chen Zhuo. In addition to the present works (see cat. no. 8), there are at least six additional in mainland Chinese museum collections: Pavilion in the Cloudy Mountain (*Yunshan louge tu*) in the Guangdong Provincial Museum; Pavilion in the Immortal Mountain (*Xianshan louge tu*) in the Shoudu Museum; Landscape (*Dingwei shanshui tu*) painted in the *dingwei* year [1667]) in the Tianjin Art Museum; Landscape Fan Painting (*Shanshui shanmian*) in the Nanjing Museum; Water Village (*Shuicun tu*) in the Nanjing Museum; and Green Mountain, Cloudy Mountain (*Yunshan qingzhang tu*) in the Anhui Provincial Museum. (See Chen Chuanxi, "Guanyu Jinling bajia de duozhong jizai he Chen Zhuo," *Dongnan wenhua* [1989, no. 4/5]: 152.)

Inscription: In the eighth month of the year *guiwei* [1703], autumn, by Chen Zhuo.
Artist's seals: circular relief legend, *Chen Zhuo* (陳卓) and square intaglio legend, *Zhongli* (中立).
Collector's seals: two small circular legends, [?] *Qing* ([?]清) and *Qizhang* (其璋); and square relief legend, *Ziming* (子明).

26. Gong Xian (1618–1689)
Mountain Pavilion by a Stand of Trees
Collection of the Nanjing Museum, 7:6258

Inscription: "Painted for respected brother Feiru, by Banmu Xian."
Artist's seal: square relief and intaglio legend, *Chaizhang* (柴丈).
Collector's seal: square relief legend, *Baitao* (白匋).

Note:
1. *Gong Banqian shanshui ketugao* (Chengdu: Sichuan Renmin Chubanshe, 1935).
2. Zhou Lianggong, *Du hua lu*, juan 2, p.30.
3. Ibid.

27. Gao Cen (active 1643–after 1687)
Autumn Mountains amid A Myriad Trees
Collection of the Nanjing Museum, 7:78

Inscription: In imitation of Fan Zhongli (Fan Kuan), *Autumn Mountains amid a Myriad Trees*, by Gao Cen of Shicheng [Nanjing].
Artist's seals: square intaglio legends, *Gao Cen zhiyin* (高岑之印) and *Weisheng* (蔚生).

Notes:
1. Fan Kuan's famous masterpiece, *Travelers Amid Streams and Mountains* (*Xishan xinglu tuzhou*), is in the National Palace Museum, Taipei. See Wen C. Fong and James C.Y. Watt, *Possessing the Past* (New York: Metropolitan Museum of Art; Taipei: National Palace Museum, 1996), pl. 59.
2. During this period, the literati depicted in paintings were often dressed in red robes. This may be associated with the custom of the students preparing for imperial examinations to dress in red. See Qian Hang and Cheng Zai, *Shiqi shiji Jiangnan shehui shenghuo* (Taipei: Taibei nantian shuju, 1998), p. 274.

28. Kuncan (1612–after 1686)
Green Mountains Reach to the Sky
Collection of the Nanjing Museum, 7:65

Kuncan, a Buddhist monk, was originally surnamed Liu, and his style name Shixi (石谿). He was also known by the names Jiexiu (介休), Baitu (白禿), Yerang (曳壤), Candaoren (殘道人), Dianzhu Daoren (電住道人) and, in his later years, Shidaoren (石道人).

Inscription: "The time is late autumn in the *gengzi* year [1660]. Noted by Shixi, Decrepit Monk."
Artist's seals: square intaglio legends, *Shixi* (石谿) and *Dianzhu Daoren* (電住道人).

Notes:
1. Victoria Contag, *Chinese Masters of the 17th Century*, trans. Michael Bullock (Rutland, Vt. and Tokyo: Tuttle, 1969), pp. 25–26.
2. Zhang Zining, "Gong Xian he Kuncan," *Dongnan wenhua* (1990, no. 5): 35–39.
3. Ma Hongzeng, "Gong Xian de yipin lun yu 'Jinling sanyi,'" *Dongnan wenhua* (1990, no. 5): 18–24.
4. Yang Xin, "Kuncan," in Liang Baiquan, *Nanjing bowuyuan cangbao lu* (Shanghai: Shanghai wenyi Chubanshe he sanlian Shudian, 1992), pp. 200–20. For additional clues to Kuncan's character and the solace that he found in nature, see the translated colophons in Contag, *Chinese Masters*, pp. 26–30.

好山青

南京博物院藏十七世紀山水畫

海蔚藍

並附李鑄晉教授論文

標題：龔賢書法集字

插圖：郭存仁，金陵八景，鍾山祥雲，局部

唯有家山不厭看：十七世紀的南京與金陵畫學

海蔚藍

南京，古稱金陵（意為：金色的山），今江蘇省省會，是中國最著名的四大古都之一（餘為西安，洛陽，北京），這個繼西安之後，歷史最悠久的中國古都，自公元前472年始至1949年，在漫長的兩千多年中，以其非同尋常的山川地理優勢，曾為十代政權選作都城。在此期間的歷史和文化的勃發和演變，積澱和延續，使這鍾靈秀毓之地，釀就了深厚的文化底蘊，尤其值得注意的是，在中國和世界文化史上獨樹一幟的中國文人文化，正是在江南清遠秀麗的山水和人文環境中，得以孕育，誕生和發展的，在南京則先後有引人注目的六朝，南唐和明清之際的三次文化高潮，從而構成了十七世紀南京的特殊歷史和文化背景。

六朝，自公元三世紀至六世紀，以南京（當時先後稱為建鄴，建康）為都，在這裡開創了中國文化史上最偉大的時代之一。曹魏時代的曹丕（187-226），首先用了"文人"這一詞來形容讀書能文的人。這一批人在文學藝術上的創造，其儀止風範和人格氣質形成了中國社會中很特別的一族。六朝時，名士們口談以老莊之説發展而來的玄學，以出身門第，容貌儀止，虛遠清談的魏晉風度相標榜，形成一代風氣。文學上以謝靈運，謝朓為首的詩人在此期間開創了山水文學，以雅麗工巧的文字，描繪自然山水之風貌，意境一新，開創了純文學的美學意境，使山水文學成為中國文學的主題之一，並且對山水畫在此期間的成長和日後成為中國畫的重要畫科，都有契合。在這裡還產生了劉勰的【文心雕龍】，是中國文學史上最早的一部最有系統的文學批評著作，蕭統的【昭明文選】，則是中國文學史上的第一部文學作品選本，而劉義慶的【世説新語】不僅以簡潔雋逸的詞句記錄了時人清談的風貌，並且開創了後世小品文的先河。

美術史上，這是一個空前絕後的時代。產生了鍾繇等書法家，尤其是被譽為千古書聖的王羲之以翩若驚鴻，矯若遊龍，縱橫流離，行雲流水般的行書，風靡了一代，也風靡了百代，創造了書法藝術遒勁

飄逸的獨特美學感受，故六朝以"晉字"的美譽與唐詩，宋詞，元曲獲得同等的歷史地位。繪畫上，題材的擴大，山水畫科的初建，花鳥畫科的萌芽，釋道畫的流行，畫史的初創，畫論的問世，不僅有山水畫畫理畫法的闡微發奧[1]，而且這一時期所提出的一些繪畫理論如顧愷之的"遷想妙得"，"傳神寫照，正在阿堵之中"的繪畫傳神論[2]，謝赫提出品評繪畫的"六法"和評定畫家高下的六品[3]，和宗炳提出，藉山水畫來體味聖人之道，從而"暢神澄懷"的理論[4]，都成為傳統中國繪畫理論的經典，並且奠定了今後中國繪畫的各畫科，無論人物畫或山水畫創作的理論基礎。藝術的蓬勃發展和將之上升為理論，使人們對藝術的價值和藝術家有重新的認識，如王微在【敍畫】中開門見山道："以圖畫非止藝行，成當與'易'象同體"。即圖畫不居於技術行列，而應當與聖人所創之道處於同等的地位[5]，初次將藝術家奉為精神文化的創造者，為藝術家從此開始脫離低等伶人的地位邁出了第一步，也為藝術的獨立性和藝術家的個性發展奠定了基礎。當時的南京，確實產生了許多傑出的畫家，謝赫的【古畫品錄】便記載了二十七位，如陸探微，曹不興，顧愷之等，皆為後人奉為百代宗師。

六朝時代在文學藝術上的創造，是六朝人對宇宙和生命的深沈思辨，對人對物唯美的追求，並在那個動亂時代以知識分子所造就的淡遠沖和，逸倫超群的魏晉風度表現出來，這種特殊的文化氣質，奠定了後世傳統中國文學藝術尤其是文人藝術的基調，使之成為世界文化中一個獨一無二的美學範疇。南京正是這文人藝術的源頭之一。

南京在文學藝術上的第二次高峰是在公元十世紀的南唐，當時稱為江寧府。雖然南唐不過短短數十年的歷史，但在文學和繪畫上的突出成就，得以獨領一代風騷。南唐的中主李璟和其兒子李煜都是有名的文學家，尤擅作詞，上有所好，下必有甚，整個南唐在統治者的愛好和倡導下，對文學的狂熱前所未有，就連任用大臣也以文學程度的高下作為標

準。南唐二主的詞曾風靡一時，尤其是後主李煜的詞作，雖僅有三四十首傳世，但其高度的藝術成就，開拓了新的纏綿幽深，淒絕悲壯的美學境界，被尊為一代詞宗。清末的大學者王國維（1877-1927）評價道"詞至李後主而眼界始大，感慨遂深。遂變伶工之詞而為士大夫之詞"[6]。藝術上，南唐時由朝廷設置翰林圖畫院，為繼西蜀之後中國歷史上最早成立的畫院之一[7]。而且李氏王族都喜愛繪畫藝術，對繪事促進非小，遂集一代名家於京都，如周文矩，顧閎中，王齊翰，董源等，產生了許多傑作，如顧閎中的"韓熙載夜宴圖"，周文矩的"重屏會棋圖"。而被蘇東坡稱為"洗出徐熙落墨花"的徐熙水墨淡彩的花卉風格，被後世尊為"徐體"，對水墨花卉的創作影響深遠。山水畫一方面是將人物，界畫樓閣與山水自然景觀的巧妙結合，如衛賢的"高士圖"，趙幹的"江行初雪圖"作品，另一方面有董源水墨淡著色山水的一家之法，成為後世文人山水畫的鼻祖。

南京在文學藝術上的第三次高峰，是在十七世紀的明末清初。當時的南京聚集了文學藝術上的各路人才，是中國歷史上一個突出的雅俗文化相融合的時期，文學上從詩歌，清言小品，到巨著"儒林外史"和"紅樓夢"，戲曲的繁榮則產生了像"桃花扇"之類的傑作，和遍地開花的民間戲曲藝術，而且，由於木版印刷的發達和流行，使得文學藝術作品得以廣泛傳播。繪畫上，畫家雲集的南京，成為明清之際眾多畫派交流溶會之處，為許多畫家流連駐足，產生了為史所稱的"金陵八家"等，遂與其他同時代的畫家一起，共同形成了中國封建時代山水畫的又一個高峰。而在此期間趨於成熟的，於文學藝術乃至生活各方面，以"清雅"作為品評標準的美學觀點，更是畫龍點睛的一筆，將中國的文人文化推向了高潮。

綜觀南京歷史上的這三次文學藝術高峰，不論從文化的表現形式，所追求的美學感受和價值，到文化的氣質風度，都一脈相承，暗承心曲之處，其精神和元氣之所趨，餘波之震蕩，貫穿和影響了整個的中國文化藝術史。文化上每一個令人矚目的現象的出現，除了個人才能的因素外，多為其特定的地理歷史人文的環境所左右，並為其所特有的歷史和文化的遺傳基因所驅使，故表現為歷史的重復也好，螺旋式的上升也好，其中錯綜複雜的因素和媒介，造成的變化和結合，雖難以歸納為一加一等於

二這樣的程式，卻並非羚羊挂角，無跡可求，對其的分析解剖，或可在某種程度上再現一個整體的歷史文化環境，從而有助於瞭解其地其人和其文化藝術之產生的因緣。在我們試圖理解十七世紀金陵畫家的藝術時，且讓我們在瞭解了南京於文化史上的貢獻後，再來回顧一下南京的歷史和十七世紀的南京，解析一下金陵藝術之所以產生的土壤。

一・南京的地理位置與歷史沿革

南京地處北緯三十二度二分，東經一一八度五十三分，位於長江下游的南岸，東距長江入海口約三百公里，西為皖南丘陵區，北有江淮平原，南有太湖流域，境內綿亙著寧鎮山脈的西段，東有鍾山，西有石頭山，長江橫臥於西北，秦淮蜿蜒於東南，佔據了古人所謂"龍盤虎踞"的優越地理位置[8]，是大江南北的要津重鎮，她不僅佔據了交通便利，山川險峻，易守難攻等古代選擇城址的要素，而且，由於地處長江三角州之首，東南有太湖流域的魚米之鄉，西北有江淮平原的農貿基地，使其又具備得天獨厚的處於經濟中樞的地位[9]。加上轄區境內山環水抱，蔥籠毓秀，山水城市融為一體，學者論為"形勢若此，帝王之宅宜哉"[10]，詩人詠歎道："江南佳麗地，金陵帝王州"[11]。甚至近現代的政治家如孫中山先生還在其於1918年寫的【建國方略】中盛讚"南京有高山，有深水，有平原，此三種天工鍾毓一處，在世界之大都市，誠難覓此佳境也"，故擇都於此[12]。

位於如此佳境的南京，其本身的地貌以低山小丘陵與縱橫的江河為特色，屬亞熱帶氣候，四季分明，雨水充沛，適宜農耕[13]，農業的歷史始自新石器時代，以稻麥二熟制為主，並有發達的畜牧業和水產業，而且本地的物產豐饒，有金銀銅鐵各種金屬及石灰石白雲石等非金屬礦產，其後又有絲織業，金箔業等手工業的興旺，其本身不但具備良好的經濟條件，更由於地處南北之間，自然成為南北商業和文化的交融匯合之處。

南京的建城史始於東周元王四年（公元前472年），越王勾踐滅吳後，命越國大夫范蠡築城於秦淮長幹（今雨花臺下），名之為越城。南京作為封建割據王朝的都城始自東吳孫權（黃龍元年，公元229年），其後的一千七百多年中，陸續成為東晉（317-420），劉宋（420-479），南齊（479-502），蕭梁（502-

557），陳（557-589），南唐（923-936）明代（1368-1644，以南京為都1368-1421）等封建王朝的都城，及農民政權太平天國（1853-1864）的首都和民國政府（1921和1927-1949）的首都，故被譽為十代故都。

在這漫長的歲月中，南京有金陵，秣陵，建康，白下等數十個名稱（參見附錄1）而尤以金陵最為古雅。據【景定志】記載：周顯王三十六年（333BC），楚子熊商敗越，盡取吳地，以此地有王氣，因埋金以鎮之，號曰金陵。【建康實錄】道：楚威王（339-329 BC在位）因山立號，置金陵邑[14]。自此，文獻古籍中常用金陵一名，尤以文學藝術作品中更為普遍。南京一名則於洪武元年（1368）朱元璋即位時宣佈將北宋故都開封府為北京，以應天府為南京[15]，擁有江寧，上元，句容，溧水，溧陽之地，東西二百三十五里，南北四百六十里，以上元為首邑[16]。

二 · 明代的南京

1. 名都的再建立

1356年，籍著元末農民起義軍的旗幟，和尚出身的朱元璋攻克了元代的集慶路（今南京），將之命名為應天府，並以此為基地，轉戰十多年，至1367年攻克了大江南北。1368年朱元璋稱帝立國，國號明，年號洪武，以應天府為國都，命名為南京，這個自古便被認為有王氣的地方[17]，第一次作為一個全國性的封建都城出現在南京的建城史上，故明太祖朱元璋精心設計，自1366年動工到1386年完成各主要城門，前後共歷時21年之久，動用了江南的財力和全國範圍內的工匠，建立了一座在中國建城史上史無前例的，城周達33。67公里的巨大磚城。一位研究南京歷史的美國學者莫特不由讚歎道：這是一個最不規則形狀的，但卻是中國歷史上最高，最長，最寬，最堅固，和最令人歎為觀止的城牆[18]，為這樣一個史無前例的巨大城牆所拱衛的城市，也是當時世界上最大的城市[19]。

明代南京城的設計一反漢唐以來城池以方形為主，並將宮城位於都城中部偏北的傳統，而是根據實際的地理形勢和防守的需要，作南北狹長，東西略窄的不規則形狀，並將宮城安排在都城的東部。城市的整體佈局以城中央設鐘鼓二樓以報時辰，城東是

以皇城為代表的政治區，城北是軍事區，城南及西南則沿襲傳統為手工業，商業集中的區域，城南和城中並散佈著功臣，官僚和其他貴族的府第，在城南的夫子廟和城中雞籠山麓則集中著國家的最高學府國子監和祠廟，城西北有龍江船廠及商埠和軍事設防。整個都城的城牆北面沿玄武湖的西岸向北修築，南面則沿著秦淮河向西修築，在周長近34公里的城牆上，築有13座城門[20]，既為交通亦為軍事防守之要道，每座城門的上部都建有高聳的城樓，而以南面的聚寶門（今中華門）最為壯觀，有城牆四道，每兩道間的空間稱作"甕城"，可作為戰時防守之用。為了加固防衛，朱元璋又命沿城北的鍾山，城南的雨花臺，和城北的幕府山等制高點，建造外郭城，"周一百八十里"，主要利用城外的黃土丘陵，在險隘處則用磚砌一部分城牆並開設城門，俗稱"土城頭"，有門十六[21]。

從洪武元年（1368）到永樂十九年（1421），明王朝以南京為都共五十三年。明成祖朱棣在南京奪取帝位後，出於政治和國防上的考慮，至永樂十九年遷都北京，而將南京稱為"留都"，或"南都"，以顯示南京的重要地位。到明英宗正統六年（1441），明中央政府分為南北兩京的制度就被固定下來，一直沿用到1644年明朝滅亡。南京的獨特地位，一方面是因為明太祖的皇陵（孝陵）建在南京，又距龍脈所出的濠州鍾離（今安灰鳳陽）不遠，因此，陪京乃祖宗根本重地，每年都派遣大臣到南京舉行各種祭祀[22]。一般人士前往南京祭祀帝陵也是常事，著名的文人藝術家徐渭便曾前往南京，祭拜明孝陵，作有"拜孝陵詩意圖"，現藏於日本大阪市立美術館[23]。出於尊祖敬宗的緣故，政本故在南是有明一代無論官宦或士人的基本思維定勢。另一方面，"帶北江以敷席，佩蔣皋以垂歷，東連三吳通財賄之利，西引皖楚致材木之用"[24]的南京既是江南地區農業，手工業和商業貿易的中心，也是經濟文化的中心，被譽為"東南大都會"。因此有明一代，在北京和南京建立了兩套大致相同的中央政府機構，雖然南京機構規模小，編制少，虛職多，但兩京制的存在已足以證明南京在明代整個政治格局中佔據著不可或缺的位置。這在中國封建社會歷史上也是絕無僅有的現象。

明朝北京中央政府為李自成的農民起義軍推翻後，安徽鳳陽總督馬士英利用江北四總兵實力，於崇禎十七年（1644年）擁立福王朱由崧於南京，建立南

明政權，年號弘光，事實上成為明王朝的某種延續。雖然南明弘光帝於1645年被清軍在蕪湖俘虜，次年被殺，但南明各路政權的存在至少在相當一部分人的心中（其中還包括了清朝皇帝和將軍們）有著重要的象徵意義。因此，清廷佔領北京以後，一切職官制度全都模仿明制外，亦暫時保留了明朝的兩京制度。清代初年，康熙，乾隆皇帝並親自對以南京為中心的江南地區作了多次巡訪，這些都顯示了南京作為政治象徵的重要地位。

2. 名都之華

明代建都南京之初，政府採取了一系列措施來繁榮城市經濟，首先是有目的地遷徙各類人士以充實京師，並設立"坊廂"制來管理[25]，在明初的洪武，建文和永樂三代，南京城有四十萬人，是當時全國人口最多的一個城市，人口的成分則以從全國各地徵調來的手工業匠戶，"充實京師"的富戶，各級官員，駐守禁衛軍，國子監學生為主。在政府的授意和督導下，這些移民以其財富和技能，智慧和工作，從經濟文化各方面為造就一代繁華之都作出了貢獻。

明代的南京擁有當時世界上最好的觀象臺，由政府的"欽天監"管轄，設在城中部的雞籠山上，終明一代，掌管國家的天文星象事宜。明代南京又是全國製造銅錢和印製紙幣的中心。太祖朱元璋在攻佔金陵後不久，避"元"之名諱，鑄有"大中通寶"，明代正式建國南京後，又鑄"洪武通寶"，其錢背面，都加鑄"京"字，以別於其他各省鑄造的銅錢。洪武七年（1374）又在南京設立"寶鈔提舉司"，大量印製紙幣"大明通行寶鈔"。

明代的南京還設有當時最大的造船廠，著名航海家鄭和從永樂三年（1405）起至宣德十年（1435）先後七次出洋所用的寶船，大部分由設在城北江邊的龍江寶船廠製造。鄭和率領的大規模的航海活動，促使了南亞和西亞的二三十個國家紛紛與明朝建立外交關係，而南京遂成為重要的國際碼頭和對外交流的中心。據記載，僅永樂二十一年（1423）的一年內，各國使臣，教士和商人來南京的就達一千二百多人，他們分別住在位於今通濟門內公園路一帶的會同館（招待使臣一級）和烏蠻驛（招待使臣的隨從人員），外國商人們則住在城外江邊的"龍江驛"（今下關）和"江東驛"（今江東門外）[26]。這些來

往，使天文曆學醫學物理學到圖畫建築等西方文化，都得以介紹到中國。時人顧起元記載利瑪竇到南京時，住在正陽門的西營中，曾展示其攜來的書籍，自鳴鐘和西畫的宗教人像，"臉之凹凸處，正視與生人無異"[27]。這種西洋的透視畫法，亦為當時的畫家所學習[28]。

明代的南京還以他的建築奇跡大報恩寺震驚世界。報恩寺與靈谷寺和天界寺同為明代南京的三大佛寺，位於聚寶門（今中華門）外0.5公里的古長幹里（今長幹橋東南，雨花路東側），即是六朝長幹寺和宋元天禧寺的原址。永樂十年（公元1412年）永樂皇帝為紀念他的生母碩妃而敕建，寺周長達9里13步，幾乎包括今長幹橋東南和雨花臺以東的全部地區。寺內的大雄寶殿，俗稱"碩妃殿"和天王殿以白石做台基，雕刻精緻，壯麗如皇宮，九層八面的寶塔高約80米左右，以白瓷磚和五色琉璃築成，飾有佛像，飛天，各類瑞獸的雕塑和152個風鈴，146盞油燈由100名少年日夜輪流點燃，寺內還栽種著鄭和從國外帶回的各類奇花異草。費時十六年，塔於宣德三年（1428）建成後，永樂皇帝題榜為"天下第一塔"，時人稱為"中國之大古董，永樂之大窯器…永樂時，海外夷蠻重譯至者，百有餘國，見報恩塔必頂禮讚歎而去，謂四大部洲所無也"[29]。遂成為中外人士遊歷的必到之處，當時參觀過此塔的外國商人和傳教士，都認為是中古時期的七大建築奇跡之一，可於意大利羅馬的大劇場，比薩斜塔和埃及亞歷山大陵墓等媲美[30]。寺裡長住和尚有數百名，當時中國佛教的各大宗派都在此設立講座，又在永樂皇帝的欽定下負責雕版印刷大部佛經，號稱"南藏"（南京版"大藏經"），並專門建有藏經殿和廂經廊來保存這批佛經。除了報恩寺之外，有明一代，據不完全統計，南京在萬曆年間有佛寺一百七十餘座，到明末更增至三百多座，成了全國的宗教聖地。

明代的南京還以絲織業和手工業聞名天下。自六朝以來就生產的雲錦和明代孝陵衛一帶生產的衛絨享譽全國。絲織業在南京官營手工業中佔有很大比重，如明代皇室所用的各種絲織品，以及賞賜臣下和向國外贈送的綢緞等，有很大一部分是在南京織造的，其傳統延續至清代，朝廷仍在南京設置江寧織造府以督察生產。當時南京的城市商業中與絲織業有關的就達二十多種之多，如荷包，顏料，染坊，踹布坊，織機零件，包裝紙等行業亦相應地興起，並出現了絲市，網巾市，綾莊巷和顏料坊等專

業商市和坊巷。這些官私營的絲織產業成了繁榮南京城市經濟的一大支柱，也影響了人們的穿著，由於絲織品的眾多和豪華，到十七世紀時，社會上已打破了明初遵循官制服飾和色彩以樸素為主的要求，而以華服為時尚，顧起元道："南都服飾，在慶曆（隆慶萬曆年間為1567-1620）前猶為樸謹，…首服之侈汰，至今日極矣"[31]。

手工業中，南京的"金陵摺扇"天下聞名。當時的製扇工匠多集中在城東南通濟門外和東北郊棲霞石埠橋兩處，扇面和扇骨分別由獨立的行業生產，今通濟門外還遺留有"扇骨營"的舊地名。當時的扇骨主要有竹木兩種，普通的以竹為骨，高檔的有檀香，烏木為骨，製骨以水磨和模雕兩種方法加工[32]，扇面亦主要有兩種，素紙為面者稱為蘇面，和繪圖者。摺扇不僅作為生活用品，而且從一開始便成為深受喜愛的社交禮品。明代初，由內府定制，皇帝將摺扇賜給群臣。正統年間（1436-1449），南京民間已開始仿製，至成化（1465-1487）年間已頗精緻，並有名工[33]。明末以來，摺扇之流行，已是文人學士和貴族官吏之必備之物，傳世的眾多扇面便可為證，社會上各界人士也以有名人所繪扇面為雅事[34]。藝術家的介入創作，使這小小工藝品上升為藝術品，因而流行不衰，延續至二十世紀初葉，成為中國畫中引人注目的一個品種。

絲織業和手工業的發達，促進了南京的商業活動，由於南京"北跨中原，瓜連數省，五方輻輳，萬國灌輸…天下南北商賈聿趾"[35]。當時江南形成了許多著名的商人集團如徽商，洞庭商，浙江商，閩商，粵商等。由於南京離徽州不遠，故徽商在南京經商的很多，經營範圍也很廣，尤以鹽，典當，茶，木為最著，故徽商的資本最為雄厚。當時南京的商業幾乎全為這些外來的商人操縱，時人顧起元道："諸凡出利之孔，拱手以授外土之客居者，如典當鋪在正德前皆本京人開，今與紬緞鋪鹽店皆為外郡外省富民所據矣"[36]。南京商業的繁榮狀況，在由明人所繪的【南都繁會圖】中生動地表現出來[37]，在這手卷中，生動地描繪了南京城內的各行各業達一百多種，人物有一千多個，從城郊的各類家禽牲口行，油坊，染坊到城內的布店，糧食店，百貨雜貨店，銀鋪等。許多店鋪還以擁有名人所書的店名招牌為榮，據記載："牛市口之肥皂香粉店，直匾'古子敬家'四字系劉青田（基）所書，三山街之氈貨店，橫匾'伍少西家'四字系顧胝翁（起元）所

書，行口大街之南貨店有長方匾'楊君達家海味果品'八字系余學士（孟麟）所書"[38]。劉基為明朝開國功勳，文學大家，顧，余二位皆為當時的知名學者，商界的附庸風雅和打名人效益於此可見，徽州商人還以有否古董來區別高下，當時的富商們或以重金購買名畫，或延請畫家到家裡作畫，以家藏名畫為榮而名噪社會的事是屢見不鮮的。社會上和這些商人集團對文化藝術的需求，又成為促進藝術發展和興旺的動力，當時文人以鬻畫為生者已是常事，不但是本地的畫家，外地的畫家亦常進京賣畫。

3. 文化之都

不論是最初作為明朝的首都，或其後作為南都，南京都是當時世界上最引人注目的大都市，從教育，文學，藝術，娛樂，生活等各方面，處處表現出其大都會的無窮魅力。

作為教育的中心，被後人譽為"東南第一學坊"[39]的南京，是江南文人的主要集中地之一，又是江南地區考舉人的場所，和有明一代國立大學——國子監的所在地，其為國家培養著從政的各級官員，由此象徵著一種正統的政治地位和代表國家最高教育的權威，成為明代士人學子景仰的去處，每年有學生萬餘人，是世界上最大的大學[40]。國子監設在城中的雞籠山南，有宿舍一千多間，幾十間講院。除了培養學生，國子監還參與其他的編輯出版項目，例如中國古代最大的一部百科全書【永樂大典】就是明成祖期間，在南京國子監編抄而成的。設在城西南朝天宮的應天府學是地方一級的高等學府，而設在城南夫子廟的貢院則是中央設在南方的考場。因此，地方和全國的才子高士雲集往來，考生號舍最盛時多達兩萬多間，為全國最大者，彙聚著有明一代的智慧和才情於南京。

南京的雕版印刷和出版業在明代也居全國之首。朱元璋定都南京後，曾調集浙江等地的印刷工人來南京刻印【元史】，和【大明律】等書。皇宮內府，國子監，各部院府以及宗親蕃王，也都有自己的印刷廠，出版發行了大量書籍，尤其是南京的國子監，憑藉著皇家圖書館的豐厚藏書和得天獨厚的人才優勢，集中宋元時期江南各地的木刻書版，多次繼續印刷出版，號稱"南監本"，其主要來源是洪武八年（1375）從杭州西湖書院運來的南宋國子監舊版和元

代西湖書院新刻的書版。據不完全統計，明代南京國子監所刻的書累計達271種，有經，史，子，集，類書，韻書，雜書，石刻等九大類，是全國主要的官營印刷中心。

民間的雕版印刷和出版業在官方同業的刺激下也很興盛，而且當時的社會風氣也促進了雕版印刷業。明代的讀書人做官後，通常都要出錢刻一部書來傳名，當時刻工工資低廉，刻一百字只需二十個銅錢，花三十兩銀子就可刻成一部十萬字的書，所以官僚地主在南京刻書的很多[41]。特別從明中葉（公元十六世紀）始，插圖本的戲曲和小説很流行，招致毗鄰的安徽徽州，甚至遠途的福建建陽等傳統雕版中心的熟練技工紛紛前來，除普通木刻書外，並開始使用木活字和銅活字，和流行用紅黑兩色套印，並出現了多色套印的彩色木刻畫，技法以"豆版"和"拱花"為主[42]。至明末，僑居南京的徽州人胡正言，於天啟七年（1627）完成第一部以"豆版"法彩色套印的作品【十竹齋畫譜】，又於崇禎十七年（1644）以"拱花"法繼續刻印了【十竹齋箋譜】，這兩部彩色套印作品在中國印刷技術史上具有劃時代的意義。清初畫家王概，王著等人所作的【芥子園畫譜】，也受到【十竹齋畫譜】的影響。明清以來插圖本的流行，便得益於這些彩色套印技術的進步。金陵插圖版本享譽全國，有明一代，南京遙遙領先地率領著全國的雕版印刷業，被譽為"金陵，圖書之府也"[43]。（插圖1）

插圖1：王概（1645-約1710）"芥子園畫傳"，清代木刻本，南京博物院提供

雕版印刷技術的進步，使文化事業在十七世紀獲得了空前的發展，其重要的標誌之一，便是出現了遠遠超過前代的各種書籍。南京的書坊之多，佔全國之首位，據統計有九十多家，主要分佈在今南京城南三山街和內橋一帶，如萬曆年間由唐家開設的

"金陵唐繡穀世德堂"和"金陵唐對溪富春堂"，由陳家開的"秣陵陳大來繼志齋"（又作金陵陳氏繼志齋），還有徽州文人，戲曲家兼出版家汪廷訥開設的"環翠堂"。南京的書坊以唐姓為最多，有十幾家，並為家族經營，世代相傳。這些書坊集出版社與書店的功能於一體，以贏利為目的，只要有銷路，什麼都可以印。在明末，最熱門的出版物有三種，一種是制藝，是為學子們參加科舉考試提供閱讀參考的八股範文。二是時務書籍，是關於當時社會政治，經濟，文化的熱門話題，頗類似今天的各類雜誌。第三種是文學作品。由於江南社會生活優裕，文化程度普遍較高，加上具有追求閒情愜意的市民文化的深厚傳統，使得文學作品有相當的市場，尤以通俗小説種類豐富，流傳廣泛。同時，江南戲曲的流行，也使劇本的印刷達三百多種之眾。這些書坊不僅是一個商業場所，而且，還是一個文化和社交場所，買書的，看書的，聚談會晤的，如南京三山街的蔡益所書坊，佈置清雅素淡，常有東林黨遺孤和復社成員來此聚會，有時還住在書坊的客房中。蔡益所也很為自己的書坊驕傲，作為著名的戲曲【桃花扇】中的一個角色，他一出場便自報家門道："在下金陵三山街書客蔡益所的便是。天下書籍之富，無過俺金陵，這金陵書鋪之多，無過俺三山街，這三山街書客之人，無過俺蔡益所"[44]，自豪之情溢於言表。

印刷出版業的活躍，書籍種類的眾多，印本的易得，於是明清時代在江南民間湧現了眾多的藏書樓，尤以南京，揚州，蘇州，常熟一帶為主。著名的如常熟錢謙益的"絳雲樓"，毛晉的"汲古閣"，南京黃虞稷的"千頃堂"等。這些藏書樓主人致力於對古籍的收藏保管，考訂校勘，著述出版等，為中國文化的傳承作出了很大的貢獻。有些藏書樓也成為文人學習和聚會的場所，如錢謙益的"絳雲樓"，以其豐富的藏書和優雅的環境，吸引了許多年輕學子前來問學，閱讀，抄錄，有時還住進錢家，潛心鑽研[45]。

與此相應的是文具，書畫裝裱等各類文化服務行業的興盛，許多技工為大都市的需求和魅力所吸引而前來，他們大多居住在城南秦淮河一帶，現在在秦淮區還有"裱畫廊"等地名。在上述明人所繪【南都繁會圖卷】中，就出現了"書鋪"，"畫寓"，"裱畫"，"古今字帖"和"刻字鐫碑"等店鋪招牌。在這些鋪戶裡，有來自各地的許多技藝高超的

工匠，並且這些"有一材一技自負者，或修琴，或補壚，或作扇，或鬻古書，或裝字畫，或刻木石墨跡，甘與文人為知己，不肯向富貴家乞憐"[46]。這些文化服務行業和商業經營，無疑為文化藝術的發展和交流提供了便利，亦從側面激勵了文學藝術的創造。

南京又是江南文學的中心。當時的文學雅俗交融，呈多元狀態，一方面是文人高雅文學的沿續，眾多的詩社和詩人，代表者如錢謙益，文才詩名享譽大江南北，著有【列朝詩集小傳】，與龔賢同時代的顧與治是南京文人集社賦詩的著名主持人，著有【顧與治詩集】。除了傳統的詩歌創作，晚明的散文，或稱作清言小品，尤其是明代文學中引人注目的一種形式，並形成公安，竟陵等幾個派別[47]，南京亦成為活動的中心，例如竟陵派代表的鍾惺便在秦淮河畔的水閣著書撰文，著有【隱秀軒文集】等，他自己善畫，曾作有"金陵圖冊"，現為香港北山堂收藏[48]，他也與畫家相友，在他離開南京時，曾與畫家胡宗仁有詩畫的相酬唱。另一方面，由於市民通俗文化的普及，和文人介入其創作而形成了俗文化的新高潮。明末清初，南京成為通俗文學創作的聚焦點，【二拍】，【桃花扇】，【儒林外史】，【紅樓夢】等傑作均與之有關。代表人物之一的凌蒙初，自30歲後居住南京，完成了【拍案驚奇】，和【拍案驚奇】二編，人稱"二拍"。另一代表人物李漁也在南京築"芥子園"，又在南京的翼聖堂刻印插圖本小說和戲曲集。清代前期的三部著名文學作品【桃花扇】，【儒林外史】和【紅樓夢】都是以南京為主要背景來進行寫作的。【桃花扇】的作者孔尚任，曾多次遊歷南京，踏訪明朝遺跡和書中主人公秦淮名妓李香君的故居。【儒林外史】的作者吳敬梓則長期寄居

在南京，在秦淮河畔完成了他的這一巨著。更負盛名的小說【紅樓夢】的作者曹雪芹，從他的曾祖到父親，前後幾代在南京擔任"江甯織造府"的官職達五十九年之久，從而構成了【紅樓夢】的重要歷史背景材料。憑著曹家與皇室的親緣關係，康熙皇帝六下江南都到了南京，並有五次住進了"江甯織造府"以為行宮，今天的地名"大行宮"即因此而來。更值得一提得是，一代文豪曹雪芹於康熙五十年（1711）誕生在此並度過了他的青少年時代，【紅樓夢】的故事就從這裡肇始。（插圖2）

南京作為當時江南戲曲的中心，其形成與明初以來定都南京的朱氏皇朝對戲劇的偏愛和鼓勵有關，據記載，明太祖朱元璋便愛好戲劇，特別欣賞"琵琶記"，這是一部由元末高則誠根據民間傳說改編的戲劇，講述進京考試的文人和在家盡孝的妻子最後團聚的故事，他曾說："【五經】，【四書】，布帛菽粟也，家家皆有；高明'琵琶記'如山珍海錯，貴富家不可無，（因而）日令優人進演"[49]，明成祖朱棣則於永樂年間在南京建勾欄教坊，相當於國家劇院，規模宏大精美，以後的武宗，神宗皆重視戲劇和優人，武宗曾在正德年間在南京迎春，演劇作樂，又至內閣尚書楊一清家看"西廂記"，一部由元代王實甫創作，描寫書生張珙和大家閨秀崔鶯鶯衝破封建禮教自由戀愛的故事。回京時還帶走了南教坊的伶人。神宗則更是設立制度，保障戲劇，使之留於宮中。當時的文人也熱衷於戲曲創作並將之上升至理論的高度，如李漁（笠翁）作有【李笠翁十種曲】，並設女子戲班，還在南京的翼聖堂督察插圖版劇本的印刷。明末的大戲曲作家湯顯祖曾在南京做過南常寺（掌禮樂郊省社稷事）博士等職，並改寫創作了"紫釵記"，一部根據唐代傳奇"霍小玉傳"改編的愛情劇。

十七世紀，約有十餘種影響較大的聲腔和劇種在江南各地流行，如以浙江金華方言為特色的婺劇，在江蘇蘇州昆山一帶流行的昆腔等。民間的戲班也很盛行，有商業性的演出團體和自娛性的私家班子。職業戲班多由演員自行組織，周遊各地作營業性演出，如南京的興化班，華林班還搭擂臺比試高下。自明中期以後，大戶人家蓄養戲班亦成風尚，如達官顯宦阮大鋮（約1587-約1646）的家班多在南京活動，曾自編自演"燕子箋"。家班的演出，絕大部分是在主人的廳堂庭院，著名文人錢謙益曾對豪門家中演劇既講究舞臺的排場，又注重道具服裝和表演

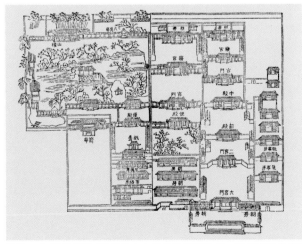

插圖2：江寧行宮圖（清乾隆十六年織造廨署改建，圖載南巡盛典）

119

的質量有精采的描寫[50]。戲曲的演奏也成為民間各類節慶和茶社客店不可或缺的娛樂節目[51]，並按照不同的活動配有相應的劇目，如南京的文人紀振倫編有【樂府紅珊】，選了一百多出戲以適應慶壽，慶婚，宴會等種種不同的場合和目的。戲曲清樂也是文人雅集宴會不可或缺的娛樂節目，龔賢曾有詩記載秦淮詩社的集會，生動地描寫了集會中有歌舞戲曲助興的場面，"須臾日夕動簫鼓，俳優傀儡登幾叢，金陵一時稱勝事，鍾山紫氣增龍𥹢"[52]。

從以上選擇簡介的幾方面，不難看見，明代的南都南京，江連南北，山川秀麗，物華地利，經濟繁榮，文化領先，難怪為時人讚道："金陵佳麗，仕宦者誇為仙都，遊談者指為樂土"[53]而引來了四面八方的人才，尤其為文人所好，寓居往來，或聚集會訪，成為一代風雲場所。

三·晚明文人的生活時尚

文人在明清之際是舉足輕重的一族。文人的藝術，其實是對生命情調的追求，追求那看不見，摸不著，只可意會，不可言傳的生命的詩意。這種追求有意識地萌發於六朝時期，以文學藝術上的純美學意境的創造和生活實踐中的魏晉風度為代表，在為歷史所稱的六朝金粉氣的相佐中得到了擅發。這種風度和金粉氣雖然一再為文學作品和歷史記載所追懷感憶，但其實踐卻在爾後的歷史時代中有跌宕起落，難為再繼。然而那種歷史的基因和媒介是深植於這片土地中的，只是在等待著再生的時機。明末清初，在社會又一次的動亂變更之際，自明代中葉以來哲學思想界王陽明以心為天地萬物之主的心學理論，李贄把"童心"當作人的先天本性，而應當自由抒發個性的理論，和禪學以吾心即佛，禪定頓悟的理論，都極大地影響了十七世紀中國知識分子的思想和心態，從而引發了一個個性覺悟和個性解放的高峰。加之明末江南太湖流域發達的手工業和商業又促進了市民階層的形成，以及通俗文化的流行，從而創造了一種更為自由的氛圍，因而在南京這個"仙都"裡和以其為中心的江南地區，中國文人從各方面尋求著這種個性的解放，並有意無意地或潛意識地循著六朝人的足跡，繼續著對生命情調的追求，並將這種追求從雅俗兩方面相結合，任情適性，而達到了一種極致，創造出了一種特殊的文化環境和生活時尚，從中濃郁地映現出那一時代特殊的文化氣質和人格。我們將從當時文人的交遊，娛樂，讀書行旅，特殊的審美趣味幾方面來作一探討。

1. 晚明文人的交遊

中國文人對友情的珍重，視之為激蕩才思，鼓舞精神，引發創作靈感的不可少的媒介。故文人雅士歷來崇尚和心賞春秋戰國時的一曲高山流水和鍾子期為伯牙斷琴的故事，以之作為知音相互激賞的經典[54]。明代晚期，文人交往的規模和範圍之擴大，交往之頻繁，前所未有。主要是江南文人盛行結成各種社團，這是一種類似現代文人沙龍的結構，只要意氣相投，或讀書，或論事，或作詩，幾人便可組成，並舉行不定期的集會，成為當時文人交往的主要形式之一[55]。當時江南最主要的社團是復社，成立於明天啟年間，初為一個文學小團體，以"興復古學"為目標，進而匯合大江南北的各種社團，全盛期會員達兩千多人，遍佈江蘇，浙江，安徽，江西，福建，湖廣，貴州，山東，山西，河南等省。其麾下集合了明末許多才華橫溢，正直愛國的知識分子，以其敏銳的觀察力和正義心，針貶時弊，鞭撻奸宦，為國擔憂。南京作為江南首府，自然成為一個重要的聚會之地，復社歷史上召開的三次重大集會之一的"金陵大會"便於1630年在南京舉行。1636年，明末著名的四公子之一冒襄（辟疆）又發起和組織了復社成員在南京的桃葉渡集會[56]，聲討奸宦魏忠賢，阮大鋮迫害東林黨人的罪行，表現了中國文人前所未有的，集群而起，憂國憂民，伸張正義的精神，復社成員中的佼佼者如黃宗羲，夏允彝，陳子龍，方以智，朱彝尊等人，則成為中國早期民主主義思想的卓越代表，影響其後三百年的歷史。金陵畫家中如龔賢，年輕時便與復社成員顧與治，方文為友，意氣相投，交往密切。其他的金陵畫家如葉欣等也與復社成員有來往（參見圖錄6-5號）。

較少政治色彩的社團的雅集更為普遍，例如在南京有江浦著名藏書家丁雄飛與金陵千頃堂書樓主人黃虞稷一起結成古歡社，專以考據為樂，兩人還每月訂了日子互相走訪，參閱彼此的藏書，互通有無，丁於每月十三日拜訪黃，黃於每月二十六日回拜丁[57]。金陵畫家中，如龔賢除了與復社成員有來往，與南京的這些藏書家和同道的文人亦相唱酬。清代潘宗鼎在其所撰龔賢【小傳】中道："顧夢遊，胡易簡與之善，往來唱和無虛日，或泛舟於桃葉渡，珠簾畫舫，蕩漾清波，偶得佳句，為遠近所傳誦。江寧黃居中家，構'千頃堂'，藏書極富，慕其名，因結詩社於秦淮"[58]。龔賢還曾在秦淮參加由范鳳翼

為社長的詩社，並作詩讚歎秦淮詩社才子佳人聚會歌舞，飲酒賦詩之狀，追述這一當時南京文人的勝事[59]。1687年，龔賢訪問揚州期間，應友人孔尚任的邀請，參加揚州春江社雅集於秘園，與會者有查士標，僧石濤等三十餘人。詩酒唱酬，書畫相贈，是為當時文人雅集的寫照。雅集上，龔賢贈給孔尚任書畫，孔亦回贈詩札。

不以結社面目出現的文人雅集和朋友間的私下走訪，自然更是歷來文人交往的普遍形式，在明末清初則更多見於記載。當時的大文人錢謙益所作的【列朝詩集小傳】一書中，便描述了許多文人們退出政壇後，以詩酒唱和相會的雅集。以詩畫為互通心曲的工具可謂中國文人的傳統，從唐詩的唱酬，元畫的相題贈中均不難找到例子。明清時代此習更為普遍，被譽為金陵八家之首的龔賢，一生好結交志同道合之友，常借詩畫表達心跡和友誼，1683年樊圻（時68歲）作"歲寒三友圖軸"，龔賢為之題詩，1685年，龔賢作"索畫"詩二首寄王翬（石穀）求繪"半畝園圖"，圖成後致書感謝，並贈以詩畫。在他生命的最後兩年間（1687－1689），他與孔尚任之間的詩畫唱酬亦很頻繁，在他死後，也是孔尚任為其打理後事的[60]。在這種禮尚往來和社會的應酬中，時下流行的金陵折扇，亦成了廣受歡迎的最佳禮品。從流傳至今的扇面大多題為某人所作，即為證明。例如龔賢曾於1682年為雲笠同學畫"山水"扇，胡慥於1653年作"葛洪移居圖"扇面，亦題為"大宗老社長"所作[61]。這些題款既表現了金陵畫家與社團與友人的來往，也印證了當時繪扇相贈的時尚或甚而作為藝術商品出售。江南夏日悶熱，摺扇易於攜帶，便於使用，隨時展玩，若有名家墨寶，自然品味陡增，故繪扇之流行，為明清兩代各階層人士所鍾愛，是一個易於表達風雅的寵物。其他知己間之攜琴訪友，書屋論道，品茗鬥酒，應韻賦詩，都是文人間相互切磋交流，相互鼓勵的形式，由來已久，但在明末清初文人的交往中得到了更多的實踐，並屢屢成為繪畫的題材。

2. 晚明文人的娛樂

明末清初南京文人的娛樂生活大多不脫品茗飲酒，青樓曲坊，即使是在社團的集會和文人交往中，也常常"遊則必置酒招歌舞"[62]。

在南京，最著名的文人嗜酒的形象和典故，首推六朝

"竹林七賢"諸君子逃避世事，而飲酒竹下的故事，故事雖然發生在洛陽，卻以磚印壁畫的形式，在南京得到了鍾愛[63]，又有唐代李白醉酒尋月的傳說[64]和杜牧沽酒杏花村的詩作[65]，酒給人們創造了一個相對自由的世界，歷來是文學藝術家尋求自由不羈的狀態而激發藝術創造力的重要途徑。有明一代，飲酒之風很甚，並由文人進一步地賦予高雅的品位。

明代初年，太祖朱元璋下令在南京城內外的交通要道上開設16座大型酒樓如醉仙，翠柳等，分佈在江東門，三山門，石城門，聚寶門和三山街一帶，以接待四方來賓，並供功臣，貴戚，官僚和文人消遣享樂之用。飲酒之習自上而下，蔚然成風，除了官家所開酒樓外，民間亦盛行，在秦淮河一帶酒家林立，據說以名為"問柳"的酒樓為最古。酒坊在明代後期的南京也有較大的發展，產品有自唐代以來便著名的"金陵春"酒為大眾所愛，而"士大夫所用惟金華酒"[66]。（插圖3）

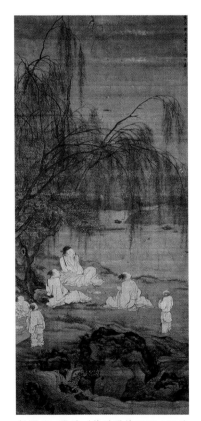

插圖 3：張翀（約活躍於1628-1644）"鬥酒聽鸝圖軸"，南京博物院提供

明代中期始，文人著重於將酒與飲酒變成一種使日常生活藝術化的情趣，著名的文學家袁中郎著【觴政】一書，闡述飲酒的一些準則，飲具，飲飾，醉酒的樂趣，還品評當時的酒友。酒更是文人雅集聚會的必備之物，籍文酒之會激勵才智，吟詩作畫，抒情遺興，此習傳統悠久，歷來被視為一種風雅。例如明末清初的大收藏家周亮工"性嗜酒，喜客，客日滿座，坐必設酒，談諧辨難，上下古今，旁及山川草木，方名小物，娓娓不倦，觴政拇陣，疊出新意，務極客歡而去"[67]，康熙八年（1669年），周亮工罷官

後，畫家吳期遠特到南京慰問，十一月，邀請"白下諸公"舉辦了一次詩酒盛會，出席者有胡玉昆，樊圻，吳宏，張修，鄒喆，夏森，陳卓，葉榮木等近二十人，周亮工說是"詞人高士，無不畢集，數十年來未有之勝事也"，他的學生黃俞臺為此寫了"長歌"，描述了包括金陵八家在內的與會畫家。席間，眾人讚賞倪瓚，黃公望的妙畫，崇敬沈周，文徵明的風度，詳細地記載了畫家文人飲酒作詩，繪扇相贈的這一盛會[68]，美酒與風雅之緣，於此可見一斑。

文人嗜酒，是當時的一般風氣，對酒的論述也應運而生，時人馮時化著【酒史】，謝肇淛在其【五雜俎】一書中亦辟章節"論酒"，王焯在他的【今世說】一書中還記載文人甚而不惜典當衣物以沽酒的故事[69]。在明末清初之季的亂世，美酒更成了澆愁之物，尤其在明代亡國之後，羈絆於亡國之痛的遺民們，尋求於美酒的沈醉，龔賢的詩文中便充滿著酒味，尤其在他的晚年，1683年，他自稱道："我號詩人與酒家"[70]，晚年詩作中"酒"字，"醉"字，幾乎每首詩中都用到，還有詩道："道衰宜縱酒，世亂莫談詩…"[71]，詩中透露的全然是借酒澆愁的無奈和沈痛。龔賢並不孤立，借酒澆愁者不乏其人，同時代的畫家石濤也道："飄零歲月向誰論，且對清江醉一樽…"[72]。借酒忘懷，正是當時一般不滿現實的文人的普遍舉止。

除了飲酒之外，飲茶亦為文人所好。明清時代，植茶有新發展，大江南北，遍佈茶園。文獻中曾記載南京的牛首棲霞兩山皆產茶葉，因生於山頂，而名之為雲霧茶，為僧人採來款待貴客的。城西五臺山亦種植茶樹，但只為一般人所用[73]。南京最早的茶社，雖然根據顧起元記載為宋初文字學家徐鍇的兒子在金陵攝山（棲霞山）前開設，人稱"徐十郎"[74]。但茶社在南京城內的開設或流行據說則始於明末，萬曆癸丑年（1613），有新都人開一茶坊於鈔庫街，被認為是"此從來未有之事"。萬曆四十六年（1618）又有一個僧人開茶社於柵口，曰"五柳居"[75]，以後茶樓，茶坊才逐漸增多並講究品味。例如當時在土街口道旁有個茶坊，飲具十分精緻清潔，用炭火煨陳雨水，沖泡龍井，銀針之類的上等名茶，很受歡迎[76]。一般人家也講究飲茶的質量，以河水濁而有土味，便習慣積攢雨水，待三年後方用來烹茶，其水口味清冽，故後人有詩道："為憶金陵好，家家雨水茶"[77]。

茶本中國人所謂"開門七件事"的日常用品，但到

了明代文人手中卻點鐵成金，被奉為具有高雅層次的文化，與人生境界的修養休戚相關，文學家屠隆（1542-1605）曾道："茶之為飲，最宜精形修德之人，兼以白石清泉，烹煮如法，不時廢而或興，能熟而深味，神融心醉，覺與醍醐甘抗衡，斯善賞鑒者。使佳茗而飲非其人，猶汲泉以灌蒿萊，罪莫大焉；有其人而未識其趣，一吸而盡，不暇辯味，俗莫甚焉"[78]。吳派文人畫領袖文徵明曾專門作有"茶具圖卷"，現為日本一私人收藏[79]，與金陵八家之首的龔賢交往密切的大詩家方文（1612-？），為安徽桐城人，客居金陵，工詩，著【嵞山集】五十卷，他性格豪爽，好結交四方名士，曾有詩述及與龔賢相見時，以茶待客，"花下一杯茗，頓覺開襟顏"，生動地描寫了與知音共品清茶，互傾肝膽的愉悅[80]。故文人們對茶葉，水質，茶具，甚而飲茶的環境都很有講究，飲茶與否被視為去俗氣添清雅的風度之一[81]。對飲茶的講究，致使明代出現了相當數量的有關論述，文震亨在他的著作【長物志】中便開闢章節對茶寮的設置，對茶品，洗茶用具，甚至燒茶所用的炭都細加評論指點，如茶壺以紫砂為好，但造形俗氣者如雙桃形，臥瓜形者皆不可用[82]。其他如張岱的【陶庵夢憶】，袁枚的【隨園食單·茶酒單】等多種著作中，皆有記載。在此時期的繪畫題材中，與飲茶有關者也常有表現，文徵明曾作"惠山茶會圖"卷，現藏於上海博物館[83]，金陵畫家亦有這一題材的作品（參見圖錄第9號）。

南京的酒樓茶坊，尤以秦淮一帶為著。秦淮河是長江下游的一條支流，位於南京城南和南郊一帶，全長110公里，在通濟門外分為兩支，其中一支為"內秦淮"，從東水關入城，經夫子廟，鎮淮橋（中華門內）出西水關（水西門稍南）長約5公里，另一支為"外秦淮"，也是明朝南京城南的護城河。秦淮河的下游兩岸即南京的城南，在六朝時代即為居民區和商業區，被稱為"六朝金粉之地"，最熱鬧的是從聚寶門水關到通濟門水關這一段，明太祖建都南京以後，內秦淮從武定橋，長板橋，經桃葉渡到大中橋，沿河兩岸建築著精緻華美的河房，雕欄畫檻，綺窗珠簾，或為酒樓茶坊，或為青樓曲院，或為別墅富宅，入晚河中燈船往來，笙歌不絕，形成了一種畸形的繁榮。秦淮的燈船，伎樂和青樓文化都是南京的特殊文化現象，盡為天下所知。

此燈船為秦淮特色，據說明太祖洪武二年（1372）的元宵節（正月十五日），朱元璋曾經下令在秦淮河

上燃放水燈萬盞，相傳為一代盛事。時人記載道：
"秦淮燈船之盛，天下所無，兩岸河房，雕欄畫檻，
綺窗絲幛，十里珠簾…薄暮須臾，燈船畢集，火龍
蜿蜒，光耀天地，揚桴擊鼓，蹴蹋波心。自聚寶門
水關至通濟門水關，喧闐達旦"[84]。秦淮的元宵燈市
便由此而來，且沿襲不衰。而"夾岸樓閣"的曲院
繡坊和河中舟船的"中流簫鼓，日夜不絕"的戲曲
清樂[85]，為秦淮增添了無限丰釆，許多著名的曲壇高
手雲集於此，如正陽鍾秀之，徽州查十八都是當時
"清彈琵琶"的著名演奏家，有些文人和富商曾遠道
來訪，聽他們演奏，並且有人"執弟子禮"向他們
學技藝。明朝末年，柳敬亭的說書是南京表演界的
一絕，儘管他滿臉麻疤，其貌不揚，人稱"柳麻
子"，但其技藝之高超，敘說故事描寫刻畫，微入毫
髮，斬截乾淨，入情入理，疾徐輕重，入筋入骨，
深受聽眾歡迎，據說，柳敬亭一天說書一回，定價
一兩（銀子），還須十日前預定，否則常不得空[86]，
故時人道："金陵歌舞諸部甲天下"[87]。

與秦淮的名演員們同領風騷的是天下聞名的青樓文
化。秦淮產生了許多著名的才貌雙全的青樓女子，著
名者有"秦淮八豔"，如馬湘蘭，董白（小宛），李香
君，柳如是，卞玉京（卞賽），寇湄，顧媚（橫波），
陳圓圓等。為取悅於光顧青樓的文人雅士，或富家豪
門，這些女子自幼便接受文學藝術的訓練，均能吟詩
作畫，度曲彈唱，在這種特殊的條件下，女子在藝術
上的才能有了公開發揮的機會。從另一角度看，也是
文人將這一部分生活藝術化的結果，泛舟秦淮，賞樂
聽曲，挾妓飲酒，吟詩作畫，是晚明以來的文人風
度。時人余懷在其著作【板橋雜記】中詳細記載了秦
淮河畔高級妓女區的舊院的種種風情，且記載道"舊
院與貢院遙對，僅隔一河，原為才子佳人而設。逢秋
風桂子之年，四方應試者畢集，結駟連騎，選色徵
歌，轉車子之喉，按陽河之午，院本之笙歌合奏，迴
舟之一水皆香，或邀旬日之歡，或訂百年之約；葡萄
架下，戲擲金錢，芍藥欄邊，閒拋玉馬；此平康之盛
事"[88]。當時著名文人與秦淮名妓相戀相賞而相互激
勵的故事不絕，如著名文人錢謙益與秦淮八豔之一的
柳如是結為伉儷，明末四公子之一的侯方域與李香君
的愛情故事是著名戲曲"桃花扇"中的主旋律，這些
都是明代以來盛行的才子佳人文化的典型代表，展品
中秦淮八豔之一的寇湄的肖像畫，和畫上的題跋亦透
露了這一時代的習俗（參見圖錄16號）。從秦淮特有
的文化中，足以窺見當時江南文風鼎盛，風流倜儻的
生活時尚。

3. 讀萬卷書，行萬里路

讀書本文人之天職，唐代大詩人杜甫道："讀書破
萬卷，下筆如有神"[89]。這不僅是指讀書的數量，而
且是進而對事物的理解，觸類旁通，溶彙一體，而
達到境界的升華，這是一種曠日持久的身心修養，
而修養的高下則將從文學藝術作品中表現出來。畫
家追求繪畫的文學意味，而形成將詩書畫結合的表
現形式和新的繪畫審美觀，就逐漸形成了宋元以來
的文人畫家。然而將讀書的多少與繪畫境界的高低
聯繫在一起，並明確強調文學修養的重要性，則比
較多地見於明中葉以後的文獻中。明代中葉的文學
家，畫家李日華（1565-1635）曾論道"繪事必須多
讀書，讀書多，見古今事變多，不狃狹劣見聞，自
然胸次廓徹，山川靈奇，透入性地時一灑落，何患
不臻妙境？"[90]，以沈周，文徵明為首的吳派畫家，
對此有很好的實踐。吳派畫家注重文學修養，強調
文學意趣的表達，這不僅僅是將詩與畫在形式上的
結合，而且注重整個繪畫本身，從結構，筆墨，都
要富於文學趣味，從而使整幅繪畫透露出所謂的書
卷氣，即文人畫實際上是畫修養畫學問的實踐。這
一實踐，立足於對前代文人畫精神的深刻理解，並
上升為對文人畫理論的新發展，對文人畫家也提出
了更高的要求，即畫家不僅要有嫻熟的繪畫技巧，
而且需要具備相當深厚的文學修養和人品修養，而
這修養的養成多得益於讀書。故時人論道："要得
胸中有數十卷書，免墮塵俗耳"[91]，更有評論激烈者
"雲間先生嘗雲：不讀書人，不足與言畫"[92]。故讀書
是當時文人畫家的必修課。沈周在青少年時代便努
力讀書，經史子集釋道無不遍覽，所以極為博學。
繼沈文之後，極力主張文人畫的董其昌，陳繼儒對
讀書都提出了要求，陳繼儒有【讀書十六】，輯蘇軾
等名家讀書之名言和韻事，以為讀者指導，他自己
視書為友人，在序言中道："讀未見書，如得良
友，見已讀書，如逢故人"。他採集的讀書名言如引
倪文節公（南宋禮部尚書倪思）論讀書："松聲，
澗聲，山禽聲，夜蟲聲，鶴聲，琴聲，棋子落聲，
雨滴階聲，雪灑窗聲，煎茶聲，皆聲之至清者也，
而讀書為最"[93]，他的名言和書一起廣泛傳播，在當
時產生了很大的影響。

因此在這一時期，有相當多的反映讀書題材的畫
作，沈周有"蕉石讀書圖"，原藏故宮博物院，和
"山水讀書圖"，文徵明於80歲時還作"真賞齋圖"，
描繪一個收藏家所精心布置的書齋。金陵畫家中的

吳宏應人之邀作"柘溪草堂圖"（參見本圖錄14號），龔賢也作"松林書屋圖"[94]，對於讀書和涵養胸中之氣以增畫境的關系，他於1676年，59歲時作的二十四頁"山水"巨冊的第六幅的題跋中，更深有體會地道："余弱冠時見米氏雲山圖，驚魂動魄，殆是神物，幾欲擬作，而伸紙吮毫，竟不能下，何以故，小巫之氣也。歷今四十年，而此一片雲山，常懸之意表，不意從無意中得之。乃知讀書養氣未必非畫苑家之急事也"[95]，在進一步論及如何提高畫家自身的修養時，他道："聞之好畫者曰：士生天地間，學道為上，養氣讀書次之，即遊名山大川，出交賢豪長者，皆不可少，餘則攻詞賦書畫棋琴"[96]。

遊歷名山大川對提高畫家畫藝和修養的關系，早由六朝姚最提出"心師造化"的觀點[97]，提倡投身自然，感受山川之勢，以陶冶性情，怡養筆墨之趣，在此時期廣泛地為畫家們所實踐，此一向自然的學習大約有間接和直接的兩種途徑。

間接地向自然學習，可謂神遊山川，主要是學習古人的山水畫，如龔賢所說，學習古人也是為了領悟自然之"理"，這就將臨摹古人山水跳出了僅僅學習筆墨技巧的局限，而試圖探索古人山水畫的精神內涵。他說："古人之書畫，與造化同根，陰陽同候，非若今人泥粉本為先天，奉師說為上智也。然則今之學畫者當奈何？曰：心窮萬物之源，目盡山川之勢，取證於晉唐宋人，則得之矣。"[98]他自己便汲汲不倦地學習前輩大師，由尼爾森-阿特金斯博物館收藏的"雲峰圖"卷，作於1674年，在題畫的長跋中，他詳細地敘述了自己的師承關系，列舉了自五代董源到明末馬士英等二三十位畫家，足見其不拘一家，廣采博納，轉益多師的學習態度。金陵畫家中的樊圻，高岑等也師事廣泛，宋元以來諸家山水大師如荊浩，關同，范寬，馬遠，夏珪，黃公望，王蒙等，皆是其臨摹的師範，博采各家之長，琢磨自然之理，以增畫藝。

直接向自然學習的途徑，當然主要是身歷其境的造遊。明代文人造遊山川和名勝的熱情前所未有，尤以明中葉以後為甚，導遊作品也因此而相當流行，如南京的學者余孟麟著【金陵雅遊編】，有圖有詩，是對金陵名勝的生動介紹[99]。為方便出遊者，甚至有專門書籍介紹旅遊用品的，如屠隆著有【遊具雅編】一書，將每一件東西，如笠，杖，魚竿之類都點化成文人養生悅性的工具，把旅遊本身則點化成實現

高雅人生的樂事。因此，紀遊的山水詩文，紀遊的山水畫作在此時期也非常流行，大凡在山水畫上有所作為的畫家皆有壯遊的經歷。龔賢對此深有體會，他在於六十二歲至六十四歲時所作"溪山無盡圖卷"中自題道："…覺寫寬平易而高深難，非遍遊五嶽，行萬里路者，不知山有本支而水有源委也"[100]。龔賢歷來懷有壯遊之志，以感受自然，雖然為經濟所限，未能遠遊"萬里"，但從現存史料來看，他至少去過富春江（在今浙江），泰山（在今山東省），黃河，北京，姑蘇（今蘇州），黃山（在今安徽省）等地[101]，這些遊歷活動拓寬了他的視野，也豐富了他的素材，其繪畫題材廣闊，面貌多變，既畫大山大水，又畫村野邊角，既畫冊頁小品又畫萬里長卷。金陵畫家中的樊圻有"春山策杖圖"，或為遊春的感受（參見圖錄第12號），高岑的"金山寺圖"是遊歷名勝後的記述，（參見圖錄第13號）。金陵畫家中的吳宏更是壯志凌雲，不辭辛勞，騎驢尋訪戰國魏都遺址，憑吊古代俠義之士，緬懷先人壯舉偉業，借此開拓襟懷，添增豪邁之英氣。他自己覺得歸而若有得焉，因而"筆墨一變，縱橫森秀，盡諸家之長，而運以己意"[102]。除了壯遊以外，山居也是明代文人熱衷的生活方式和時尚，龔賢曾作"雲林山居圖"，現為日本一私人收藏[103]，他自己最後也結廬清涼山下，葺半畝園，栽花種竹，力圖擺脫塵俗，將自身與自然融為一體，在他筆下的清涼山景色，真實地刻畫了群山，大江，清涼台，古城牆的同時，還細膩地表現了陽光下的光照感，可謂是與自然朝夕相處，觀察入微的紀實[104]。

不論以何種方式，與自然為伍，或遊歷山川，晚明以來的文人畫家們都十分看重遊山尋勝與讀書養氣，將此作為陶冶身心，涵養境界的重要手段，並且將那一份歷史的深沈和文學的浪漫融入到繪畫藝術之中，是對唐代張璪總結的"外師造化，中得心源"的深入理解和親身實踐。明代的重要畫家董其昌曾更形象地道"不行萬里路，不讀萬卷書，欲作畫祖，其可得乎"[105]。髡殘引申道："論畫精髓者，必多覽書史，登山窮源，方能造意…"[106]。將人生之旅，壯遊山川，讀書養氣，藝境昇華都冶煉於一爐，來涵養氣質情操，成為晚明一代文人對自己的要求和實踐的總結，因此，"讀萬卷書，行萬里路"的格言，也為後繼的文人奉為座右銘，成為他們終生的追求。清朝初年的文人魏禧更具體地提出一生的安排，是為讀二十年書，出遊二十年，著書二十年的觀點，認為這才不愧負了"讀萬卷書，行萬里路"的旨意[107]。

4. 晚明文人的特殊審美趣味 "清"

"清"之一字，歷來為文人所好，但特別為晚明文人所強調，並將每一種生活感受均與之掛上鈎，有清妙，清拔，清雅，清奇，清靜，清淨，清虛，清遠，清狂，清饞等等，"清"字成了"高潔超俗"的代名詞，作為人生的最高境界，和天地民物之源，千古高人逸士之根也[108]。為了追求這"清"，晚明文人喜清言，金陵畫家中的魏之璜便喜酒喜清言，而得到當時士宦的敬愛（參見圖錄10號）。晚明文人還有每天必修的 "清課"，"焚香，煮茗，習靜，尋僧，奉佛，參禪，說法，作佛事，…"[109]。龔賢的清課則是："長夏山中無事，晨起移小幾坐竹中，隨畫隨題，日得一幅，以為清課"[110]。晚明文人對 "清" 的追求還不僅僅將之作為一種性情的修養，和高雅談吐的形式，而局限於 "清言" 和 "清課"，並且力圖將這一審美觀落實到日常生活中，來構造出一個充滿藝術氣息的生活環境和氛圍。這種將生活全方位的藝術化和理想化的實踐和理論，在中國文化史上也並不多見。因而，明代有相當數量的書籍專論文人之物，如屠隆的【考槃餘事】，雜論文房清玩，縱談書版碑帖，品評書畫琴紙，話說筆硯爐瓶，以至一切與文人有關之器用服禦。其【遊具雅編】一書中，亦將便於遊覽之具如笠，杖，漁竿之類，一一加以論說點化，使每一樣東西都成為文人養生悅性的工具，使每一件物品都成為塑造文人形象的道具。而計成的【園冶】雖為治園之作，卻表達了典型的文人心目中的理想生活環境。

晚明文人對 "清雅" 的追求，在文學上的表現，是清言清賞小品的盛行，如樂純的【雪庵清史】，屠隆的【婆羅館清言】，陳繼儒【岩棲幽事】，【讀書十六觀】，吳從先【小窗自紀】，洪自誠的【菜根談】等，將晚明文人追求的清雅生活，對生活，人生，宇宙的深沈思索，以富有哲理意味的精緻而優雅的三言兩語表達出來，在表達形式上是對六朝劉義慶【世說新語】的繼承，在舉止上是晚明文人對六朝魏晉風度的新實踐，也是對歷來文人高介超俗的氣節的崇尚，更是晚明文人在特定的歷史階段，對其所具有的生活理想和情趣的獨特的審美感受和藝術表現。如陳繼儒的【岩棲幽事】便多記載人生感言，山居瑣事，讀書品畫，談禪說詩，品山水，賞花草，焚香點茶的閒居幽雅的生活。又如屠隆道："何以適志，青山白雲。何以娛目，朝霞夕曛。上有長林，下有回溪。黃麏晝出，玄猿夜啼。耳聽松風，以當管弦。匡坐大石，手汲清泉。樂哉山居，可以徘徊。岩洞陡絕，谺焉中開。竹房內幽，石壇外朗。有客清言，無客獨往。人世隔絕，神冥大虛。一事關心，焚香展書"[111]。這是一個何等超然而閒適的物質和精神世界！

這種追求閒適的江南山居式的生活情致，又善於將日常生活藝術化的作法，不僅突出表現了晚明文人的任情適性，亦或是晚明文人在複雜的政治和歷史現實生活中為避世而營造出的一個新桃花源？亦或是他們對人生真諦洞達徹悟的結果？其中的微妙之處和細微感受雖難以歸納於一，但無疑都表現了晚明文人所特有的文化氣質和處世態度。

這種對 "清" 的追求，也深深地影響了美術界，而左右了繪畫的審美觀，品味和格調，因而明人倡導 "畫有四宜：宜文，宜清，宜逸，宜咫尺隔別"[112]。自明中葉以後，繼文沈力主文人畫後，尤其有董其昌又提出畫之南北宗的觀點，與陳繼儒等同心協力，推崇董巨倪黃，獨尊文人畫，對師承北宗的浙派，江夏派繪畫竭力貶責，流風之下，士大夫看到不符合文人畫要求的，便一概貶為 "邪道"，而以 "清" "濁" 論畫家和畫派遂成為明末清初的準則。當時的標準是文人畫清雅，"利家（文人畫家）畫有士氣故能高"，匠人畫粗野，"行家（畫匠）畫有匠氣故畫濁"[113]。對文人畫的一味鼓吹，使之在明末清初達到了顛峰，其 "清雅" 的標準則自明末至清代三百年間在文學藝術各方面，甚而包括對園林建造，戲曲表演等的欣賞中，都產生了巨大的影響，形成了以 "雅" "俗" 為界的品評原則，以書法，印章，山水，詩歌等典型文人品味的 "雅" 的藝術表現形式，也得到社會一般階層的欣賞，因此為其他的一些日用工藝品所模仿和運用，如陶瓷品上加蓋陶工名章和閒章之風氣也日益流行，如德化窯瓷器作品中所見[114]。

5. 十七世紀文人的文化人格

十七世紀是一個極富歷史意味的階段，先是承二三百年的升平繁華，以南京為留都的江南地區，在經濟，文化，藝術上都達到了前所未有的繁榮，在生活時尚上創造了一個前所未有的切實而閒雅的格調，然而，由於明代中期以來朝廷內的閹宦專斷國政，摧殘忠良，繼遭滿族更立朝代，清兵血洗南京城鄉，殺戮無辜之災，再遇清初順治嚴厲統治，大

興文字獄之禍，在如此巨大的社會變化中，造就了這一時代文人的特殊的文化人格。

十七世紀前期，明清王朝尚未交替之時，江南書畫家一般多還過著比較優閑的生活，"儀觀偉然，雄懷顧盼，舉止蘊藉，吐納風流"，"文人學士得以跌宕於詞海酒場間"[115]，是當時文人追求的典型風度和生活方式，其創作中也較多地體現了文人藝術的獨特面貌，其創作心境，大都與各自的生活遭遇相關，一般表現出來的，總以閑適優雅為主。但隨著明王朝的崩潰，江南士人的民族意識充滿著反清復明的英雄氣概，有的甚至直接介入反清復明的戰鬥。而在這一努力失敗後，有的遁入空門，有的守志隱居，有的鬻藝謀生，有的趨炎附勢，有的以技逢迎，有的則借歌舞青樓，流連詩酒來排遣愁懷，但從整體上來說，這一時期的文人都有一腔難以遣去的亡國之痛，對故國的深戀和對異族憤滿的鬱積之氣常通過詩文書畫表現出來。

總之，十七世紀的江南文人一方面是溫柔敦厚，淡泊明志的儒雅，另一方面都有著非同尋常的經世濟民的愛國熱忱，其忠正的情義和分明的愛憎，是中國知識分子中難能可見的，顧炎武"天下興亡，匹夫有責"的疾呼，便是此時正義文人的寫照，成為千古名言，這種強烈的正義感和愛國激情，反映了整個時代的正氣之所在。其次，這一時期的文人仍然具有傳統的文化使命感，通過集社聚會，探討詩文，學術，將傳播文化，師範風雅，引導輿論作為己責。其三，是這時期的文人汲汲以求生命的情調和真諦，而又切切實實地施之於生活實踐，他們將飄渺超脫的藝術情調融入到日常生活的每個細節中，從而追求一種超越自然生命本身涵義的生命境界，這種對生命格調的追索，正是文人文化和藝術的精髓，而晚明文人則將這種聽來虛無飄渺的情調，在平常的生活中一一地體現出來，而成為最富有人性和最懂得生活情趣的一群。總之，在江南得天獨厚的地理，文化生態環境和特殊的文化遺傳基因中，十七世紀以南京為中心的江南文人所表現出來的愛國熱情，正義感，使命感，在山水，詩酒，書畫，歌舞和日常生活中，任情適性地追求清雅唯美，形成了獨特的文化人格，代表了中國知識分子的典型面貌。

四．金陵畫學 — 金陵畫家和金陵山水

在如此波瀾起伏的歷史舞臺上，在如此絢麗多彩的

文化時尚中，以南京為中心的江南地區，產生了比歷史上任何時代和地區都要多的畫派和畫家。【明畫錄】記載的畫家有800多人，其中江蘇約有370人，浙江占了200多人，兩地畫家占總數的75%[116]。尤其是執書畫壇牛耳者幾乎均為江南人。特別是在明清之際，畫壇顯得異常活躍，在提倡師古的正統派和注重文學意味的文人畫的兩種繪畫思想影響下，文人畫家一方面追求自己的個性，同時，師承相同，風格相近者也在各地活動，或聚合一處，倡導變革風氣，形成了許多畫派，如以松江人董其昌為首的"松江派"，以常熟畫家王石谷為代表的"虞山派"，以明末畫壇泰斗王時敏之孫王原祁為首的"婁東派"，以梅清為首的"黃山派"等，南京作為江南首府，明代南都的丰姿，歷史的悠久，山川的秀麗，贏得了詩人畫家的不絕的歌詠描繪，其文化的昌盛，經濟的繁榮，生活時尚的風流，與書畫有關的各行業的便利，皇親國戚，富商大賈和書畫收藏家的存在，使其具有磁鐵般的大都會的吸引力，自本地孕育出了一批畫家，也將來自四面八方的藝術家凝聚一起，各派畫家聚合會晤，或過往相從，使南京自然成了這種時代潮流的匯合處，產生了為史所稱的以"金陵八家"為首的一批畫家，並有矚目的創作，自十七世紀初到十八世紀上半葉，縱橫畫壇一個世紀之久[117]。

1. 金陵藝術家和金陵八家

金陵的畫壇，自十四世紀明初建都以來，至十六世紀中期，在明代皇室的偏愛下，先由浙派畫家領風氣之先。以承繼北宋以來范寬似的佈置茂密，山勢偉岸的巨嶂式山水的整體構圖，運用大斧劈皴和墨汁淋漓，快速運筆而形成強勁粗放筆墨效果的所謂浙派繪畫，得到農民出身，具有豪獷雄健性格的明皇室貴族的青睞。自永樂初浙派第一代實力人物戴進到達南京，先後有第二代浙派畫家吳偉於1475年挾畫技到南京，十七歲的小夥子很快便以其重速度，筆墨酣暢，雄氣橫發的縱筆揮灑的繪畫風格，受到了金陵貴族的喜愛。吳偉曾與諸王孫交遊甚歡，年年踏春杏花村[118]，而吳偉所喜愛的狂歡劇飲，挾妓喧鬧，來刺激他繪畫的方式，也在著名的秦淮河上得到了實現。繼吳偉之後，第三代的浙派畫家活躍於金陵的有蔣嵩，張路，汪肇等。

自十六世紀始，由於南京文化界上層階級中文人士大夫升為主流，其品味的改變，逐漸導致對繪畫品

味的改變，而欣賞將詩書畫相結合，意趣深秀，若有所寄的以沈周和文徵明為首的吳派文人山水畫。隨著金陵當地文人的興起，至嘉靖中期，開始了"金陵初盛之時"，許多來自蘇州，華亭的文人和因宮廷政治鬥爭中被貶謫的保守派成員離開北京至南京，形成一些凝聚力極強的文士集團，互相唱和，這批自居清流的士大夫對藝術的見解，也因政治，歷史的緣因，而產生一種不願妥協現實，而以私人化"遣興"於書畫的形式作為一種對自尊的維護和對現實的抗議，故以吳派為代表的文人山水畫得以興盛，而浙派在其大本營的金陵，終因文人文化勢力的高漲，而終於完全失去了勢力，由此開始了中國文人畫的高峰[119]。

十七世紀，南京雲集了本地和來自各地的畫家，1669年，龔賢曾在周亮工【名人畫冊】上題曰："今日畫家以江南為盛，江南十四郡以首都（南京）為盛，郡中著名者且數十輩，但能吮毫者奚啻千人"[120]，享有畫名的許多畫家如文徵明，徐渭，董其昌，石溪，石濤，程正揆等，或造訪，或遊歷，或寓居，都與南京有關，史稱的金陵八家，亦有大半為外地來京寓居者，因此使畫家們相互間的學習，切磋和激勵也有了許多機會。例如，龔賢自少年時便師董其昌，與石溪，石濤和程正揆等畫家都有交往，也與金陵畫家共同作畫，據記載，1679年，龔賢便與鄒喆，吳宏，樊圻，高岑，高遇，王概，柳堉，謝蓀一起為伴翁作"山水花卉冊"，現藏於北京故宮博物院。畫家程邃也在一個手卷的題跋中記述其與吳宏，戴本孝，龔賢，柳堉等常常飲酒論畫的友情（參見圖錄第3號）。

南京得以凝聚畫家的原因，首先與南京作為東南大都會所具有的吸引力和悠久的文化傳統有關，並且，在明代亡國後，南京又作為明代故都和故國之象徵，從心理上和精神上凝聚了一代遺民藝術家；其次，從藝術的發展來看，因其為大都會，得以廣納百川，融會諸家，較少門戶之見，雖然也許不易產生如小城鎮所易形成的因血緣和師徒關係為主的派別，但卻利於藝術家自由追求和發展其個性和風格；此外，南京為貴戚，富商，高官彙聚之地，有相當的收藏書畫的潛力，例如當時著名的官僚，文人和收藏家周亮工[121]，身為朝廷命官，但心喜書畫，他不遺餘力地收藏品評作品，獎掖提拔畫家，也象一塊重要的磁鐵，將畫家們紛紛吸引前來。龔賢在1669年為周亮工題其所集"名人畫冊"中曾有記述："詩人周櫟園先生有畫癖，來官茲土（指南京）結讀畫樓。樓頭萬軸千箱，集古勿論，凡寓内以畫鳴者，聞先生之風，星流電激，惟恐後至。而況先生以書召，以幣迎乎…"[122]。周與許多書畫家來往密切，他在南京秦淮河畔的居處便成為眾好友的活動中心。為史所稱的"金陵八家"都與周亮工有密切的聯繫，龔賢便為其府上的常客，周氏汗牛充棟的藏書藏畫使他大飽眼福。龔賢與周亮工有將近二十年的友誼，詩畫唱酬，造訪論道，不絕於時。1672年，周亮工卒，龔賢悲痛地作有"哭櫟下先生"七律四首，有句雲"哭公獨我頭全白，在世人誰眼更青"[123]。其他如樊圻在丁酉年（1657）題為周亮工作的"江浦風帆圖卷"，現藏遼寧省博物館[124]，葉欣在丁亥年（1647年）題為周亮工作的"山水冊"，現藏故宮博物院[125]，高岑作"金陵四十景圖"，由周亮工題跋[126]，鄒喆亦與其詩畫往來[127]。

憑著對南京畫家的瞭解，周亮工對南京畫風的演變和發展曾提出一些觀點，"秣陵畫，先知惟魏考叔兄弟，翰之出，而秣陵之畫一變，士夫衲子，無不宗之"[128]。繼被視為金陵畫派先驅人物的魏之璜（字考叔），魏之克兄弟（插圖4）和朱翰之後，又由周亮工率先提出"金陵八家"一說[129]，他所列名的八位畫家為：陳卓，吳宏，樊圻，鄒喆，高岑，武丹，蔡澤，李又李。然而認同者僅有乾隆年間成書的【上元縣誌】，稍後活動於雍乾時期的張庚，在【國朝畫徵錄】中合稱龔賢，樊圻，高岑，鄒喆，吳宏，葉欣，胡慥，謝蓀為"金陵八家"[130]，得到較多人的認可。清末秦祖永的【桐陰論畫】，李濬之的【清畫家詩史】，等均主其說，雖然這八家並不是一定代表當時知名度最高的畫家，且因其師承不同，風格迥異，也難以簡單地以"畫派"一詞來歸納，但這一個鬆散的畫家群體，都有著相近的生活經歷和思想感情，在動蕩的明清之際，有亡國之痛，有忠君之義，不事新朝，遁迹山林，以詩畫寄興，雖然個性各異，但都安貧樂道，潔身自好，在當地享有"高

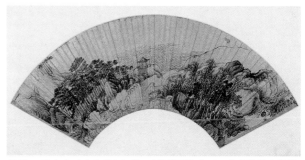

插圖4：魏之克（十七世紀）"江天樓閣圖"扇面，南京博物院提供

士"之名[131]，彼此間亦有詩文書畫往來，並有共同的朋友圈子相交往。他們之間也有較多共同的創作思想，如借繪畫抒寫真情，不拘於派系之爭，不論浙派吳派，善法必學，故能自辟蹊徑，標樹己風。在筆墨技法上也有相似之處，如常用硬直之筆，作整飭的線條，畫面結構清晰和注重筆墨的整體感，講究墨色的對比和映襯等[132]，在作畫題材上，多以南京近郊山水為粉本，均表現出一種簡樸平實的繪畫風格，由此形成十七世紀金陵山水畫的獨特面貌。

2. 十七世紀金陵山水畫的文化特徵

金陵畫家所創的山水畫，具有比較鮮明的地方特色，首先是表現了南京及附近的山水特點。南京雖然為青山環繞，但基本上是以小山頭為主的丘陵地帶，鍾山最高峰也不過海拔442米[133]，然而山色秀美蒼潤，時人顧起元曾讚歎道："金陵之山，形家言為南龍盡處，精華之氣，髮露無餘，故其山多妍媚，而郁紆煙容嵐氣，逶翠霏青，望之如古佛頂上之螺，美人眉間之黛，而特未有奇峰削壁，拔地刺天，如瑤篸玉劍，突起於雲霄之上者。江水一瀉千里，沙騰浪湧，天日為昏，最為怪偉。至靜夜無風，江聲隱起，余嘗夜臥洪濟燕磯聽之，洶洶如欲崩四壁也。後湖泓渟坦迤，堤楊洲葖，綽約媚人，山色四圍。如靚妝窺鏡，湖山之美，何減虎林，所少者獨瀑布與寒泉耳"[134]。金陵畫家創作的山水便多以此山景水色為藍本，起伏的丘陵，蒼秀的林木，而北方的那種雄渾偉岸的大山大勢則比較少見。第二是南京連接江南水鄉，河湖港汊較多，行船泊舟，最是家常便飯，故畫家筆下江汀舟楫之景多見，岸磯草亭也成了常見的景色。第三，江南的空氣濕潤，雲霧時起於山林，煙靄常生於河湖，尤其南京冬天晝夜溫差有異，水面易生煙氣，夏天炎熱悶濕，暑氣常多漫漫，又似薄霧輕煙，與天相接。在詩人畫家的筆下，這氤氳的雲煙是別饒情趣的，唐代的詩人杜牧在"夜泊秦淮"中歌詠道："煙籠寒水月籠沙"，羅隱在"金陵夜泊"中歌詠："冷煙輕淡傍衰叢"，明代的詩人顧夢遊則有詩句道："落日淡生煙"，龔賢有詩道："老樹迷夕陽，煙波漲南浦"。畫家筆下的金陵山水因此亦多雲煙繚繞之狀，幾乎每個畫家都有描繪，其表現或柔和或飄逸或濕潤或輕揚，因景因情，因畫家的感受不同而富於變化（參見圖錄4，19，21，23，25號）。第四，金陵山水中表現當地特色的景物較多見，例如，鍾山的

松樹，據記載，鍾山自東晉時便人工植松，宋代也曾種植，明代在鍾山建造明代開國皇帝太祖朱元璋的孝陵，更是植松十萬株[135]，鍾山青松便成為此一時期常見的山水畫題材，（參見圖錄2，4，5號）。第五，金陵山水畫中有許多表現了時下文人的生活時尚和愛好，如山居，書屋，旅行，品茗，賞妓等，因南京為一著名的山林城市，這些反映時尚的畫面也大多安置在秀麗的自然景觀中。

金陵山水畫中也映現出濃重的懷舊情結。南京以山明水秀，名勝古迹，文化遺風和風流時尚著稱，歷來是一個魅力四射的山林城市，其處處可成為觸景生情的詩，落筆成文的畫，在詩人墨客的筆下，金陵懷古是一個永恆的題材，尤其是六朝的名勝典故，更是一個千古難解的情結，令一代又一代的文人陶醉。自唐代以來，最著名的詩人如李白，杜甫，李商隱，劉禹錫，都有著名的詩句傳世，此後各代的詩人都不乏佳句[136]。明末清初的文人詩作中或金陵山水畫中若題有詩歌的，常常都會流露出這種對以往歷史的追懷，六朝的名勝典故，總象幽靈一樣地在文人的詩畫中徘徊。龔賢曾作"金陵懷古"詩道："短笛喚愁生，江船夜復去，月明挑戰地，潮打受降城，殘柳欲無影，哀鴻只一聲，石磯飛不去，淒絕古今情"，以西晉克吳，孫皓受降的六朝典故，抒發自己亡國的哀痛情懷[137]。又有詩道："江南六代風流地，白下多年翰墨物。古物已無王逸少，名人獨剩顧長康。量寬嗜酒難逢醉，才大論詩莫禁狂。急辦青錢買山隱，坐聽深樹候鶯簧。"[138]詩中綜述六朝的文化和影響，對王羲之，顧愷之等名人和六朝飲酒論詩等風流時尚的傾慕追往。

即使那些暫居或遊訪過南京的畫家，對南京也是難以忘懷。十七世紀的著名畫家石濤曾有冊頁名"秦淮憶舊"，為應友人之邀而作，回憶昔日與友人同在南京秦淮賞梅聚會的往事，亦引用六朝典故，其中一幅題畫詩道："沿溪四十九回折，搜盡秦淮六代奇，雪霽東山誰著屐，風高西壘自成詩，應憐孤琴長無伴，其剩槎矛只幾枝，滿地落花春未了，酸心如豆耐人思"[139]。六朝的文化，就像是一種樣板，在明末清初的文人心中反復地出現和被吟詠，足見這種歷史懷舊情結的堅韌。（插圖5）

其三，金陵山水畫反映出強烈的熱愛故鄉的情懷。十七世紀，以地方景色為題的山水畫比較流行，例如南京博物院收藏有明代宋懋晉的"江南十八景圖

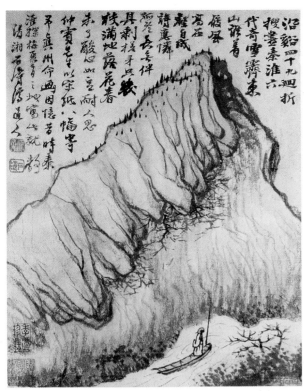

插圖 5：石濤（1642-約1718）"秦淮憶舊"冊頁，美國克利夫蘭博物館提供
Daoji (Shitao), Chinese, 1641-after 1704, Qing dynasty. *Reminiscences of the Qin-Huai Rever.* Album of eight leaves, ink and light color on paper, 25.5 x 20.2 cm. © The Cleveland Museum of Art, John L. Severance Fund, 1966.31

冊"，吳縣一帶的畫家以虎丘山為題的繪畫等，是文人畫走向社會的表現，也是市民文化發達的結果，而以金陵風景名勝為題的山水畫尤其突出，是這一題材中的佼佼者。南京人愛戀故鄉的強烈和真摯的程度，是其他古都歷史上所少見的。早在六朝之初的孫吳時期（甘露元年，265年），當吳末帝孫皓由建鄴（今南京）遷都湖北武昌，百姓便有童謠道："寧飲建鄴水，不食武昌魚；寧還建鄴死，不止武昌居"[140]，這種不計生死的眷戀，只得讓吳帝於次年還都建鄴（266年），這在中國歷史上恐怕也是絕無僅有的。另一個著名的例子是南唐後主李煜在被宋人俘獲北上後，所作詩詞中透露的對故國山河的深深懷念，令人愁絕痛絕，無止無休，"恰象一江春水向東流"，是超越時空界限的永遠的傷懷。明清之際，金陵八家中，除樊圻和胡慥為本地人外，其餘都為外地或郊縣寓居南京的畫家[141]，但都表現出對南京的情有獨鍾，書畫署名喜用"石城"，"金陵"等南京的古稱，將自己稱作南京人。金陵八家之首的龔賢雖然自昆山移居南京，但對南京的感情很深，將之視作為家，在外的奔波使他愁苦傷懷，"身老愁為客，迢迢返舊京"，亟盼著早些回到南

京，並把南京選作自己最終的生活地點。明亡後，當他與友人費密同遊金陵勝景，登上石頭城，遙望長江，觸景生情，激起了滿腔難平的民族意識，遂發出"橐駝爾何物，驅入漢家營"的悲憤呼號[142]。這種熱愛故鄉，熱愛南京的情感，在藝術家們的筆下便誕生了金陵山水的另一種表現形式——"金陵四十八景"，將金陵的歷史典故，風景名勝以山水畫的形式和詩歌的吟頌來表現，並籍著雕版印刷的簡便，而得到雅俗的共賞。

"金陵四十八景"的形成約在清代初年，其他則先後有零星的以金陵景色為題的書畫，較為人知者如"金陵八景"，"金陵十景"，"金陵十八景"，"金陵二十四景"，"金陵四十景"等。"金陵八景"據畫末題跋可知，作於萬曆庚子年春月（1600年），為江甯人郭存仁所繪，八景為"鍾阜祥雲，石城瑞雪，鳳臺秋月，龍江夜雨，白鷺晴波，烏衣晚照，秦淮漁唱，天印樵歌"，一圖，一詠，多基於六朝以來的歷史典故和著名詩作（參見圖錄第2號）。"金陵十景"，據【石渠寶笈續編】記載，是吳派畫家之首的文徵明，在遊覽了金陵山水名勝後所作。"金陵十八景"為文徵明的侄子文伯仁（1502-1575）所繪，他號稱攝山老農（攝山即今棲霞山），曾居住在南京，為金陵美麗的風光所感動而繪此圖冊。"金陵二十四景"，據1956年在湖南省長沙市發現的文物，是由文學家吳敬梓（1701-1754）所寫"金陵景物圖詠"，每篇詩末都注明所仿的碑帖，詩句工整，對南京的歷史了如指掌。"金陵四十景"為太史朱之蕃所作。朱之蕃，江寧人，字元竹，號蘭嵎，萬曆二十三年（1595）進士第一，工山水畫，注意收集家鄉江甯的山水名勝資料，"共得四十景，屬陸生壽柏策蹇浮舫，躬歷其境，圖寫逼真，撮舉其概，各為小引，系以俚句"。圖詠成後，朱之蕃命名為"金陵四十景圖考詩詠"，並與當時的另一位太史杜士全常在金陵雅遊，相互憑圖詠唱[143]。清初，金陵八家之一的高岑，字蔚生，雖老家在杭州，客居南京，但也傾心相愛這個城市，常署名"石城高岑"，平時也注意收集南京的歷史資料，遍遊南京的風景名勝，並在前人研究金陵勝景的基礎上，精心繪製了【金陵四十景圖】，清戶部右侍郎，著名文人周亮工（1612-1672）為該圖冊寫了題跋，這些圖以後被刊入康熙年間的【江寧府志】。清代初年，又發展成為金陵四十八景（參見附錄2）。

金陵畫家包括八家的山水畫中，亦有許多以金陵勝

景為題的作品，甚至幾代畫家都鍾情於此，父子者如鄒典，鄒喆，便都介入這一題材的創作。美國學者高居翰的景元齋收藏的"晚明人山水冊"，共有十頁，為不同的畫家所繪，但都以南京的景色為題，如，魏節"燕子磯"，黃益"獻花岩"，龔達"龍江關"，謝成"幕府台"，龔賢"清涼台"，黃益"雞籠山"，盛於斯"天闕山"，陸瑞征"玄武湖"，鄒典"靈谷"，張翀"報恩塔"[144]。又如，龔賢有"攝山棲霞圖"，"清涼環翠圖"藏北京故宮博物院，其他的金陵畫家中：樊圻有"江浦風帆圖"，高岑有"天印樵歌圖"，藏天津藝術博物館，描繪南京附近天印山的景觀，鄒喆有"石城霽雪圖"藏上海博物館，描繪南京的雪景，葉欣作"鍾山圖"，藏北京故宮博物院，描繪南京這一名山的景色[145]。本書收錄的樊圻的"金陵尋勝圖"，按照畫後的題跋來看，應當還有吳宏的"燕磯""莫愁"，龔賢的"清涼""攝山"，陳卓的"天壇"，"冶城"，柳堉的"天印"等畫，皆是依金陵名勝的各景點而作的命題畫（參見圖錄第3號）。

更難能可貴的是，柳堉在樊圻所繪的金陵尋勝圖卷的題跋中還記載了當時南京人收藏金陵山水畫，並以邀得名家作此命題畫為榮的風尚，被視為金陵勝事（參見圖錄第3號），並引用一句"唯有家山不厭看"的古詩來解釋這種特殊的現象。雖然這些地方山水畫的繁榮或許與商業有一定的關係，但這種來自社會的熱情要求和支持，足見南京人對自己故鄉的熱愛，這確實也是促使十七世紀金陵山水畫發達的原因之一。

總之，以金陵八家為首的金陵畫家，雖然各有師承，面目不一，但都能深入生活，以金陵近郊的山山水水為其粉本，融六法之精髓，入天然之丘壑，將熱愛故國故鄉的一腔真情，和滿腹懷戀，都傾注於山嵐變幻，草木蔚然的山水畫中，故使金陵山水畫獨樹一幟，在十七世紀的畫史上留下了輝煌的一頁。古人道：詩為心聲，畫為心印，書為心畫，明末清初的十七世紀，金陵畫家們所具有的獨特的藝術面貌，正是從特定的歷史文化環境所造成的，畫家們無限的傷心和滿懷勃鬱的精神氣質昇華而來，那種強烈的民族意識和愛國情結，正是金陵畫派山水作品內涵的共鳴，精神的統一，和靈魂的所在。"唯有家山不厭看"！一位西方學者巴瑞·提爾曾指出，南京是中國古都中最引人注目的城市，因為她曾經是並將永遠是中國最令人懷舊和動情的城市[146]。

確實，那千古的金陵歷史，千古的詩泉畫源，千古的文人之魂，正是十七世紀南京文化藝術繁榮的歷史基因，也正是她所具有的永恆魅力。

注釋

1. 傳世之作以顧愷之【論畫】，【魏晉勝流贊】，【畫雲臺山記】，謝赫【古畫品錄】，姚最【續畫品錄】，宗炳【畫山水序】，王微【敘畫】，梁元帝【山水松石格】等為主，其中，顧，宗，王，謝被認為是六朝繪畫理論的四大家。參見陳傳席【六朝畫論研究】，臺灣學生書局，1999。

2. 張彥遠【歷代名畫記】引顧愷之語，【古畫品錄】第319頁，上海古籍出版社，1991。

3. 謝赫【古畫品錄】第3頁，"六法者何也；一氣韻生動是也，二骨法用筆是也，三應物象形是也，四隨類賦采是也，五經營位置是也，六傳移模寫是也"。又依六法將畫家評為六品。上海古籍出版社，1991。

4. 宗炳"畫山水序"，載於嚴可均校輯【全上古三代秦漢三國六朝文】"全宋文"，卷二十，第2545-2546頁，北京中華書局，1958。

5. 陳傳席【六朝畫論研究】第165頁引王微的"敘畫"，臺灣學生書局，1999。

6. 王國維【人間詞話】第8頁，四川人民出版社，1981重印。

7. 郭若虛【圖畫見聞志】卷六，第568頁，載於【古畫品錄】，上海古籍出版社，1991，並參見王伯敏【中國繪畫史】第219頁，上海人民美術出版社，1983。

8. 葉楚傖，柳詒徵【首都志】卷三第231頁引三國時代蜀國軍師諸葛亮語，南京古舊書店，1985。

9. 美國學者F.W. Mote在其論文中，綜合國外學者的研究，對南京在經濟，軍事方面的優勢，亦有詳細和生動的論述，"The Transformation of Nanking, 1350-1400" in [The City in Late Imperial China] edited by G. William Skinner, Stanford University Press, Stanford, CA 1977。

10. 周應合【景定建康志】卷17，"山川志"序，第3頁，【欽定四庫全書】史部十一。

11. 蕭統【文選】卷二十八，南朝。謝朓"隨王鼓吹曲。入朝曲"，上海書店，1988。

12. 孫中山【建國方略】，第三部分，第467頁，北京華夏出版社，2002重印。

13. 歐陽海【南京氣候志】第17頁，載【南京文獻】第四冊，上海書店，1991重印。

14. 葉楚傖，柳詒徵【首都志】卷上，第3頁引，南京古舊書店，1985。

15. 張廷玉【明史】卷一"太祖本紀"，"成祖本紀"，卷四十"地理志一。南京"，北京中華書局，1974。

16. 【洪武京城圖志】第3頁，載【南京文獻】第一冊，第259頁，上海書店，1991重印。

17. 葉楚傖，柳詒徵【首都志】上冊第4頁，引【建康實錄】"始皇三十六年【當為三十七年】東巡，自江乘渡望氣者雲，五百年後，金陵有天子氣，因鑿鍾阜，斷金陵長隴以通流，至今呼為秦淮，乃改金陵邑為秣陵縣"，南京古舊書店，1985重印。

18. 美國學者F.W. Mote在其論文"The Transformation of Nanking，1350-1400"中，記述了各家對南京明代城牆實際

長度的討論，並引用美國軍隊於1945年製作軍用地圖時的測量結果，城牆的周長是為23.2英里，約70華里。G.William Skinner edited [The City in Late Imperial China]第136頁，Stanford University Press, Stanford, CA 1977。

19. 當時世界上其次的大城市為法國巴黎，城周為29.5公里。參見季士家，韓品崢主編【金陵勝迹大全】第91頁，南京出版社，1993。

20. 【明史】卷四十，【地理志一‧南京】"南曰正陽（今光華門），南之西曰通濟，又西曰聚寶（今中華門），西南曰三山（今水西門），曰石城（今漢西門），北曰太平，北曰天平，北之西曰神策（今和平門），曰金川，曰鍾阜，東曰朝陽（今中山門稍南），西曰清涼，西之北曰定准，曰儀鳳（今興中門）"，北京中華書局，1974。

21. 【明史】卷四十，【地理志一‧南京】："東曰姚坊（今竟化門），仙鶴，麒麟，滄波，高橋，雙橋，南曰上方，夾崗，鳳台，大馴象，大安德，小安德，西曰江東，北曰佛寧，上元，觀音"，北京中華書局，1974。

22. 顧起元【客座贅語】卷三，第70-71頁，北京中華書局，1997重印。

23. 玲木敬編輯【中國繪畫總目圖錄】第3卷，第112頁，JM3-061，東京大學，1983。

24. 【同治上江兩縣誌】卷二十九，敘錄，江蘇古籍出版社1991年重印。

25. 顧起元【客座贅語】卷二，第64頁，北京中華書局，1997重印。

26. 蔣贊初【南京史話】第138頁，南京出版社，1995。

27. 顧起元【客座贅語】卷六，第193-194頁，北京中華書局，1997重印。

28. 方豪【中西交通史】下冊，第914頁，中國文化大學出版部。

29. 張岱【陶庵夢憶】卷一，第4頁，吉林文史出版社，2001重印。

30. 張星銀【中西交通史料彙編】第一冊【古代中國聞見錄】，中古七大奇迹還包括中國萬里長城，英國沙利斯布里石環，土耳其的索菲亞大清真寺。北京中華書局，1977。

31. 顧起元【客座贅語】卷一，第23-24頁，北京中華書局，1997，冒辟疆在其【影梅庵憶語】一書中亦道："士民競以華服相誇耀，鄉間婦女亦好為華服"，上海古籍出版社，2000。

32. 陳作霖【金陵瑣志】卷二"金陵物產風土志"，第15頁，清光緒乙酉本（1885）。

33. 季士家，韓品崢【金陵勝迹大全】第757頁，南京出版社，1993。

34. 鄧之誠【古董瑣記】第260頁，記載有人偶爾買到明代禦史左懋第題書的扇子，贊其精妙而寶之，於此可見一斑。中國書店，1991。左懋第（1601-1645）字蘿石，山東萊陽人，崇禎進士，任戶部給事中，南明政權時任禦史，北上與清議和，南京失守，拒降被殺，【辭海】第156頁，上海辭書出版社，1979。

35. 張瀚【松窗夢語】卷四，第74頁，上海古籍出版社，1986。

36. 顧起元【客座贅語】卷二，第67頁，北京中華書局，1997年重印。

37. 該畫曾為"常熟翁氏舊藏"，署名為"明人所繪南都繁會景物圖卷"，畫面尾署"實父仇英制"，為設色絹本，高44釐米，橫350釐米，現藏中國歷史博物館，論文見王宏鈞，劉如仲【明代後期南京城市經濟的繁榮和社會生活的變化】載

38. 【中國歷史博物館館刊】，1979，總第一期，第99－106頁。

38. 陳作霖【炳燭里談】卷中，南京十竹齋，1963重印。

39. 金鼇【金陵待征錄】卷八，第1頁，光緒二年（1876）金陵刻本。

40. Till, Barry [In Search of Old Nanjing], P. 105, Hong Kong: Joint Publishing Co., 1984.

41. 蔣贊初【南京史話】第130頁，南京出版社，1995。

42. "豆版"，即一幅畫用幾十塊板子，分別先後輕重，印刷幾十次後，將畫幅中花葉的顏色深淺和陰陽向背表現出來的技法。另有"拱花"，即不用任何顏色，只將紙壓在雕有花紋的凸板上印成的技法著稱。

43. 陳作霖【金陵瑣志五種】卷二"金陵物產風土志"，第14頁，清光緒乙酉本，哥倫比亞大學中文圖書館書號3069.8174.6。

44. 孔尚任【桃花扇】第29出，第136頁，臺灣商務印書館，1974。

45. 錢杭，承載【十七世紀江南社會生活】第188頁，臺北南天書局1998。

46. 金鼇【金陵待征錄】卷八，第7頁，光緒二年（1876）金陵刻本。

47. 吳承學【晚明小品研究】第108-109頁，公安派以湖北公安袁宗道，袁宏道和袁中道三兄弟為代表，為文主張自然坦率，抒發性靈。竟陵派以湖北竟陵人鍾惺，譚元春為代表，提倡以"幽深孤峭"的藝術風格來表現"幽情單緒"的內容。江蘇古籍出版社，1999。

48. 鈴木敬編輯【中國繪畫總目圖錄】第二卷，S7-045，第53-54頁，東京大學，1983。

49. 錢杭，承載【十七世紀江南社會生活】第234頁引徐渭【南詞敘錄】，臺北南天書局，1998。

50. 錢謙益【牧齋初學集】卷16，"冬夜觀劇歌"，載【四部叢刊初編‧集部】，上海書店出版社，1989。

51. 張岱【陶庵夢憶】卷四記載在泰州客店的演藝和卷五記載蘇州八月十五節慶時的演藝，第93和109頁，吉林文史出版社，2001年重印。

52. 林樹中"龔賢年譜"載【東南文化】第5期，第51頁引【扶輪廣集】卷七，龔賢"寄范璽卿社長"，南京博物院，1990。

53. 【古今圖書集成。職方典】第6100頁，臺灣鼎文書店，1985。

54. 【列子。湯問】卷三，第61頁，"伯牙善鼓琴，鍾子期善聽。伯牙鼓琴，志在登高山，鍾子期曰：'善哉！峨峨兮若泰山。'志在流水，鍾子期曰：'善哉！洋洋兮若江河。'伯牙所念，鍾子期必得之。伯牙遊於泰山之陰，卒逢暴雨，止於岩下，心悲，乃援琴而鼓之。初為霖雨之操，更造崩山之音，曲每奏，鍾子期輒窮其趣。伯牙乃舍琴而歎曰：'善哉，善哉！子之聽夫志，想象猶吾心也，吾於何逃聲哉！'載【諸子集成】，上海書店出版，1986。

55. 謝國楨【明清之際黨社運動考】第8頁，中華書局，1982。

56. 明末四公子還有方以智，陳貞慧，侯方域。

57. 金鼇【金陵待征錄】卷八，第7頁，光緒二年（1876）金陵刻本。

58. 蕭平，劉宇甲【龔賢】第3頁引，吉林美術出版社，1996。

59. 林樹中"龔賢年譜"載【東南文化】第5期第51頁，引【扶輪廣集】卷七，龔賢"寄範璽卿社長""十五年前曾拜翁，發如好女朱顏童。秦淮大社壇上，百二十人詩獨雄。薛岡並坐黃居中（明立），鄭（千里）魏（考叔）張（隆父）林

（茂之）位次同。詞客錙銖不足數，衣冠劍佩聯星虹。出僧
榖語與介立，眉生雙玉衫袖紅。是時顧二（顧與治）猶小
友，依柱若吟愁未工。翁攜鸚鵡毛五色，玉為飲門金織籠。
口誦心經終一卷，懸之飛閣臨青空。齊侯張宴內家地，欄外
雪消春水融…須臾日夕動簫鼓，俳優傀儡登幾叢，金陵一時
稱勝事，鍾山紫氣曾龍從…”，範鳳翼號墅卿，官太祿寺
卿，東林黨要人，詩中所提諸人：薛岡，東林黨人，黃居
中，金陵藏書家，鄭千里，魏之金陵畫派先驅畫家，張隆
父，林茂之，皆當時文人。南京博物院，1990。

60. 林樹中【龔賢年譜】載【東南文化】第5期，第68頁，南京
博物院，1990。

61. 時人稱社團的領導為“社長”，彼此間稱呼為“同學”或“同
志”，見陸世儀【復社紀略】卷一，卷二，楊鳳苞【秋室集】
卷五，王慶奎【柳南續筆】卷二。畫見【金陵八家畫集】
第324頁，天津人民美術出版社，1999。

62. 錢杭，承載【十七世紀江南社會生活】第91頁引陳維崧【陳
迦陵詩文詞全集】“冒辟疆序”，臺北南天書局，1998。

63. 梁白泉主編【南京博物院藏寶錄】第264頁，上海文藝出版
社及三聯書店，1992。

64. 【南京民間故事】太平軍破地道陣】第98頁，“李太白跳
月”，江蘇人民出版社，1962。

65. 【太平寰宇記】和【秣陵集】皆記載南京的杏花村即?杜牧
詩中所指者，但仍有爭議。杜牧的“清明”詩道：“清明時
節雨紛紛，行人路上欲斷魂，借問酒家何處去，牧童遙指杏
花村”。詩載明代謝榛【四溟詩話】卷一，【詞源】第824
頁，商務印書館，1998。

66. 顧起元【客座贅語】卷九，第303頁，北京中華書局，1997
年重印。

67. 錢杭，承載【十七世紀江南社會生活】第302頁引王焯【今
世說】，臺北南天書局，1986。

68. 周亮工【讀畫錄】卷四，第56-58頁，“…還思西園雅集古來
幾？合寫團扇留君家。”【畫史叢書】第九冊，上海人民美
術出版社，1963。

69. 錢杭，承載【十七世紀的江南社會生活】第303頁引王焯
【今世說】，臺北南天書局，1998。

70. 林樹中"龔賢年譜"載【東南文化】第5期，第64頁，引日本大
阪美術館藏龔賢"書畫合璧冊"詩九之九，南京博物院，
1990。

71. 蕭平，劉宇甲【龔賢】第30頁引，吉林美術出版社，1996。

72. 鈴木敬主編【中國繪畫總圖目錄】第四卷，JP34-074，第394
頁，東京大學，1983。

73. 陳作霖【金陵瑣志五種】卷二“金陵物產風土志”，第5頁，
清光緒乙酉本（1885），哥倫比亞大學中文圖書館號
3069.8174.6。

74. 顧起元【客座贅語】卷四，第133頁，北京中華書局，1997
重印。

75. 吳應箕【留都見聞錄】卷三，第三頁，載【金陵秘笈】，征
獻樓民國三十七年【1948】刊本，南京博物院圖書館藏書。

76. 甘熙【白下瑣言】卷六，第9頁，民國十三年【1924】刻
本，南京圖書館古籍部書號50063。

77. 陳作霖【金陵瑣志五種】卷二“金陵物產風土志”第5頁，
清光緒乙酉本（1885）哥倫比亞大學中文圖書館號
3069.8174.6。

78. 吳承學【晚明小品研究】第66頁引屠隆【盆玩】，江蘇古籍
出版社，1999。

79. 鈴木敬編【中國繪畫總合圖錄】第四卷，JP68-001，第516
頁，東京大學，1983。

80. 蕭平，劉宇甲【龔賢】第23頁引，吉林美術出版社，1996。

81. 孔尚任“答龔半千”剳雲：“得妙染佳詩，充盈幾案，小小
劃子，人亦指？書畫船，頓令坐蓬窗，持茶杯者，鬚眉顧
盼，皆有風度，誰謂人俗不可醫？”孔尚任【詩文集】卷七
“剳”，丙寅丁卯存稿，北京中華書局，1962。

82. 文震亨著，陳植校注，楊超伯校訂【長物志校注】卷一，第
31頁，和卷十二，第418-419頁，江蘇科學技術出版社，
1984。

83. 【中國古代書畫圖目】第二卷，第327-329頁，文物出版社，
1995版。

84. 余懷（1616-1696）【板橋雜記】“雅遊”，第3-4頁，上海大達
圖書供應社，1934，哥倫比亞大學中文圖書館號54298994。

85. 謝肇淛【五雜組】卷三，第22頁，日本，平安書肆，寬政
7年（1795）刻本，哥倫比亞大學善本藏書。

86. 張岱【陶庵夢憶】卷五，第105頁，吉林文史出版社，2001
重印。

87. 錢杭，承載【十七世紀的江南社會生活】第91頁引陳維崧
【陳迦陵詩文詞全集】，“冒辟疆序”，臺北南天書局，
1998。

88. 餘懷【板橋雜記】第5頁，上海大達圖書供應社，1934。哥
倫比亞大學中文圖書館。

89. 杜甫著，高仁標點【杜甫全集】卷一，第1頁“奉贈韋左丞
丈二十二韻”，上海古籍出版社，1996。

90. 周積寅編【中國畫論輯要】第394頁引李日華[墨君題語]，江
蘇美術出版社，1997。

91. 周亮工【讀畫錄】卷一，第2頁，載【畫史叢書】第九冊，
上海人民美術出版社，1963。

92. 周亮工【讀畫錄】卷一，第3頁，載【畫史叢書】第九冊，
上海人民美術出版社，1963。

93. 【說郛續】卷三十二，第1頁，明刻本，中國圖書館號
6346。

94. 1684年作，藏中國旅順博物館，見【金陵八家畫集】第83
頁，天津人民美術出版社，1999。

95. 林樹中“龔賢年譜”【東南文化】第5期，第61頁，引上海博
物館藏畫，第5期，南京博物院，1990。

96. 林樹中“龔賢年譜”【東南文化】第5期，第66頁，南京博物
院，1990，引故宮博物院藏龔賢“水墨山水”題跋，載於
【虛齋名畫錄】卷6著錄。

97. 姚最【續畫品】“湘東殿下”，載【古畫品錄】第14頁，上海
古籍出版社，1991。

98. 蕭平，劉宇甲【龔賢】第111頁引周二學【一角編】乙冊，
上海人民美術出版社，1986。

99. 藏北京大學圖書館，見於【北京大學圖書館藏書展覽
Exhibition of the Peking University Library's Collection】第24
頁，北大和日本有鄰堂出版，1987。

100. 【金陵八家畫集】，第65頁，故宮博物院藏，天津人民美術
出版社，1999。

101. 蕭平，劉宇甲【龔賢】第21頁，吉林美術出版社，1996。

102. 周亮工【讀畫錄】卷三，第42頁，【畫史叢書】第九冊，上
海人民美術出版社，1963。

103. 玲木敬編輯【中國繪畫總目圖錄】第四卷，JP30-020，第331
頁，日本東京大學，1983。

104. 畫作參見【金陵八家畫集】第79和80頁，天津人民美術出版
社，1999。

105. 董其昌【畫禪室隨筆】，沈子丞編【歷代論畫著彙編】，第

269頁，北京文物出版社，1982。

106. 劉綱紀【歷代畫家評傳】卷下，"弘仁與髡殘"第28頁，香港中華書局，1986。

107. 錢泳【履園叢話】卷二十三，第604-605頁，"雜記"："國初魏叔子（即魏禧）嘗言：人生一世間，享上壽者不過百歲，中壽者亦不過七八十歲，除老少二十年，而即此五、六十年中，必讀書二十載，出遊二十載，著書二十載，方不愧'讀萬卷書，行萬里路'"。北京中華書局，1997。

108. 王思任【清課詩引】載【文飯小品】卷二："清者，天之所爭也。癡雲昏露，暴雨終風，有以閟之，則其心不快。每見秋澄碧落，境界愈高，天心愈杳，愈覺矜喜，乃知最上之物，天自取之，其中於人也，為佛為仙，為聖賢豪傑。人世有五福而清不與，清又天之所最吝也"。長沙嶽麓書社，1989。

109. 【袁宏道集箋校】卷十一，【張幼於】，上海古籍出版社，1991。

110. 林樹中"龔賢年譜"第62頁引【龔賢冊頁】，【東南文化】第5期，南京博物院，1990。

111. 吳承學【晚明小品研究】第67頁引，【翠娛閣評選屠赤水先生小品】卷一，江蘇古籍出版社，1999。

112. 周積寅【中國畫論輯要】第153頁引明。唐志契【繪事微言。名人畫圖語錄】，江蘇美術出版社，1997。

113. 王伯敏【中國繪畫史】第483-485頁，上海人民美術出版社，1983。

114. P.J. Donnelly [Blanc de Chine] P.354 with potters' seals, London, Faber and Faber, 1969。

115. 錢杭，承載【十七世紀江南社會生活】第87頁引趙翼【二十二史劄記】卷34，臺北南天書局，1998。

116. 徐沁【明畫錄】，載於盧輔聖主編【中國書畫全書】第十冊，第1-36頁，上海書畫出版社，1994。

117. 根據【中國古代書畫圖目】記載的金陵畫家的紀年作品，最早的為崇禎16年（1643）由樊圻所繪的人物扇面，由北京故宮博物院收藏，最晚的為陳卓所繪的壽星圖，畫於康熙52年（1713），由上海文物商店收藏，若以此紀年為依據，這批為歷史上各家所稱的金陵畫家的繪事創作已長達70年，事實上加上其首尾的萌發和延續，和未紀年的作品，這批畫家活躍的時間當更久。承蒙梁白泉先生指示。

118. 周暉【金陵瑣事】卷二，"吳小仙春日同諸王孫遊杏花村，酒後甚渴，從竹林中一老嫗索水飲之，次年複與諸王孫遊之，老嫗已下世數月，小仙目想心存，遂操筆寫其象，與生時無異，老嫗之子得之，大哭不休"，北京文學古籍刊行社，1955。

119. 石守謙【風格與世變：中國繪畫史論】，臺北允晨文化公司，1996。

120. 臺北故宮博物院藏【周亮工集名家山水冊】，參見林樹中【龔賢年譜】，載【東南文化】第5期，第58頁，南京博物院，1990。

121. Hongnam Kim【Life of a Patron】, New York, China Institute Gallery, 1996。

122. 蕭平，劉宇甲【龔賢】第26頁，畫冊藏於臺北故宮博物院，吉林美術出版社，1996。

123. 上海博物館藏【龔半千自書詩稿】真迹，上海圖書館藏抄本。

124. 【金陵八家畫集】第120頁，天津人民美術出版社，1999。

125. 【金陵八家畫集】第294頁，天津人民美術出版社，1999。

126. 陳開虞著【江寧府志】卷二，第1-43頁，康熙6年刻本，北京大學圖書館藏。

127. 周亮工【讀畫錄】卷一，第8-9頁，載【畫史叢書】第九冊，上海人民美術出版社，1963。

128. 周亮工【讀畫錄】卷一，第9頁，載【畫史叢書】第九冊，上海人民美術出版社，1963。

129. 也有學者考證認為方文的【嵞山集】中首先提出"繪事江東有八家"之說，但其僅提出樊圻一名而已。而周亮工約在1663年品評了金陵八家，參見林樹中【龔賢年譜】，載【東南文化】第5期，第57頁，南京博物院，1990。

130. 張庚【國朝畫徵錄】，載盧輔聖主編【中國書畫全書】，第十冊，第428頁"龔賢字半千號柴丈，家昆山流寓金陵。為人有古風，工詩文，有香草堂集若干卷，善書畫，家貧，歿不能具棺殮，會曲阜孔東塘客遊金陵為經理其後事撫其孤子收其遺文，半千得北苑法稱沈雄深厚蒼老矣惜秀韻不足耳，同時有聲者，樊圻字會公，高岑字蔚生，鄒喆，典之子，字方魯，吳宏字遠度，葉欣字榮木，胡慥字石公，謝蓀字緗酉，號金陵八家。"，上海書畫出版社，1996。

131. 參見周亮工【讀畫錄】有關各位畫家的記載，【畫史叢書】第九冊，上海美術出版社，1963。

132. 【金陵八家畫集】單國強序文，天津人民美術出版社，1999。

133. 歐陽海【南京氣候志】第2頁，載【南京文獻】第4冊，上海書店，1991。

134. 顧起元【客座贅語】卷十，第311頁，北京中華書局，1997重印。

135. 葉楚傖，柳貽徵【首都志】卷三，第233頁和242頁引【建康志】"引金陵地志，蔣山本少林木，東晉令刺史罷還都種松百株"，【輿地志】"宋時令刺史栽松三千株，下至郡守各有差"。【秣陵集】"孝陵之建，有松十萬株，長生鹿千"。上海書店出版，1991重印。

136. 季伏昆主編【金陵詩文鑒賞】，和俞律，馮亦同編【詩人眼中的南京】，南京出版社，1998。

137. 蕭平，劉宇甲【龔賢】第321頁引，吉林美術出版社，1996。

138. 蕭平，劉宇甲【龔賢】第300頁引'龔半千自書詩稿。題夏茂林小像'。吉林美術出版社，1996。

139. 美國克利夫蘭博物館藏石濤山水冊頁"秦淮憶舊"，館藏號66。31。

140. 陳壽撰【三國志】卷61【吳書。陸凱傳】第1399頁，北京中華書局，1959。

141. 龔賢，江蘇昆山人，高岑，浙江杭州人，鄒喆，江蘇吳縣人，葉欣，華亭松江人，謝蓀，江蘇溧水人，吳宏，江西金溪人，蔡澤，江蘇溧水人，陳卓，北京人。參見俞劍華【中國美術家人名大辭典】，上海人民美術出版社，1996。

142. 蕭平，劉宇甲【龔賢】第347-348頁引自卓子任【明末四百家遺民詩】卷八，吉林美術出版社，1996。

143. 季家勝，韓品崢【金陵勝迹大全】第702頁，南京出版社，1993。

144. 蕭平，劉宇甲【龔賢】第40頁，吉林美術出版社，1996。

145. 【金陵八家畫集】第79，80，120，210，224，304-305頁，天津人民美術出版社，1999。

146. Till, Barry [In Search of Old Nanjing] P.105, Hong Kong: Joint Publishing Co., 1984。

南京的藝術

李鑄晉

南京在中國歷史，政治及文化上一直都具有一個很重要的地位。從地理位置上來看，她不僅是長江下游的一個重鎮，而且在歷史上也曾是一些較短的朝代及較小的王國的首都，但是它的地位卻遠不如歷史上的長安（現在的西安），洛陽，臨安（現在的杭州），及北京等古代都城，也比不上其他的名城如蘇州，揚州，及上海等。一般人很少聽到關於南京畫派的説法，雖然歷史上確實存在這樣的一個畫派。從藝術上來看，南京歷來就產生了不少的名畫家。這就是目前這一個展覽以南京博物院藏品為主的主要目的。

南京為清初之文化中心

清朝初年，南京成為一個文化中心。它的地理位置，一是長江下游的主要城市，二是接近長江與運河相交之處，使它成為整個江南自南宋以來逐漸發展成全國文化最興盛地區的主要城市。除了南宋的首都杭州以外，其他的城市如蘇州、徽州、及其他別的城市都成為小的文化中心。不少的著名畫家，如吳彬、弘仁、髡殘、石濤、程正揆、鄒之麟、及其他，雖然並非南京本地人仕，卻以南京畫家而名于世。其實其中有數位畫家後來都命為"遺民"，因為他們在入清以後仍持有對明朝衷心之感。他們的藝術表現了一種獨立不屈的精神而有創新。他們之來到南京也許是因為南京是南明的首都因而反映了強烈的明朝的精神。

另一方面，也就在清初的時候，一群本地畫家出現並成為南京的名畫家。其中最著名的是稱為金陵八家的龔賢、樊圻、高岑、吳宏、胡慥、葉欣、鄒喆、與謝蓀。首先，曾與多位上列畫家為友的文人周亮工在其【讀畫錄】提到這八家。其後另一文士，張庚，在其【國朝畫徵錄】一書中，首先稱他們為金陵八家。他們雖從各地而來但都在南京度過盛年，他們雖然各有各的個人作風，卻都在生活上有共同的風格，他們都有過簡樸的一生，也從未在清廷作官。在他們的畫作中，也都表現了獨立的精神，走向各種不同的方向。

此外，還有一些南京的畫家不屬於這八家之內。其中

有數位畫家，本不屬於這一組，但生於南京，包括張風。此外有多位畫家，雖非生於南京，卻在南京定居，包括道濟、髡殘、吳彬、查士標及其他。關於南京在當時的重要性可見于龔賢在為其友周亮工所作之畫冊中所提到的情形："今日畫家以江南為盛。江南十四郡以首都為盛，郡中著名者且數十輩，但能吮筆者奚啻千人"。

這一題跋反映了清初南京的重要地位。

南京藝術的特質

晚明之際，尤其是在江南，不少地區都具有很清晰而易於辨識的風格，這些畫派之中，每一個都有一個或數個畫家為首領。其中最重要的就是位於蘇州的吳派，以沈周與文徵明為首，是明代最能代表文人畫派的大師，其他還有唐寅與仇英等，也有明顯的個人風格。此外還有浙派，以浙江人戴進為首，與吳派追求詩意的文人畫完全不同，他追隨南宋畫院的傳統，繪畫多數用較大而粗的筆觸，有時稱為"大斧劈"皴的，以及較為戲劇性的構圖。此外還有松江派（或稱華亭派），以曾在朝廷任高官的董其昌的理論與風格為代表。他的作品多受宋元名家影響，但又以吳派的文人作風為主。此外還有新成立的徽派，為安徽省的畫家，繪畫以幹筆為特點。此外，在這個階段中，還有幾個新的畫派，例如四五派與揚州派二者為最重要。

但是南京與上面所提到的各種地區的畫派不同。它並沒有一系列的特徵或是一個雄視一方的畫家來影響整一代的年青畫家來追隨他的作風。雖然其他各地的畫家常到南京，帶來其各自的風格，而此時活躍于南京的畫家也表現出其他畫派的特點，例如吳派、浙派、華亭派，以至於徽派等，但卻未產生領導時代潮流的影響。此外，南京本地的畫家中，並沒有任何一個曾在宮廷或官府任要職，或以其家資財力而邀人注目。唯一例外的是龔賢。他在入清以後就成為一個隱士，晚年尤為貧困，除了少數追隨者外，不足以召喚眾多

的後輩來弘揚他的畫風。因此，南京畫派的面貌並不十分清晰。

南京藝術的另一種特徵是它在歷史上有一陣陣的創造力的表現，但都僅曇花一現，不能繼續而成為一個長期的傳統。這最明顯的是在東晉時代的兩位書法家王羲之及獻之。他們雖在後世被尊崇為最高成就的大師，影響全國，但在其家鄉卻未能影響晚輩。同樣的，南唐時的幾位畫家如董源巨然等，雖對後世全國畫風有極大影響，卻沒有構成一種南京畫風的傳統。從清初直到十八世紀中，情形也是一樣，雖然在龔賢、道濟及髡殘的作品中，都表現出一股極強的創造力，但他們的畫風都沒有得到延續，這是南京畫派的一個特點。

上文提到的"金陵八家"雖然並非一群志同道合的畫家，風格也各異，但其繪畫足以提供對金陵畫家的認識，且讓我們從幾個畫家的成就中來作一瞭解。

金陵畫派的畫家

清朝初年是南京文化發展史上的黃金時代之一，產生了不少的文學家、戲劇家及藝術家。其中有不少藝術家，雖非生於南京，卻因南京的文化環境或者藝術的市場，而到南京來定居。除了許多著名的外來定居或常來的畫家如道濟、髡殘、查士標及其他許多人外，在南京最活躍的一群就是被稱為"金陵八家"的。其中以龔賢為最著名。目前這一個展覽即包括大半這些名家的作品來反映當時各種不同的畫作及其盛況。在此我們先提及"金陵八家"中之七家，至於龔賢則留待下文再談。

八家之中的樊圻（1616-約1694），正如龔賢一樣，一般認為是南京畫派的領導人物。他生於一六一六年，較龔賢長兩歲。而且長壽，活到九十餘歲。在這展覽中有他的五件作品，可以代表他一生繪畫經歷的不同階段，反映了他多方面的才能。最先的一張是【金陵尋勝圖卷】，描寫南京的勝境，以直接，屬實的手法而作，並有當時著名文人所書的題辭。與這畫對比的是清初金陵秦淮河的一個名妓寇湄的小像，作於1651年，由樊圻畫像，背景則為另一位金陵八家之一的吳宏所作。這張小像，在樊的作品中是例外，因為他的畫多為山水，以宗師北宋山水的雄奇為主，正如另一張於1666年所作的山水雪景所見。但他有時在一些小畫中描寫他舊日的感覺，如【金陵八家山水冊】中有

一頁寫一位文士坐於四面蘆葦及石塊之中，表現一個詩意的情調。他最奇妙的作品是一張長卷，表現一條河流的景色，沿途有不少的山石，顯露了他對宋人山水的仰慕。這張畫現藏于德國柏林東亞美術館，可以充分地表現他多方面的才能。總體來說，他的山水卷表現了他一方面從黃公望的山水傳統中出來，但另一方面又具有浙江派山水畫的特色。

至於其他金陵六家，關於他們的生平，一般所知很少。其實他們為何被選為金陵八家，亦不可知。但從金陵八家扇面冊來看，就不難發現他們在構圖及筆法方面都受到宋元名家的影響。在這一冊的八張扇面中，除了龔賢及樊圻所作的兩幅外，最特別的為謝蓀的扇面，就像洋洋大觀的一幅狂想的山水畫，充滿了許多奇妙的細節。全景有不少高聳入雲的山峰從近景直至遠處，左面有怪誕的山石及樹木，以及一個宏大的瀑布從岩石與雜樹間直瀉而下，直到最深遠處的指天山峰。中部有一岩洞，從頂上垂下不少鍾乳奇石。在洞之上有許多房舍，好像一個小鎮一般。從這裏直望扇面正中的遠處，可見一個高聳的寺塔。扇的右面有數株巨樹從一個高山的山脊伸出，它的強大使下面乘車而行的一位旅客顯得十分細小，他正向著岩洞上的小鎮而行。這是一個很複雜的構圖，不但使人想起一些宋畫家的山水，也與謝蓀同時而居住在城外一個寺院的畫家吳彬所作的山水相似。此冊中還值得注意的另一扇面是高岑的畫，描寫一位女士坐於小船頭，漂於河上，四面環山及大樹，均用墨畫成，這種風格顯然易見地來自元朝畫家吳鎮。高岑還有另一張力作藏于南京博物院，題為【秋山萬木圖】。據其自題此軸系臨北宋畫家范寬所作同題之畫。此畫構圖以上部高山頂上有奇形的樹石，與臺北故宮博物院所藏之【秋山行旅圖】所寫的相似。此外冊中另有一扇面亦從宋元名畫而來者為葉欣之扇，其構圖似宋人，其筆法似元人。此外同冊中另一扇面為鄒喆所作，其山水亦有同樣之宋構圖及元筆法者，畫面亦以奇山峻嶺為主，間有樓閣。

這幾位金陵畫家表現了承襲各種不同傳統而形成的畫風，而龔賢的繪畫則大不相同。其實這種素質與龔賢的創造力是一個很強的對比。龔賢作為他那時代最偉大的畫家之一，象道濟、髡殘、梅清等人一樣，其作品具有很強的創新意識與有力的表現。

以這幾位南京畫家為首的金陵畫派，在清初的南京文化藝術舞臺上可謂是曇花一現，沒有延長。但其中幾

位最偉大的畫家，包括龔賢、樊圻、道濟、髡殘、與查士標等都為中國的山水畫作出了貢獻。其實金陵畫派的全部發展，都在當時出版的一本書即王概的【芥子園畫譜】中可見。王概是一個南京畫家，他利用當時新發明的彩色木板印刷術來編寫這本畫譜，正反映當時這種印刷術通用之廣，並將全部中國繪畫史自古直到當代以南京所見的國畫為主，都編入譜中。這些情形都反映了當時南京的藝術氣氛，確實不愧為一個文化中心。

南京首席畫家龔賢

龔賢（1618-1689），毫無疑問是這一時代中南京所產生的最偉大的畫家。龔的父母原是上海附近的昆山人，在龔賢年幼時移居南京。龔賢便在南京長大，他年青時大概對於晚明普遍的政治腐敗十分失望，因此與當時不少文士都參加的復社來往密切。復社是晚明時代江南一帶的文人組織，希望可以恢復儒家在政治上的精神。龔賢為了要躲避當局的注意，曾數次搬遷以避嫌。到了清軍佔領南京之後，他就離開南京而在蘇北一帶流浪長達十年之久。到了江南安定之後，他回到南京，過著較清苦的生活。他在城郊的清涼山住下，以教書畫為生。他的晚年似乎十分窮困，在他逝世後，他的家人無力為之舉行葬禮，結果是由他的一位至友孔尚任幫忙。孔是以【桃花扇】而著名的劇作家，孔為他收拾後事，並撫養其子，及出版他的一冊論文。

龔賢早年的畫作極為稀少。因此關於他早年的師承以及他早期畫藝的發展，我們所知甚少。但他的晚年，尤其他在明亡後流浪十年之後，其畫作達到了一個很優秀的階段。在堪薩斯城的尼爾遜‧阿特金斯博物館就有幾張佳作。首先是一本水墨山水畫冊，包含他各種不同的作品及多種的畫風。其中有數張系仿北宋畫家董源和巨然的雄偉山水。另有數頁則描寫他個人或他友人的隱居之地。在同一博物館中又有兩件手卷由真山真水而來，代表他的畫藝完全成熟的最高成就，起伏的崇山與彎曲的河流充滿全卷，這種山河互相交錯的發展正是他畫藝的最佳表現。此外，在瑞士蘇黎世城的瑞堡博物館，有他的一張立軸，名為【千岩萬壑】亦為其代表作。該畫為長方形，起伏的山峰丘嶺表現於不同的排列中，時而橫向，時而直趨，大部分都構成為三角形，從近景一直延伸到最深遠處，在這些形象之間有數條橫列的白雲及直趨之瀑布，在黑白相向的比照間，縱橫地構成一個陰暗而深沈的境界。

這是他晚年的標準風格，暗示了明亡之後他仍然忠於明朝的精神。這張立軸可說是集龔賢優秀品質於大成的傑作

南京博物院藏有數件龔賢的繪畫，可以表現他一生發展的幾種風格。首先，第一張是【秋江漁舍圖】，這畫很明顯是承襲元代畫家吳鎮及倪瓚的畫風。在構圖上此畫分成上下兩部。上部寫河上或湖泊的遠處的群山，用較粗的線條鈎勒而用淡筆作渲染。下面則寫幾株樹木及一排房舍在數個沙洲上，用平行的筆觸及點子畫成。這種寧靜的河上風光直接從上述的元畫家發展下來。此景中部有一個孤獨的亭子站在河的中間，似乎就是龔賢本人當時境遇的象徵，無疑是龔賢畫作的特點之一。在畫的最上部，有畫家自題詩一首，是文人畫傳統的標準之作。以風格而言，這應該是一六六零年代的作品，是龔賢四十多歲時所作。

以年代而論，第二張作品應該是一張扇面【山亭溪樹圖】，寫一比較複雜的構圖。左面以八株松樹為主，右面則為數列石壩與河流。在畫的中部我們又可以見到一個孤獨的亭子。在這畫中，龔賢後期作品最獨特的筆法已經形成，即用一種較粗的線條來畫樹木或山石，其間用數點黑墨，這是集元代四大家而成的特徵。即使在一個很小的構圖中我們就可以見到他在構圖與表現上已形成了他個人的畫風。

南京博物院所藏的五件龔賢的作品中最重要的是一幅很長的手卷，亦名為"千岩萬壑"，與瑞士蘇黎世的瑞堡博物館收藏的立軸同名。描寫一連串的山頭起伏於一條河流或湖泊中，有一開一合的節奏，延綿不斷地達到二點九米之長：從平行的水波與直立的樹木，到石塊，山頭與高山起伏不斷的斜線，再加上偶然出現的瀑布，山舍，石塔等細節，使這一卷成為一件黑白相間變化萬端的傑作。這不僅是龔賢本人的佳作，也是中國繪畫史上的完美作品。它是龔賢一生中最有創造力時代的作品，那時他正是五十歲。在這一個階段中他曾完成了數件長卷，都是與這一張有異曲同工之妙的傑作，包括北京故宮博物院之一件和堪薩斯城尼爾遜博物館所藏的兩件。

除了上述的長卷之外，南京博物院還有其他兩件龔賢的作品，在風格上屬於他晚年約在六十到七十歲間的作品。其一是【夏山過雨圖】軸。此畫構圖較為簡單，前景有十二株高高的大樹，而背景則有無數高山延綿不絕，從前景一直到背景深處到全畫的最高處。

這件作品也許是畫在較吸水的宣紙上，以致于所有的樹木均黑，而山巒較敦厚，但缺乏了他在幾張長卷中所表現的大自然裏所有事物變化多端的活力。其他的一張，也是扇面，在【金陵八家扇面集冊】中。它的構圖與上面提到的【山亭煙樹】扇相若。但與前扇不同的是筆法粗而快，與他晚年作品相若。這都表現他晚年時對一切較熟悉，因而感到一切自如而用較粗較快的筆來作畫了。

南京對中國藝術的貢獻

南京在中國地理上，是長江下游的一個重鎮，在歷史上，從春秋戰國以來，一直都是軍事與政治舞臺上的一個重要角色。在文化上，具有其優良的傳統，在藝術方面，也有很高的成就。在書法史上，王羲之、獻之父子，將書法從早期的篆隸以至於楷書的整整齊齊的寫法中解放了出來，而發展到行草的變化多端。在畫史上，南唐的董源和巨然，都是在從人物畫轉變到山水畫的過程中，從早期的嚴謹發展到自我表現的大師。其後在明末清初之際，一群富有新意的創造者如道濟、髡殘及龔賢等明遺民都有他們輝煌的成就。

到了清朝中葉，長江下游有了新的發展。一是揚州的興起，成為全國東西與南北交通樞紐，尤其到了乾隆時代最盛。二是上海的新發展，主要是在鴉片戰爭以後，從十九世紀中葉，上海及其他各地都先後成立租界，以致西方的影響，陸續不斷到中國來。南京離這兩個新興的城市不遠，因此也受到一些影響，而繼續有些發展。不過在全國的文化發展中，已不能扮演重要的角色。不過在政治上，南京確曾一度有新的開展。十九世紀中葉由洪秀全領導的反抗清朝廷的運動，從南方開始，數年之間，支配了長江流域以南的地區，就在南京建立了太平天國，統治了十多年。不過因為時間不足，不能建立一個新的文化。到了1863年之後，全部瓦解，南京因此也受了很大損失。

到了二十世紀，南京再在全國的政治發展中演了一個重要的角色。最先在一九一一年辛亥革命之後，孫中山在南京成立了臨時政府，成為全國首都。不過，在民國初年政治動蕩甚烈的期間，政治中心多仍回到北京。其後到了一九二七年，當蔣中正領導北伐軍達到長江流域之後，又在南京建都，直到一九四九年為止。其間經過了一九三七到一九四五的中日戰爭其間，為日軍佔領，而遷都到重慶。但在一九二七到一九四九這個時期，南京曾一度在中國藝術的發展史上，扮演一個重要角色。其時國立中央大學成立了一個藝術系，由徐悲鴻主持，一度吸引了不少重要畫家到南京來。例如黃君璧、呂斯百、潘玉良、傅抱石等。訓練了不少下一代的藝術家。南京就成為當時的一個藝術中心。一九四九年中華人民共和國成立後，首都設在北京，但南京仍舊是一個很重要的藝術中心，並進入了又一個黃金時代。在傅抱石領導下，一群新的畫家出現了，包括錢松岩、宋文治、亞明，及其他不少的新人。這是南京藝術的又一個新開端。

展品介紹（彩色圖版參見英文部分）

海蔚藍

第一部分：金陵勝景

金陵（今南京）的建城史始於兩千多年前，其秀麗的自然環境，突出的城市建設，和在此發生的許多重大歷史事件和文學藝術上的建樹，使她成為中國最著名的古都之一，金陵勝景為一代又一代的人們所追懷歌詠，成為文學藝術的不竭源泉。

1. 金陵省城古迹圖
 清代（1644－1911）
 立軸，紙本，木版印刷
 通高202釐米，橫91釐米
 南京博物院，7.1：2193

此清代省城圖[1]，清晰地標出了明代城牆的界圍，是依自然的山水屏障而築；城內外的山水走向，如自城東的鍾山（紫金山，蔣山，金陵山），東北的攝山（棲霞山），燕子磯，幕府山，獅子山，西北的石頭，馬鞍山，至城南的牛首山，東南的方山（天印山）等，及秦淮和長江等水道。

地圖除了標出城內的街道里巷和故國皇城外，尤其還標出了古代著名的名勝景點如六朝名寺"瓦官寺"，是著名畫家顧愷之（約345-406）繪維摩詰壁畫，而為寺廟日捐萬錢的地方，加以擁有著名雕塑家戴逵（？-396），戴顒父子的佛像雕塑和獅子國（今斯里蘭卡）贈送的高達四尺以上的白玉佛像，而以瓦官寺三絕聞名於世[2]；位於城西南的自六朝和唐代即已聞名的"孫楚酒樓"[3]，"鳳凰臺"，"杏花村"等名勝。並標出一些重要景點的地理位置和歷史遺迹，如梅岡（在城南），古名石子岡，為古代金陵人賞梅的地方，是為今天的雨花臺，有名人的墓塚[4]。方山，距省城四十里，又名天印山，傳說秦始皇欲破金陵王氣而在此鑿山通水，水西流而名之為秦淮，該處有定林寺，及明代功臣墓等。

1 清順治二年【1645】平定江南，改南京為江南省，故稱之為省城。葉楚傖，柳貽徵【首都志】卷一，第30頁，南京古舊書店，1985。
2 蔣贊初【南京史話】第69-70頁，南京出版社，1995。
3 孫楚為晉時人，富於才藻，【晉書】有孫楚傳，曰：楚少時欲隱居，謂濟曰：當欲枕石漱流，誤雲：漱石枕流。濟曰：流非可枕，石非可漱。楚曰：所以枕流，欲洗其耳，所以漱石，欲勵其齒。可見其辯才。為西晉名士，酒樓以其為名。參見【掌故大辭典】第742頁，北京團結出版社，1990。
4 此地有東晉宰相謝安（320-385）和五代中書侍郎韓熙載（902-970）的墓，後者是顧閎中（約943-961）所繪名畫"韓熙載夜宴圖"中的主角。

2. 郭存仁（約1580-1620）
 金陵八景圖卷，1600年
 紙本，設色手卷
 畫面橫645釐米，縱28.5釐米
 （通卷橫1，168.5釐米，縱31釐米）
 南京博物院，7：7779

據目前所見，由郭存仁所作的"金陵八景"為所知多種描繪和歌詠金陵景色的較早的例子，每景皆有圖詠，此卷為左圖右詠。至十七世紀末，此一題材日益流行，將歷史典故軼聞等與山水相結合，詩詠圖繪，逐漸衍變為金陵四十八景（參見附錄2）。

郭存仁，亦名郭仁，號水村。工寫大幅山水，佈置渲染，具有成法[1]。

"八景"之名據清初學者朱彝尊【曝書亭書畫跋】所說為"宋度支員外郎宋迪工畫平遠山水，其平生得意者為景凡八。今人所仿瀟湘八景是也。然當時作者意取平遠而已，不專寫瀟湘風土。迫元人形之歌詠，其後自京國以及州縣誌，靡不有八景存焉"[2]。

此卷卷首以大篆題"明郭水村金陵八景圖詠"，並以行書題跋："水村此卷詩字並工，允稱三絕，又所繪乃吾土風景耶，宜吾耿兄珍而藏之。辛未七月獲觀於吳門，因題並記。江甯鄧邦述群碧"。鈐白文方印"鄧邦述印"，朱文方印"群碧居士"。

第一幅："鍾阜祥雲"。以偏藍的色調，繪鍾山之蒼翠，飄逸的線條，繪繞山之雲彩，奔流之山泉。畫面左下方有白文方印"郭存仁印"。詩中歌詠了鍾山的巍峨，和對明代定都於此的重要，並引經據典，歌詠了鍾山紫金色紅土岩的吉祥瑞和。

題詩以篆書道："屹崒中天紫翠擎，莫安於此定神京，勢凌滄海蓬萊小，雄顧金陵泰華平。五色昭回隨日見，九重披佛雁時呈。悠揚遙望彤墀上，招引龍車鳳輦行。又鍾阜祥雲"。鈐三白文方印"存仁之印"，"元父"和"恬淡生"。

鍾山古稱金陵山，蔣山等，位於南京城東郊，屬寧鎮山脈東段，山體作東西向延展，長7公里，南北約寬3公里，全山面積約計20餘平方公里。鍾山景色迷人，並有著名景點如五里松等，在而後的金陵四十八景中又稱"靈谷深松"，昭明太子讀書臺，在金陵四十八景中又稱為"臺想昭明"等[3]。

第二幅："石城瑞雪"。繪金陵雪景，以幹筆皴擦，禿筆所繪的樹枝以顯冬日之蕭條，天地渾然一色，一片潔白中，唯有二高士身著紅袍，曳杖賞雪。畫面右下方鈐朱文方印"元父"。

題詩以行楷書道："危石巉岩倚半天，千尋峭壁勢何堅，山迴雉堞寒鳴柝，潮接龍江夜泊船，滕六散花歸閬苑，天孫種玉遍藍田，禎祥三白符光兆，試聽歌謠大有年。右石城瑞雪"。鈐兩白文方印"存仁"，"郭氏元父"。

石城又稱石頭城，在今天的草場門一帶。當時位於城西北的江邊，石城最早為東吳孫權在楚國金陵邑城的舊址上所造。因其位於石頭和馬鞍二山之間，自六朝時起便為兵家必爭之地，因其在軍事上的重要性，故被喻為"石城虎踞"[4]。

第三幅："龍江夜雨"。繪夜雨中，南京城北，面臨長江的龍江關，畫面右下角有朱文聯珠方印"存""仁"。

題詩以隸書道："天塹西來一派橫，百川歸附向東瀛。六朝不洗英雄恨，午夜偏牽旅客情，蓬底瀟瀟眠未穩，枕邊滴滴夢難成，岸頭暗促雞聲急，多少風帆待曉晴。右龍江夜雨"。鈐一白文聯珠方印"存""仁"，白文方印"元父"。

龍江關在南京城北今下關的三汊河一帶。為明代的海關所在，並在宋代造船廠的基礎上建設了龍江寶船廠，著名航海家鄭和所乘船只大多由此造船廠所造[5]。

第四幅："鳳臺秋月"。繪金陵名臺鳳凰臺上，二高士閑坐，侃侃而談，筆簡墨淡，蕭散之氣頓生。

題詩以草書道："高臺百尺倚城樓，幾（？）鼓清笳起舊愁，彩鳳不來雲漫漫，玉簫空斷夜悠悠。冰輪聲輾三更漏，銀漢絲生萬籟秋。相近六朝歌舞地，最憐圓缺照荒丘。右鳳臺秋月"。鈐朱文聯珠方印"存""仁"，白文方印"郭氏元父"。

鳳凰臺在今南京城西南的花露岡上，是一處南朝名勝。據說劉宋年間，曾有三隻類似孔雀的異鳥飛來此地，並吸引了許多鳥兒前來"百鳥朝鳳"，被朝廷視為吉兆，故建了高臺名之為"鳳凰臺"。唐代大詩人李白有膾炙人口的名詩"登金陵鳳凰臺"，而將鳳凰臺揚名千古。清人陳作霖所著【鳳麓小志】一書中，對鳳凰臺歷代沿革及歷代的吟詠詩作都有詳細的描寫[6]。

第五幅："白鷺晴波"。繪江汀垂柳，近渚泊舟，以雙勾線條畫漾漾水波，青藍色調繪依依垂柳，悄然地，幾根檣桅出於柳絲之中。畫面右下角有一白文方印為鳥篆，未識，或為"郭存仁"三字。

題詩以篆書道："江心水鳥舊名州，江勢平分兩岸流。天霽月明澄似鏡，雨收風靜碧如油。潮生潮落芒（忙）漁艇，年去年來送客舟。佇立三山閑縱目，遙空一色共悠悠。又白鷺晴波"。鈐長方朱文印"元父氏"，白文方印"芝蘭室"。

白鷺州在今城西江東門附近，現有白鷺州公園。但在千年以前，當唐代大詩人李白來遊金陵的時候，白鷺州還在江水之中，故李白有詩句云"二水中分白鷺州"[7]。

第六幅："烏衣夕照"。用筆乾鬆，多用青色苔點，增畫之野逸之氣。而彌漫的煙雲，自由流動，又平添了幾分浪漫。畫面左下角鈐朱文長方印"元父氏"。

題詩以行楷書道："朱雀橋更今幾年，烏衣舊巷尚

依然，豪華已逐前朝去，名譽空由後士傳，落日返暉明故址，殘霞拖影抹遙天。焉知畫棟雕梁燕，巢遍薜蘿草舍邊。右烏衣夕照"。鈐朱文方印"恬淡生"，白文方印"與木石居"。

烏衣巷位於城南夫子廟前內秦淮河南岸，三國孫吳時是禁軍駐地，由於當時的禁軍官兵身著黑色軍服，人們就俗稱之為烏衣營，烏衣巷之名亦由此而來。六朝時這裏是王導，謝安為首的兩個世家大族的居住地，烏衣巷遂成為貴族豪華府邸的代名詞，唐以來有許多歌詠的詩篇[8]。

第七幅："秦淮漁笛"。青山碧柳環抱中，一池平湖，臨湖水榭，搖曳遊船，遠方依稀處，古剎寶塔。畫面右下方鈐白文方印"存仁"。

題詩以隸書道："強秦決磯欲如何，為識金陵王氣多。兩岸桃花浮宿浪，一川楊柳蘸清波。昔聞商女留賓處，今見漁郎放棹過，釣罷船頭橫楚竹，新腔吹出太平歌。右秦淮漁笛"。鈐二白文方印，一似為鳥篆如前"郭存仁"，一為"元父"。

秦淮河是長江的一條支流，也是流經南京城內的第一大河。其源有二，北源出於句容縣寶華山南麓，稱句容河，南源出於溧水縣東廬山，稱溧水河，南北二源在江甯縣方山埭西北村合流，從外城的上方門處進入南京市區，至內城的通濟門外的九龍橋分成內外兩支，各向西北流經南京城內外，至西北彙入長江。秦淮河兩岸歷來為商業和居住的繁華地區，尤其在南京城南夫子廟一帶，為藝妓之金粉樓臺，和會考貢生應試的貢院之所在，酒樓茶館，夜夜笙歌，十分繁華[9]。秦淮之名據說源于秦始皇聽信望氣者之言，鑿方山以泄王氣，其水成河，故後人稱之為"秦淮"。畫家題詩的開首兩句，即指這一故事。

第八幅："天印樵歌"。兩樵夫著青色短褂，荷柴擔枝，交談而還。遠處青山飛瀑，白雲飄蕩，伽藍翹簷，山深徑幽。畫面左下角鈐白文方印"郭氏元父"。
題詩以草書道："一璽高擎萬仞山，雲霞時作篆文刊，朱池遠汲秦淮水，印色常凝葛井丹，晴日好花春煦煦，暖煙芳草路漫漫，采薪歸去聞賡唱，互答相酬興不闌。右天印樵歌"。鈐兩白文方印"郭存仁印"，"恬淡生"。

天印山，本名方山，位於南京中華門外東南20公里左右的江甯縣方山鄉橫嶺村，以形似方印得名，又說仿佛一顆天印墜地，故又稱"天印山"。天印山高208米，占地3.3平方公里，周圍13公里，是一座死火山，山頂為凹狀盆地，可以耕作。天印山據平曠之勝，是登高遠眺之佳處，又為古代運輸的重要水陸碼頭，金陵人送客亦常送至此地[10]。

卷尾畫家以行草書自題道："象山翁丈以素卷見屬，因圖金陵八景，並書八詠，應命，醜（丑）不能工，奈何，聊為宵中博笑耳。（接著似為其簽名？）萬曆庚子春月，郭存仁記事"。鈐白文方印"郭存仁印"，"元父"。此跋左下角並鈐長方形白文方印"頤情館藏"。

並有另一題跋："咸豐辛酉夏至後四日，介休馬礪生觀于吳陵客邸，漫書以志欣幸"。鈐白文方印"礪金長壽"。

1 俞劍華【中國美術家人名辭典】第948頁，上海人民美術出版社，1985。
2 朱彝尊【曝書亭書畫跋】，載黃賓虹，鄧實【美術叢書】第一冊，第535頁，江蘇古籍出版社，1986。另參見Alfred Murck "Eight Views of the Hsiao and Hsiang Rivers by Wang Hung" in Wen Fong, et al., [Images of the Mind], P. 214-235, Princeton, NJ, The Art Museum, Princeton University, 1984。
3 季士家，韓品錚編【金陵勝迹大全】第453－459頁，江蘇南京出版社，1993。
4 參見上注，第516－517頁，李蔚然撰。
5 參見上注，第562－563頁，李蔚然撰。
6 陳作霖【鳳麓小志】載【南京文獻】第二冊，第23-72頁，上海書店，1991重印。
7 喻守真編【唐詩三百首】第225頁，李白"登金陵鳳凰臺"，北京中華書局，1982。
8 呂武進【南京地名趣話】第94－95頁，南京出版社，1998。
9 季士家，韓品崢【金陵勝迹大全】第491-497，南京出版社，1993。
10 呂武進【南京地名趣話】第30－32頁，南京出版社，1998。

3. 樊圻（1616－約卒於1697後）
 金陵尋勝圖卷，1686年
 紙本，設色，手卷
 縱32.5釐米，橫249釐米
 南京博物院7：6672

此殘卷即為描繪當時流行的金陵勝景，或許為四十景或四十八景之系列，現留存繪畫兩幅，一為"杏村問酒"，一為"青溪遊舫"，用筆輕柔，設色淡

雅，各幅畫面後均有多人的題跋。另有“清涼環翠”和“棲霞勝概”兩題及跋，但畫已佚。

樊圻（1616－1697後）字會公，更字洽公，江寧人。善畫山水，人物，花卉，周亮工讚為“莫不極其妙境”。樊圻有兄名沂，亦善畫，兄弟倆“居迴光寺畔，疏籬板屋，二老吮筆其中，蕭蕭如神仙中人”。二老均是隔世絕塵，不逐名利時尚之高士[1]。繪畫風格清淡雅麗，概出乎于其淡然于世俗之本性也。但也有人以其繪畫與燈節彩繪的風格有相似之處，而批評其為“金陵習氣”（參見圖錄第6-2）。

從畫卷末清初畫家柳堉（約活躍於1660至1690）的題跋中亦可見，金陵畫家畫金陵，金陵人收藏金陵山水畫，也是一時之風尚。從其中畫家程邃的一則題跋中可知，該手卷的原主人黃實葉，便曾邀當時著名的畫家，包括史稱“金陵八家”的樊圻，吳宏，龔賢和陳卓等各繪金陵數景以合成一冊，表現了無論是藝術家或社會名流對金陵山水都具有的鍾愛和狂熱，這是其他歷史名城中所少見的。

第一幅：“杏村問酒”，描繪石城牆內，桃紅柳綠，緩緩起伏的丘陵中，私園疊石，人家相望，春風中，有人射箭遊戲，有人問路牧童。

杏花村在南京城郊西南花露岡的鳳凰臺旁，鳳凰臺以唐代李白“登金陵鳳凰臺”一詩而名滿天下，而杏花村則自唐代詩人杜牧作“清明”一詩而出名，遂使杏花村成為酒莊之代名詞[2]，因此踏春尋酒遂成為金陵春天的勝景。尤為畫家詩人所樂道，有明一代，此俗不減。時人的記載中有記畫家吳小仙（偉）年年與公子王孫相邀，踏春青山，尋酒杏花村的故事[3]。

畫尾題款“丙寅冬日畫擬黃老道兄七十一老樊圻”。鈐朱文方印“圻”，白文方印“會公”。收藏印朱文方印“長平祝氏之鏐叔私父鑒藏金石書畫記”。隔水處收藏印為白文方印“畢氏家藏”。

“杏村問酒”的題跋之前有引首印為長方形白文，未識。接著為楷書題詩：何羨嘶驄醉玉樓，窗催鶯語杖扶鳩，出牆紅豔招村店，照水嬌姿助冶遊，莫遣春風吹細雨，但邀新月上高丘，青蚨買得黃壚睡，童豎扶攜下壟頭。又一首道：雨膩風柔二月天，杏村春色正當前，細調鶯語迎初旭，獨把花枝憶少年，誰謂人非愁裏客，卻憐臣是醉中仙，但教日有

高陽侶，酒債何妨負十千。鈐白文方印“王楫之印”，朱文方印“汾仲”。

並有：杏花村在鳳臺邊，多少遊人費酒錢，董叟種來花似錦，牧童行處草如煙，昔年江去旗亭改，舊日樓空燕子還，紫玉絲鞭君緩著，林間月上又初弦。鈐朱文方印“柳堉”，白文方印“公韓”。收藏印朱文長方印“海梯珍藏”。

第二幅：“青溪遊舫”，描繪沿溪河房，白牆青瓦，幹欄式支撐的水閣，多有紅榻臨風，垂柳綠樹間，一溪溫柔水，載輕舟遊人。青溪是六朝時建康（今南京）的主要河道，發源於鍾山南麓，南向流經建康城東後，注入秦淮河，因河道多曲，故有九曲青溪之美稱。六朝時此地為防守城東的要地，也是當時著名的風景區，史載東晉時已有人泛舟青溪，每經一曲，便賦詩一首，南朝時的貴族亦夾溪而居，構築園池[4]。青溪泛舟之習在明清兩代盛而不衰，此風此景，自然成為明末清初流行的金陵四十八景之一。

畫尾自題：“畫似黃老道兄，樊圻”，鈐白文方印“樊”，朱文方印“圻”。押朱文方印“長平祝氏之鏐叔私父鑒藏金石書畫記”。畫面右下角，朱文方印“海梯手定”。

“青溪遊舫”的題跋之前有引首印同前，楷書題詩：“誰鑿溪流九曲分，緣溪甲第舊連雲，吳船簫鼓喧中夜，紫閣簷櫳燦夕曛，煙水五湖徒浩渺，香風十里自氤氳，百壺縱酒油囊載，鷗鷺無驚泛作群”。又一首道：“青溪十里七紅橋，縐綠波紋稱畫橈，村近杏花人酩酊，渡經桃葉女嬌嬈，春風曲檻青油幕，夜月高樓碧玉簫，疑向晶宮最深處，江淹詞筆可能描。鈐白文方印“王楫之印”，朱文方印“汾仲”。

並有：“葉葉輕舟泛若鷗，秦淮東去板橋頭，闌虛翠幕珠襜冷，宅散烏衣劍珮收，日永露荷清小簟，涼生風柳入高樓，為憐內曲燈船鼓，半襪邊聲胡拍謳”。鈐朱文方印“柳堉”，白文方印“公韓”。

此外還有數人題跋，雖非直接論及青溪之畫題，但有論述南京當時繪金陵勝景的風氣和收藏金陵山水圖畫的風氣，可見當時眾多畫家皆以此為題，是一流行的題材，也可映見時人對南京的熱愛。茲逐次錄於此以備考：

1. 引首橢圓朱文印“家在桃源深處”，題跋：“尺幅之中，便具如許丘壑林巒，煙雲變幻，使觀者一展卷，便思投足其中，此自作者精神與造化相融洽，故著筆便成真境。因思昔人爲歌詩可以泣鬼神，感靈蟲矣，只是一片神氣流行耳，況暴群賢之墨妙若斯乎？余以丁卯三月丙夜觀此，不覺芒鞵（鞋）竹杖之興已勃勃於殘更斷漏時矣。江摘旅人王楫識”。鈐白文方印“王楫之印”，朱文方印“汾仲”。

2. “以金陵人藏金陵圖畫，即索之金陵佳手筆，亦一時勝事也。古人句云：唯有家山不厭看，雖從太白“相看兩不厭中”化出，然自有妙義，淡而古旨耳。惟鷹阿山人（即鷹阿山樵戴本孝1621-1691）一江之隔，不肯作金陵景，胸中筆底，亦復大別。主人既檥余畫，復征余詩跋，不覺昕然自笑，因並識之。半水園主柳愚谷氏題”。鈐朱文方印“柳堉”，白文方印“公韓”。

3. 引首葫蘆朱文印未識，朱文聯珠印“肅”，“室”。題跋：“予嘗謂：一代之興必有一代之士，或長於詩，或善於畫，或工于詩古文詞。作者果能精神融注，自然不可磨滅。後世珍之，不啻巨（昏）明理所固有，數使然也。吾鄉黃實葉年翁，世居天都，家從閥閱，每與諸名士放情山水，怡情丘壑，擇其尤者彙成卷冊：吳子度爲燕磯，莫愁，使江湖靈氣蕩於筆端；龔子半千作清涼，攝山，碧雲江樹儼在目前；樊子會公爲杏村，青溪，酒旗曲水不減當年；中立陳子作天壇，冶城，望遠登高如親馳騁；戴子之龍江夜雨；柳子之天印方山；各抒性情，備極其美；使金陵諸勝燦於目前之數公者，與予生同時而交同好，葉子黃實年翁謂予爲知音，囑余爲跋，予與竹使，鷹阿，半畝，愚谷諸君子，時時奉教，嘯杯倡酢（酬），不一而足。今展玩斯卷，如見其人。其人往矣，其致猶存；觀其筆墨，想其風采，令人有今古之歎；後之覽者，亦將有感於斯文矣。葉子真賢士哉，不然何以能留藏若此也，且汾仲，公函兩先生歎賞歌詠之不置也。辛巳清和望日，黃山詩老梅城道者題”。鈐朱文圓印“上清遊”，朱文方印“程邃”，白文方印“昆舍居（人？）”。

4. 行草：“黃老道翁于余長夏鍵以時，出示此卷，皆余老友筆墨也。恍若解帶北窗，頓忘煩悶。爲題數幅，並記歲月。丙戌伏日，秀水王概”。鈐白文方印“王概之印”，朱文方印“安人氏”。

5. 引首印同前，但蓋倒了。無畫但有題“清涼環翠”：“幾度探奇歷翠微，四山環列錦屏圍。吟風喬木堪祛暑，浴日晴江遠惜輝。殿址久湮滋徑蘚，齊廚新供採山薇。觀空自識清涼意，一片閑雲伴鶴飛”。又：“探幽何必向巖阿，西郭連岡梵宇多。僧出茂林穿藹翠，人來芳徑踏青莎。竹間碁石苔還潤，松下書窗鳥自歌。爭得投閑來此地，看雲攀樹日婆娑”。鈐白文方印“王楫之印”，朱文方印“汾仲”。

並有：“石城山路入清涼，四面幽林隱夕陽。虎踞關前春草綠，龍蟠山上暮雲黃。高僧若入六時定，天女何勞一夜香。莫道金陵今改舊，遂留雲樹宿蒼茫”。鈐朱文方印“柳堉”，白文方印“公韓”。

6. 引首印同前。無畫但有題“棲霞勝概”：“東帝頒春繖作山，徧鍾靈藥濟塵寰。嶺頭佛日惺心境，岩外仙霞照鬢顏。宅捨微君碑屹立，泉穿白鹿水潺湲。直淩峰頂江流繞，知是岷源第幾灣”。又：“到來始悟攝山名，孤峙形如結繖成。嶺複曙霞明殿角，峰懸秋月照江聲。莊嚴像現千層石，嬾慢情消一局枰。試溯流泉尋白鹿，微君曾此濯塵纓”。鈐白文方印“王楫之印”，朱文方印“汾仲”。

並有：“誰曾採藥入丹梯，嶺山雲生鍾阜齊。春碉溜崩千尺雪，紫峰松結萬年枝。木魚聲響空山寂，石佛龕閑野鹿棲。此與天臺同一路，卻令人迹到村迷”。鈐朱文方印“柳堉”，白文方印“公韓”。

並有：“不到棲霞寺，今幾四十年。情懷猶稚子，跳躍忘華巔。垂乳樹驚失，循溪徑屢遷。依然紫峰閣，重重雲裏眠（末兩字原作顛倒）。天池生自題：畫作大抵全無花葉相，一團蒼老暮煙中。半畝是作亦無丘壑，於一團蒼老而已。客笑曰：子是什亦然！湖邨概”。鈐白文方印“王概之印”，朱文方印“安節”。

手卷卷尾隔水處，有朱白文方印“介眉過目”，白文橫長方印“蘇完瓜爾佳氏”。

142

1 周亮工【讀畫錄】卷四，第44頁，載【畫史叢書】第九冊，上海人民美術出版社，1963。

2 中國有數處地方自認為是杜牧詩中所指之杏花村，如安徽貴池縣，山西省汾縣，按杜牧詩中所寫之杏花村，據專家從氣候，習俗，景觀等各方面考證，應為金陵之杏花村，杏花村的繁華毀於19世紀的太平天國。現為花露岡一帶。2002年夏，與南京大學教授，南京地方史專家蔣贊初先生的訪談紀實。

3 周暉【金陵瑣事】卷二，北京文學古籍刊行社，1955。

4 季士家，韓品崢主編【金陵勝迹大全】第502－503頁，南京出版社1993。

4. 鄒喆（約生於1610--約卒於1683後）
 山水圖冊
 十七世紀
 紙本，水墨設色，十二開
 縱12.3釐米，橫13.7釐米
 南京博物院，7：79

以金陵景色入畫，或山石樹景，或春秋風光，或攜友踏岸，或停舟秦淮，或觀石城風帆，或贊鍾山松枝，畫家的筆觸變幻，設色典雅，表現濃重的地方景色和時尚，尺幅雖小，卻頗具氣勢，尤其是畫松的幾幅作品，而畫家亦以擅長畫松而得美譽（參見圖錄6-4號）。每頁無題款，但均鈐有"鄒喆"和"方魯"白文二方印。

鄒喆，生卒年不詳，約在1683年後辭世，字方魯，吳縣人，善畫山水花卉。父親鄒典（字滿）客遊金陵後便寓居南京，為畫家，亦為高介絕俗之士，安貧樂道，自勵其志，只與寥寥知者相往還。鄒喆"敬事父友，謹慎保其家"，"君畫筆意高秀，絕去甜俗一派"，"畫宗其父，圖松尤奇秀"[1]

4-1 以淡石青和墨綠著色，繪山石亭閣和遠山沙汀，欲泊之江帆。

4-2 以石門中開似的構圖，繪深澗孤舍，在樹石的掩隱中，有萬丈之深，遺世獨立之態。

4-3 以柔和的筆觸，繪孤舟泊岸，水榭臨池，池內浮萍點點，垂柳嫋嫋，儘是江南初夏的嬌媚。

4-4 以濃淡深淺的墨筆，繪晨霧繚繞的疏林，或是嚴冬，或為初春，但有仙氣飄緲之感。

4-5 近景岩石突兀左向，與其餘山勢岩石的走向稍

異，卻已造成崢嶸感，加之前景中幾株挺拔的松樹，使小小的畫面中充滿了力量和個性。

4-6 以繁密的構圖，示重疊的深山，赭褐的山石，蔥綠的樹木，紅牆青瓦，幾戶人家，絕世的清靜。

4-7 山岩俯澗，一木溪橋，秋葉紅黃，遠山青黛，兩老者拄杖過橋，相顧交談，是明末清初文人喜邀山遊的寫照。

4-8 以不同墨色表現松林的深邃和晨霧的迷濛，古剎幽紅，遠山青黛，以空白留出松下幽徑，無人而勝有聲。

4-9 構圖以山岩壓卷之態，而凸現其間的山澗，和近景處樓閣中支窗遠眺的紅衣老者。幾株姿態伸展的松樹，頗具孤傲之意。

4-10 以濃淡深淺之墨筆，繪雲煙彌漫中的松林。近景的幾株軀幹虯曲，枝低針堅，奮力挺拔，奇崛超逸之態，為繪松的畫作中不可多見的構圖和格調。

4-11 依山築城，城堅牆高，紅色箭樓上標明"西門"二字，可知為石頭城一角，時江水直至城下，泊舟桅立，行帆近渚，畫面著意于江水的寬闊浩渺，歸舟的安寧憩息。

4-12 疏枝幾條，叢山皆白，天色灰蒙，萬物肅然，空谷幽湖邊，唯有遺世之人家。此幅右下角裱框處押收藏印，朱文方印"伯韓珍藏"。

1 周亮工【讀畫錄】卷一，第9頁，載【畫史叢書】第九冊，上海人民美術出版社，1963。

5. 高岑（約活躍於1643-1687）等　金陵各家山水冊
 十七世紀
 金箋，水墨，淡設色
 縱29.4釐米，橫35釐米（不等）
 南京博物院7：82

此冊共十頁，為當時的金陵畫家們所繪，表現山水，林木，茅屋，小橋，舟楫，翠竹等，大多可尋

見南京附近之景色和當時高士之喜山居的風尚。多數構圖工整，運筆超逸，亦有逸筆草草之作。

5-1 濃淡不同之墨筆，寫新竹幽篁之勃發，斷續虛舍的空白，示晨霧繚繞的春山，臨溪依岩而築的幾間茅舍，以竹籬隔世，草堂內矮幾床榻，只待主人。構圖工整，運筆秀逸，靜謐之態畢至。畫面左下角鈐朱文方印"方維"[1]。

5-2 以披麻皴寫左邊山岩的陡峭，右邊山勢的平緩，中有溪流和傍溪而立的山房。墨綠的松樹夾著初變的紅葉，應是新來乍到的秋景。

5-3 逶迤的松林，覆蓋山谷，飄浮的雲霧，騰躍平湖，遠山青黛，古剎幽紅，臨湖水榭，高士獨立。此景為金陵山水畫中所常見，當為城東鍾山一帶的景色。畫面左下角鈐二白文方印"鄒喆"，"方魯"。

5-4 以簡單的墨筆鈎畫出山勢的挺拔，又以多種筆法表現各種樹木的蔥蘢，點染的紅葉告之著秋的來臨，在山泉流響中，有一獨橋通向湖邊岩磯，臨水建築的水榭，有幹欄式和以石塊壘成冰裂紋狀的石牆式，並有臺階通往湖水。一紅衣高士憑欄遠眺，一青衣侍童持琴前往。

畫面右上方題款："庚子（1660）冬月寫。石城鄒喆"，鈐二白文方印"鄒喆"，"方魯"。

5-5 墨筆草草，寫空山茅舍，小橋幽溪。左下角鈐一白文方印，"鄒喆"。

5-6 墨筆，以披麻皴寫渾厚的山坡，以硬直的線條鈎畫平頭山岩的挺拔。苔點稍雜，與直立或斜伸的樹木構成蔥鬱的景色，一高士端坐臨澗的高軒，靜對空山。右下角鈐一白文方印"鄒喆"。

5-7 以花青，赭石諸色鈎勒的山峰飄浮在虛幻的白雲中，山腳下，薄霧升騰中是一池渺渺湖水，遠處的寶塔，中部的木樁長橋，泊岸孤舟和近景處的沿湖綠樹和人家，都靜靜地宣示著南京東北方向的玄武湖和鍾山的秀麗景色。

5-8 此圖用墨極簡，僅以幾筆繪出圖中危立於江岸的山岩，數點樹叢和一二樓軒，然而左邊的空白引

人設想無盡的山勢，右邊的空白則將人引向無涯的大江，畫面雖小而平添壯闊和浩淼之感，江中的幾葉風帆則更為畫面增添了生命，是為南京城東郊棲霞山臨江的景色。畫面左側署款為"葉欣"，鈐二白文方印"葉欣"，"榮木"。

葉欣，生卒年不詳，約卒於1671年或稍後，字榮木，華亭（今上海松江）人，流寓金陵，工畫山水，學趙令穰[2]，筆法方硬，自成一格。按周亮工的記載，其貌不揚，性格特殊，不喜與人交往，而所畫山水，常有勝人之幽處。周亮工道："予藏榮木畫，每不欲觀，然不能禁，每展玩，開口與攢眉交並：蓋此老善結構，能就目前所見，一一運之紙，一經其筆，雖極無意物，亦有如許靈異，故往往引人勝地"。曾為周亮工摘陶淵明詩百幅[3]，"用筆楚楚"，更倍增陶公詩句的幽澹。周寶愛之，特作百陶舫藏之並時常賞閱之。友人見之，亦歎為"未曾有也"[4]。

5-9 青山松樹古塔是金陵山水畫中所常見的另一題材，或為東郊之靈穀寺。此圖著意于刻劃虬曲伸展的松樹和蔥鬱勁挺的松針。畫面左下角署款"庚子（1660）冬日石城高岑寫"，鈐二白文方印"高岑""蔚生"。

高岑，生卒年不詳，活躍於1643－1687，約卒於1687年或稍後，字蔚生，浙江杭州人，寓居南京，善畫山水，水墨花卉，筆法生動入神。與其兄高阜（字康生）同有時譽，其侄高遇字雨吉，亦喜畫。據周亮工記載，高岑蓄著長髯，形象俊健，喜佛，愛中晚唐詩，自己也時有佳句。曾從高僧遊佛寺，"居茹蔬淡，雖年少，訥然靜默，鬚眉間無浮氣。幼時學同里朱翰之畫，晚乃以己意行之"。周亮工並生動地記載了高岑繪畫創作的一幕，是難能可貴的資料，"昕公（周亮工之友，陳昕，字陟江，官至侍御），筆墨妙天下，又收藏最富。予嘗在松風閣，見岑與公永夜靜談，商量位置，兩人舌本間，即具一佳畫，蠕蠕欲見之素壁。岑每以舌本所得，急落於紙，然甫落紙，或半竟，兩人舌本觸觸相生，別多幽緒，迨成時，乃無初商一筆。以此鏤精刻骨，益入微妙…阜與岑皆至性過人，所居多薜蘿，閑綠冷翠中，兩高士在焉"[5]。

5-10 此圖主要以米氏墨法，濕筆濃墨，畫蔥鬱之樹木和山坡，以淡墨平塗遠山的飄渺和近溪的迷蒙，墨筆勾勒出茅舍幾間和靜坐的高士，正對著溪岸的幽篁。畫面右上角署款"臨米元暉大堯村圖，石城高岑"，鈐二白文方印"高岑"，"蔚生"。

1 周亮工【讀畫錄】卷四，第49頁，"方維，字爾張，學畫于鄭千里，故其佛像山水，皆似千里，而稍加流動"。約活躍于辛丑（1661）前後。載【畫史叢書】第九冊，上海人民美術出版社，1963。
2 宋代畫家，字大年，山水擅平遠渺茫之景，參見沈柔堅【中國美術辭典】第126頁，臺灣雄獅美術，1989。
3 陶為東晉大詩人，約生于376，卒於427年，其詩平淡自然，其人倜儻脫俗，歷來為中國知識分子出世隱居精神的代表。
4 周亮工【讀畫錄】卷三，第45-46頁，載【畫史叢書】第九冊，上海人民美術出版社，1963。
5 周亮工【讀畫錄】卷三，第43頁，載【畫史叢書】第九冊，上海人民美術出版社，1963。

第二部分：金陵畫家的生活時尚

十七世紀是中國知識分子和文人畫家對生活予以全方位詮釋的時期，他們將生活的每個細節都點化為藝術，品味著生命，也借此來表達他們的感受，並通過繪畫來表現讀書，登高，訪友，辭別，隱居等生活時尚和社交禮節。

6. 龔賢（1618-1689）等　金陵八家山水扇面冊
十七世紀
紙金箋，水墨或設色
縱16釐米至19釐米，橫51釐米至57釐米
南京博物院7：289－7：296

此冊共八幀，收集為史所稱的"金陵八家"：龔賢，樊圻，高岑，鄒喆，謝蓀，吳宏，葉欣，胡慥八人所作的扇面，除吳宏繪寫墨竹圖外，其他七人均為山水畫，大多描寫南京及江南一帶實景，表現了大自然秀麗景色，賦予了一種蓬勃不息的生機。

扇面是明末清初很流行的一種繪畫形式，常作為社交禮物。使繪畫成為可隨時欣賞把玩的物件，促進了文人品味的普及，推動了社會普遍追求風雅的習俗。

冊頁封面為藍團花紋錦，中央有題簽："金陵八家畫

簽吳氏梅景書屋珍藏真迹湖帆題"。吳湖帆（1894-1968），江蘇蘇州人，清末大學者，畫家吳大澂之孫，現代書畫家，鑑賞家，名翼燕，字通駿，更名萬，字東莊，號倩庵，別署醜簃，書畫則署湖帆，齋名梅景書屋，1949年後，曾任上海中國畫院畫師，中國美術家協會上海分會副主席等。善山水，富收藏[1]。吳氏寶愛此冊，在冊頁之首以篆體再題："金陵八大家集簽"並題跋道："清初龔半千等八家開金陵法派與華亭妻東[2]堪稱鼎足。梅景書屋珍集。湖帆"。這八幀扇面，大多均押有吳湖帆及其太太潘靜淑的收藏印，每幀扇面的裱框均有吳湖帆的題識。從題記中可見，吳氏在確定了收藏目標後，歷時二十多年，苦心搜索集藏的甘苦。當他最後找到謝蓀的扇面，從而收全了金陵八家的扇面時，不由自主地在題跋中寫道"欣幸無已"，興奮之情躍然紙上。

6-1 龔賢（618-1689）山水圖
紙金箋，水墨，縱18.9釐米，橫57釐米。畫幅上方自題："幾間茅屋老嶺阿，花影重重掩薛蘿。當面至饒幽邃地，好山偏是隔江多。畫為荻翁先生。龔賢"。鈐"半""千"聯珠文印。

江邊小景，茅屋兩三，岩石幾塊，雜樹數株，水不揚波，夾岸而去。本為蕭疏的景色，經濃墨和苔點及短促的皴法等筆觸勾畫，而富有動感，顯出生機。

龔賢（1618－1689），一名豈賢，字半千。號野遺，半畝，柴丈人[3]。江蘇昆山人，少年移居南京，曾以當時名畫家董其昌為師，擅畫山水，取法董源，用墨濃重蒼潤，在當時即名滿江東，被後世視為"金陵八家"之首。並以詩作名重一時，有"草香堂集"傳世。據同時代的大收藏家周亮工的記載，龔賢之為人，性格孤僻高介，隔世絕塵，唯與知者相往來。尤其在其生命的最後二十年，隱居南京清涼山半畝園，以詩畫為生。其畫宗宋元，自研筆墨之奧妙，以元人之精神，探宋人之丘壑，而"掃除蹊逕，獨出幽異。自謂前無古人，後無來者"[4]當時的另一個大畫家程正揆很少贊許別人，但對龔賢卻十分敬佩，題其畫道："畫有繁簡，乃論筆墨，非論境界也。北宋人千丘萬壑，無一筆不減；元人枯枝瘦石，無一筆不繁。通此解者，其半千乎？"[5]有趣的是，自視甚高的龔賢對程正揆的畫藝也是由衷地推崇，1669年，龔賢在一則題跋中道："逸品首

推二溪：曰石溪，曰青溪⋯石溪，殘道人也；青溪，程侍郎也，皆寓公，殘道人畫，粗服亂頭，如王孟津書法；程侍郎畫，冰肌玉骨，如董華亭書法，百年來，論書法則王、董二公應不讓，若論畫筆，則今日兩溪奚肯多讓乎哉"[6]，真是古人所謂：唯有英雄識英雄。其山水畫中的意境筆墨之趣，確實高出同輩，並影響後世。

吳湖帆題："龔半千別號至夥，曰半畝，曰豈賢，曰野遺，曰柴丈人。以善畫名，流寓南京，為金陵八大家之冠，著名畫訣，香草堂集。此箋墨氣淋漓，尤為平生傑構，萬金易歸，以冠是帙。

收藏印：左下角為白文方印"天景樓"，右下角有兩印，白文方印"香雨樓"，朱文方印"兼吾佳足"。

6-2 樊圻（1616-約卒於1697後）山水圖

紙金箋，設色，縱18.4釐米，橫54.5釐米，畫幅右上自題："己未（1679）春日畫擬以政道兄"。署款"樊圻"，鈐"會公"朱文長方印。

春山環抱中，蜿蜒小溪，木橋橫架，連接村舍。岩邊雜樹幾枝，新葉搖曳。空山明靜，于青翠柔麗中透露了滿紙溫情。樊圻自題中所用"擬以政道兄"之"擬"字，或通"似"和"作"字，都是這一階段常見的題語用詞，這三字相通，其義相同，均是"為"之意[7]，而且此一時期在題跋中論及名字時，亦常要空出一格以示區別，以示尊重，或為當時題跋的習俗。

吳湖帆題："樊會公與龔半千為金陵派領袖，然余以為習氣太深，反不如鄒方魯，葉榮木等為雅韻耳。康熙十八年己未（1679）時六十四歲"。

收藏印：右下角，朱文長方印"梅景書屋"，左下角，白文方印"潘靜淑珍藏印"，朱文方印"吳湖帆珍藏印"。

6-3 高岑（約活躍於1643-1687後）山水圖

紙金箋，水墨，縱16.6釐米，橫51.7釐米。畫幅上方自題："溪雲過雨斂芙蓉，翠瑣迴流樹幾重，隱約樓臺人不到，隔溪惟聽數聲鍾"。署款："壬子（1672）夏日並題似子翁老長兄教政。高岑"。鈐朱文方印"臣岑"。

以雜樹，茅舍，流泉，孤舟等江岸小景入畫，構圖則突出中心，兩側虛淡致遠。筆墨濃潤，然又有空靈處以示山中水邊升騰的煙氣，是南京一帶江汀山巒的典型特點。

吳湖帆題："高岑學半千而無半千雄氣，便具金陵習尚矣。康熙十一年壬子（1672）"。

收藏印：左下角，白文方印"潘靜淑珍藏印"，朱文方印"吳湖帆珍藏印"，朱文長方印"梅景書屋秘笈"。另有一枚橢園朱文印於畫面右上方，漫漶未識。

6-4 鄒喆（約生於1610-約卒於1683後）山水圖

紙金箋，水墨設色，縱16.6釐米，橫51釐米。畫幅左邊署款"鄒喆"，鈐"鄒喆"，"方魯"二白文方印。

俯視的構圖，將中央的樓閣和其俯瞰的大江引入視野之中，兩岸的山岩突兀崢嶸又不失青翠蒼潤。

吳湖帆題："鄒方魯頗致力於唐子畏，雖有金陵積習，尚具逸趣"。

收藏印：左邊依次而下，朱文長方印"吳湖帆藏"，朱文方印"鐵笛樓"，白文方印"儷芒審定"。右側至右下角，朱文長方印"梅景書屋"，朱文方印"潘靜淑珍藏印"，朱文方印"吳湖帆珍藏印"。

6-5 葉欣（約活躍於1640-1673）山水圖

紙金箋，設色，縱16.1釐米，橫51.2釐米，畫幅右邊自題："甲申（1644）春三月，仿一峰老人筆[8]，為旅堂先生教我，社弟葉欣。"鈐"葉""欣"朱文聯珠方印。

雖以相同的溪山村舍題材入畫，構圖似不經意捉住，且筆簡墨淡，具閒逸蕭散之氣，難怪為吳湖帆論其無金陵習氣者是也。從其署名的自稱為"社弟"，可知葉欣亦曾加入當時文人的集社。

吳湖帆題："葉榮木乃金陵八家中獨樹一幟而

無金陵習氣者。康熙四十三年甲申（1644）"。

收藏印：左下角，白文方印"潘靜淑珍藏印"，朱文方印"吳湖帆珍藏印"

6-6 胡慥（約活躍於1650-1662）山水圖

紙金箋，設色，縱17.6釐米，橫51.5釐米。畫幅右上方自題"慈烏陣黑疑雲過，老木聲酣認雨來"。鈐"石公"白文長方印。

畫中紅葉深秋，昏鴉撲飛，一高士總髮紅袍，拱手前行，一小童抱琴相隨，向掩隱于樹石間的幾椽茅屋歸去。

胡慥，一作造，字石公，金陵人，善畫山水，人物，尤工寫菊。山水蒼茫渾厚。周亮工生動地記載道"石公善噉，腹便便，負大力拳勇，而最工寫菊。菊冷花，經石公手，洗盡鉛華，獨存冰雪，始稱真冷；然筆墨外，備極香豔之致，此則非石公不能為也。惜哉，未六十而沒！子清，濂，皆能畫"[9]。

吳湖帆題"胡石公慥金陵八家之一，其山水絕無僅見，斟畫中九友之張爾唯尤為罕有[10]。此箋與樊會公頗相近，餘亦未之見耳。己卯春日見胡石公仿董，巨[11]中幅于俞生子才靜觀樓，樹石諸法與此絕合。湖帆記"。

收藏印：左下角有朱文圓印未識，右下角，白文方印"潘靜淑珍藏印"，朱文方印"吳湖帆珍藏印"。

6.7 謝蓀（約活躍於1679）山水圖

紙金箋，設色，縱19.5釐米，橫54.1釐米。畫幅右上署款"謝蓀"，鈐"謝蓀"白文方印。

此扇面構圖嚴謹，用筆細密，設色淡雅，加之對山石尖峭陡動之姿的誇張描繪，使畫面具有清幽奇絕之態，別具一格。

謝蓀，生卒年不詳，約活躍於1679前後，字緗酉，又字天令，江蘇溧水人，常住南京。擅長山水，花卉，為"金陵八家"之一。

吳湖帆題"謝蓀號天令，為金陵八大家之一，

其畫流傳之尠較畫中九友中張爾唯尤甚，余搜訪二十年只得此一筆，他亦未見，可知其作之名貴矣。甲申夏六月，湖帆題記，八大家畫籛告全，欣幸無已。"

收藏印：左側，白文方印"籛吾神遊"，下角並列朱文長方印"頌閣心賞物"，白文方印"天景樓"。

6-8 吳宏（約1610-約1690）墨竹圖

紙金箋，水墨，縱16.6釐米，橫52.2釐米。以茂密的竹葉覆壓畫面左上方，嫩枝新篁橫伸其下，構圖別致，筆墨酣暢，吳湖帆論為以草書法寫竹之佳作。

吳宏，約生於1610，卒於1690前後。字遠度，號竹史，江西金溪人。寓居南京。善畫墨竹，山水。周亮工曾給與很高評價，"（吳宏）生長于秦淮，幼好繪事，自辟一徑，不肯寄人籬落。癸巳甲午間，渡黃河，遊雪苑，歸而筆墨一變，縱橫森秀，盡諸家之長，而運以己意…范中立以其大度，得名曰寬；遠度亦名宏，遠度偉然丈夫，人與筆俱闊然有餘，無世人一毫瑣屑態。令范吳論之，世未有不豁然大度，而能以筆墨妙天下者，宏與寬並傳矣…"[12]，其畫的恢宏氣度恰如其人，詩人宋琬曾記其初觀吳宏之山水畫，已可知其人，待在南京相見，"見其襟期浩渺瀟灑出塵，乃知圖畫中固有真性情焉。遠度為予言，曾策蹇驢過大梁之墟訪信陵公子侯嬴朱亥之遺迹歸而若有得焉"[13]，可見遊歷山水對於心有靈犀者的調教和影響，確為深遠莫測。

畫幅右邊自題："蘇長公墨法[14]，作為渭水詞宗教之，臨川吳宏"。鈐朱文方印"遠度"和白文方印"吳宏之印"各一方。

吳湖帆題"吳遠度宏為金陵八大家之一，山水專長北宗，有李希古風骨[15]，獨無金陵習氣。尤工畫竹，以文（同），蘇（軾）為法，此箋以草書法寫竹，趙文敏[16]後不多見也，堪稱遠度傑構。湖帆"。

收藏印：左下角，白文方印"潘靜淑珍藏印"，朱文方印"吳湖帆珍藏印"。

1 沈柔堅主編【中國美術辭典】第258頁，臺灣雄獅美術，1989。

2 此為17世紀中國畫的兩個流派，均靠近今上海。華亭派初由顧正誼及其子嗣領首，婁東派以王原祁為首。沈柔堅【中國美術辭典】第19和80頁，臺灣雄獅美術，1989。

3 關於龔賢的生年，有生於1599，1617，1618，1619和1621等幾說，現按照林樹中"龔賢年譜"【東南文化】第5期，第48頁，南京博物院，1990。

4 周亮工【讀畫錄】卷二，第30頁，載【畫史叢書】第九冊，上海人民美術出版社，1963。

5 周亮工【讀畫錄】卷三，第30頁，載【畫史叢書】第九冊，上海人民美術出版社，1963。

6 臺北故宮博物院藏"周亮工集名家山水冊"，參見林樹中"龔賢年譜"載【東南文化】第5期，第58頁，南京博物院，1990。

7 "擬"，"似"，和"作"這三字在古漢語中為同源字，故同義，據北京師範大學教授，古文字學專家周曉陸先生指示。

8 即元大畫家黃公望【1269-1354】，沈柔堅【中國美術辭典】第150頁，臺灣雄獅美術，1989。

9 周亮工【讀畫錄】卷三，第45頁，載【畫史叢書】第九冊，上海人民美術出版社，1963。

10 周亮工【讀畫錄】卷三，第32頁，"爾唯太守學曾，又號約庵，山陰人，畫仿董北苑，辛卯秋，為予作數幅，極為程青溪所賞"，載【畫史叢書】第九冊，上海人民美術出版社，1963。又畫中九友為明末清初董其昌，楊文驄，程嘉燧，張學曾，卞文瑜，邵彌，李流芳，王時敏，王鑒九位畫家的合稱，清初吳偉業作"畫中九友歌"，參見沈柔堅主編【中國美術辭典】第81頁，臺灣雄獅美術，1989。

11 董源【？-約962】，為五代南唐畫家，巨然，十世紀時五代宋初畫家。

12 周亮工【讀畫錄】卷三，第42頁，載【畫史叢書】第九冊，上海人民美術出版社，1963。

13 【清】馮金伯編【國朝畫識】引宋琬【安雅堂集】，載盧輔聖主編【中國書畫全書】第十冊，第590頁，上海書畫出版社，1996。

14 即蘇軾【1036-1101】宋代大詩人，書法家，畫家，墨竹別具一格，參見俞劍華【中國美術家人名詞典】第1527-1528頁，上海人民美術出版社，1996。

15 李唐【1066-1150】，北宋末南宋初畫家，參見沈柔堅【中國美術辭典】第131頁，臺灣雄獅美術，1989。

16 即趙孟頫【1254-1322】，元代大畫家，參見俞劍華【中國美術家人名詞典】第1281頁，上海人民美術出版社，1996。

7. 高岑（活躍於1643－1687後）
山樓登眺圖
1663年
紙本，設色，冊頁。
縱17.3釐米，橫54.9釐米
南京博物院7：6242

此頁構圖平穩而嚴謹，筆法細膩，設色淡雅，畫面右邊繪山岩秀嶺，山泉奔流直下，中景為水中岩磯，山下林木蔥郁，紅葉鳴秋，村舍錯落，木橋溪水。高處山樓中，有一老者憑眺遠處，畫面虛出很大的空間，是為一片秋水，飛鴻遠去，蒼茫渾樸，意境深遠。而山石樹根間濃重的褐色苔點，陡增躍動的生命力。

畫幅上方自題："癸卯夏六月似子老詞宗正。石城高岑"。鈐"高岑"朱文方印。

收藏印：右下角朱文方印"白匋"。

扇面對開的另一頁上有題跋道："此幀題識經水剝落，俗手裝池，描筆失神，初見未有不疑為贗鼎者。辛丑冬，韓慎先，張蔥玉二君以放大鏡細加審閱，斷為蔚生真迹。白匋識"。鈐朱文長方印"鳳褐"。

白匋為吳白匋，江蘇揚州人（1902-1992），三十年代畢業于金陵大學，擅長文史，戲曲。後曾為江蘇省文化局副局長，文聯副主席，南京大學中文系教授，教授民間歌謠，古文字，和中國書畫鑒定，人稱"吳郎"，有多部戲曲作品傳世，尤以錫劇"雙推磨"，"紅樓夢"和揚劇"百歲挂帥"為著。韓慎先曾為天津藝術博物館館長，張蔥玉即張珩，著名書畫鑒定專家，兩人均為中國五十年代第一個書畫鑒定小組的成員。

8. 陳卓（1634-約卒於1709後）
攜琴訪友圖軸
1694年
金箋，設色
縱255釐米，橫67釐米
南京博物院，7：75

遠山青黛，臨湖倚崖，一草堂以面湖之樓臺水榭，矗立於蔥郁的雜樹叢中。一老者獨坐水閣，遙望嫋嫋湖水，一童子正端持一物以侍。草堂以竹籬圍繞，柴門半開，通向塵世的湖灣小徑上，一高士總髮至頂，長袍及地，拱手前行，一小童雙髻總角，短衣長褲，抱琴尾隨。

陳卓，字中立，晚年自號純癡老人，北京人，家金陵（今南京），山水工細，千丘萬壑，具宋人精密，惜無元人靈秀。人物花卉均極擅長。康熙八年（1669）嘗

與白下（今南京）諸生同赴周亮工的宴會[1]，是次文人雅士的宴會，被視作當年金陵的一件盛事，為數十年間所未曾有者。年方35歲的陳卓，在雲集的詞人高士之中，其畫藝得到周亮工很高的評價[2]。清人秦祖永（1825-1884）在【續桐陰論畫】一書中將其列為能品一類，在乾隆，同治，嘉慶年間所修的南京地方誌，還曾將他品評為金陵八家之首[3]。

中國古琴被認為最古雅最接近自然之聲的樂器，其憂鬱敏感的琴聲，觸人心弦，習琴難，聽琴亦不易，均要求雙方有很高的文學藝術修養和對世間事物的感悟，故古琴為歷代文人視為修身養性，以及與知己互通心曲的工具[4]，更有伯牙鍾子期借一曲"高山流水"得"知音"的歷史故事，代代相傳，成為摯友知己的代名詞，因而，古琴歷來為中國文人所重，而攜琴訪友遂成為文人交往之常事，也是中國文人畫家所喜愛的畫題之一。

畫面左上方落款"甲戌春月畫為旭翁先生。陳卓"。鈐白文方印"陳卓"，朱文方印"中立"。收藏印于左下角，為朱文長方印"式古堂書畫印"。

1 俞劍華【中國美術家人名辭典】第1002頁，上海人民美術出版社，1985。
2 周亮工【讀畫錄】卷四第56-57頁，"吳子遠"條，附黃虞稷所寫長歌，載【畫史叢書】第九冊，上海人民美術出版社，1963。
3 陳傳席"關於'金陵八家'的多種記載和陳卓"，載【東南文化】第4/5期，第152頁，南京博物院，1989。
4 參見美國Stephen Addiss【古琴遺韻】，紐約華美協進社中國美術館，1999。

9. 蔡澤（約活躍於1662-1722）
　　松蔭品茶圖卷
　　1701年
　　絹本，設色，手卷
　　縱36釐米，橫200釐米
　　南京博物院，畫10327

虯曲的老松幹下，山石蒼潤，流泉奏響，兩老者寬袍方履，一倚松，一倚石，閒散清談。兩童子著短衣長褲草鞋，一在俯身煎茶，一捧茶盤侍奉。山石蒼松皆用筆較重，而愈顯松蔭之清涼，人物皆為淡白衣衫，而陡增風神之瀟灑。

蔡澤，生卒年不詳，約活躍於康熙年間（1662-1722），字蒼森，霖滄，或霖蒼，號雪岩，江蘇溧水人。善人物兼山水，花鳥，為清初好手[1]。

品茗為明代士人所重，是修身養性的清課之一，"拂石待煎茶"也是文人山水畫中的題材之一。當時的知名文人文震亨在其【長物志】中曾鄭重地建議士人要依山築茶寮，"內設茶具，教一童專主茶役，以供長日清談"[2]。松下品茗之習也是由來以久，宋代宰相王安石老年久居金陵，築舍鍾山腳下，曾有詩道："與客東來欲試茶，倦投松石坐倚斜"[3]。百年之後，蔡澤此畫將王安石的詩意形象地表現了出來。

畫尾題款"松蔭品茶圖，辛巳杏月（三月），為雪園先生清鑒，蔡澤"，鈐朱文方印"澤"。南京博物院還藏有其"秋澗古松圖軸"，據題款畫於"庚辰（1700年）…於碧浪山堂（或為其畫室，或書屋名），雪岩蔡澤"，並鈐朱文方印"澤"和白文方印"霖蒼"。其作品亦見藏於中國歷史博物館"洗桐圖"，落款為"雪岩畫"，鈐"澤"及"霖蒼"二印。

1 俞劍華【中國美術家人名辭典】第1374頁，上海辭書出版社，1996。
2 明文震亨原著，陳植校注【長物志】第31頁，江蘇科學技術出版社，1984。
3 顧起元【客座贅語】卷三，第87頁，中華書局，1997重印。

10. 魏之璜（1568－約卒於1645後）
　　水閣圖扇面
　　1613年
　　紙金箋，冊頁，推蓬裝
　　通高63釐米，橫61釐米
　　南京博物院，7：6252

疏散的小景，草亭，岩石，雜樹，流水，高士閒坐觀之，幹筆淡墨，清雅之氣幽然而起。

魏之璜，字考叔，生於1568，至順治二年（1645）仍作有林巒煙雨圖，但卒年不詳。魏之璜"起孤貧業丹青以糊口。真書師黃庭經，結構微密，神采流麗，寫山水不襲粉本，自抒規制，岩壑樹石，特標靈異。生平畫幅，絕無雷同。晚用濃墨突筆，意貴蒼老，稍輸風韻"[1]。據周亮工記載"（其）工山水，可稱能品，老年筆尤蒼勁…淡墨花卉，頗有天然之致，此則可據勝場矣。餘猶及交公，蒼顏修髯，似深山老煉士，望

之使人肅然起敬。少孤貧，匿影閉門，日事盤礡。天性孝友，養老親，撫諸弟，皆取給於十指，不肯幹人"[2]。喜酒喜清言，為當時士宦所崇敬之。在金陵畫史上，魏氏之畫曾享有盛名，據周亮工言"秣陵（南京之古稱）畫，先惟知魏考叔兄弟"[3]。後代的學者亦有認為其為金陵畫派之先驅者[4]。

畫面中題署"癸丑三月寫似芳林兄，魏之璜"，鈐朱文方印"魏之璜印"。畫面右側中部有朱文收藏印"白匋"。在對開的一頁有題道："癸丑為萬曆四十一年，公元一六一三，白匋識"，並鈐長方朱文印"鳳褐"。

1 俞劍華【中國美術家人名辭典】第1498頁，上海人民美術出版社，1996。
2 周亮工【讀畫錄】卷一，第7頁，載【畫史叢書】第九冊，上海人民美術出版社，1963。
3 周亮工【讀畫錄】卷一，第9頁，載【畫史叢書】第九冊，上海人民美術出版社，1963。
4 林樹中"金陵畫派與金陵文化"載【東南文化】第4/5期，南京博物院，1989。

11. 程正揆（1604-1676）
　　山水冊
　　十七世紀
　　紙本，水墨淡設色，六開
　　縱31釐米，橫52.5釐米（雙頁對開）
　　南京博物院7：84

此冊構圖別致，用筆稚拙，設色淡雅，具書卷氣，文靜超逸，描繪金陵山水和高士出遊之時尚。

程正揆，字端伯，別號青溪道人，青溪老人，青溪舊史，湖北孝感人。1631年進士，榜名正葵，清初改名"正揆"，官工部侍郎，1657年挂冠，但仍寓居南京，直到1673年返回老家，從此未來南京[1]。是當時較具文人氣質的金陵畫家，其書法師李邕（北海），而豐韻蕭然，不為所縛。山水初得董其昌指授，後則自出機軸，多用禿筆，枯勁簡老，設色穠湛。嘗言北宋人千邱萬壑無一筆不減，元人枯枝瘦石，無一筆不繁。嘗作溪山臥遊圖五百卷。周亮工云"曾見其三百幅，或丈許，或數尺，繁簡濃淡，各極其致。然矜貴不肯輕以與人，唯于石和尚無所吝耳"。其畫高雅，蓋"胸中多數百卷書耳，此事固當讓青溪獨步矣"[2]。時與石溪得"二溪"之美譽，極

為龔賢所推崇（參見圖錄6-1號）。

12-1 單頁，以淡墨和花青皴擦，繪兩石相拱如門，中有瀑布疊蕩，一人踞坐岸岩觀瀑。畫面右上角有朱文方印"端伯"。對開之頁無畫，但在左下角鈐收藏印，朱文方印"宮子行寅父共欣賞"。

12-2 單頁，以淡墨，花青和赭石勾畫平頭之山岩，山中綠樹和山房中對坐相談的高士。畫面右上角鈐朱文方印"青谿"。

12-3 雙頁對開，簡單的幾塊石頭，幾株樹木，兩間草房，以稚拙的筆意和淡雅的設色，具有野逸蕭散之氣。畫面右上方鈐朱文方印"端伯"，左下角鈐收藏印，朱文方印"宮子行寅父共欣賞"。

12-4 雙頁對開，以生動的筆觸繪連綿之山勢，中景之巨石尤具拔地欲舞之態，山中雲氣升騰處，青瓦紅牆的河房中分溪流，綠樹掩隱的山徑上，一高士有一侍童相隨，往河房走去。畫面左上方鈐朱文方印"揆"，左下角鈐收藏印，朱文方印"宮子行寅父共欣賞"。

12-5 雙頁對開，以淡墨和花青赭石勾勒輕皴，繪山腳下流泉汩汩，湖中岩磯上幾株雜樹，兩戶人家。有倪雲林山水之蕭散之氣。畫面左上方鈐朱文方印"端伯"，其下鈐收藏印，朱文方印"宮子行寅父共欣賞"。

12-6 單頁，為程正揆之自題"陸龜蒙[3]有句云，耕耘閑之資，此盛時事也，若乃世無樂土，民不聊生，奚暇農哉，唯茲筆墨尚可與語。青谿"。鈐白文方印"臣正揆"。此頁左下角鈐白文長方印"守吾過眼"，加白文長方印"康甫"。另一頁空白，唯在左下角鈐收藏印兩枚，均為朱文，一為長方形"泰州宮氏珍藏"，另一為方形"可為知者道"。

1 林樹中【龔賢年譜】載【東南文化】第5期，第62頁，南京博物院，1990。
2 周亮工【讀畫錄】卷二，第22-23頁，載【畫史叢書】第九冊，上海人民美術出版社，1963。
3 唐代文學家，生年不詳，約卒於881年，【辭海】第416頁，上海辭書出版社，1979。

12. 樊圻（1616-約卒於1697後）
　　春山策杖圖軸
　　1694年
　　金箋，設色
　　縱79.2釐米，橫47.4釐米
　　南京博物院，7：74

圖繪春日中的高山峻嶺，近山以淺褐石綠暈染加墨，和墨綠苔點，遠山以淡石青渲染，山間茅亭，為怒放的粉梅環繞，溪水繞山注入湖中，湖岸三株垂柳，搖曳生姿，柳樹下一老者策杖回首，不舍春意。

構圖工整，用筆輕柔，設色淡雅，全圖充滿盎然春意，意境清新，正合了周亮工所謂"金陵畫學秀絕江左"，"嫵媚一流"的畫風[1]，這種畫風多工細，設色清雋淡雅，在除了龔賢，石溪，程正揆以外的金陵畫家的作品中常能見到，與南京的市俗特別是元宵的燈節上用於裝飾的紗燈畫，和市民的審美愛好有關，因而歷史上曾有"紗燈派"的非議，或被指為金陵習氣[2]，吳湖帆便曾評樊圻"金陵習氣"太深（參見圖錄6-2號）。

此圖雖為畫家七十九歲時作，而如此清新的畫作，足可映見畫家純淨絕世的處子之心。周亮工便曾描寫樊圻兄弟倆結廬迴光寺旁，與世隔絕而吮筆作畫的超然物外的生活狀態（參見圖錄6-2號）。

畫幅左上署款"甲戌春日畫擬旭翁老先生正，七十九歲老人樊圻"。鈐白文方印"樊圻"，朱文方印"會公"。右下角收藏印為長方朱文"式古堂書畫印"。

1　周亮工【賴古堂書畫跋】"題胡元潤畫冊"，載盧輔聖主編【中國書畫全書】第七冊，第941頁，上海書畫出版社，1994。
2　林樹中"金陵畫派與金陵文化"載【東南文化】第4/5期，第146頁，南京博物院，1989。

13. 高岑（活躍於1643-1687後）
　　金山寺圖軸
　　十七世紀
　　絹本，設色
　　縱181釐米，橫94.7釐米
　　南京博物院，7：5911

以近景之此岸的古松山岩始，由行走之風帆引向中景的山磯小島上的寺塔，中景所占的很大篇幅，在構圖上是所謂虛淡的空間，恰好表現了江水煙波的寬闊浩淼，遠景繪隔岸之綿緩的丘陵樹木，紅牆青瓦的人家，沿江的城牆泊舟。橫剖面似的構圖，突出表現了畫面的主角金山寺，屹立在兩邊無涯的浩浩長江之中，背景則是霧靄之中的村落和清晨的寧靜。

金山寺在江蘇省鎮江市區西北，原名氏父山，又名金鼇嶺，也叫浮玉山。唐代起通稱金山，山高60米，周約500米，原屹立于長江中，後由於長江水流變遷，在清道光年間，金山開始與南岸相接，現已成了內陸山。金山寺在金山上，始建于東晉，原名澤心寺，唐代因開山得金，從此即通稱金山寺。廟宇依山勢而造，山寺混為一體，獨具風格，歷來為人讚賞。宋真宗天禧年間（1016-1021）因夢遊金山寺，賜名龍遊寺，王安石遊金山寺詩道："數重樓枕層層石，四壁窗開面面風，忽見鳥飛平地起，始驚身在半空中"。清代康熙皇帝南巡時亦到此並賜名"江天禪寺"。是江南的一處名勝[1]。

畫面左下角署"石城高岑寫"，鈐白文方印"高岑之印"，朱文方印"蔚生"。

1　【中國名勝詞典】第340頁，上海辭書出版社，1983。

14. 吳宏（約生於1610-約卒於1690）
　　柘溪草堂圖軸
　　1672年
　　絹本，水墨設色
　　縱160.5釐米，橫79.9釐米（畫面）
　　南京博物院，7：5496

此為江蘇省長江以北的景觀，河汊湖沼相交，葦葉雜樹相掩，水氣雲色迷蒙，隱士之居，築沿河棧廊，草堂高閣，主人似乎正與摯友捧書傾談，忽聞窗外之聲而抬首張望，暫泊的一葉漁舟，兩個童子正在搬書上岸，如此草堂，不啻為世外桃源，僅有那唯一的一架木橋將之與塵世相連。

此圖為吳宏應喬萊之邀，畫其父喬可聘居讀處"柘溪草堂"的景色。喬萊（1642-1694），字子敬，亦字石林，江蘇寶應縣人，康熙進士，曾任內閣中書等職，並曾參加纂修【明史】[1]。其父喬可聘字君徵，又字聖任，為天啟壬戌進士，官御史，曾與阮大鋮，

馬士英等奸宦相鬥爭，辭官而去。南明時又出任掌河南道，南明亡後歸老還鄉[2]。圖成後，喬家十分寶愛和自豪，喬萊曾示畫與當地文士，或邀文士來訪小住，並攜畫遊歷，與同道者共賞，邀寫題跋。故此畫裱框處幾乎全為各家之評賞所填滿，其中不乏當時的著名文人學者如朱彝尊，梁清標，著名畫家如查士標，程邃等，充分表現了中國文人以畫會友的雅習。而且主人公不戀官場之高祿，秉公正直，寧可歸為野老，以讀書自娛，怡養天年的作為，深受文人的愛戴，其生活的柘溪草堂，是其讀書避世之處，故也被喻為桃花源[3]，成為文人心目中的理想世界。因此，這些題跋，反映了當時文人的性情，愛好，直接地披露了他們的內心世界。

畫家在自題中表明為模擬宋代山水畫大家李成（919-967）的筆意，用筆蒼潤秀麗。畫面左上方有自題與署款：「柘溪草堂圖。壬子秋九月擬李成熙筆意呈石翁先生教之。金溪吳宏」。鈐白文方印：「吳宏私印」，朱文方印「遠度」。

裱框周圍有十家題跋：
1. 畫面上方兩題跋
引首印朱文長方印「賴（懶）老」。

行書：「我愛白田好，未向白田去，白田城南有柘溪，聞是白田最佳處，溪邊草堂稱清幽，古木千章竹萬頭，奇石名花看不足，湖光更上東南樓，向年獲識石林子，為言別業正在此，太公九十瑞人間，早歲棄官遂知止，閑來倚石手一編，倦即拋書石上眠，華髮蕭蕭眸炯炯，無人知是地行仙，石林先生行最少，能讀父書得其要，芥拾榮名自等閒，翰墨聲詩兼從妙，命余為作草堂圖，佳句傳來幻有無，伸紙躊躇筆不下，儼如咫尺貌蓬壺，名園勝地世多有，主者何人斯不朽，輞川吟詠祝平泉，千載流傳復誰久，柘溪之水清且漣，湖波萬頃繞平田，太平樂事長如此，還為高人結大年。曩為石林先生畫柘溪草堂圖漫系拙句，先生復命錄之此幅，名詠如林，能無形穢之誚，時丙辰九月下浣（同澣）二日查士標」。鈐兩朱文方印

「悚（懶）容」，「？？天暖」。

引首印朱文長方印「蕉林」。

行書：「侍御結廬溪水潯，萬株桑柘畫陰陰，迤邐

晴沙眠野鷺，高低灌木鳴春禽，編籬插槿蔽風雨，琴書北牖何蕭森，門無車馬驚鈴索，中有幽人事苦吟，幽人為誰侍御是，直節當年山嶽峙，正笏曾陳痛哭書，拂衣早辦登山履，經綸袖手賦歸來，白頭高臥鄉堂裏。海水揚塵歲月移，草堂無恙日舒遲，蒹葭秋色霜飛後，雞犬村扉晝閑時，巾車野服臨湖岸，載酒輕舠泛射彼，屏居白眼向寥廓，聞說先生猶健鶴，令子忻看傍鳳池，閑身不羨圖麟閣，倚杖頻耕萬畝雲，延年豈假千金藥，遙望伊人水一方，客來獨拜德公床，疑是李願住盤穀，不然種柳如柴葉，我欲從之問丹訣，放歌散髮濯滄浪。題柘溪草堂圖為聖翁老先生並求教定。趙郡梁清標敬書」。鈐朱文方印：「清標」，「鈺」。

2. 畫面左側四題跋
引首印朱文橢圓形印未識。

楷書：「石林寓齋懸尺素，披離滿幅多奇樹，湖光千頃浸柴門，數椽古屋臨荒圃，問君疑是江南村，指點為言柘溪路。柘溪今日之青門，老親五十歸丘樊，祇今八十有餘矣，渚鷗汀鷺同朝昏，我聞此語肅然敬，先生抗節如松勁。少簪直筆彈要津，老讀殘書悟之性，君今圖畫多深情，心在江南身帝京。歸夢迢迢柘溪去，醒來壁上生煙雲。今年揮手承明廬，射陽秋水上鱸魚。歸看青山侍華髮，柘溪幽處草堂居。我披此圖看不已，身入畫中當何如。癸丑八月一日長安客齋題柘溪草堂圖，呈聖翁老年伯教，兼送石林年兄南歸。龍眠年家子張英」。鈐白文方印「張英之印」。

行書：「桑柘陰中響桔槔，大人行處樂陶陶，林間老卻青驄馬，多事蛙聲鼓吹高，樹繞高齋水繞村，柘溪吾欲擬桃源，登樓梯子何須去，世事如今總不言，樹裏樓臺面水涯，堂前來往許農家，郎君那用仍懷橘，皓首多年學種瓜。癸丑初夏為聖翁老先生題，兼呈石林道兄，渭北孫枝蔚」。鈐白文方印：「孫枝蔚印」。

楷書：「柘溪草堂在何許，茅簷遠隔邗江濱，側聞侍御抗氣節，當朝往往批龍鱗，卻來遂志耽丘壑，簪纓不戀戀釣緡，有書可讀酒可飲，海內逃名今幾人，羨君有才能濩伏，羨君有子何嶙峋，伯也通籍忝附驥，仲君高弟登要津，內廷載筆生珠玉，大野置戈搜鳳鱗，每當揮毫皆氣奪，門下文采罕與倫，忽聞得請歸江畔，正逢侍御懸孤辰，宮衣起舞大官

152

饌，到家毋乃江南春，看君圖書江之滸，柳絲百尺輕如塵，草堂數椽盡足通，今將祿養奉老親，愧余將毋志未遂，對圖拂拭還逡巡，吁嗟！對圖拂拭還逡巡，柘溪樂事天倫真樂。題柘溪草堂為聖翁老年伯壽，兼似石老年兄正之，年家子徐倬"。鈐白文方印："徐倬之印"，朱文方印"方"。

楷書："江河日彌漫，小邑鮮樂土，城南扁舟路，煙靄澹容與，曠絕塵事少，賢者意獨取，先生有茅堂，況乃力田祖，相沿及數世，子孫滿堂廡，白髮頻往還，春秋課場圃，簡樸實所尚，著述稱學府，時復依柘陰，同人說晴雨，五十漸憂患，貞固難悉數，茲更踰八十，浮雲閱今古，圖中亦有致，憩坐見洲渚，寧知先生心，浩浩關出處。余于丁未客荊門時，為聖任老伯先生作也，今越丙辰，忽已十稔，石林老世兄復命書於幅尾，不計工拙，實多汗愧耳。同里陶徵"。鈐朱文方印："雩昀冀肘"。

3. 畫面右側四題跋
引首葫蘆形朱文印"銃懋"

楷書：白馬湖東葭菼萋，中有村原名柘溪，四圍足種萬株樹，三時常散千張犁，隴畞粲列儼圖畫，屋宇相接聞犬雞，回波小港百千曲，漁父蕩船時欲迷，行人盡日到村舍，深柳一帶鳴黃鸝，此鄉居人只一姓，我公世德開蓬蔾，致身柏台挺高節，清名直與文姚齊，烏程當國欲邀結，我公鄙絕如漆泥，是時逆閹織黨禍，清流一一遭排擠，拂袖歸田托終養，十年不出安伏棲，思陵之初始再出，倏忽陵穀驚鼓鼙，文謝之儔那可道，紛紛長樂驕其妻，我公甘心老農圃，白頭萬卷吟常低，草堂閑開禾稼熟，池喧鵝鴨兼鳧鷖，讀書講道適天性，食肉不廢鹽與齏，諸郎奉養足豐美，我公一味歌簡兮，此圖已如仲長統，展玩令我中心悽，負米曾無半畝地，買山那得多錢攜，待我他年賣書籍，結屋東鄰來灌畦。當題聖翁老年伯柘溪草堂，兼呈石林老年兄正，癸丑三月年家子汪懋麟草於十二研齋。鈐朱白文方印："汪懋麟五"，朱文方印"蛟門"。

隸書："秋水才深四五尺，湖館修脩兼倍客，種松皆老化龍鱗，膾一隻，鶴一隻，周步一池消半日，顏貌只如三二十，年來漸覺髭鬢黑，人間豈不是神仙，紫毫筆，珊瑚席，滴露研朱點周易。集唐人句，調寄天仙子，題柘溪草堂圖，並壽聖翁老先生，通家後學秀水朱彝尊"。鈐白文方印："朱彝尊印"，朱文方印"錫鬯"。

行書："一幅畫圖，諸家詞句，班馬參同，笑滄桑幾度，爾家丘壑，經權出處，天下中庸，廣廈庇人，卑棲養節，有子通身，清廟風忘情，若只種瓜種秫，遊戲談空，麗湖珠如虹，歲歲洪波洗鬱蕙，今之世猶克見，魯靈光殿，得天者豈此老還童，至樂庭闈，苦心宇宙，衡泌洋洋接混濛，娛親事，引漁樵物外，雞犬雍容。右瑞鶴仙為石林秘書題，上聖翁太老先生壽，兼求教誨。後學程邃"。鈐白文方印："程邃"，朱文方印"程倩"。

引首印為長方朱文"書巢"。楷書："當年曾傍柘溪住，溪水蒼茫雜煙霧，矮屋黃茅幾十家，老柏清陰數千樹。中有叢篁綠裏門，正是先生棲隱處，先生舊著柏台威，夂繡煒煌冠鐵柱。霜面誰當聰馬來，冰心定使豺狼去。一朝拂袖翻冥（溟）鴻，釣雪鋤煙伴鷗鷺。至今九十髮婆娑，朱顏不用丹砂駐，令子早達趨承明，繡虎才稱獨步。內人解識紫薇郎，紅藥翻階拂毫素。皓首思親望白雲，淮南冀北心迴互。秋風忽起鱸魚肥，抗疏寧親走如鶩，手攜一幅柘溪圖，琳琅珠玉題無數，歸來開向草堂前，空青儘是煙雲護。先生笑玩扶青藜，摩挲不覺雙睛注，熟徑真思著屐行，橋通竟欲褰裳度。坐臥十日心神舒，徘徊欲去頻回顧。世間何地覓桃源，柘溪即是桃源路。後學陳鈺敬題"。鈐朱文方印："陳"，白文方印"鈺"。

1 【中國人名大辭典。歷史人物卷】第136頁，上海辭書出版社，1990。
2 【小腆紀傳】卷十四，光緒乙亥金陵刻本，又參見【中國人名大辭典】，上海商務印書館，1933。
3 東晉詩人陶淵明【約376-427】作散文"桃花源記"，描述湖南西北山區一個與外世隔絕的和平安逸的世界，後來用以形容避世隱居的地方。【辭海】第1300頁，上海辭書出版社，1979。

15. 胡宗信（約活躍於1620－1664）
秋林書屋圖軸
1664年
紙本，水墨淡設色
畫面縱56釐米，橫37釐米，
通高縱240釐米，橫48釐米
南京博物院，7：31

此軸構圖工整，用筆不苟，略施淡彩，繪聳岩疊

嶂，流泉奏響，穿越紅綠相間的樹林，跌宕成澗，澗邊岩臺上，茅屋一間，一文人總髮于後，身著紅袍，盤坐席上，面前有書籍，茶盅等。全畫洋溢著書卷氣氛

胡宗信，生卒年不詳，約活躍於1620-1664年間，字可復，上元（今南京）人，為胡宗仁弟，亦善畫，山水秀潤。其一家兄弟三人宗仁，宗信和宗智（世稱雪村），皆善畫山水，宗智子胡玉昆，士昆亦善畫，士昆尤善畫蘭，康熙三年（1664）曾為周亮工（1612－1672）作墨蘭圖卷。周亮工曾描述這胡氏一家道："皆學畫。蓽門晝掩，茗碗爐香間，閣筆盈案，…可想見其家庭之樂"[1]。

讀書為明代尤其是明末文人所推重，是修身養性，排遣世憂之良方，而山林書屋是文人的理想去處。故此一時期常見以書屋或佈置為書房的草堂為題的繪畫，邀友人或畫家為自己的書屋草堂作畫或演繹其理想的書屋，亦很流行，如此幅繪畫即是胡宗信為另一畫家所繪的理想之書屋，又如前述的柘溪草堂圖的主人曾多次邀請畫家為其書屋寫真（從題跋中可知，查士標亦曾受邀為之作畫）。

畫面右上方裱框處有題簽"胡可復秋林書屋圖。雲壺題"[2]。

畫面右上方自題"甲辰春二月二十又四日，為長倩先生[3]寫秋林書屋圖。胡宗信"。鈐兩白文方印"宗信"，"可復氏"。

收藏印於畫面右下角，兩枚朱文方印"風雨樓"，"怍昔珍秘"。

1 周亮工【讀畫錄】卷二，第20頁，載【畫史叢書】第九冊，上海人民美術出版社，1963。
2 雲壺為顧澐【1835-1896】江蘇吳縣畫家，俞劍華【中國美術家人名辭典】第1547頁，上海辭書出版社，1996。
3 即范允臨【1558-1641】江蘇吳縣人，萬曆二十三年進士，工書善山水，與董其昌齊名。俞劍華【中國美術家人名辭典】第637頁，上海辭書出版社，1996。

16. 樊圻（1616－約卒於1697後）和
 吳宏（約生於1610－約卒於1690）
 寇湄像軸
 1651年

紙本，水墨
縱273釐米，橫80釐米
南京博物院，7：3530

此畫以不同的墨色和筆法繪溪旁嫩草，初生幽篁，和頂天立地勁挺的老樹，枝丫交錯，新發綠葉，墨色蒼潤，春意始來。在如此墨色濃潤的山水景物之中，以細筆描繪一年輕婦人，髮髻後挽，勒子遮額，著白衣高圓領長袍，坐于古樹蒼石之上，左手搭膝，右手支頤，抬首前瞻，其清新飄逸之狀有出世之相。此畫提供了金陵畫家間合作和交往的例子，而畫家間相互題跋的例子則更為多見。

此畫亦透露了金陵藝妓文化的一斑。自畫中題跋至周遭各家所題，佈滿所有空間，明末清初的繪畫中有如此鋪天蓋地般題跋的作品，雖有所見，但多為文人互通心曲之作。此為一貴族之侍妾，而能得到當時及以後文人學士的如此賞識，雖是源於金陵自古便有的尊崇藝妓文化的傳統，然主要是與主人公非同尋常的經歷和高尚不羈的人格有關。從題跋和有關記載中可知，畫中主人公寇湄是當時聞名的美人，能畫蘭作曲吟詩，是著名的"秦淮八豔"之一[1]。崇禎十五年，明代功臣保國公朱國弼以重金將其贖出妓院，並舉行了明代南京最大的一個迎親場面，以五千親兵手執紅燈籠迎娶，盛況空前。甲申春，京城淪陷，保國公投降，家人為官府拘沒，保國公欲賣寇湄等歌妓婢女以贖身。寇湄規勸主人讓其回金陵，保證在一月內以萬金將主人贖出。保國公思忖後同意了，寇湄遂短衣匹馬帶著婢女鬥兒歸返金陵，在舊院姐妹幫助下，籌集了萬兩銀子將主人贖回。當保國公想重續舊夢時，則遭到寇湄的回絕，並告之曰，當年你以銀子贖我脫籍，今天我亦以萬金將你贖回以報之。遂在金陵築園亭，天天與文人墨客吟詩作畫，飲酒抒懷，或歌或哭，歎美人之遲暮[2]。其女俠般的義氣和國破家亡後的痛心，為同時及後世的文人所欽佩和引發共鳴，此畫在文人中流傳閱覽，而多致題跋。

畫面左側題跋："寇湄字白門，娟娟靜美，跌宕風流，能度曲善畫蘭，粗知拈韻能吟詩，然滑易不能竟學，十八九時為保國公貽之貯以金屋，若李掌武之謝秋娘也[3]。甲申三月，京師陷，保國公生降，家口沒入官，白門以千金，予保國贖身，匹馬短衣從一婢而歸，歸而為女俠，築園亭結賓客，日與文人騷客相往還，酒酣耳熱或歌或哭，自歎美人之暮，嗟紅豆之飄零也。錢牧齋詩雲寇家姐妹總芳菲，十

八年來花事迷，今日秦淮恐相值，防他紅淚一沾衣。則寇家多佳麗，白門其一也。三山余澹心書于秦淮水閣"。

落款：校書[4]寇白門湄（鈐白文方印"湄"）小影，鍾山圻金溪宏合作。時辛卯秋杪，寓石城龍潭朱園碧天無際之堂。

鈐白文方印："樊圻之印"，朱文方印"會公"，朱文方印"吳宏"，白文方印"遠度"。收藏印：畫面跋下，畫芯左側長方朱文："明尚居士鑒賞"，"梁溪秦清曾藏"。其下在畫作側下角，朱文方印"頤梅廬秦通里藏書畫印"。右側下角，朱文長方"瞿伯謙審定書畫印"，朱文方印"城南心賞"。

其餘在畫芯上下兩方和左側裱框處還有14處題跋。

一·畫芯上方有七人題跋

1. "悵銀雲寫影，麝月描眉，前夢逐波遠。一片蒼茫冷，欄杆外，只留香印深淺。畫圖瞥見，倚夕陽，難訴幽怨。算垂柳多是凝情處，美人淚曾濺。閑了青羅團扇，便黃金能贖，身世都換。匹馬天涯路，吹芳草東風，容易春晚。銅仙故苑，想者（這）時，紅豆悲滿。問俠骨誰尋天半，蝶衣零亂。玉井先生囑題寇校書小影，調寄'眉嫵'，轂人吳錫麒"。鈐白文方印"錫麟"。

2. "白板門荒，青溪人杳，小幀墨痕留影，碧天無際，畫堂東簷，娟娟樹涼風靜，芳菲乍冷，悵紅豆，飄零難定。想當時，有黃金作屋，伊誰堪並，而今省，馬上弓彎幸，踏南歸鐙。行藏渾似謝秋娘，話章臺，後先相映，珠衣繡領恐吹起餘香。還剩向朱園何處，頹廊斷井。調'西子妝'題白門小像，請玉井先生正定。雲溪江立拜稿"。鈐朱文方印"玉屏道人"。

3. "豔質春初寵侯門，歡頓換愁新，繁華夢破，幽淒妝淡，俠脫千金，秦淮歸坐林陰悄，粉淚漬單襟。憐教墨妙，圖留韻態，傳伴名人。調寄'眼兒媚'，請玉井老先生郢正，由奉城草堂費融稿"。鈐白文方印"費融"。

4. "掃盡輕煙淡粉痕，板橋舊跡黯消魂，何人剩此春風筆，有識當年寇白門，身世沈淪感不任，蛾眉好是贖黃金，牧翁斷句餘生紀，為寫青樓一

片心，百年俠骨葬空山，誰灑鵑花淚點斑，合把芳名齊葛嫩，一為死節一生還。玉井閔華題"。鈐兩白文方印："曲竹風堂"，玉井"。

5. "千金一曲度瓊簫，身在侯門寵不驕。輸與吾家狂祭酒，當筵曾見舞弓腰。贖身傾篋出黃金，紅粉飄零悵爾深。年少紛紛輕薄子，阿誰可結歲寒心。條桑懶出賽蠶官，世外瑽華一見難。往事閑尋春夢斷，無言小立玉欄幹。修娥淡掃卸濃妝，靜志偏能禮自防。銀硯墨花香午夜，研光殘寫十三行。揮金結客妙當時，跌宕風流冠掃眉。管彤他年傳女俠，豪情羨煞五陵兒。胡宮回首劫灰飛，千里關河匹馬歸。悟得榮華如草露，空箱常疊金縷衣。和家梅村先生贈詩原韻，梅查吳均題"。鈐白文方印"吳三公印"。

6. "蒙叟題詞，余家紀筆，白門往事曾聞得，阿誰寫此更流傳，百年競爾親顏色，朱邸名姬，青樓豔質，圖中何故偏蕭瑟。千金贖後，返江南須知儘是愁時節。春橋朱方藹題"。鈐聯珠朱文方印"方"，"藹"。

7. "千古秦淮水一涯，橋橋殘柳剩棲鴉。寇家姐妹風流甚，不見丹並蒂花。想見初辭冀北時，歸裝結束小腰肢。輸他廄吏曾親見，翠袖搖鞭駿馬馳。樂耕吳士歧題"。鈐朱白文方印"鳳山"。

二·畫芯下方六跋

1. "吹橫波片玉，等覷三災，怎（不）及個人遠。一樣蟾蜍淚，風煙後，誰描娥子清淺。寫生若此見，倚樹根，閑著愁怨。數青鏤舊日簪花夢，憶娘墨同濺。依約年時桃扇，絮香君情緒，桑海俄換。掌武非前墨，歌金縷當筵，蒼香晚。南朝舊苑，恁百般，聲咽河滿。問白下朝雲早報，埭雞鳴亂"。"勝秦淮疏柳，也麼雙娥，遺恨莫愁遠，蝶夢韓品錯。輕煙散，天教紫玉緣淺，驚鴻瞥見，欠玉京，焦尾彈怨，笑紅豆高跂尚書履，恐它淚珠濺，休問鈸衣哥扇，抱剛腸俠骨，竿木頻換，舊燕廬家憶，崎嶇路細馬，駃卿歸晚。邗江勸客，賺月明，西湖光滿，怕妒（妬）影眉娘照水，黛痕凌亂（白樓姬人號眉生，故及之）。調寄【眉嫵】二闋題寇白門小影，和轂人祭酒韻，為白樓仁弟作。時嘉慶九年仲冬月遲悔生廷慶書於戴山講舍"。鈐兩白文方印："廷慶"，"舊史臣"。

2. "記青溪舊事,桃葉風情,一夢東京遠。水閣丁家在,鈿轅到,雙娥鏡裏猶淺。梅根冶畔,罷素箏,無端哀怨。看描出箱底石榴裙,秋風淚珠濺。休道阿龍執扇,歡紅妝,鱸魚美,歸來又值秋晚。卞沙老去,舊院門,衰草填滿。問疏柳板橋誰禁,絮風撩亂。調寄【眉嫵】,次載人祭酒韻,白樓仁兄正拍。烏程張塡"。鈐白文方印"張鑑",朱文方印"?氏"。

3. 綠水無波柳絮飛,秦淮春暖啟瓊扉。誰教舊院淒涼後,匹馬單衣薊北歸。春風畫閣燕來時,應悔陽臺夢醒遲。管領東南觴詠地,敢將歌泣使人知。白樓先生正之,梅叔阮亨"。鈐朱文方印:"梅叔"。

4. 淒涼問故國,長板橋頭誰第一,曾記滄心妙筆,歡匹馬南歸,舞衣空疊,柔腸俠骨,又夢雲飛去。無迹驚鴻杳雪泥,小影約略見顏色,珍惜百年詞客,有多少青衫搵濕,商邱聞說,近日扇底桃花飄零非昔。李香君小照舊藏商邱陳中丞家,今未知歸何處。畫圖間省識聽細雨,春寒測測同心處,蘭芬清供,旅邸話晨夕。丙寅春仲白樓大兄攜此來邗上,時與余同寓志館,以素蘭作供,為譜霓裳中序第一,竹嬾徐鳴珂"。鈐白文方印:"鳴珂"。

5. "當年歌哭向何人,匹馬歸來賸(剩)此身。莫怪容顏憔悴甚,好花經雨不成春。俠骨柔腸空復情,千金能贖一身輕。飄零紅粉知多少,猶幸披圖識姓名。戴光曾題"。鈐一白文方印:"戴光曾"。

6. "柔腸俠骨好腰身,不櫛朱家有替人。舊侶叢殘多入道,神仙容易見揚塵。腰間寶玦王孫淚,馬上桃花白下春。欲問煙花南都錄,藝香試與喚真真。
"郭麐"。鈐一白文方印:"臣麐私印"。

三·畫芯外左側邊跋
"手致千金解報恩,白門憔悴愴朱門,愁來一唱梅村曲,擁髻鐙前有淚痕,才出侯門又唱歌,尊前感舊涕滂沱,圓圓削髮河東死,總教覺風塵俠骨多。伯謙仲若世丈先生教削,已未孟陬壁城鐙下寫記,時客淮上節署"。鈐白文方印:"胡璧城印"。

1 清。張潮【虞初新志】卷三,河北人民出版社,1985。
2 俞允堯【秦淮古今大觀】第157－158頁,江蘇科學技術出版社,1990。
3 唐人稱太尉為"掌武",唐代牛李黨爭的重要成員李德裕曾任太尉,人稱李掌武,有愛妾歌妓謝秋娘,遂以隋煬帝"望江南"曲調作"謝秋娘",後白居易改為"憶江南",後人亦有根據白居易詩中的"江南好"的詩句而將詞牌改名為"江南好"者。明。胡震亨【唐音癸簽。唐曲】,載【掌故大辭典】第887頁,北京團結出版社,1990。
4 "校書"為舊時對妓女的雅稱。【辭海】第1301頁,上海辭書出版社,1986。

17. 胡宗仁(約活躍於1598-1618年)
山水圖軸
1598年
紙本,水墨
縱108釐米,橫33釐米(畫面)
南京博物院,7:30

此軸畫面構圖有似倪瓚,江岸岩磯,塊石疏枝,筆墨蕭散清逸。

胡宗仁,生卒年不詳,字彭舉,號長白,上元人(今南京)。工詩畫,山水師法倪瓚,亦善墨竹,工漢隸[1]。著名文人顧起元論及當代的文墨英才時道"胡彭舉宗仁,詩奇峭多新致"[2]。著名收藏家鑒賞家周亮工道:其"畫自文五峰伯仁來,晚出入王叔明(蒙),黃子久(公望)二家。其筆意古質,頗有五代以前氣象。貌傲岸,高蹈絕俗。晚年衲衣拄杖,反手徐步,修髯從風,見者目為神仙中人。八分書學'禮器碑',無一點俗態。工詩,本富家子,老而食貧,不謁時貴,時人重之"[3]。

此圖為萬曆戊戌(1598)年胡宗仁為送友人張隆甫返回武夷山舊居時所作。張氏自海路還閩,畫面以水濱之景寄意。這幅畫反映了兩個值得注意的社會現象,一是反映了明代士人結社的風氣,二是中國知識分子相沿已久的送行禮節。從所題的詩文中可知,張氏在南京時與同好結詩社,時常相聚,賦詩作詞,情懷相通。臨別時,友人設宴款待送行,飲酒敘舊,並贈送詩畫,這正是中國文人間送別的時尚。

中國人極重送別,還以送程的長短來喻情意的深淺,古人遂有"送君千里,終有一別"之說來勸阻戀戀不捨的送客。古代著名的送客典故如長安的灞橋折柳,從長安城到灞橋約有十多公里,主人送客

至此，依依不捨，折柳告別[4]。南京的方山據城有二十公里，如此之遙的地點，卻是六朝人的送客之處，主人自城裏送客，船行一天到達此地，盤宿一夜，次日才依依相別[5]。

畫面上方有時賢十一人的贈詩題跋，反映了當時文人所崇尚的品格和相互間交往的禮節和時尚。其中有好幾位畫家的題詩，如吳彬和被周亮工稱為金陵畫家先驅的魏之璜的題詩。

一·署款

"萬曆戊戌夏仲，張隆甫歸尋武夷舊居日，作此圖兼成二絕句以送之：送君淇上水泠泠，一曲悲歌暫駐聽，更浣流霞翻竹葉，謳歌聲恨不似秦（青），武夷山中舊有居，白雲常在近何如，歸時應自除三徑，莫忘天南一經書。賴（懶）仁"。鈐白文方印："彭舉"，朱文方印"胡宗仁印"。

二·畫芯上方有十一題

1. 楷書："夏日送隆甫社丈還閩：我留白門裏，君泊越溪濱，客館宵開宴，天涯曉離群，兩鄉秋月共，千里夏雲分，棹發空江渚，餘聲遠不聞。新都鮑士瑞"。鈐白文方印："鮑士瑞印"。

2. 楷書："三伏正炎時，攜家返武夷，江空暑氣薄，帆疾曉風吹，漸去鄉心近，長懷客夢隨，淮南虛桂社，故國莫留遲。郭郡畢良晉。鈐白文方印："康侯"。

3. 楷書："論交歡未足，溝水復西東，脈脈離情重，迢迢去路窮，經時榕葉綠，到日荔枝紅，復想承萱暇，餘溯迴遠風。秣陵魏之璜。鈐朱文方印："考叔"。

4. 楷書："數載詞林好，今朝爾獨歸，夏雲迎去斾，暑雨逐征衣，海國梯航沮，邊城羽檄飛，嗟餘猶作客，未得掩巖扉。南湖鄭如雨"。鈐白文方印："鄭氏景時"。

5. 行書："石頭城下水連天，岸柳汀莎散綠煙，君欲攜家渡炎海，何人不道孝廉船。海湯汪廷對"。鈐白文方印："汪廷對印"。

6. 楷書："武夷圖畫自天開，君去還饒濟勝才，三十六峰曾入夢，張騫終疑泛槎來。江左張振

英"。鈐兩白文方印："張振英印"，"字吉慶"。

7. 楷書："碧堤垂柳惜分祛，江燕牆鳥帶雨餘，別席共班西侯草，擔囊歸著茂陵書，年移志士傷遲莫（暮），柱促離徽怨索居。抗迹武夷仍羽客，俯看塵世日蕭疏。新都羅彝序具草"。鈐兩白文方印："羅彝印"，"四倫"。

8. 楷書："三年文酒荷君知，一日懷鄉暫別離，都下正傳平子賦，洛中忽動季鷹（詞），舟過劍浦猵（猿）啼切，家在壺山雁到遲，回首夏雲迷舊閣，傳蓬應不待瓜期。秣陵陳恭"。鈐兩白文方印："陳慕之印"，"陳氏幼謙"。

9. 楷書："江水微茫白鷺洲，張騫一舸放中流，忽辭建鄴千峰色，欲度閩關五嶺頭，炎海雲光新結夏，冰壺月影尚涵秋，遙憐鷗社群相憶，赤鯉無忘慰舊遊。天都汪元勳"。鈐兩白文"汪元勳印"，"曉卿（？）"。

10. 楷書："托迹都門不識閩，還閩不忍別都人，迢遙東去瞻雲樹，故國他鄉兩地親。秣陵劉光"。鈐朱文方印："君厚"，白文方印："劉光"。

11. 楷書："兩岸青山送去航，分攜無語淚沾裳，未諳何日床頭酒，更對君家醉故鄉"。"唱罷新詞怨夕暉，離情鄉思兩依依，憑君為語壺公識，好整雲林待我歸。織屬生吳彬"。鈐白文方印："吳彬之印"，朱文方印"仲文"。

其他鈐印及收藏印：

畫面左下角，白文方印："賴（懶？）叔"；右下角朱文方印"風雨樓"，白文長方印"錫山華氏珍賞"。

1 俞劍華【中國美術家人名辭典】第621頁，上海人民美術出版社，1996。
2 顧起元【客座贅語】卷十，第314頁，中華書局，1997年重印。
3 周亮工【讀畫錄】卷二，第19頁，載【畫史叢書】第九冊，上海人民美術出版社，1963。
4 宋程大昌【演繁露】：霸陵折柳，三輔皇圖曰：灞橋柳，灞水為橋也，漢人送客至此，折柳為別。故李白樂府曰：年年柳色，霸陵傷別。【掌故大辭典】第14頁，北京團結出版社，1990。
5 呂武進編【南京地名趣話】第30—32頁，南京出版社，1998。

第三部分：山水抒懷

中國山水畫歷來是表達畫家心曲的一種特殊藝術語言，從而抒情遣懷，擅發畫家們心目中對理想世界的憧憬和嚮往。尤其在十七世紀，明清兩代交替的歷史時期，忠於明朝的畫家們無以排遣的亡國之痛，常常借助筆墨而抒之於山水畫中，從謳歌故國的美麗中尋求靈魂的慰籍。

18. 龔賢（1618－1689）
　　千岩萬壑圖卷
　　1673年
　　紙本，水墨，手卷
　　縱27.8釐米，橫980釐米（畫面）
　　南京博物院7：4356

此為作者精心構制的宏圖大卷，以積墨法[1]繪寫江南大自然秀麗的景色。在將近32英尺長的畫面中，自寬闊的江面始，引向夾岸的連綿起伏的峰嶺坡巒，山間林木蔥郁拔翠，晨霧欲滴，巒中煙靄吞吐，白雲出岫，一棧通澗，溪水泪瀉，屋宇廟幡，隱落翠微之間，清江浩渺，數葉舟艇，橫泊葦灘。畫面壯闊雄渾。古人道書畫乃抒胸中之塊壘，由此長卷中可見，其非戲言。胸中筆下，畫家調遣筆墨的功夫以臻出神入化之境界，又有多少不盡之言，難言之情，令人費解。

清初四大家之一的王原祁（1642－1715）曾論道："古人長卷皆不輕作，必經年累月而後告成，苦心在是，適意亦在是也"[2]。龔賢在他生命的最後二十幾年中，先後創作了好多幅長卷，不僅是其藝術上集大成而臻頂峰的表現，從他同時的詩文中，輾轉透露出他沈重地懷念故國的深情，可以想象到在明代亡國後的痛苦和清初文字獄的禁忌和恐怖中，這些明遺民無法闡述情懷，唯有寄託於長卷山水畫中的一片深意[3]。此圖作於1673年，大約在此前後的二十多年間，龔賢作了好多幅類似題材和尺寸的長卷。據研究，存世的三百多件龔氏作品中，約有十六幅長卷，除早期的白描山水和一卷詩畫山水外，其餘皆為1666年以後所作[4]。

這些長卷不僅全面地反映了畫家的作畫技能，而且從所題的題跋中還可深入瞭解畫家的藝術成長過程，其生活狀況和內心世界，例如作於1674年的

"雲峰圖"（現為美國尼爾森－阿特金斯博物館藏），以十七張紙相接而成，圖中山重水復，雲起煙生，境界極為悠遠，題跋述及其師承淵源。還有的長跋中述及其與達官和收藏者的相交往，作畫的辛苦和僅以得到基本生活所需之米和酒便足矣的事實。如作於1679年，為天津人民美術出版社藏的"山水"卷，和為故宮博物院藏的作於1682年的"溪山無盡圖"卷的題跋中，皆記錄了一個誠實的畫家兢兢業業追求藝術的艱辛[5]。

畫末自題"癸丑嘉平半畝龔賢寫"。鈐朱文方印"龔賢"。

畫末隔水處有收藏印八枚：白文方印"錫蕃審定"，白文方印"是吾齋鑒藏印"，白文方印"于邠公讀畫記"，朱文方印"泉唐姚玉漁鑒藏書畫"，白文方印"臣近源印"，朱文長方印"蘇芷主人鑒定"，朱文方印"于氏子子孫孫永保之"，白文方印"幼卿考藏書畫"。其相連的題跋處空白，但有一白文方印鈐于左下角"翁之廉印"。

1　積墨法為宋人所創層層渲染以求沈雄深厚之山色的繪畫筆法，龔賢吸取之，並從自己的繪畫實踐中形成了新的積墨技巧和理論，是為："一遍為點，二遍為皴，三遍為染，四五六遍仍之，如此可謂深矣濃矣濕矣…"。【龔半千山水課徒說】，四川省博物館藏，蕭平，劉宇甲【龔賢】第240頁引，吉林美術出版社，1996。
2　周積寅【中國畫論輯要】第117頁，引【麓台題畫稿】，江蘇美術出版社，1997。
3　龔賢此一時期的詩作在【金陵詩徵】，【明末四百家遺民詩】中均可尋見。參見蕭平，劉宇甲【龔賢】一書中所輯詩文，吉林美術出版社，1996。
4　蕭平，劉宇甲【龔賢】，第20頁，吉林美術出版社，1996。
5　參見 "Eight Dynasties of Chinese Painting: The Collections of the Nelson Gallery-Atkins Museum and The Cleveland Museum of Art", Cleveland Museum of Art, 1980. 並參見【金陵八家畫集】天津人民美術出版社，1999。

19. 龔賢（1618－1689）
　　夏山過雨圖軸
　　十七世紀
　　絹本，墨筆
　　縱141.7釐米，橫57.8釐米
　　南京博物院，7：72

此畫以積墨法層層皴擦渲染而成，近景以蔥蘢的樹木為主，遠景繪層巒疊嶂，構圖工整，虛實相間，

飄渺的雲煙，以S形自近景延向遠方，不僅使山勢增加了縱深感和仙活之氣，而且籍著雲煙間顯露出的幾戶人家，使空山深林富於生命。

龔賢積墨法的形成約始於其四十歲左右[1]，龔賢自十三歲繪畫，曾以董其昌為師，並在而後的實際學習中，能以不拘一家，不囿一說的態度，博採眾長，在其於1674年所作"雲峰圖"（現為美國尼爾森－阿特金斯博物館藏）的題跋中，闡述了自己的師承，列舉了自五代董源宋代范寬巨然李成郭熙到明末的楊文驄馬士英等二十三位畫家[2]。龔賢在其繪畫生涯的前三十年的時間，專研筆法，多以簡筆勾勒，幹筆淡墨，然後稍加皴點，略施渲染而成。此期作品是為鑒賞界常謂"白龔"之時期，代表作如北京故宮博物院藏"自藏山水圖"軸，又如蘇州博物館藏"江山林屋圖卷"為其最早的手卷。在其三十八九至四十五六歲之間，龔賢著重對墨法進行了研究，有著一段所謂"灰龔"時期，用墨清淡，畫面有一種朦朧感，代表作如美國洛杉磯市立博物館藏龔賢山水，署名為"石城龔賢畫"。為人所稱的"黑龔"時期約成熟於四十五六歲之後，其風格轉變的契機，有相當的原因是他在四十歲左右時，得以造訪揚州的收藏家[3]，並與金陵收藏家周亮工為友，故得以遍覽各家所藏古代名作，而米氏以混點積墨表現雲山和雨山的獨特技法，賜與了龔賢靈感，加之積累三十多年繪畫和遊歷的經驗，龔賢已有不同尋常的氣韻凝積于胸，如其所道："歷今四十年，而此一片（米氏）雲山常懸之意表"，故在其晚年的山水畫中，執意追求墨法的變幻，來表現山水的渾茫壯闊和蒼厚沈雄，尋求米氏山水中透露的"氣可食牛力如虎"的神韻[4]，至此其積墨法已有幹積法，濕積法，幹濕並用法等，運用幹濕，深淺的墨色層層渲染而達到"靜極"和"淨極"的美學境界。上海博物館藏"自藏山水冊"作於1668至1669年間，是表明其"黑龔"面貌形成的作品，此後其作品多以"黑龔"的面貌出現。美國夏威夷火奴魯魯美術學院藏"師董巨山水"圖軸，是他最後的作品，作於其71歲時，筆墨蒼厚，尤其令人讚歎的是，在此耄耋之年，他還在孜孜不倦地探索結合宋元的畫理和靈逸之間的關係，在題跋中直道"以倪黃為遊戲，以董巨為本根。吾師乎！吾師乎！"，表明了他一生的追求是在探討中國繪畫領域最高層次的神品和逸品，即"本根"和"遊戲"之間的關係[5]。

龔賢發展而成的墨法在當時便贏得"龔生墨妙冠江東"之名[6]。他曾在【龔半千課徒稿】中詳述自己積墨法的技巧，以樹葉為例"一遍點，二遍淡加，三遍染，…三遍點完墨氣尤淡，再加濃墨一層，恐濃墨顯然外露，以五遍淡墨渾之"，雖以五遍得繪一葉，期間仍然層次分明，不應落於板滯，如其所論"望之蓊蔚，而其中實葉葉分明者，燥濕得宜也。點燥而染濕，濕不掩燥。點濃而染淡，淡以活濃。"[7]。從此軸"夏山過雨"圖中便可領略其以積墨法而成的"黑龔"之面貌。

畫面左上方題款"武陵龔賢"[8]，鈐白文方印"龔賢"。畫面左下角收藏印白文方印"香洽之印"，右下角有白文方印"巨峰鑒賞"。

1 蕭平，劉宇甲【龔賢】第54頁，吉林美術出版社，1996。
2 蕭平，劉宇甲【龔賢】第20－21頁，"山水董源稱鼻祖，范寬僧巨繩其武。復有營丘與郭熙，支分派別翻新譜。襄陽米芾更不然，氣可吞牛力如虎。友仁傳法高尚書，畢竟三人異門戶。後來獨數倪王黃，孟端石田抗今古。文家父子唐介元，少真多膺休輕侮。吾生及見董華亭，二李惲鄒尤所許。晚年酷愛兩貴州，筆聲墨態能歌舞。我於此道無所知，四十春秋茹茶苦。友人索書雲峰圖，菡苕茉莉相競吐。凡有師承不敢忘，因之一一書是甫。"引"雲峰圖"題跋。吉林美術出版社，1996。
3 龔賢在約六十歲時有一則題跋道："十年前，余遊廣陵。廣陵多賈客，家藏巨�範者，其主人喜鑒賞，必蓄名畫。余最厭造此門，然觀畫則稍柔順。一日，堅欲探其笈筒，每有當意者，歸來則百遍摹之，不得其梗概不止。今住清涼山中，風雨滿林，徑無屐齒，值案頭有素冊，忽憶舊時所習，複加以己意出之…"。蕭平，劉宇甲【龔賢研究】第250頁，引"二十四幅巨冊"跋，吉林美術出版社，1996。
4 蕭平，劉宇甲【龔賢】第56－57頁，吉林美術出版社，1996。
5 蕭平，劉宇甲【龔賢研究】第74頁，吉林美術出版社，1996。
6 方文【嵞山集】1667年詩作"題龔半千畫贈曹明府"第24頁，上海古籍出版社，1979。
7 蕭平，劉宇甲【龔賢】第56頁引【龔半千山水課徒稿】，吉林美術出版社，1996。
8 武陵在湖南省，但此地或許不是表明其族出的地望，而僅為龔賢引以為自己值得驕傲的出身和對理想境界的憧憬。魯力"龔賢研究補遺"載【東南文化】第5期，南京博物院，1988。

20. 樊圻（1616－1697後）
雪景山水圖軸
1666年
絹本，設色，
畫面縱83釐米，橫48.3釐米，
通高226釐米，橫61釐米
南京博物院，7：83

淡墨薄染以示冬日之黯淡天光，在此背景中，映照著以硬直線條勾勒的挺拔山巒，兩峰對峙，恰似天

門洞開，覆蓋的白雪，增添其凌霄突起之氣勢，山谷中，松林屹立，山廟寂然。

冬日之雪景雖為中國山水畫中所見，但並不如描寫其他季節的畫作般流行。清初大畫家王原祁在【麓台題畫稿】"仿大癡九峰雪霽"一條中，簡述雪景之創作變遷道："畫中雪景唐以前但取形似而已，氣韻生動自摩詰開之，至宋李營邱，畫法大備，雪景之能事畢矣。大癡不取刻畫，平淡天真，別開生面，此又一變格也"[1]。因雪景山水所繪之物極簡，留白多而筆墨亦不能繁，如何以少許的筆墨，別創一格，得其神韻，實非易事。清初的唐岱在其【繪事發微】論雪景時題道："雪圖之作無別訣，在能分黑白中之妙，萬壑千岩如白玉合成，令人心膽澄澈"[2]。以此觀之，對黑白層次的微妙處理，是描繪雪景的關鍵所在。此軸大有冰清玉潔，凜然獨立之姿態，可謂得雪景之真韻者。

南京的雪景曾深為文人學士所歎為觀止，著名文學家鍾惺（1574-1624）曾有文道："看雪無博于庚辛冬春鍾子之在白門者。由今想之，於木末亭，於雞鳴寺塔下，于烏龍潭，於孝陵，于秦淮之舟。大要木末之雪秀，秀于木，於煙；雞鳴寺眺後湖，後湖之雪曠，曠于湖，烏龍潭之雪幽，幽於潭，亦于木，於煙；孝陵之雪雄，雄於陵；秦淮雪舟，前此未有也。雪則蔣山，蔣山之雪活，活于從水看山"[3]。如此富於詩情畫意的南京雪景，因而亦被畫家們描繪表現，著名者如"石城霽雪"即為著名的金陵四十八景中之一景（參見附錄2）。

畫面左上方落款"丙午（1666）鞠月（九月）鍾陵樊圻畫"。鈐二白文方印"樊圻之印"，和"會公"。

1 王原祁【麓台題畫稿】，載黃賓虹，鄧實編【美術叢書】第一冊，第67頁，江蘇古籍出版社，1986。
2 唐岱【繪事發微】載黃賓虹，鄧實【美術叢書】第一冊，第261頁，江蘇古籍出版社，1986。
3 吳承學【晚明小品研究】第173頁，引鍾惺【隱秀軒集】卷第四"五看雪詩"，江蘇古籍出版社，1999。

21. 武丹（活躍於1667--1684年前後）
　　林巒煙靄圖軸
　　1677年
　　紙本，水墨淡設色
　　通高縱248釐米，橫60釐米
　　南京博物院，畫5399

此軸以"S"形的構圖，從左下角的湖中小橋，行至右側樓宇，然後左向至小丘上的亭閣，右向至峭岩下之樓臺，繼續忽左忽右地蜿蜒而去，將高拔之山勢引向深遠，使一紙之上而得百里之遙。此圖重在表現煙霧之不可捉摸，而以細密的皴法，濃淡深淺不一的渲染，柔和潤澤之感，造成霧靄之中山石林木的朦朧飄渺。山巒及樓閣則輕罩赭褐，為山林增色。

武丹，字衷白，山水清勁不苟。從其署名為"白門"可以推測，他或許為南京人。康熙二十三年（1684）嘗作"梅花書屋圖"[1]。

此畫畫面右上方落款"丁巳除夕寫奉豈（祈）老道先生粲正。白門武丹"。鈐兩方印，一為朱白合文"武丹之印"，一為朱文"衷白"。

1 俞劍華【中國美術家人名辭典】第536頁，上海人民美術出版社，1985。

22. 龔賢（1618－1689）
　　秋江漁舍圖軸
　　十七世紀
　　絹本，設色
　　縱142釐米，橫58釐米
　　南京博物院，畫5667

圖繪金秋時節漁居夕照的景色。畫面取董北苑筆意，遠景用披麻皴繪寫山岩，略施淡赭罩染，中景畫叢林，以橫筆大混點點出紅葉，綠葦，茅舍，草亭，小橋，漁舟，是作者作品中少見的粗筆設色山水，展現了作者的另一風格。恣意揮灑的書法與畫中披麻皴，橫筆大混點等粗筆的風格相吻，足見畫家舉筆作畫時的疏放傲岸之心態。

畫幅上方自題"蕩胸湖水際秋天，天外風生夕照邊。說與漁郎結茅住，不須重棹武陵船。紅蝦紫蟹易盈筐，入市遂能買酒漿，楚食不知關孔聖，一聲歌出喜滄浪"[1]。畫尾署款"蓬蒿人自題"[2]。鈐白文方印"臣賢私印"。龔賢一生未曾出仕，此處自稱為"臣"，是表示對故國明朝的忠心[3]。畫幅右下角押收藏印白文方印一枚"？西王柚號仲清賞鑒之章"。

畫面外框上有平子題跋道"此幅秋江漁舍圖，用筆蒼古，有元人遺意。半畝老人嘗居金陵，今掃葉樓

遺迹尚在。畫江岸漁居，極似秣陵風景，想即作于掃葉樓者，漁陽山人[4]'江幹都是釣人居，柳陌菱塘一帶疏，好是日斜風定後，半江紅樹賞鱸魚'一詩以題此畫，恰正相合。近人頗有以喜老人畫者，實因日人愛重老人之故，其價昂亦因此可哂也。平子題"。鈐朱文方印"平等閣主人"。平子為狄平子（1872-1940），江蘇溧陽人，近代鑒賞家，畫家。原名狄葆青，字楚青，別署平子，工行書及近體詩，亦善畫，家富收藏，精鑒別[5]。

1 典出楚國詩人屈原的"漁父辭"："漁父莞爾而笑，鼓枻而去，歌曰：滄浪之水清兮，可以濯吾纓，滄浪之水濁兮，可以濯吾足。遂去，不復與言"。後世以濯足滄浪喻回歸自然，潔身自好之志。陳子展撰【楚辭直解】第295頁，江蘇古籍出版社。
2 龔賢用"蓬蒿人"一款，據猜測是取意李白"南陵別兒童入京"一詩中句"仰天大笑出門去，我輩豈是蓬蒿人"，以喻其在清代的統治下，自己一人顛沛流離，如生活在野草間人。參見魯力"龔賢研究補遺"，載【東南文化】第五期，第134-144頁，南京博物院，1988。
3 張寶釵"龔賢'秋江漁舍圖'試析"【東南文化】第五期，第150頁，南京博物院，1988。
4 王士禎1634-1711，字貽上，號阮亭，自號漁洋山人。載俞劍華【中國美術家人名大辭典】第58頁，上海人民美術出版社，1985。
5 路錫三【當代名人書林】，中華書局有限公司，1932，及沈柔堅主編【中國美術辭典】第249頁，臺灣雄獅美術，1989。

23. 鄒喆（約生於1610－約卒於1683後）
　　雲巒水村圖軸
　　1661年
　　金箋，墨筆。
　　縱154.2釐米，橫47.8釐米
　　南京博物院，畫10301

此幅頗有粗筆山水的風格，以硬直線條勾畫高拔之山勢，以披麻皴作山之肌理，用橫扁之苔點以飾蒼岩，雲煙起處，溪石木橋，夾岸幹欄式水榭，寬敞臨風，蔥蘢的樹木以多種葉法和色彩表現，自然又是高士理想境界中的一方淨土。

畫幅右上方有題款為"辛丑九月鄒喆寫"。鈐兩方印，一為白文"鄒喆印"，一為朱文"方魯"。

24. 龔賢（1618－1689）
　　岳陽樓圖軸

絹本，墨筆
高281釐米，橫240.4釐米
南京博物院，7：5387

此為巨幅立軸，於畫面左邊寫山崖聳立，樹木蔥鬱，山下林木叢生，彎曲的城牆掩映於樹叢中，城牆上建有一座重簷歇山式的城門。畫幅右面和中部以大片的空白，來表現湖水的浩瀚，湖中有一座小島，遠處群山起伏，整個畫面給人以幽深清新的感覺。

畫幅上方畫家自題："風煙樹杪岳陽樓，樓上湖光潑眼流。萬頃玻璃同一色，月明中夜正深秋。微茫莫辨君山影，水鶴無聲二女愁。豈有半帆開蚌蛤，漁郎何處挂扁舟。此時笛韻焉能少，折柳梅花想不休"。署款"半畝龔賢"，鈐白文方印"龔賢之印"。龔賢或曾到此一遊，而興起畫意詩情，或憑想象而繪此圖，雖尚且無從考證。但畫家此畫的意境高雅，畫月夜而無月，但有為中秋月光所映照的寂靜的湖山，正是岳陽樓所能極目遠望而興起無盡詩意的最佳時光，畫面捕捉了岳陽樓最迷人的一瞬，也展現了在寥闊清空下，縹緲無垠的思絮，和寧靜致遠的情操。

岳陽樓是中國四大名樓之一[1]，為湖南岳陽縣西門的城樓，面對碧波萬頃的洞庭湖，這座城樓始建于唐朝，樓為三層，幾經興廢，歷盡滄桑，然歷代文人騷客爭相登臨，留下了許多名作，如唐朝的詩人李白，杜甫，韓愈，白居易等都有題詠岳陽樓的詩句，如杜甫便歌詠道："昔聞洞庭水，今上岳陽樓。吳楚東南坼，乾坤日夜浮。親朋無一字，老病有孤舟。戎馬關山北，憑軒涕泗流"[2]。宋慶曆五年（1045）巴陵守滕宗諒重修，著名文人范仲淹為撰"岳陽樓記"，其"先天下之憂而憂，後天下之樂而樂"的名言，千古不朽，使岳陽樓聲名遠噪。其後歷代皆有修葺。

此畫曾為著名畫家劉海粟（1895－1990）於三十年代末收藏，並經吳湖帆，張大千，朱屺瞻等名畫家，或收藏家鑒賞，皆推崇備至。後劉海粟於五十年代捐贈南京博物院。畫上收藏印有"海粟歡喜"，"藝海賞"，"海翁"，"劉氏家藏"。

1 其他為湖北武漢黃鶴樓，江西南昌滕王閣，山東蓬萊閣。
2 【唐詩三百首】第182頁，中華書局，1981。

161

25. 陳卓（1634-1709年之後）
 青山白雲圖軸
 1703年
 絹本，設色
 縱257釐米，橫66釐米（通高）
 南京博物院，畫48

此軸為陳卓七十歲時所作，構圖工整，從山澗木橋，循水而上，沿崖之棧道，跌宕之瀑布，飄逸之雲煙，中有古廟仙閣，至凌天絕頂，陡峭山崖上懸掛的飛流，是一般所謂山水構圖中"高遠"的範例。而以宋人法，用剛硬的線條勾勒山岩的奇崛，然後皴以小斧劈皴，再著濃重的石青，赭石等色，以石綠繪蒼石青松之勁挺，幾點胭紅飾秋意的深沈，數塊粉白言雲煙的無心。廟宇則以界畫法仔細勾勒，雕欄畫棟，飛簷歇山和屋頂相望之鴟吻，整幅畫面有景有情，有技法有色彩，繼唐代以來青綠山水之餘韻，而表現了宋畫"實，硬，密，厚，重，和謹嚴"的風格。

據研究，存世的陳卓繪畫尚有六七幅為中國各博物館收藏，如廣東省博物館藏"雲山樓閣圖"，首都博物館藏"仙山樓閣圖"，天津藝術博物館藏"丁未春日山水圖"，南京博物院藏"山水扇面"，南京市博物館藏"水村圖"，安徽省博物館藏"雲山青嶂圖"等[1]。

畫面右上方落款：癸未（1703）秋八月陳卓。鈐一朱文圓印"陳卓"，一白文方印"中立"。收藏印在左下方有兩小圓印，一為"？清"，一為"其璋"，右下角有一朱文小方印，"子明"。

1 陳傳席"關於金陵八家的多種記載和陳卓"，載【東南文化】第4/5期，南京博物院，1989。

26. 龔賢（1618－1689）
 山亭溪樹圖扇面
 1679年
 金箋，水墨
 縱20.9釐米，橫60.4釐米
 南京博物院，7：6258

此扇面以勾皴為主，寫湖濱小景。淡墨繪遠山連綿，近處墨稍濃重，繪山石的疊嶂，濃墨的苔點和

幾株自在的野樹，伴著溪岸邊的草亭，溪水平闊如鏡，空山杳無一人。用筆蕭散，意境疏曠。

這類小景的疏秀畫法多見於龔賢晚年的扇面之作。章法意趣從倪瓚處來，愈老而筆意愈加松靈蕭散。在其老年時的課徒畫稿一圖中，道其妙處"此謂之倪（瓚）黃（公望）合作。用倪之減，黃之松。要倪中帶黃，黃中有倪，筆始老，始秀，墨始厚，始潤。"是龔賢追求筆墨趣味的逸品[1]。

畫幅上方自題"為飛如道兄畫。半畝賢"。鈐"柴丈"朱白文方印。

收藏印：左下角朱文方印"白"。

1 蕭平，劉宇甲【龔賢】第236頁引1935年商務印書館版【龔半千山水課徒稿】，吉林美術出版社，1996。

27. 高岑（活躍於1643－1687後）
 秋山萬木圖軸
 十七世紀
 絹本，設色
 縱148釐米，橫57.7釐米
 南京博物院，7：78

此圖寫深山秋景，正中奇峰突起，如擎天之柱，雄偉峻險，頂峰樹木蔥蘢，飛流直下，山下空朦一片，溪谷間雲煙彌漫動蕩，林木蕭疏，紅葉挂枝，小橋高架于石間汩汩的溪水之上，山徑間，一高士著紅衣白袍黑風帽，柱杖前行，一侍童則著青衣短褲背包相隨。

此畫為高岑自題臨寫宋代山水畫大家范寬的"秋山萬木圖"，故在構圖上極為相似，雖然用筆工整而顯拘謹，不及范氏的大家風範，欠其雄渾而更多秀麗，但從總體上來說，高岑的落筆仍然具有雄健之氣，墨色蒼潤，尤其是雲煙幻動，生態盎然。不失為高岑臨寫的佳作。此圖與現藏於臺北故宮博物院的"溪山行旅圖"絕似，而臺北故宮的畫僅有"范寬"二字的名款而無題款，此畫與高岑所臨寫的"秋山萬木圖"是何關係，當待考[1]。

以侍童相隨或友人結伴的山遊，歷來為中國士人所好，在明代的山水畫中則更為多見。此期畫中的士

人還多見著紅衣者，大約與明末讀書貢生必穿淺紅道袍的習俗有關[2]。

畫幅左上自題："臨范中立秋山萬木圖"，署款"石城高岑"。鈐二白文方印"高岑之印"，"蔚生"。

1　參見Wen C. Fong and James C.Y. Watt "Possessing the Past", New York, Metropoitan Museum of Art and Taipei: National Palace Museum, 1996. PL. 59.
2　錢杭，承載【十七世紀江南社會生活】第274頁，臺北南天書局，1998。

28. 髡殘（1612－約卒於1686後）
　　蒼翠淩天圖軸
　　1660年
　　紙本，設色
　　縱226釐米，橫59釐米（通高）
　　南京博物院，7：65

此軸構圖繁密，有王蒙之遺意，自山頭疊宕的山泉和以S形攀沿的山徑，和沿徑之山廟野寺，使這繁密構圖的深山叢林間，陡然具備了生意。尤其畫面左下方幾椽茅簷下，一老者黑風帽紅長袍，伏案獨坐，凝視山景，似有所思，將這山水之景與高士的心境又有了聯絡。筆觸蒼勁老到，筆墨疏散靈活，稍許赭石和花青，使青山獨具古雅蕭逸之態。

髡殘，字石溪，一字介休，號白禿，一號曳壤，自稱殘道人，電住道人，晚號石道人。俗姓劉，湖南武陵（今常德）人。居江甯（今南京），為僧後曾居金陵（南京）牛首寺。性寡默善病，每以筆墨作佛事，偶然遊戲，便寫山水，奧境奇辟，緬邈幽深，峰巒渾厚，筆墨蒼茫，長於幹筆皴擦，得元人勝

概。詩文畫法亦古奧。有【浮查集】，與原濟石濤並稱二石[1]。亦為龔賢所稱讚的"二溪"之一，（參見圖錄第6-1號）。居南京時，與龔賢，程正揆皆為好友。龔賢與他同為南京幽棲寺住持覺浪道盛的弟子，有書畫往來，並相互視之為通解筆墨的知音[2]。有學者將髡殘，與龔賢，程正揆並提為金陵三逸，視為金陵畫家的中堅人物，將這三者的繪畫評為代表繪畫最高境界的逸品一列[3]。

畫面右上方有自題"蒼翠淩天半，松風晨夕吹，飛泉懸樹杪，清磬徹山屋，屋古摩崖立，花明倚磵披，剝苔看斷碣，追舊起餘思，遊迹千年在，風規百世期，幸從清課後，筆硯亦相宜。霧氣隱朝暉，疏村入翠微，路隨流水轉，人自半天歸，樹古藤偏墜，秋深雨漸稀，坐來諸境了，心事託天機。時在庚子深秋，石溪殘道人記事"。鈐白文方印"石溪"，白文方印"電住道人"。

從此畫的題詩和所繪的景物，可知畫家作畫並非為畫而畫，實乃有其無法明言的"心事"，在畫家于康熙九年（1670）所作的"山水冊"的題跋中，便透露了此"心事"，原來是"老去不能忘故物，雲山猶向畫中尋"，他正是通過山水來尋找那失落的故國，故鄉，寄託自己永遠無法釋懷的戀情[4]。在經歷兩個朝代的更替之間，與自己故國無法割捨的情結，正是明末許多遺民畫家借畫抒懷的原動力。

1　俞劍華【中國美術家人名辭典】第1170頁，上海人民美術出版社，1985。
2　張子甯"龔賢和髡殘"，載【東南文化】第五期，第35-39頁，南京博物院1990。
3　馬鴻增"龔賢的'逸品'論與'金陵三逸'"，載【東南文化】第五期，第18-24頁，南京博物院，1990。
4　梁白泉主編【南京博物院藏寶錄】楊新"髡殘【蒼翠淩天圖】"第200－201頁，上海文藝出版社和三聯書店，1992。

APPENDICES
附錄

BRIEF INTRODUCTION TO NANJING'S ANCIENT NAMES

南京古代名稱簡介

Late Western Zhou Dynasty–
 Warring States Period (B.C. 841–221)
周－戰國

Jinling, Yecheng, Yuecheng
金陵，冶城，越城

Qin Dynasty (B.C. 221–206)
秦

Moling, Jiangcheng
秣陵，江乘

Han Dynasty (B.C. 206–220 A.D.)
漢

Moling, Danyang, Hushu
秣陵，丹陽，湖熟

Wu Kingdom (222–280)
吳

Jianye, Shitoucheng
建鄴，石頭城

Southern Dynasties (420–589)
南朝

Jiankang, Linjiang, Baixia, Baimen, Tongxia, Yangzhou
建康，臨江，白下，白門，同夏，揚州

Sui Dynasty (589–618)
隋

Jiangzhou
蔣州

Tang Dynasty (618–907)
唐

Shangyuan, Shengzhou
上元，昇州

Five Dynasties Period (907–960)
五代

Jinlingfu (Yangwu), Jiangningfu (Southern Tang)
金陵府（揚吳），江寧府（南唐）

Song Dynasty (960–1279)
宋

Jiangningfu (Northern Song), Jiankangfu (Southern Song)
江寧府（北宋），建康府（南宋）

Yuan Dynasty (1279–1368)
元

Jiqinglu
集慶路

Ming Dynasty (1368–1644)
明

Yingtianfu, Nanjing, Shangyuanxian, Jiangningxian
應天府，南京，上元縣，江寧縣

Qing Dynasty (1644–1911)
清

Shangyuanxian, Jiangningxian
上元縣，江寧縣

Tianjing (Heavenly Kingdom of Great Peace, 1853–1864)
天京（太平天國）

Although some ancient names of Nanjing were associated with the administrative divisions of specific periods, they were often used, especially in literary works, regardless of the change of dynasties. Jinling is one such example. Also, throughout the history of the city, some nicknames and elegant names associated with its geography or history were developed, such as Zhongshan, Qinhuai, Dili, etc.

南京的古代名稱許多與行政建置有關，自開始使用之日，有些名稱在歷代的文獻中皆沿用之，以指南京，例如"金陵"。另有與地理地貌和歷史有關的代稱雅稱等，如"鐘山"，"秦淮"，"帝里"等。

Based on "Shangyuan Xianzhi" in *Nanjing wenxian*, vol. 3 (Shanghai: Shanghai Shudian, 1991) and Ji Shijia and Han Pinzhen, *Jinling shengji daquan* (Nanjing: Nanjing Chubanshe, 1993). 據【南京文獻】第3冊收錄的【上元縣志】和季士家，韓品崢主編的【金陵勝迹大全】。)

THE FORTY-EIGHT VIEWS OF JINLING

金陵四十八景

達摩古洞	Ancient Cave of Damo	來燕名堂	Hall of Fame at Laiyan
謝公古墩	Ancient Hills of Xiegong	獻花清興	High Spirit at Xianhua
幕府登高	Ascending the Heights at Mufu	木末風高	High Wind at Mumo
清涼問佛	Asking Buddha at Qingliang	憑虛遠眺	Looking Far at Pingxu
東山秋月	Autumn Moon at Dongshan	獅岭雄觀	Magnificent View at Shiling
杏村沽酒	Buying Wine at Xingcun	栖霞勝概	Magnificent Views at Xixia
神樂仙都	Celestial Music at Xiandu	樓懷孫楚	Memories in Pavilion of Sunchu
長橋選妓	Choosing the Ladies at Changqiao	牛首烟嵐	Misty Peak at Niushou
鐘阜晴雲	Clear Cloud at Zhongfu	莫愁烟雨	Misty Rain at Lake Mochou
虎洞明曦	Clear Sunrise at Hudong	北湖烟柳	Misty Willows at Beihu
祁澤池深	Deep Pond at Qize	長干故里	Old Neighborhood at Changgan
靈谷深松	Dense Pines at Linggu	赤石片磯	Piece of Rock at Chishi
雨花説法	Discussing Buddhism at Yuhua	台想昭明	Reminiscing at the Platform of Zhaoming
嘉善問經	Discussing Scripture at Jiashan	石城霽雪	Snow Ends at Shicheng
祖堂振錫	Encouraging Bestowal at Zutang	燕磯夕照	Sunset at Yanji
龍江夜雨	Evening Rain at Longjiang	報恩寺塔	Temples and Pagodas of Bao'en
桃渡臨流	Facing the Stream of Taodu	高飆別館	The Villa at Gaobiao
化龍麗地	Fair Land at Hualong	鳳凰三山	Three Hills at Fenghuang
甘露佳亭	Fair Pavilion at Ganlu	雞籠雲樹	Trees in Cloud at Jilong
星崗落石	Falling Stones at Xinggang	鷺州二水	Twin Rivers at Luzhou
三宿名岩	Famed Rocks at Sansu	珍珠浪湧	Waves Surging at Zhenzhu
秦淮漁歌	Fishing Songs at Qinhuai	冶城西峙	West Hill at Yecheng
永濟江流	Flowing River at Yongji	青溪九曲	Winding Nine-Curves of Qingxi
天界招提	Greeting Banks at Tianjie	天印樵歌	Woodcutter's Songs at Tianyin

Based on Jiang Zanchu, *History of Nanjing* (Nanjing: Nanjing Chubanshe, 1995), pp.146–8. Translated by Ben Wang. 據蔣贊初【南京史話】，汪班翻譯。

ARTISTS IN THE EXHIBITION: BIOGRAPHICAL DATA
展覽中的藝術家資料

Pinyin	Dates	Characters	Zi (style name)	Hao (sobriquet) and other names
Cai Ze	active 1662–1722	蔡澤	Cangsen 蒼森 Lincang 霖滄	Xueyan 雪岩
Chen Zhuo	1634–after1709	陳卓	Zhongli 中立	Chunchi Laoren 純痴老人
Cheng Zhengkui	1604–1676	程正揆	Duanbo 端伯	Qingxi Daoren 青溪道人 Qingxi Jiushi 青溪舊史 Qingxi Laoren 青溪老人
Fan Qi	1616–after 1697	樊圻	Huigong 會公 Qiagong 洽公	
Gao Cen	active 1643–after1687	高岑	Weisheng 蔚生	
Gong Xian Gong Qixian	1618–1689	龔賢，龔豈賢	Banqian 半千	Yeyi 野遺 Banmu 半畝 Chaizhangren 柴丈人
Guo Cunren Guo Ren	ca. 1580–1620	郭存仁，郭仁		Shuicun 水村
Hu Zao	active 1650–1662	胡慥（造）	Shigong 石公	
Hu Zongren	active 1598–1618	胡宗仁	Pengju 彭舉	Changbai 長白
Hu Zongxin	active 1620–1664	胡宗信	Kefu 可復	
Kuncan	1612–after 1686	髡殘	Shixi 石溪 Jiexiu 介休	Baitu 白禿 Yerang 曳壤 Candaoren 殘道人 Dianzhudaoren 電住道人 Shidaoren 石道人
Wei Zhihuang	1568–after 1645	魏之璜	Kaoshu 考叔	
Wu Dan	active ca. 1667-1684	武丹	Zhongbai 衷白	
Wu Hong	ca. 1610–ca. 1690	吳宏	Yuandu 遠度	Zhushi 竹史
Xie Sun	active around 1679	謝蓀	Xiangyou 緗酉 Tianling 天令	
Ye Xin	active 1640-1673	葉欣	Rongmu 榮木	
Zou Zhe	ca. 1610-after 1683	鄒喆	Fanglu 方魯	

SELECTED CHINESE CHARACTERS

中文辭匯選錄

(bai) Gong	白龔	Gu Zhengyi	顧正誼
Bai niao chao feng	百鳥朝鳳	*gujin zitie*	古今字帖
Bai Tao Fang	百陶舫	*Guo chao hua zheng lu*	國朝畫徵錄
Bailuzhou	白鷺洲	Guozijian	國子監
Bao'ensi	報恩寺	*hei Gong*	黑龔
Biaohua	裱畫	Hongren	弘仁
Biaohualang	裱畫廊	Hu Lian	胡濂
Boya	伯牙	Hu Qing	胡清
Cai Yisuo	蔡益所	Hu Shikun	胡士昆
cao shu	草書	Hu Yijian	胡易簡
Caochangmen	草場門	Hu Yukun	胡玉昆
Caoxiang Tang Ji	草香堂集	Hu Zhengyan	胡正言
Changwu zhi	長物志	Hu Zongzhi	胡宗智
Chen Jiru	陳繼儒	Hualu Gang	花露崗
Chen Xin	陳昕	Huang Daozhou	黃道周
Cheng Sui	程邃	Huang Gongwang	黃公望
Dai Benxiao	戴本孝	Huang Yuji	黃虞稷
Dai Jin	戴進	Huating	華亭
Difushan	氐父山	*Huayu*	畫寓
Dong Qichang	董其昌	*hui Gong*	灰龔
Dong Yuan	董源	Ji Cheng	計成
Donglin	東林	Jiang Shan	蔣山
Du Fu	杜甫	Jiangdongmen	江東門
Du Hua Lu	讀畫錄	Jiangnan	江南
Du Mu	杜牧	*Jiangshan*	江山
er xi	二溪	*Jiangtianchansi*	江天禪寺
Fan Kuan	范寬	*Jiankang shilu*	建康實錄
Fan Yi	樊沂	*Jiaoshu*	校書
Fang Shan	方山	Jieziyuan	芥子園
Fang Wen	方文	*Jilongshan*	雞籠山
Feng Shihua	馮時化	Jin'aoling	金鰲嶺
Fenghuang Tai	鳳凰臺	*Jingding zhi*	景定志
Fu She	復社	Jinhua	金華
fupi cun	斧劈皴	*Jinling sanyi*	金陵三逸
Fuyushan	浮玉山	*Jinling xXiqi*	金陵習氣
Fuzimiao	夫子廟	*Jinling yayou bian*	金陵雅遊編
Gao Fu (also named Kangsheng)	高阜，康生	*Jinshi*	進士
Gao Ming (Zecheng)	高明，則誠	*Jiushi*	酒史
Gao Yu (also named Yuji)	高遇，雨吉	Jubao	聚寶
Gaoyuan	高遠	Juelang Daosheng	覺浪道盛
Gu Hongzhong	顧閎中	Juran	巨然
Gu Kaizhi	顧愷之	Jurong	句容
Gu Mengyou	顧夢遊	*kai shu*	楷書
Gu Qiyuan	顧起元	*Kaopan yushi*	考槃余事

kezi juanbei	刻字鐫碑	Qiao Kepin	喬可聘
Kong Shangren	孔尚任	Qiao Lai	喬萊
Kunqu	昆曲	*qin* (zither)	琴
Kunshan	昆山	*qing*	清
Li Bo	李白	*qing jing*	清靜
Li Cheng	李成	*qing ke*	清課
Li Jing	李璟	*qing tan*	清談
Li Shangyin	李商隱	*qing xu*	清虛
li shu	隸書	*qing ya*	清雅
Li Yong	李雍	*Qingliang Huancui*	清涼環翠
Li Yu	李煜	Qingliangshan	清涼山
Li Zicheng	李自成	Qingming	清明
Liang	兩	*Qingxi Youfang*	清溪遊舫
Liang Qingbiao	梁清標	Qinhuai	秦淮
Linggu shensong	靈谷深松	Qiu Ying	仇英
Lingu Si	靈谷寺	Qixia Shan	棲霞山
Lishui	溧水	*Qixia Shenggai*	棲霞勝概
Liu Du	留都	Ruan Dacheng	阮大鋮
Liu Haisu	劉海粟	Sanshan Jie	三山街
Liu Yu	柳堉	Shadeng Pai	紗燈派
Liu Yuxi	劉禹錫	*Shang zheng*	觴政
Longjiang Baochuan Chang	龍江寶船廠	Shangfangmen	上方門
Longjiang Guan	龍江關	Shangu Ying	扇骨營
Longyousi	龍遊寺	Shangyuan	上元
Loudong	婁東	*Shanju*	山居
Lu Guimeng	陸龜蒙	Shanlin Chengshi	山林城市
Ma'an Shan	馬鞍山	*Shanshui*	山水
Mei Gang	梅崗	*Shanshuiketugao*	山水課徒稿
Mi Fu	米芾	*She*	社
Ming shi	明史	*shen pin*	神品
Mochou	莫愁	Shen Zhou	沈周
Mufu Shan	幕府山	*Shenyou*	神遊
Nandu fanhui tu	南都繁會圖	*Sheshan*	攝山
Ni Yuanlu	倪元路	Shi Kefa	史可法
Ni Zan	倪瓚	Shicheng	石城
Ningzhen	寧鎮	Shicheng huju	石城虎踞
Niushou Shan	牛首山	Shitao	石濤
Pan Jingshu	潘靜淑	Shitou Shan	石頭山
Penghaoren	蓬蒿人	Shitoucheng	石頭城
pima cun	披麻皴	Shixi	石溪
pingyuan	平遠	*Shizhuzhai shuhua pu*	十竹齋書畫譜
Pipa Ji	琵琶記	Shizi Gang	石子崗
Pushuting Shuhua Ba	曝書亭書畫跋	Shizi Shan	獅子山
Qian Qianyi	錢謙益	*Shuicun tu*	水村圖

SELECTED BIBLIOGRAPHY

Addiss, Stephen, et al. *Resonance of the Qin in East Asian Art*. New York: China Institute Gallery, 1999.

Barnhart, Richard. *Peach Blossom Spring: Gardens and Flowers in Chinese Painting*. New York: Metropolitan Museum of Art, 1983.

Cahill, James. *The Compelling Image: Nature and Style in Seventeenth-Century Painting*. Cambridge, Mass.: Harvard University Press, 1982.

———. "The Early Styles of Kung Hsien." *Oriental Art*, n.s. 16, no. 1 (1970): 51–71.

Chen Chuanxi. "Guanyu Jinling bajia de duozhong jizai he Chen Zhuo." *Dongnan wenhua* (1989, no. 4/5).

Chen Zuolin. *Fenglu Xiaozhi*. In *Nanjing Wenxian*. Juan 2. 1947–49; reprint, Shanghai: Shanghai Shudian, 1991.

———. *Jinling suozhi wuzhong*. Woodblock edition, n.p., Guangxu *yiyounian* [1885].

Contag, Victoria. *Chinese Masters of the 17th Century*. Trans. Michael Bullock. Rutland, Vt. and Tokyo: Tuttle, 1969.

Dufu quanji. Shanghai: Shanghai guji chubanshe, 1996.

Eight Dynasties of Chinese Painting: the collections of the Nelson Gallery-Atkins Museum, Kansas City, and the Cleveland Museum of Art. Cleveland, Ohio: Cleveland Museum of Art, 1980.

Exhibition of the Peking University Library's Collection. Beijing: Beijing University and Youling Tang of Japan, 1987.

Fang Wen. *Tushan ji*. Shanghai: Shanghai guji Chubanshe, 1979.

Fong, Wen C. *Beyond Representation: Chinese Painting and Calligraphy 8th–14th Century*. New York: The Metropolitan Museum of Art, 1992.

———. "Creating a Synthesis." In *Possessing the Past: Treasures from the National Palace Museum, Taipei*, edited by Wen C. Fong and James C. Y. Watt. New York: The Metropolitan Museum of Art, 1996.

Fong, Wen C. and James C.Y. Watt, ed. *Possessing the Past*. New York: Metropolitan Museum of Art; Taipei: National Palace Museum, 1996.

Gong Banqian shanshuiketugao. Beijing: Beijing shangwu yinshuguan, 1935.

Gu Qiyuan. *Kezuo zhuiyu*. Reprint, Beijing: Beijing zhonghua shuju, 1997.

Ji Shijia and Han Pinzheng. *Jinling shengji daquan*. Nanjing: Nanjing chubanshe, 1993.

Jiang Zanchu. *Nanjing shi hua* (The History of Nanjing). Nanjing: Nanjing Chubanshe, 1995.

Jin Ao. *Jinling daizheng lu*. 1844; woodblock reprint, Jinling, the second year of Guangxu [1876].

Kim, Hongnam. *The Life of a Patron: Zhou Lianggong (1612–1672) and the Painters of Seventeenth-Century China*. New York: China Institute, 1996.

Laing, Ellen Johnston. "Neo-Taoism and the 'Seven Sages of the Bamboo Grove,' in Chinese Painting." *Artibus Asiae* 36 (1974), no. 1/2: 5–54.

Liang Baiquan. *Nanjing bowuyuan cangbaolu*. Shanghai: Shanghai wenyi chubanshe and Sanlian shudian, 1992.

Lin Shuzhong. "Gong Xian nianpu." *Dongnan wenhua* (1990, no. 5).

———. "Jinling huapai yu Jinling wenhua." *Dongnan wenhua* (1989, no. 4/5).

Liu Gangji. *Lidai huajia pingzhuan*. Juan 2. Hong Kong: Zhonghua shuju, 1986.

Lu Li. "Gong Xian yanjiu buyi," *Dongnan wenhua* (1988, no. 5): 134–144.

Lu Wujin. *Anecdotes of Locations of Nanjing*. Nanjing: Nanjing Chubanshe, 1998.

Ma Hongzeng. "Gong Xian de yipin lun yu 'Jinling sanyi'. " *Dongnan wenhua* (1990, no. 5).

Mote, F. W. "The Transformation of Nanking, 1350–1400." In *The City in Late Imperial China*, edited by G. William Skinner. Stanford: Stanford University Press, 1977.

Murck, Alfreda. "Eight Views of the Hsiao and Hsiang Rivers by Wang Hung." In *Images of the Mind*, by Wen Fong, et al. Princeton, N.J.: The Art Museum, Princeton University, 1984.

Ouyang Hai. *Nanjing qihou zhi*. In *Nanjing wenxian*. juan 4. Reprint, Shanghai: Shanghai shudian, 1991.

Qian Hang and Cheng Zai. *Shiqi shiji Jiangnan de shehui shenghuo*. Taipei: Taibei nantian shuju, 1998.

Qian Yong. *Luyuan conghua*. Beijing: Zhonghua shuju, 1997.

Siren, Osvald. *Chinese Painting: Leading Masters and Principles*. New York: Ronald Press,1958.

Soper, Alexander C. "A New Chinese Tomb Discovery: the Earliest Representation of a Famous Literary Theme." *Artibus Asiae* 24 (1961), no. 2: 79–86.

Suzuki Kei. *Comprehensive Illustrated Catalog of Chinese Paintings*. 5 vol. Tokyo: University of Tokyo Press, 1983.

Wang Bomin. *Zhongguo huihua shi*. Shanghai: Shanghai renmin meishu chubanshe, 1983.

Wang Hongjun and Liu Ruzhong. "Mingdai houqi Nanjing chengshi jingji de fanrong he shehuishenghuo de bianhua." *Zhongguo lishi bowuguang guankan* (1979, no. 1): 99–106.

Wang Qingzhen. "The Arts of Ming Woodblock-printed Images and Decorated Paper Albums." In, *The Chinese Scholar's Studio: artistic life in the late Ming period*, edited by Chu-Tsing Li and James C.Y. Watt. New York: Asia Society, 1987.

Wen Zhenheng. *Zhangwu zhi*. Nanjing: Jiangsu kexue jishu chubanshe, 1984.

Wu Chengxue. *Wanming xiaopin yanjiu*. Nanjing, Jiangsu guji chubanshe, 1998.

Xiao Ping and Liu Yujia. *Gong Xian*. Changchun: Jilin meishu chubanshe, 1996.

Xie Guozhen. *Mingqing zhiji dangshe yundong kao*. Beijing: Zhonghua shuju, 1982

Xie Zhaozhe. *Wu za zu*. Reprint, Kyoto: Kobayashi Shobe, Kansei 7 [1795].

Xu Zi. *Xiao tian jizhuan*. Woodblock printed, Jinling: n.p., Guangxu 13 [1887].

Yang Xin. "Kuncan." In *Nanjing bowuyuan cangbao lu*, by Liang Baiquan. Shanghai: Shanghai wenyi Chubanshe he sanlian Shudian, 1992.

Ye Chucang and Liu Yizhi. *Shoudu zhi*. Reprint, Nanjing: Nanjing gujiu shudian, 1985.

Yu Huai. *Banqiao zaji*. Shanghai: Dada tushu gongyingshe, 1934.

Yu Jianhua. *Zhongguo Meishujia Renmin Cidian*. 1981; reprint, Shanghai: Shanghai Renmin Meishu Chubanshe, 1996.

Yu Yunyao. *Qinhuai gujin daguan*. Nanjing: Jiangsu kexuejishu Chubanshe, 1990.

Zhang Baochai. "Gong Xian 'Qiujiangyushe tuzhou' shixi." *Dongnan wenhua* (1988, no. 5).

Zhang Chao. *Yuchu xinbian*. Juan 3. Shijiazhuang: Hebei Renmin Chubanshe, 1985.

Zhang Dai. *Tao'an mengyi*. Reprint, Changchun: Jilin wenshi chubanshe, 2001.

Zhang Zining. "Gong Xian he Kuncan." *Dongnan wenhua* (1990, no. 5).

Zhou Hui. *Jinling suoshi*. Juan 2. Beijing: Beijing wenxueguji kanxingshe, 1955.

Zhou Jiyin. *Zhongguo hualun jiyao*. Nanjing: Jiangsu meishu chubanshe, 1997.

Zhou Lianggong. *Du hua lu*. In *Huashi congshu*, edited by Yu Anlan. Juan 10. Shanghai: Shanghai renmin meishu chubanshe, 1963.

———. *Laigutang shuhuaba*. In Lu Fusheng, *Zhongguo Shuhua quanshu*. Juan 7. Shanghai: Shanghai Shuhua Chubanshe, 1994.

Zhu Yizun. *Pushuting Shuhua ba*. In *Meishu congshu*, edited by Huang Binghong and Deng Shi. Juan 1. 1928; reprint, Nanjing: Jiangsu guji Chubanshe, 1986.

CHINA INSTITUTE GALLERY EXHIBITIONS: 1966–2003

** 1. SELECTIONS OF CHINESE ART FROM PRIVATE
COLLECTIONS IN THE METROPOLITAN AREA
November 15, 1966–February 15, 1967
Curator: Mrs. Gilbert Katz

** 2. ART STYLES OF ANCIENT SHANG
April 5–June 11, 1967
Curator: Jean Young

** 3. ANIMALS AND BIRDS IN CHINESE ART
October 25, 1967–January 28, 1968
Curator: Fong Chow

** 4. GARDENS IN CHINESE ART
March 21–May 26, 1968
Curator: Wan-go H.C. Weng

** 5. CHINESE JADE THROUGH THE CENTURIES
October 24, 1968–January 26, 1969
Curator: Joan M. Hartman

** 6. FOREIGNERS IN ANCIENT CHINESE ART
March 27–May 25, 1969
Curator: Ezekiel Schloss

** 7. CHINESE PAINTED ENAMELS
October 23, 1969–February 1, 1970
Curator: J.A. Lloyd Hyde

**8. ALBUM LEAVES FROM THE SUNG AND
YUAN DYNASTIES
March 26–May 30, 1970
Curator: C.C. Wang

** 9. MING PORCELAINS: A RETROSPECTIVE
October 29, 1970–January 31, 1971
Curator: Suzanne G. Valenstein

**10. CHINESE SILK TAPESTRY: K'O-SSU
March 24–May 27, 1971
Curator: Jean Mailey

** 11. EARLY CHINESE GOLD AND SILVER
October 21, 1971–January 30, 1972
Curator: Dr. Paul Singer

** 12. DRAGONS IN CHINESE ART
March 23–May 28, 1972
Curator: Hugo Munsterberg

** 13. WINTRY FORESTS, OLD TREES: SOME
LANDSCAPE THEMES IN CHINESE PAINTING
October 26, 1972–January 28, 1973
Curator: Richard Barnhart

** 14. CERAMICS IN THE LIAO DYNASTY:
NORTH AND SOUTH OF THE GREAT WALL
March 15–May 28, 1973
Curator: Yutaka Mino

** 15. CHINA TRADE PORCELAIN:
A STUDY IN DOUBLE REFLECTIONS
October 25, 1973–January 27, 1974
Curator: Claire le Corbeiller

** 16. TANTRIC BUDDHIST ART
March 14–May 24, 1974
Curator: Eleanor Olson

** 17. FRIENDS OF WEN CHENG-MING:
A VIEW FROM THE CRAWFORD COLLECTION
October 24, 1974–January 26, 1975
Curators: Marc F. Wilson and Kwan S. Wong

** 18. ANCIENT CHINESE JADES FROM THE
BUFFALO MUSEUM OF SCIENCE
April 3–June 15, 1975
Curator: Joan M. Hartman

** 19. ART OF THE SIX DYNASTIES:
CENTURIES OF CHANGE AND INNOVATION
October 29, 1975–February 1, 1976
Curator: Annette L. Juliano

** 20. CHINA'S INFLUENCE ON AMERICAN
CULTURE IN THE 18TH AND 19TH CENTURIES
April 8 –June 13, 1976
Curators: Henry Trubner and William Jay Rathburn
(Exhibition traveled to the Seattle Art Museum,
October 7–November 28, 1976.)

21. CHINESE FOLK ART IN AMERICAN
COLLECTIONS: EARLY 15TH THROUGH
20TH CENTURIES
October 27, 1976–January 30, 1977
Curator: Tseng Yu-Ho Ecke

22. EARLY CHINESE MINIATURES
March 16–May 29, 1977
Curator: Dr. Paul Singer

** 23. I-HSING WARE
October 28, 1977–January 29, 1978
Curator: Terese Tse Bartholomew
(Exhibition traveled to the Nelson Gallery of Art,
Kansas City, February 19–May 21, 1978,
and the Asian Art Museum of San Francisco,
June 16–September 21, 1978.)

For information on availability of these titles and others, please contact China Institute in America at (212) 744–8181

** No catalog or exhibition catalog published by another institution*

*** Catalog out of print*

CHINA INSTITUTE

Clare Tweedy and Howard McMorris
Theresa M. Reilly
James and Joanne Quan Reynolds
Daniel Shapiro
Linda R. Shulsky
Anthony M. Solomon
Ronald P. and Mei Wu Stanton
Charles J. Tanenbaum
Henry and Patricia P. Tang
Theow-Huang Tow
Mary J. Wallach
Shao F. and Cheryl L. Wang
Charlotte C. Weber
Marie-Hélène and Guy A. Weill
Wan-go H.C. Weng
Yvonne V. Wong
Yvonne C. and Frederick Wong
Robert P. and Barbara Youngman
Ivan D. Zimmerman and Taryn L. Higashi

Academic
Annette L. Juliano and Joseph L. Geneve
William Raiford

GALLERY COMMITTEE

John R. Curtis, Jr., Chair

Susan Beningson
Maggie Bickford
Claudia G. Brown
Robert Harrist
Maxwell K. Hearn
Annette L. Juliano
H. Christopher Luce
David Sensabaugh
Marie-Hélène Weill

GALLERY

Willow Weilan Hai Chang, Director
Pao Yu Cheng, Gallery Coordinator
Leigh Tyson, Gallery Registrar

DOCENTS

Nora Ling-yun Shih, Senior Docent
Stephanie Lin
Roberta Nitka
Nora Olsen
Susan S. Yu
Bin Yuan

VOLUNTEERS

Ann Dillon
Jackie Handel
Pamela May
Mary McFadden
Jeannette N. Rider
Anna-Rose Tykulsker
Yvonne V. Wong
Anastassia Zinke

Jinling (Gold Mountain)
Seal by Zhou Xiaolu